Soap Operas and Telenovelas
in the Digital Age

Toby Miller
General Editor

Vol. 20

The Popular Culture and Everyday Life series
is part of the Peter Lang Media and Communication list.
Every volume is peer reviewed and meets
the highest quality standards for content and production.

PETER LANG
New York • Washington, D.C./Baltimore • Bern
Frankfurt • Berlin • Brussels • Vienna • Oxford

Soap Operas and Telenovelas in the Digital Age

Global Industries and New Audiences

EDITED BY DIANA I. RIOS AND MARI CASTAÑEDA

PETER LANG
New York • Washington, D.C./Baltimore • Bern
Frankfurt • Berlin • Brussels • Vienna • Oxford

Library of Congress Cataloging-in-Publication Data

Soap operas and telenovelas in the digital age: global industries
and new audiences / edited by Diana I. Rios, Mari Castañeda.
p. cm. — (Popular culture and everyday life; vol. 20)
Includes bibliographical references and index.
1. Television soap operas. I. Rios, Diana I. II. Castañeda, Mari.
PN1992.8.S4S575 791.45'6—dc22 2010046188
ISBN 978-1-4331-0823-5 (hardcover)
ISBN 978-1-4331-0824-2 (paperback)
ISSN 1529-2428

Bibliographic information published by **Die Deutsche Nationalbibliothek**
Die Deutsche Nationalbibliothek lists this publication in the "Deutsche
Nationalbibliografie"; detailed bibliographic data is available
on the Internet at http://dnb.d-nb.de/.

FSC
Mixed Sources
Product group from well-managed
forests, controlled sources and
recycled wood or fiber

Cert no. SCS-COC-002464
www.fsc.org
©1996 Forest Stewardship Council

Cover concept by Joseph B. Krupczynski

The paper in this book meets the guidelines for permanence and durability
of the Committee on Production Guidelines for Book Longevity
of the Council of Library Resources.

© 2011 Peter Lang Publishing, Inc., New York
29 Broadway, 18th floor, New York, NY 10006
www.peterlang.com

Contents

SECTION IV: ENDURING ISSUES FOR TELEVISION
IN THE ERA OF GLOBAL HYBRIDITY

Introduction

Diana I. Rios & Mari Castañeda

When researchers mention that they study popular mass media and specifically soap operas and telenovelas, other scholars, and at times members of the public, become wide-eyed with wonder. They may even suppress laughter. They are indicating surprise or hidden delight that melodramatic serials can be the subject of serious academic deliberation. Why does the study of this tele-visual genre incite such reactions that other media topics would not? Can tel-evision programs that we, the editors, have utilized as ways for spending time with our *abuelitas* (grandmothers), be the basis for generating scholarly work? The answer is, most certainly. In fact, soap operas and telenovelas are watched by millions of people per day around the world, and telenovelas specifically are some of the most important commodity exports from Latin America and are becoming important media exports for other world regions. In addition, telenovelas have become sites for governmental communication (e.g. in the recent U.S. Census), family and community gatherings, connections to cul-ture and identity, and contributors to the public sphere with regard to socie-tal and political issues. As cultural, social, and economic phenomenon, soap operas and telenovelas are worthy of examination and must be studied if we are to understand the role of global media content in the digital age. As these programs continue to be exported and transformed at regional levels, and through digitalization, it is more important than ever to analyze where the genre has been, where it is now and where it is going. This collection brings together original scholarship on melodramatic serials that originate in various parts of the world. The chapters address pressing issues, relevant theories, and debates that are inextricably linked to soap operas and telenovelas as global

industries, as sites for new audiences, and as hybrid cultural products within the digital landscape.

Indeed, along with the rapid transformation of mediated communication, soap operas and telenovelas continue to be persistent theoretical, socio-cultural, and politic-economic global media. Increased technological innovations (for instance, YouTube, Web fan sites, DVDs, mobile communication devices), programming hybridizations, population migrations, and historical tastes are some elements that have fueled the persistence and transformation of these serialized melodramas. This trans-disciplinary, popular mass communication volume will address several overlapping concerns of the melodramatic serial in localized, translocal, and global contexts. The major, interconnected areas to be addressed are the political economy of the global soap opera and telenovela industry, creative writing, visual production, media labor, international-flow patterns, and communication regulatory policies as well as how the serials are used for entertainment-education and health promotions, social learning, subversive practices, unique experiences of ethnic and racial minorities, and intersections of gender and class.

What we call soap operas and telenovelas are mediated serials that are constructed by commercial organizations and consumed by audiences in the United States and around the globe. These dramas have witnessed wide-ranging success in their countries of origin such as in the U.S., Mexico, Brazil, and India, and have gained important export value to countries such as Italy, Israel, Kenya, and Korea. Also, this genre is experiencing tremendous change. This edited volume examines mediated functions of soap operas and telenovelas within changing media industries and how this is intricately connected to the ever-shifting audience. Consequently, our approach to the topic expands the theoretical and empirical analyses from previously established research while anchoring itself in the field of communication.

This book builds on the important work produced by many scholars who have written on melodramatic television. This includes but is not limited to Allen (1985) *To be Continued. . .Soap Operas Around the World*; Hobson (2003) *Soap Opera*; Spence (2005) *Watching Daytime Soap Operas: The Power of Pleasure*; Mazziotti's (2006) *Telenovela: Industria y Practicas Sociales*; and most recently, Benavides (2008) *Drugs, Thugs, and Divas: Telenovelas and Narco-Dramas in Latin America*; and Stavans (2010) *Telenovelas*. These works along with many other scholarly books and articles have contributed to the understanding of soap operas and telenovelas as serving functions for viewers, impacting the development of globalized popular culture, and constructing national and transnational audiences. However, gaps in the research exist. More of a comparative global framework is needed along with a broader range of case studies that both include and expand beyond the U.S., U.K.,

and Latin America contexts. Our research offers a global range of content and perspectives. In an effort to accomplish this, the book is divided into four areas. We begin with *Contextualizing the Historical, Industrial, and Cultural Flow of Telenovelas and Soap Opera Productions*, followed by *Global Case Studies of Serial Television Dramas and the Emergence of New Audiences*. The third area is called *Sexuality and Gender as Powerful Forces in Telenovelas and Soap Operas*. Our final area is called *Enduring Issues for Television in the Era of Global Hybridity*. Together, these four areas demonstrate the continuing importance of telenovelas and soap operas in the digital age, and the value that this tele-visual genre produces as a globalized media commodity and site for community connections. We now turn our attention to brief descriptions of each chapter.

Our first section begins with a chapter by Mari Castañeda titled *Transcultural Political Economy of Telenovelas and Soap Operas in the Digital Age*. The author examines the ways in which trade policies and digital media have impacted the telenovela industry on a global scale. The chapter by Jaime S. Gomez, *Telenovelas from the Rio Grande to the Andes: The Construction of Latin American Identities through Media Production Creative Processes*, provides a descriptive account and analysis of two telenovela producers, including their vision of production and reception. Sung-Yeon Park, Gi Woong Yun, and Soo Young Lee write about the *Emergence of Asian Dramas as a Global Melodramatic Genre: The Case of Korean Television Dramas*. They examine the "Korean Wave," a prominent media trend in Asia that has direct relevance for Korean drama fans and their online activities. Tamar Ginossar writes about *Media Globalization and "The Secondary Flow": Telenovelas in Israel*. She examines the processes of production and consumption of telenovelas in Israel.

Section two begins with a chapter by Cacilda M. Rêgo titled *From Humble Beginnings to International Prominence: The History and Development of Brazilian Telenovelas*. Rego examines the history and development of the Brazilian *novela*, and how it has thematically and aesthetically transformed with the times. In the chapter called, *The Cultural and Political Economy of the Mexican Telenovela, 1950–1970*, by Melixa Abad-Izquierdo analyzes telenovelas from the late 1950s to early 1970s and the social and political contexts of post-revolutionary Mexico. Next, Daniela Cardini discusses key moments in the history of the Italian soap opera as a new television genre and the Italian television system in her chapter titled, *Looking for 'A Place in the Sun'?: The Italian Way to Soap Opera*. Furthermore, *Kenyan Soap Operas as Functional Entertainment: Redefining the Role of Television Melodrama for an Active Audience*, by George Ngugi King'ara, explores soap operas as entertainment,

their functions, and implications for viewers.

The third section begins with a chapter by Petra Guerra, Diana I. Rios, and Robert Forbus called *'Fuego en la Sangre' Fires Risky Behaviors: A Critique of a Top-Rated Telenovela and its Sexual Content*. Together these authors argue that telenovelas and soap operas present misleading messages about sexuality and sexual health. Héctor Fernández L'Hoeste writes *Gender, Drugs, and the Global Telenovela: Pimping Sin Tetas no Hay Paraíso*. He critiques a famous Colombian telenovela that presents working-class teenagers moonlighting as prostitutes for drug kingpins. The research by Catherine Medina called *The Third Subplot: Soap Operas and Sexual Health Content for African American and Latino Communities*, addresses how entertainment-education encourages African American and Latino communities to become engaged in HIV/AIDS prevention behaviors. The chapter called *Hybridity in Popular Culture: The Influence of Telenovelas on Chicana Literature* by Belkys Torres, examines the subversive potential of what two eminent Chicana novelists do with telenovelas.

The fourth and final area of this collection begins with a chapter by Martín Ponti titled *Globo vs. Sistema Brasileira de Televisão (SBT): Paradigms of Consumption and Representation on Brazilian Telenovelas*. He describes how the success of a particular Brazilian telenovela enabled *SBT* to gain audiences who were traditionally faithful to Globo's telenovelas. The chapter titled *'Trashy Tastes' and Permeable Borders: Indian Soap Operas on Afghan Television*, by Wazhmah Osman explores how and why Indian soap operas are one of the critical factors in the current Afghan cultures wars with their contesting claims of Afghan identity. This is followed by Courtney Brannon Donoghue's *Importing and Translating Betty: Contemporary Telenovela Format Flow within the United States Television Industry*. She examines the rise of Ugly Betty as a transnational cultural product. The final chapter of the collection is by Christa Salamandra who writes *Arab Television Drama Production in the Satellite Era*. Her work is grounded in field research among drama creators in Damascus and programming executives in the United Arab Emirates and she explores the cultural politics of musalsal (literally "series") production in the satellite era.

In conclusion, we foresee that our collective research will contribute to as well as expand the established literature on soap operas and telenovelas. The breadth, depth and originality of all the chapters demonstrate the richness of the genres and their long-term significance as the televisual landscape evolves and becomes increasingly reliant on technological and creative innovations.

We are grateful to many people for helping us bring this project to fruition. Many thanks to our authors for their participation in this important intellec-

tual endeavor and for their valuable research contributions on global melo-drama. We would also like to thank series editor Toby Miller, Mary Savigar and Sophie Appel at Peter Lang, and anonymous reviewers for their excellent editorial feedback.

Thanks for institutional support through the Institute of Puerto Rican and Latino Studies at the University of Connecticut and from the Department of Communication at the University of Massachusetts.

Lastly, *mil gracias* and *merci infiniment* to our families and friends in the United States and abroad—especially, Manuel Fernandez, Ramona C. Rios, Guadalupe Hernandez, Joseph Krupczynski, and Miguel Angel Paredes—for their love, patience and continuous support throughout this project. This collaboration would not have been possible without all of you.

Section I

Contextualizing the Historical, Industrial, and Cultural Flow of Telenovelas and Soap Opera Productions

1. The Transcultural Political Economy of Telenovelas and Soap Operas in the Digital Age

Mari Castañeda

There is a growing global demand for telenovelas and the production of soap operas that are culturally and geographically responsive. Global media companies such as Dori Media Group Ltd. (which has offices in Argentina, Israel, Switzerland and Miami) have built television content empires that solely focus on the international production, distribution and merchandising of televisual serials that include traditional and online media venues. DMG has especially emphasized the global trade of telenovelas since it strongly believes that "there is no greater loyalty-generating content" than the daily melodramas constituting the telenovela genre or more bankable audiences than telenovela fans ("Dori Media Group Company Profile," 2009). The global success of these particular televisual serials has permitted DMG to foster worldwide business connections in "approximately 65 territories and 400 TV channels worldwide." DMG also aims to create national telenovela-dedicated television channels and internationally available telenovela Websites ("Dori Media Group Company Profile," 2009). While the importation of telenovelas has historically been more successful in certain parts of the world than others, as Biltereyst and Meers (2000) have noted, the impact of telenovela products in the global media landscape is undeniable.

The economic and cultural power of telenovelas is further evident, for instance, by the recent partnership between the U.S. Census Bureau and Telemundo in order to promote the 2010 Census in the telenovela *Más Sabe*

el Diablo/The Devil Knows Best (Stelter, 2009). Many U.S. Latinos, especially those who are dominantly Spanish-speakers, remain uninformed about the purpose and activities related to the census. It's estimated that a quarter of a million Latinos to 1.3 million were not counted in the 2000 census due to language barriers, fear of government paperwork and lack of awareness ("Dori Media Group Company Profile," 2009). In *Más Sabe el Diablo*, the main character Perla Beltran begins working as a street food vendor but over the course of several encounters, she applies and is hired as a U.S. Census worker. Throughout multiple episodes, there are several scenes that amount to a somewhat "Census 101" which clarify why "the count matters" and the confidential nature of the collected information (Stelter, 2009). Not surprisingly, Telemundo views the collaboration as mutually beneficial since census figures of the Hispanic population are expected to show significant increase.

Not only does this affect congressional districts and the distribution of federal dollars, estimated at $400 billion that are apportioned to districts each year; but after years of advertising budget disparity within the mainstream media landscape, the census figures will allow Spanish-language networks to demonstrate their growing significance in the U.S. Latino consumer marketplace (Stelter, 2009). Thus televised serials such as telenovelas are venues that can provide audiences with informational, emotional and/or political substance and also function as sites for corporate profit-making and government interventions.

By applying a transcultural political economic framework, this chapter aims to explore why and how this is the case, especially given the changing media landscapes that telenovelas and soap operas find themselves operating within. Ultimately, the chapter argues that these televisual cultural products are gaining greater importance because they embody the ultimate crossover phenomenon of penetrating global markets, with a proven commercial product, while also giving pleasure to audiences. None of this is lost on media owners who clearly recognize that the sale, distribution and consumption of such commodities also "require and rest upon routine access to commercial media advertising" and trans/national communication systems (Mosco & Schiller, 2001, p. 12). Lastly, despite the globalization and increasingly digitalization of telenovelas and soap operas, the evolution, transformation and endurance of these genres demonstrate that melodramatic storytelling will not cease even as new forms of media programming and distribution are created. Staubhaar and La Pastina (2005) confirm that "melodrama builds on underlying oral structures, formulas, and archetypes that [have been] shared by cultures" over time through verbal, print and broadcast forms (p. 275). Therefore, while reality-based television content may deeply penetrate worldwide media markets today, its popularity does not signify the end of telenovelas and soap operas. The multi-layered "cultural proximity" of the melodrama genre—

namely the ways in which the culture of a text and local culture are linked—continues to act as important facets of the global communications trade, and within national markets (Turner, 2006; Mato, 2006).

Therefore, understanding the endurance of telenovelas as a translocal cultural form and commodity requires understanding how the local and global intersections of capital flows, the state and cultural practices create communication systems, products and experiences that are linked by transnational agents. According to Chakravartty and Zhao (2008), an analysis of the transcultural political economy of media and communications:

> . . . enables us to integrate institutional and cultural analyses and address urgent questions in global communications in the context of economic integration, empire formation, and the tensions associated with adapting new privatized technologies, neoliberalized and globalized institutional structures, and hybrid cultural forms and practices (p. 10).

The study of telenovelas thus includes an examination of the contradictions, opportunities, and fluidity between and within structural conditions and everyday practices. A transcultural political-economic framework also embodies a commitment to probing telecommunication inequities and promoting a social justice orientation to media access, uses and policy. Consequently, we are better able to discern how certain cultural and commodity forms are the result or representations of "awkward and uneven global encounters, new modes of citizenship and exclusion, and the aspirational logic of modernity, which is so viscerally embodied through the lure and promise of the global information and culture industries" (Chakravartty & Zhao, 2008, p. 15). Telenovelas and soap operas, especially their production, distribution and consumption, are excellent sites for investigating how this is the case. This chapter will do so by situating the meaning of telenovelas and discussing their role in an interconnected global economy as well as examining how trade policies and digital media have impacted the industry. Ultimately, the chapter aims to show how telenovelas "are always entangled with the interests, desires, or imaginations of those whom [corporations] seek to entice as consumers;" patrons who include not only audiences, but advertisers and governments as well (Dávila, 2001, pp. 14–15).

Situating the Meaning of Telenovelas and Soap Operas

Telenovelas and soap operas have a historical trajectory that comes from a long tradition of storytelling and community interaction (Rogers & Singhal, 1999; Hobson, 2003). Similar to other forms of community narratives, televised seri-

als provide "intimate familiarity with the characters [and issues]; moreover, the intimate familiarity is shared with other members of the audiences, so that the shared knowledge can contribute towards the belief in the reality of the genre" (Hobson, 2003, p. 31). Presently, the processes of globalization and digitalization may be restructuring the practices of telenovelas and soap operas in ways that perhaps were not initially imagined in terms of form and content. Yet as emerging studies show, many of which are included in this edited monograph, these televisual genres continue to remain meaningful for a variety of stakeholders (Baym, 2000). They create consumers and communities; they work as venues for social messages and marketing; and they reinforce and challenge the status quo, just to name some of the implications associated with telenovelas and soap operas.

Various historical studies tell the story of how U.S. commercial radio gave birth to soap operas when soap companies deliberately aimed to reach female consumers (Hobson, 2003, p. 2). By sponsoring multiple-plot professionally acted radio programs, soap and domestic products marketers could reach women on a daily basis through the mass broadcast of soap opera compositions (see Allen, 1995; Blumenthal, 1997; Meyers 2008). Similarly, the incarnation of telenovelas first emerged in Mexican radio, where many of the radio-plays were based on the mass appeal of fotonovelas, also known as printed serial narratives (see Mazziotti, 1996; Mato, 2001; Maas & González, 2005). The transition from radio to television-based novelas and soap operas heralded a new opportunity in which emerging televisual technologies could expand the reach and allure of broadcast programming and advertising since the viewing and hearing senses of audiences could now be fully employed more effectively.

Consequently, an important theme that emerges throughout the histories of telenovelas and soap operas is that they are "part of the shared knowledge of the viewing audience, part of the fabric of other media—radio, press and publishing." In the present day, this media fabric now also includes digital apparatuses such as online venues and global strategies like product placement and product integration. In addition, the telenovela and soap opera genres have operated as powerful social forces within television and popular culture because they have historically exemplified the "flagship" program and the key element of a broadcast network's "brand." They have also worked as points of connection between and amongst viewers (Hobson, 2003, p. 40). According to Hobson (2003), telenovelas and soap operas have deep resonance with audiences because they are part of what Raymond Williams calls a:

'structure of feeling' which unites the television audience and links the experience of watching cultural forms with our own life experiences. They are readily brought to mind and we associate the stories in soap operas with the times when they were current (p. 200).

Although a popular cultural form's ability to make such connections are not new—for instance, books can conjure memories for readers that often extend beyond the printed storyline—the wide access and mass appeal of telenovelas and soap operas allow viewers to form a collective memory of shared knowledge and experiences that are based on entertainment (Clifford, 2005). The programs can also frequently spark conversations about important social and personal issues that are meaningful to audiences. Telenovelas and soap operas have thus been successful as entertainment commodities because corporations have been able to exploit the "multiple pleasures" of meaning produced by this form of television viewing (Aparicio, 1998, p. 103). As the next section demonstrates, marketers have especially integrated the meaning of telenovelas with the value of advertising on a global scale.

The Role of Telenovelas and Soap Operas in an Interconnected Global Economy

Telenovelas are produced, purchased and consumed not only throughout the Americas, but also in Europe, Asia and the Middle East (see Henriques & Thiel, 2000; Schlefer, 2004; Castelló, 2007). Antonio La Pastina notes that "it is becoming impossible to speak of the future of telenovelas except as part of the wider future of the new information and entertainment systems as they become globally interconnected" (Russell, 2005, p.12). A conference on telenovelas and soap operas, summarized in a 2005 special journal issue of *Television and New Media*, demonstrate the global reach of the genre, its reconceptualization/appropriation at the local level and the central role that it plays in the everyday lives of television viewers, including other media artifacts like news programming (Slade & Beckenham, 2005). The research produced by this gathering of scholars all point to one central theme: daytime soap operas and evening televisual serials have a dynamic relationship with the societies in which they appear. The programming is a powerful social force that indeed impacts social reality, on the one hand. On the other, the material, cultural and social conditions of communities also influence the production of these media forms. It's important to keep in mind, however, that the majority of telenovelas and soap operas are often produced within a commercial landscape, which circumscribes the content, audience relationships and positionality within media systems.

Consider, for example, Televisa's ongoing drive to become a legitimate competitor in the global media arena. Televisa's CEO Emilio Azcarraga Jean views his company as competing directly with Disney, GE Corporation, and Universal Vivendi. With the Latin American diaspora immigrating beyond the US and into Europe, Azcarraga Jean is seeking to dominate the global Spanish-language media market and compete directly through bilingual programming that can cross over into English-language markets as well. Its partnership with Newscorp's direct-to-home (DTH) satellite services in Latin America, Spain and the U.S. is another demonstration that Azcarraga Jean aims to create a global Televisa. The Latin American, professional, middle class, which is growing both at home and abroad, is the key demographic that Spanish-language media companies, like Televisa, wants to attract, thus reinforcing the company's need to have "presence" in an interconnected global economy. This strategy, though long-drawn-out, was actually initiated in the mid-1980s when Televisa was divested of its U.S.-based broadcast system, the Spanish International Network (SIN), which was later renamed Univision by its new owner at the time, Hallmark (Sinclair, 1990). The more recent transnational popularity of telenovelas creates the context through which advertisers can target specific demographics on a global scale, and in some cases, actually link advertised products or include product placement in high-grossing telenovelas. For Televisa and Telemundo, the second largest (Spanish language) television network in the U.S., telenovelas has been very lucrative since the capital investments paid into producing the program can have the capacity to yield a profit that is much greater than the initial expenses.

In 2007, for example, the products of the international Clorox Company became an integral part of the storyline for the telenovela, *Dame Chocolate/Give Me Chocolate*, a nightly serial that aired from March to October on Telemundo. According to advertising executives at DDB Worldwide, they wanted to integrate Clorox products beyond the practice of produce placement. The goal was to actually integrate the consumer goods into the drama, thus expanding the melodramatic appeal for not only love and redemption, but also chocolate and cleaning products. According to Clorox's Vice President of Marketing, the inclusion of their products into the telenovela was a "great global opportunity that would work in the U.S. too" while also bolstering their significant presence in Latin America (Wentz, 2007, p. 55). One example of how product placements occurred in the *Dame Chocolate* plot centered on the false imprisonment of a main character who was only set free after an alleged blood-stained T-shirt is washed with Clorox bleach, "and the police [left] empty-handed after finding only a snowy-white shirt. Less dramatically, two housemaids in very short skirts regularly clean the mansion with Pine-Sol and Clorox, while the gardener fills up Glad trash bags" (Wentz, 2007, p. 55).

Three years after the success of *Dame Chocolate*, Telemundo has developed another telenovela with product placements. The television serial, *Perro Amor/Love Dog*, has a plot narrative that highlights an abundance of driving by main characters, especially from Miami to Key West in Ford vehicles (Wentz, 2010). The corporate partnership between Telemundo and Ford Motor Company will feature prominently in the telenovela and additional online webisodes where audiences can get a fuller view of vehicles used in the program, such as the Ford Mustang, by clicking on live links. The agency, Zubi Advertising, is working closely with Telemundo, including the area of scriptwriting, in order to create prominent yet seamless integrations of Ford commodities in the arc of the story as well as in the web and mobile sectors of the telenovela.

For instance, viewers of *Perro Amor* will receive SMS alerts on their mobile devices reminding them to watch the program, especially when there are active integrations of Ford vehicles in the episode. Thus, telenovelas are themselves becoming vehicles for marketing consumer products not only to transnational Latino audiences, but also consumers from abroad where telenovelas are exported and translated into other languages. In fact, as the next section will show, the liberalization of trade policies has been central in the transformation of telenovelas as global product advertisements (not just simply as venues for broadcasting ads) and as lucrative, creative and powerful tools for consumer product corporations eager to create a "meaningful" presence in new markets.

Liberalizing Trade for a 21st Century Media Landscape

In addition to consumer marketing, the liberalization of trade policies has also influenced the global reach, digital integration and commercialization of telenovelas and soap operas. Since the 1980s, the passage of international trade pacts that reduce tariffs and barriers to marketplace entry has engendered a "free market" approach to the global flow of cultural products, especially those on the mass media landscape. As more countries opened their economies to foreign investment and (digital) commodities, the successful expansion of multilateral trade policies are increasingly important in an emerging global information economy. Barshefsky (2001) notes that "the development of a networked world added a new set of questions [that had to address] not only tangible goods traveling by plane or boat, but also weightless products that move instantaneously around the world by wire or satellite beam" (p. 135).

The transformation of trade through the global expansion of networked

telecommunications also meant that the legal and economic structures of the analog world needed to be revamped in order to be meet growing demands initiated by the digitalization of material and electronic commerce. Iwabuchi (2002) further argues that emergence of "new cultural technologies" has created the context through which governments, especially those located in countries with limited audiovisual sectors, "to change their policies from rigid restrictions on the flow of information and entertainment to more open, market-oriented controls, [thereby opening] new possibilities for the consumption of media texts by audiences" (p. 25). Consequently, television commodities such as telenovelas and soap operas are a small but important piece in the free trade expansion of analog and digital markets around world. *Dame Chocolate*, for instance, can now be viewed online but also purchased by broadcast companies around the world eager for television content, especially popular telenovelas that are dubbed or subtitled.

In the case of Mexico, González (1996) notes that the neoliberal restructuring of trade was in many ways supported by the country's elites because such policies would foster the transnationalization of the Mexican economy within and outside the context of the Americas. The North American Free Trade Agreement (NAFTA), for instance, has expanded the political and economic opportunity for Mexican conglomerates to bolster the exportation of their goods and services, but the audiovisual sector that Televisa dominates has especially benefited from the opening of North American markets, and increasingly, markets around the globe. According to Paxman and Saragoza (2001), the opening of digital markets has also expanded Televisa's reach since:

> It possesses a massive library of programs, its production facilities churn out forty-four thousand hours of annual television output, its soccer teams anchor its extensive sports coverage, and its music recording, radio, and publishing assets reinforce the company's exclusive hold on a number of leading actors, singers, and writers. In this sense, Televisa has the advantage unavailable to U.S. Internet competitors: it has exclusive ownership over most of the content that its portal features (p. 78).

The liberalization of economic structures has thus opened the possibility for companies located in the global south to participate in the highly competitive world stage, particularly against the hegemonic force of the United States. According to Iwabuchi (2002), this can be "read as a symptom of the shifting nature of transnational cultural power in the context in which intensified global cultural flows have de-centered the power structure and vitalized local practices of appropriation and consumption of foreign cultural products and meanings" (p. 35). Yet companies like Televisa and the other dominant southern cone media conglomerates such as Globo and Venevision already exert

enormous cultural power in Latin America, and consequently, the exportation of their media programming through analog and digital venues simply reinforces their goals toward geocultural and political power but on a global scale. The Latin American companies also have very close ties to large transnational telecommunication corporations, which place them on par with other global communication titans and their next-generation wireless and media services. Thus, they may be located in the global south but their interests lie beyond it, which is challenging given their limited economic and political power compared to the multi-billion global media corporations. In certain local markets, Televisa, Globo and Venevision's products may dominate, but beyond Latin America, these companies are often part of larger corporate alliances. For instance in 2008, Televisa formed a strategic alliance with Rogers Cable, Canada's largest cable provider, in order to create two new channels and provide multicultural programming to these outlets ("Televisa Annual Report," 2008). In Brazil, Dos Santos (2009) notes that Globo, along with other national media companies, have sided "telecommunications industries in global strategies of economic dominance" (p. 709), thus integrating local capital with global corporate alliances.

In addition, it is important to remember that although these media conglomerates may be utilizing neoliberal trade policies to export their audiovisual content worldwide, the translocal interpretation of how these products are ultimately produced, distributed and consumed challenges the notion that "transcultural practices" can be predetermined. Indeed, there are "multiple interactions of material, structural, discursive forces, focused on social practice" that are operating simultaneously, unevenly, and with great force that are shaping the telenovela and soap opera global landscape (Kraidy, 2008, pp. 189–190). The emergence of telenovelas around the world and the growing importance of online media are clearly disrupting the traditional media patterns of production, distribution and consumption.

The Digitization of Telenovelas and Soap Operas

Many telenovelas and soap operas are available online and through DVDs, and these digital outlets have bolstered the global access to telenovela and soap opera cultural products. There are thousands of multi-lingual websites (although dominantly in English and Spanish) that provide synopses of the programs, viewer discussion boards, historiographies and fan blogs. A recent Google search for the term "telenovelas" produced 4,680,000 pages whereas "soap operas" produced results that topped over 12,000,000. These numbers demonstrate a real presence in cyberspace. The fact that more and more

viewers are not watching telenovelas on traditional television sets, even if they have been converted to digital, but increasingly consuming televisual serials via computer or mobile devices points to the changes of content production that are taking place in order to correspond with the changing digitally inspired practices of viewers.

The largest Spanish-language television network in the U.S., Univision, recently announced that would begin offering its telenovelas through its mobile and online channel, "Novelas and Series." This new venture from the digital unit of Univision is an attempt to increase its production of Webnovelas, access viewers through digital content and take advantage of the changing patterns of consumption since consumers are spending increasingly more time on their mobile video-enhanced devices. Not only is Univision utilizing its web channel and applications for movil (mobile phones) in order to expand content offerings beyond telenovela programs but also "novela news celebrity gossip, behind-the-scenes footage and message boards" (de la Fuente, 2010, p. 15). The emergence of such devices and changes to audiences' viewing habits thus creates a media environment that fine-tunes production and marketing through the practice of narrow-casting and interactivity. The media experience is more and more about viewers' ability to participate in the delivery of content, either through blogs, live updates or reformulated program sequences. According to the President of Univision Interactive Media, "we have significantly increased our focus on the importance of video, and we are excited about the opportunity to offer our online and mobile audience high quality novela programming from leading content producers around the world"(Univision Communications Inc., 2010, n.p.). Thus, the digitization of telenovelas and soap operas introduces new modes of interactivity while also expanding the purview of digital capitalism.

At the Fifth World Summit of the Telenovela and Fiction Industry, which took place in Barcelona, Spain 2007, the Spanish Senator Luis Salvador, noted that the digitalization of media:

> . . .is a new situation which didn't exist before and which will make formats and contents be forced to adapt precisely to the new demands. We're immersed in a technological context of continuous evolution, what will make you people of the industry have to stay more alert and rush more than ever...Personalized leisure and other ways of watching television currently pressure all of you into working in those multiple models of creation, broadcasting and consumption. These are decisions you will have to base on research and innovation of content, genres and formats. And since there has been a change as regards society and knowledge, I will ask you to step backward and enter the imagination society and, by your work in this Summit, manage to deliver us on the other side of the screen that wonderful dreamworld (*TVMAS Magazine: Only Telenovelas, Fictions and Formats*, 2007, n.p.).

Based on Senator Salvador's statement and the various panels at the 2006 and 2007 telenovela world summits, there is apparently an anxiety about how telenovela and soap opera content providers and distributors will be able to meet the challenges of emerging technological changes, and the foreign adoption of the genre. Many companies in Asia and Europe, for instance, are very interested in purchasing the rights for certain telenovela formats in order to employ nationally-located directors, actors, and film crews, thus creating a more culturally specific product. Although the importation of popular programs with high quality translation is still very important and continues to be the main format in which telenovelas and soap operas are viewed around the globe, the issue of labor and adaptation in the digital age is of great concern for those in the industry. This was evident again the following year at the First Summit on the U.S. Hispanic television market. Amanda Ospina, the Executive Director of *TVMAS Magazine* (the publication that convenes both the World and U.S. telenovela summits) noted at the start of the industry gathering that, "the exploration, definition and start up of new audiovisual services based on digitalization and interactivity, as well as projects related to technologies and personnel training for business models, [is] a real need of this complex market" (*TVMAS Magazine*, 2008, n.p.). The main quandary centers on production costs in order to maintain content quality despite labor constituting the greatest expense and digitalization altering the industry.

For instance, a telenovela program typically runs for 120–180 episodes, and each episode can cost between twenty to eighty-thousand dollars. According to Marcos Santana, the President of Telemundo Internacional which produces and distributes telenovelas worldwide, the selling price of most telenovela programs ranges from "30%–35% of their production cost" (Hecht, 2006, n.p.). While a respectable percentage, such transaction figures do not leave much room for significant profits, unless labor costs are reduced or the life of a telenovela program is extended through its sale to multiple foreign vendors. In addition to challenging the impulse to sell "the product at bargain prices," as was noted at the world telenovela summits, cutting costs increasingly includes the production of telenovelas that can be repurposed for an array of media platforms, such as handheld communication devices and online services. For instance, a telenovela program can be shown on a traditional television platform but smaller video clips about its behind-the-scenes production can become available online through computers or mobile phones, thus increasing audiences' affinity to the program. Programs can also be repurposed to match local tastes, such as the high successful *Betty, la Fea* franchise, which now includes an array of merchandising products such as t-shirts, tote bags, and DVDs. In the U.S., the ABC version, *Ugly Betty*, also included interactive Web sites and a public service campaign, "Be Ugly '07" with the aim of

repurposing content in order to maximize viewer contact. In this case, the marketing strategy circulated and created "an expansive and lucrative branded online environment" that extended the life of the program into the digital world (Esch, 2009).

The growing connection between digital media and telenovelas aims to grapple with production expenses, distribution opportunities, and widening consumer reach. Yet the utilization of digital production technologies to cut costs, outsource editing processes and utilize scriptwriting software is not a new phenomenon, but rather an emerging segment of the New International Division of Cultural Labor (NIDCL). According to Miller and Leger (2001), the NIDCL follows the same multinational business tactic that divides production between multiple nations and continents in order to take advantage of tax incentives, creative labor, and neoliberal policies. As a result,

> [J]ust as manufacturing fled the First World, cultural production has also relocated…Labor market slackness, increased profits, and developments in global transportation and communications technology have diminished the need for collocation of these factors, which depresses labor costs and deskills workers (p. 103).

In the context of the global telenovela industry, international divisions of labor are restructuring national telenovela and soap opera industries and in some cases limiting the potential for such national industries to emerge such as in the case of Nicaragua, Guatemala or Turkey. Miller and Leger (2001) further note that the expansion of information technologies is enabling significant changes "in ownership, control and programming philosophy…Screen texts are fast developing as truly global trading forms" (p. 107). Clarke and de la Fuente (2005) also note that countries such as Germany, Madagascar, Moscow, Holland and South Korea have opened their broadcast programming slots to telenovelas because they provide opportunities for cross-media promotions on analog and digital platforms. In addition, their proven script formulas lowers budgets while also increasing revenue streams, especially if a particular market is saturated, and foreign content provides an alternative for television audiences (Clarke & de la Fuente, 2005).

The rising importance of digital texts in global media and their potential for revenue generation and labor was also noted in UNESCO's *World Communication Report: The Media and the Challenge of the New Technologies* (Maherzi, 1997). This report argues that the transformation of the audiovisual market not only affects national and regional media markets, but also the flow of news and entertainment on a global scale. In addition, such flows (or lack thereof) raise questions about the human right to information and cultural works. Lastly, the report predicts that labor in all areas of production, dis-

tribution and consumption would be affected with the rise of the Internet and digital media. As a result, more co-productions would occur to save money and employ skilled expertise across multiple global sites. Since the late-1990s when the report was initially released, co-productions of telenovelas have become a large portion of the industry, with the majority of such collaborations taking place between transnational media corporations, and also with governments who lend their support.

Interestingly, new forms of labor and expertise are emerging as new media platforms for telenovelas are being created. According to de la Fuente (2010), the online sector is one of the fastest growing, especially for reaching U.S. Latinos. She notes that 64% of Hispanic adults use the Internet regularly, and with telenovelas continuing their domination within Spanish-language television programming, companies like Univision view online venues as important sites for distributing content and reaching audiences. In 2009, the company produced a three times a week, 5–8 minute each, 15-episode online-novela, *Vidas Cruzadas/Crossed Lives* for distribution on Univision.com and accessible via computers and handheld devices. The "Webnovela" featured crossover movie star Kate del Castillo and well-known leading man Guy Ecker, both of whom had starred in the highly-rated telenovela, *La Mentira* ten years prior. The Webnovela also featured interactivity capabilities, thus providing the opportunity for online users to view behind-the-scenes videos and photos as well as participate in a sweepstakes, blogs, "trivia, polls, local tie-ins, and exclusive cast interviews" (de la Fuente, 2008, p. 17). By fall of its debut year there were over two million streams by U.S.-based viewers, thus ranking it number three of all Univision online properties and promising an unprecedented global reach. Univision's recent business partnership with YouTube also illustrates the Spanish-language media company's strategic entry into the emerging Webnovela industry while retaining its stronghold on television. According to Gonzalez (2009), the emergence of e-novelas is not simply an online version of televised nightly serials, but in fact are "acculturated" second-generation telenovelas that are distinctive in their own right. The new form is produced with an online format in mind; they're bilingual with English subtitles; they have a U.S. Latina "feel" to them; the main characters are also bilingual; and the plot lines address modern issues and go beyond the rags-to-riches story that are so prominent in traditional televised telenovelas. For instance, in *Vidas Cruzadas*, the main female character, played by Kate del Castillo, is a second generation professional Latina aiming for the American Dream whose working-class parents immigrated to the U.S. from Latin America. The story of this character very much connects with the experiences of many U.S. Latinos, one of the fastest consumer groups in North America and a pop-

ulation that is increasingly connecting to online, digital media. The recent program venture between America Ferrera, MTV, Proctor and Gamble, and the television producer responsible for *Ugly Betty*, Ben Silverman also attempts to capture Latinos across the media sphere. The new MTV show called *Pedro and Maria*, will be a bilingual, telenovelaesque retelling of *Romeo and Juliet* that will include interactive features through social media such as Facebook and Twitter thus allowing audience members to vote on the direction of the storyline and provide feedback. According to CEO Silverman, the new MTV telenovela is "a groundbreaking new interactive platform that allows us to tap into [the] growing and important [Latino] demographic" (*Interactive TV Today*, 2010) by taking advantage of young people's fondness for the venerated music channel and their use of communication technologies. Consequently, the crossover and digitization of telenovelas reflects a broader trend towards what Keane (2006) calls a "cultural technology transfer" in which transnational coproductions, content expertise and global technological and cultural formats are transferred, reshaped and adopted in order to more successfully compete in today's "multichannel, post-broadcast environment" (p. 845).

Conclusion

This chapter brings together an array of issues regarding telenovelas and soap operas as an attempt to document the transcultural political economy of the industries. It specifically focuses on Spanish-language telenovelas in order demonstrate the dominance of the genre as well as the impact digital media is having on the broader industry. By briefly examining the history of the genre, the role it plays in an interconnected global economy, the influence of trade policies and the technological changes which are disrupting traditional notions of production, distribution and consumption, the chapter builds an argument about importance of telenovelas as successful cultural products that intersect local and global economic and cultural practices. Telenovelas are also becoming transformed through the rise of digital technology, and the effect this transition ultimately has on the evolution of the genre, and viewers' relationship to it is yet to be seen. However, it is clear by the international growth of the industry that telenovelas, unlike English-language U.S. soap operas, are generating considerable revenue and will continue to expand within brick-and-mortar markets as well as cyberspace well into the future. In addition, the crossover influence of telenovelas especially in the U.S. mainstream media marketplace is also being duly noted by corporate owners wanting to create repurposed hybrid media content for new audiences (Goodwin, 2009). The elephant in the room is whether transnational Latino audiences will continue to be wel-

comed as cultural citizens that are making important contributions to the political and economic landscape, and not just to media ratings. As Anzaldúa (Keating, 2009) notes, culture and ideologies are created through media forms, but by examining them we are able to make visible the contradictions, limitations and possibilities of cultural formations.

References

Allen, R.C. (1995). *To be continued…: Soap operas around the world.* New York: Routledge.

Aparicio, F.R. (1998). *Listening to salsa: Gender, Latin popular music, and Puerto Rican cultures.* Hanover, NH: Wesleyan University Press.

Barshefsky, C. (2001). Trade policy for a networked world. *Foreign Affairs, 80*(2), 134–146.

Baym, N.K. (2000). *Tune in, log on: Soaps, fandom, and online community.* Thousand Oaks, CA: Sage Publications.

Biltereyst, D. & Meers, P. (2000). The international telenovela debate and the contra=flow argument: A reappraisal. *Media, Culture & Society, 22*(4), 393–413.

Blumenthal, D. (1997). *Women and soap opera: A cultural feminist perspective.* Wesport, CT: Praeger.

Castelló, E. (2007, March). The production of television fiction and nation building: The Catalan case. *European Journal of Communication, 22,* 49–68.

Chakravartty, P. & Zhao, Y. (2008). Introduction: Toward a transcultural political economy of global communications. In P. Chakravartty and Y. Zhao (Eds.), *Global communications: Toward a transcultural political economy* (pp.1–19). Lanham, MD: Rowman and Littlefield Publishers, Inc.

Clarke, S. & de la Fuente, A.M. (2005, October 10–16). Romance abroad. *Variety,* p. A8.

Clifford, R. (2005). Engaging the audience: The social imaginary of the novela. *Television and New Media, 6*(4), 360–369.

Dávila, A. (2001). *Latinos inc.: The marketing and making of a people.* Berkeley: UC Press. http://corporate.univision.com/corp/en/pr/New_York_22022010–0.html

de la Fuente, A.M. (2010, March 21). Univision logs on more time online. *Variety,* p. 15.

_____. (2008, December 15). Univision lathers cyber–soap. *Variety,* p. 17.

Dori Media Group Company Profile (2009). Retrieved from http://www.dorimedia.com/content.asp?page=profile

Dos Santos, S. (2009). The central role of broadcast television in Brazil's film industry: The economic, political and social implications of global markets and national concentration. *International Journal of Communication, 3,* 695–712.

Esch, M.S. (2009). Rearticulating ugliness, repurposing content: Ugly Betty finds the beauty in ugly. *Journal of Communication Inquiry, 34*(2), 168–183.

First summit Miami, U.S. Hispanic market, opening remarks. (2008). Retrieved from http://www.tvmasnovela.tv/onlytelenovelas/Only_13/em.html

González, H.G. (1996). Mass media and cultural identity among the Yucatec Maya: The constitution of global, national, and local subjects. *Studies in American Popular Culture, 15,* 131–154.

González, M.D. (2009, September 26). Second generation novella or "Webnovela."

Message posted to http://ixmaticommunications.com/2009/08/25/on–cultural–relevance-second-generation-novela-or-webnovela/

Goodwin, C. (2009, January 18). Latino TV station tops US ratings: Spanish language channel Univision topples the major networks as viewing habits reflect a cultural shift among the young. *The Observer*, 47.

Hecht, J. (2006). Telenovela market: A novel approach. *The Hollywood Reporter*. Retrieved from http://www.hollywoodreporter.com/hr/search/article_display.jsp?vnu_content_id=1003157038

Henriques, E.B. & Thiel, J. (2000). The cultural economy of cities: A comparative study of the audiovisual sector in Hamburg and Lisbon. *European Urban and Regional Studies, 7*, 253–268.

Hobson, D. (2003). *Soap opera*. Malden, MA: Blackwell.

Interactive TV Today. (2010). Ben Silverman's Electus, MTV, P&G and actress American Ferrera to Produce Interactive TV Show. Retrieved from http://www.itvt.com/story/6635/ben-silvermans-electus-mtv-pg-and-actress-america-ferrera-produce-interactive-tv-show

Iwabuchi, K. (2002). *Recentering globalization: Popular culture and Japanese transnationalism*. Durham, NC: Duke University Press.

Keane, M. (2006). Once were peripheral: Creating media capacity in East Asia. *Media, Culture & Society, 28*(6), 835–855.

Keating, A. (2009). *The Gloria Anzadua reader*. Durham, NC: Duke University Press.

Kraidy, M. (2008). Critical transculturalism and Arab reality television: A preliminary theoretical exploration. In P. Chakravartty and Y. Zhao (Eds.), *Global communications: Toward a transcultural political economy* (pp. 1–19). Lanham, MD: Rowman and Littlefield Publishers, Inc.

Maas, M. & González, J.A. (2005). Technology, global flows and local memories: Media generations in 'global' Mexico. Global Media and Communication, *1*, 167–184.

Maherzi, L. (1997). *World communication report: The media and the challenge of the new technologies*. Paris: UNESCO Publishing.

Mato, D. (2001). *Estudios latinoamericanos sobre cultura y transformaciones sociales en tiempos de globalización 2*. Buenos Aires: Consejo Latinoamericano de Ciencias Sociales : Agencia Sueca de Desarrollo Internacional.

Mazziotti, N. (1996). *La industria de la telenovela: La producción de ficción en América Latina*. Buenos Aires, Argentina: Paidós.

Meyers, M. (Ed.). (2008). *Women in popular culture: Representation and meaning*. Cresskill, NJ: Hampton Press.

Miller, T. & Legar, M.C. (2001). Runaway production, runaway consumption, runaway citizenship: The new international division of cultural labor. *Emergences: Journal for the Study of Media and Composite Cultures, 11*(1), 89–115.

Mosco, V. & Schiller, D. (2001). Introduction: Integrating a continent for a transnational world. In V. Mosco and D. Schiller (Eds.), *Continental order: Integrating North America for cybercapitalism* (pp. 1–34). Lanham, MD: Rowman and Littlefield Publishers, Inc.

Paxman, A. & Saragoza, A.M. (2001). Globalization, cultural industries, and free trade: The

Mexican audiovisual sector in the NAFTA age. In V. Mosco and D. Schiller (Eds.), *Continental order: Integrating North America for cybercapitalism* (pp. 1–34). Lanham, MD: Rowman and Littlefield Publishers, Inc.

Rogers, E. & Singhal, A. (1999). *Entertainment–education: A communication strategy for social change*. Mahwah, NJ: Erlbaum Associates.

Russell, J. (2005). The telenovela flexes muscles. *Television Week, 24*(37), 12.

Schlefer, J. (2004, January 4). Global must see TV. *The Boston Globe Magazine*, pp. 12–18.

Sinclair, J. (1990). Neither West nor third world: the Mexican television industry within the NWICO debate. *Media, Culture and Society, 12*, 343–360.

Slade, C. & Beckenham, A. (2005). Telenovelas and soap operas: Negotiating reality. *Television and New Media, 6*(4), 337–341.

Staubhaar, J.D. & La Pastina, A.C. (2005). Multiple proximities between television genres and audiences: The schism between telenovelas' global distribution and local consumption. *Gazette: The International Journal of Communication Studies, 67*(3), 271–288.

Stelter, B. (2009, September 22). U.S. census uses telenovela to reach Hispanics. *New York Times*, B1.

Televisa Annual Report. 2008. Retrieved from http://www.esmas.com/documento/0/000/002/035/AR08_Business_Segments.pdf

Turner, G. (2005). Cultural identity, soap narrative, and reality TV. *Television and New Media, 6*(4), 415–422.

TVMAS Magazine: Only Telenovelas, Fictions and Formats. (2007). Fifth world summit of the telenovela and fiction industry, panel on digital airings and its challenges. Retrieved from http://www.tvmasnovela.tv/onlytelenovelas/Only_12/C2007–4.html

Univision Communications Inc. (2010). Press release: Univision Interactive Media to launch comprehensive online and mobile "Novelas y Series" channel on Univision.com. Retrieved February 22, 2010, from

Wentz, L. (2007). Clorox mixes bleach and chocolate–in a telenovela. *Advertising Age, 78*(8), 55.

Wentz, L. (2010). It's no coincidence everyone in this Spanish soap drives a Ford. *Advertising Age, 81*(5), 2.

2. Telenovelas from the Rio Grande to the Andes

The Construction of Latin American and Latina Identities through Media Production Creative Processes

Jaime S. Gómez

This chapter examines the telenovela work of two important media producers and the ways in which their creative process constructs and projects Chicano and Latin American identities. Cristina Ibarra, a Chicana writer and producer of award winning short dramas and documentaries, and Darío Armando "Dago" Garcia, a Colombian writer and producer of successful telenovelas in Colombia, embody the range of media creative processes within telenovela production today. Through a descriptive account and analysis, the chapter also discusses their visions of production and audience reception as well as the role media plays in understanding the ever-changing representation of identities. I conducted in-depth interviews with both Ibarra (in English, April 10, 2009) and Garcia (in Spanish, March 29, 2009), and used one of their best-known productions, *Dirty Laundry: A Homemade Telenovela*, and *Pedro el Escamoso (Pedro the Show-off)* respectively, as launching points for the study. *Dirty Laundry* is an experimental narrative set in El Paso, Texas, on the United States-Mexico border, and this region serves as the setting for cultural and identity clashes. *Pedro El Escamoso* is a non-conventional melodramatic piece in which the writer embeds humorous historic and social reality within the classic telenovela idyllic formula.

Ibarra and Garcia represent two different generations and perspectives in their approach to creativity and production values. Overall, these professional media producers create content that maintain a local essence as well as cultivate intense cultural and emotional relationships with multinational audiences. For instance, Garcia is a seasoned telenovela writer and producer with more than 25 years in the business. He also heads the creative division of *Caracol*, one of Colombia's largest commercial television networks and telenovela producers, whose programming is seen around the globe. Ibarra, on the other hand, is a "rising star" who has built her career over the past ten years, mainly under the auspices of public television and foundation grants. Further in the chapter is a discussion of how these different working environments (i.e., public versus commercial) affects their creative process and work in general.

In the following sections, I will briefly introduce the concept of identity with special emphasis on the complexity and multiplicity of Chicano and Latin American identities. I will then analyze the interview material in order to explore each of the producers' views and how their work speaks to broader issues of media industry structure and its impact on the creative process. I conclude the chapter by summarizing Ibarra's and Garcia's views and perspectives on their artistic approaches.

Telenovelas and Chicana / Latin American Identities

The Latin American telenovela is a fictional, serial narrative, television genre that is produced and aired during prime time in most Latin American countries. Telenovelas are arguably, the most important of all television programming in the region. Martin-Barbero (1995) characterized it as a genre that has met with enormous success among television audiences both in and outside Latin America and, "has catalyzed the development of the Latin American television industry." (p. 276). Furthermore, telenovelas have captivated viewers well beyond the cultural and geographical boundaries of Latin America in which they were created, reaching markets in the United States, Europe, China, Egypt, and Russia (Benavides, 2008). Mato (2003) used the term "globalization of the consumption of the telenovela" to describe the global ascendancy of the telenovela market (p. 46). Lastly, the telenovela's central plot is also constructed mostly within local, geographical and cultural contexts that often serve as frameworks for the representation of national and regional identities despite the fact that Latin America telenovela consumption is a transnational occurrence.

For the purpose of this essay, however, the Latin American identity will be discussed within a regional context while the Chicano/a identity is mainly framed within the U.S.-Mexico border, specifically in the area of El Paso, Texas.

This is critical since the two subjects of this essay, Ibarra and Garcia, cannot be collapsed into one simple Latin American identity. Ibarra is a Chicana whose identity is more closely associated with the concept of "Latina," which is a term used in the United States to identify immigrants of Latin American origin or descent (Hurtado & Gurin, 2004). The term "Latino" gained much popularity during the early 1990s among Chicano/a scholars and political activists because it provides spaces for resistance and dialogue against the Anglo-American culture (Aparicio, 1997). It also suggests a desire to find cultural commonalities leading to political and social unity among the Latin American Diasporas in opposition to the mainstream white culture in the U.S. (Estill, 2000). Garcia, on the other hand, is a Colombian whose identity clearly falls within the Latin American framework.

Latin American identity can be best viewed as a multiverse of cultural identities (Morse, 1996) encased in an ample container with historical, economic, political, social and geographical ingredients. The many forces shaping Latin American identity discourse among regional studies scholars have become a wide array of fragmented visions arising from many different perspectives. Sinclair (2005) sees Latin America being within a geolinguistic region defined not only by its geographical boundaries but also by commonalities of culture and language that have been established by historical relationships of colonization. Duran-Cogan and Gomez-Moriana (2001) observe, "the object of regional studies has been fragmented by political interests, nationalistic projects and typologies of texts, and has been confined within rigid and reductive fields of study." (p. xii).

Mato (2005) observes, "No less than five centuries inform the historical processes of construction of representations of local, national, and transnational identities that involve the populations denominated as 'Hispanic,' 'Latin,' 'Latin American,' 'Spanish American,' and so forth" (p. 433). Geographically, Latin America is comprised of twenty countries, the former Spanish and Portuguese colonies in the Americas and the Caribbean. Each country is made up of regions and regions of sub-regions, forming a complex cultural mosaic or what Martin-Barbero (1987) has called a cultural matrix. This matrix contains a vast array of variables, socio-economic historical events, that have been shared among the countries in the region and have created strands of new hybrid identities arising from feelings of solidarity and commonality.

In addition, there are deep political and socio-economic differences that separate countries. Confrontations between the president of Colombia, Alvaro Uribe (right-wing) and the president of Venezuela, Hugo Chavez (socialist left-wing) are a recent case during 2004–2010. The political clash of these ideological positions are highly amplified and intensified through the mass media

and have been used by each side to exacerbate nationalist sentiments which in turn have yielded much wanted political support from fellow members of the Colombian and Venezuelan imagined communities respectively. Albert Ramdin, Assistant Secretary General of the Organization of American States expressed in a 2009 interview with the Colombian newspaper *El Tiempo* that, "There was never so much tension in the region since the cold war" ("Nunca hubo tanta tensión en la región desde la Guerra Fría," 2009).

Consequently, Latin American identity is shaped by politics but also by centuries of migrations, wars, social inequities, slavery, and colonization. Spain, as the largest colonizer in the region, imposed its language, culture, values and models of conduct (Duran-Cogan & Gomez-Moriana, 2001). In addition, there is the issue of the social and economic inequalities that have plagued the region after fighting for and winning their independence. Waisbord (1998) notes that social and economic crisis of recent decades, political repression, persistent poverty and civil wars, among others, have created a fragmentation of identities, borderless cultures in the region and a "process of hybridization." (p. 415).

Hybridization is a concept introduced by García-Canclini (1995) in which he argues that the complexity of the Latin American culture can be explained by the mixing of two perspectives: the tradition focus of anthropology and the modernity focus of sociology. In his view, the mass media and economic globalization forces have reshaped the cultural sphere in which it is no longer culturally autonomous or homogeneous but rather filled with local symbols of conflict and solidarity. For instance, the Mexican and Colombian telenovelas have used their drug cartel wars as themes and background scenarios to frame their stories (Benavides, 2008). In all these processes, mass media have played a paramount role in the construction and representation of Latin American identity, yet Brunner (2002) speaks about the fragmentary nature of the present Latin American culture as an unfinished collage, not expressing any order of nation, class or state.

The Chicano/a identity, like the Latin American identity, is the subject of debate and controversy. Most people see the Chicano/a as a U.S.-born individual of Mexican descent and the U.S.-Mexico border as a political dividing line separating two nation states. However, these two views are too simplistic and do not reflect the complex realities that encompass, on one side, the Chicana/o identity, and on the other, the polysemic nature of the U.S.-Mexico border cultural space. "The border," as it is simply called by most of its inhabitants, is more than a dividing line. It is a large geographical area with many cultural spaces and national identity perceptions. Saldivar (1997) sees it as "a paradigm of crossings, intercultural exchanges, circulations, resistances, and negotiations . . ." (p. ix). Anzaldua (1999) expresses that, "The U.S.-

Mexican Border es una *herida abierta* where the Third world grates against the first and bleeds. And before a scab forms it hemorrhages again, the lifeblood of two worlds merging to form a third country—a border culture." (p.25). Staud and Spener (1998) describe it as a continuing "dialectical process" that creates numerous borderland spaces that in many cases are not located close to the political, international border itself (p. 4). It is within this spatial context, the border at El Paso, that I will discuss Chicano Identity.

Chicanos are of Mexican descent and as such come from a Latin American Diaspora. However, Chicanos do not call themselves Latin Americans per se but instead may view themselves as Latinos, which is the umbrella term for people of Latin American descent living in the United States. Hurtado and Gurin (2004) write, "The twenty-first century will be about how best to represent the hybridity of the Chicano experience to encompass groups of Latinos/as who are not from Mexico, but have joined Mexican American's political and social struggles in the United States" (p.91). Flores (1997), drawing on the Anderson concept, speaks of the Latino community as an "imagined community" (p.185).

The Chicano's political and social struggles have been accentuated by the fact that they live in no one's land, for neither Mexicans nor Anglo Americans consider them as being "one of them" (Vila, 1998, p.195). Furthermore, Anzaldua and Keating (2000) note that there are significant cultural and social differences between Chicanos from different regions, such as California and Texas (p. 24). She expresses, "look at what 'Mexican-American' means, what 'Chicano,' 'mestizo,' and 'mestizaje' mean. The definitions change from decade to decade, from generation to generation" and from place to place (p. 215).

In addition, the meaning of Chicano, from a feminist perspective, adds a new dimension to the debate. The "Chicana" lives at a crossroad or intersection of two different cultures. Hurtado (2003) conducted a study in which she interviewed 101 Chicanas with post secondary education and between 21 and 30 years old. The following quote summarizes some of the main issues faced by the Chicana in her quest for finding her true place within an environment that sustains multiple cultural and social systems—an environment like the one in which Christina Ibarra was born and raised. Hurtado writes:

> They knew they were violating cultural expectations by not marrying young, by leaving home before marrying, or by having premarital sex, but they were also not accepted in the "white' world they were joining through their educational achievement (p.24).

Consequently, there are many views and perceptions of what a Chicano or Chicana is depending on who is defining the term and under what perspec-

tive, and what the term encompasses socially, ethnically, culturally and politically. Much of this polysemic controversy arises from within the Mexican Diaspora itself. For many in El Paso the term Chicano has a negative connotation. It could mean either an individual from a lower class or one who has abandoned his/her Mexican cultural heritage, among other things. To others, a Chicano is someone who defends of his/her Mexican-ness, is proud of her "mestizaje" or Indian heritage, and resists discrimination in the U. S. (Vila, 1998, p. 207).

In summary, there is no singular definition of Latin American identity or culture despite the historical, geographical, cultural and linguistic factors which bond Latin America together. Processes of economic globalization, migration and displacements, political and social upheavals and the many facets of localized, popular cultural manifestations disseminated through mass media technology, do not allow for the conceptualization of a universal Latin American identity. Instead, the Latin American and Chicana identity can be best interpreted as localized cultures hybridizing, assimilating, merging together and changing over time as new social, economic, political and cultural conditions and circumstances emerge.

The telenovela, as one significant media vehicle for the dissemination and sharing of popular culture, has become an important factor in the construction and representation of identities. The next section presents the interviews with Cristina Ibarra and Dago García, two media writers and producers who have used telenovelas as a means to project their creative process while also constructing (and complicating) localized, Chicano and Latin American cultural identities.

Armando "Dago" García and Cristina Ibarra: Career Beginnings

García and Ibarra come from different backgrounds and had different reasons for becoming media producers and scriptwriters. In order to understand the cultural and artistic framework in which they write and produce it is important to know how they began their careers and the motives that prompted them to engage in their professional and artistic careers.

Interviewer: When did you start your career as a filmmaker, producer and scriptwriter?

García: I began my career as producer and scriptwriter approximately twenty five years ago. Our first job for television was a comedy script in 1989. However, our work came all the way back from our days at the university. We were a rather large

group of communicators from the University Externado de Colombia in Bogotá in 1985 that were doing a lot of work in video and experimental pieces and then entered the professional market.

Ibarra, on the other hand, entered her university studies thinking of going to medical or law school. After realizing the power of media as an effective tool for expressing her political views and cultural views, she switched her major to filmmaking.

> **Ibarra:** Well, what happened was I studied it in school, I studied film production. I went to college during 1990, my first year of college. I grew up in El Paso, Texas and I always wanted to leave. I never liked growing up there, I just thought it was such a small town and my eyes were always set on Austin, Texas. So I ended up going there to public school, University of Texas, Austin and when you go there, there are so many different things you can study, it's huge. I thought I was going to be a lawyer, you know, coming from an immigrant family, you either want to be a doctor or a lawyer. Those are the two options you have. So I went there thinking I was going to go to law school. To go to law school I could study anything I want. I started to take classes in Chicano studies, in media production, and those two classes really clicked for me. The history I was learning in Chicano history was really quite shocking. I took this class thinking easy "A," right? I'm a Mexican American, and I know everything there is to know about being both. When I took the class I started to find out about the movement [Civil Rights], all these ideas of immigration. I started to think about assimilation and acculturation. I started to find out that there was a [Chicano Civil Rights] movement, an entire history that I never learned, and it was really making me upset. I was thinking why growing up on the border, why didn't we know that El Paso is significant in so many ways, and yet I always thought it was a throw-away town that didn't have much. When I took the media studies classes I was realizing that I didn't quite know how to talk to people exactly, because I had these emotions, so I felt like I wanted to make these political statements, these arguments. That's how film started for me, it started as a way of expressing an argument and as an unhappiness and restlessness that I had about Chicano history.

As a result, for Ibarra, attending college provided a new vision and awareness of her own identity, and set the stage for her future creative activities in film and television production. For García, his college education provided an opportunity for creative experimentation and collective approaches to television writing and producing. The next section presents their testimonies regarding how they created their most significant works.

García and "Pedro el Escamoso (Pedro the Show Off)"

Darío Armando "Dago" García has won several Colombian Television Awards for best telenovela and other national and international awards, including

Best Writer and Producer at the 2004 Latin American Telenovela Congress held in Uruguay. He teaches script writing at several universities in Colombia and at the International School of Film and Television at San Antonio de los Baños in Cuba. He is currently the Creative Vice-President for Caracol, one of the two major private television networks in the country. As a Creative Vice-President he acts as executive producer for all the telenovelas that are produced by the network. As a successful writer-producer, he represents a new generation of telenovela writers who parted away from the classic melodramatic style of early telenovelas. He has written and produced several of the most popular telenovelas of the last decade in Colombia like *La Saga: A Family Business*, and *Capital Sins*. He co-wrote *Pedro the Show Off* with Luis Felipe Salamanca, a long time associate and co-writer.

Pedro the Show Off was aired during 2001–2003 in Colombia. It was nominated for ten of the Colombia Television Awards in 2002 and won six, including Best Telenovela and Best Scriptwriter. The telenovela tells the story of a flirtatious, womanizer who is forced to leave his small, rural town because of romantic problems. He goes to the big city of Bogotá in search of success and prosperity. He finds a job as the driver of Cesar Luis, a wealthy business man and owner of a firm. While employed at the company, Pedro meets Paula, Cesar's secretary, who is madly in love with her boss. Pedro becomes Paula's confidant and falls in love with her. When Cesar dumps Paula, Pedro sees an opportunity to take advantage of the situation.

Pedro's life is surrounded by people who believe in his fantasies and lies, and he ends up becoming a key figure in their lives. Pedro is the person who finds solutions to many people's problems. In addition, he has a very particular way of dressing and speaking that makes him emotionally appealing. Pedro's character has two distinguishing characteristics: his platonic fidelity to Paula, and his dancing. Paula is his forbidden fantasy and his unreachable dream. The song *El Pirulino* and the accompanying dance became very fashionable in Colombia, several countries in Latin America and in the United States. Thousands of people gathered wherever actor Miguel Varoni, Pedro in the telenovela, came to dance the Pirulino rhythm. The song and its choreography became one of the most important contributions that the Colombian telenovela has made to popular culture in Latin America.

The national and international success, according to García, was the writers' audacity to reverse the female and male roles. In planning the telenovela plot with co-writer Salamanca, they thought that perhaps women were tired of watching women suffering and crying in telenovelas, so they decided that in this telenovela the men would be the ones suffering and crying. The idea was to create a "feminine" male, a man who acted with a woman's logic. So, they decided to feminize Pedro's role. García said that they chose three fun-

damental elements that have traditionally been assigned to women in the classic telenovelas and transferred them to a man. The first one was fidelity: Pedro would only have a relationship with one woman. The second one was talkativeness: Pedro would be very loquacious. The third one was vanity: Pedro would be very vain, always showy, and worry about his looks.

> **García:** Everything that, generally, men would do in a telenovela, women would do in this one. Here women manipulated, here women lied, here women would play around with other men, and everything that women did in this telenovela, men [did] in the traditional ones. Then, here Pedro suffered, Pedro was the victim, Pedro was faithful and a lot of other things; then by reversing the roles we made a classic telenovela.

Thus, the writers embedded the "female spirit" of the classic melodramatic telenovela onto the male characters. The "male spirit" was placed on the female characters.

> **García:** I believe that Pedro is the feminine side that any man has. Moreover, its shine lies in the fact that this female spirit in a man's body happens in a very "machista" society. It seems to me that it is like a break; it is a very particular fact that people had consumed with so much pleasure, and I think that this is his identity. Just as *Betty la Fea* (Ugly Betty) rescued the ugliness complex, because there is a universal ugliness complex. We all, at a given moment, have felt that we are ugly and have suffered because of that feeling and that explains the aesthetics industry, that explains many things, our fear to be ugly, *Betty* capitalized on that. In the case of Pedro, he capitalized on that feminine side that any man has and any woman appreciates in a man.

Pedro the Show Off was a successful story and earned its creators several awards. As a telenovela, the writers broke away from and reversed the traditional gender roles of the male-female dichotomy in this popular melodramatic genre. The decision to do so was the result of a series of discussions and brainstorming sessions among the writers in which they constructed the plot, audiovisual syntax and semantics of the story.

Ibarra and "Dirty Laundry: A Home Made Telenovela"

Ibarra's work has been strongly influenced by her experiences growing up in an environment framed by a cultural dialectic—Mexican and American cultures meet, clash, and a "tertium quid," (*third thing*), the Chicano culture, emerges as an ethnic mix with its own distinctive identity and its own particular inner conflicts. She expressed that her stories are always set on the border and they are always Latino stories.

Dirty Laundry: A Homemade Telenovela was Ibarra's directorial debut. It won the 2001 best short fiction award at CineFestival in San Antonio, Texas. It also aired on the PBS's series "Colorvision." It is an experimental narrative and telenovela-inspired tale that takes place in the border town environment. *Dirty Laundry* tells a story, using old home movie footage, telenovela clips, and dramatized fictional footage of a twelve year old girl, Sandra, who finds herself caught in the middle of a Mexican-American cultural dialectical collision. At the center of the plot is Sandra's participation in her cousin's "quinceañera" or 15th birthday, a traditional debutante gala event that marks the end of a girl's childhood and the beginning of her womanhood. Cantu (2002) explains:

> Wherever it is celebrated, the *quinceañera* remains a cultural marker for Latinidad and, more specifically, *mexicanidad*, and for the honoree it remains a coming-of-age ritual. In all cases, the celebration signals a change, a transformation; it is therefore loaded with significant rituals behaviors that reflect the transformation (p. 18).

In the movie the social event is intertwined with issues such as adolescent sexual awakening and masturbation, Roman Catholicism and the confession sacrament. Most importantly, Ibarra underscores the conflicts arising from a cultural clash that, on the Mexican side calls for submission to the traditional feminine role, and on the American side calls for rebellion against the status quo.

Ibarra described this film as her own story. She had a lot of questions about the gender dynamics in her family and thought that there were a lot of double standards when it came to women's role within her family. Ibarra saw a great culture clash of ideas because she was a first born from immigrants parents. This culture clash became especially evident when she became a young woman and her future was the topic of many of the family discussions. For Ibarra, her future was strongly linked to her views of sexuality and telenovela notions of motherhood.

Ibarra was under pressure from an identity dichotomy. On one side she wanted to embrace the culture she came from but on the other she was rebelling against the limited cultural expectations of being a woman. She used her movie and the telenovela analogy as a way to penetrate the barriers preventing her from establishing communication and understanding with her family.

> **Ibarra:** And so the only way that I understood to talk to them was to use the "telenovelas" because what I remember the most was sitting with my mom after a long day and watching her favorite "telenovela." It was really fun and I remember it being something that really bonded us and we would talk about it and it was never us but it was the achievement of this toss-up that you can catch up on.

So I thought that I'd employ that device, that "telenovela," and use that to talk about what I was feeling.

The unusual mix of media used to construct her story, home movies, real telenovela video clips, and dramatized fictional and recreated scenes, provided her with the opportunity to tell her own story in a very unique way. She used movie snippets that she had inherited, and recycled them in order to create her homemade movie. Her film is made of mixed pieces from different media events, each piece flavored with its own particular meaning. Ibarra constructed her story, inspired by her father's occupation as an owner of a junk yard, and his manipulation of scrap pieces of metal. She also she draws from the memories of the nights she watched telenovelas with her mother.

> **Ibarra:** I found these home movies and it's really quite special because of where we came from, a working-class background, immigrant background and so to have a film camera was pretty rare and very unique. We had these rolls of film, not many, and so I played them and I decided that I would use both the "telenovela" and I would use our own home movies as a way of reaching out to my family. With these two connection points, I could tell my own story. I could recreate/remix and kind of corrupt some of these memories and inspire this new future with them. It's my own story. It's a literal inheritance, the "telenovela," the home movies. I felt like they were an inheritance that I was taking on and creating something new from them; something that embraced the culture and at the same time criticized it.

When talking about the title of her story Ibarra points out that it comes from two places. The first one is Sandra's refusal to do the obligatory confession that was part of her cousin's gala event thus shocking her whole family and jeopardizing the celebration. The second one is the recycled pieces of the home movies she used to make her own movie, which makes it sort of "homemade."

> **Ibarra:** Well the title comes from a couple of places. "Dirty laundry" because it's kind of funky and it's a curious title. "Dirty Laundry" is about this girl that doesn't want to confess, her dirty laundry. It's a metaphor for the washing machine and this is how she covers masturbation by sitting on top of the spin cycle. And so, dirty laundry, that makes sense, but home-made telenovela, it comes from this idea of all these pieces together and it's not a campaign, it's not a commercial. I don't have the support of a studio system or an entire institution.

In summary, *Dirty Laundry* is Ibarra's story. Laura, the main character in the movie, is a portrait of herself. In writing and producing a film, Ibarra found a way to use a creative process to tell her own story. She tried to reconcile the conflicting sets of values that she confronted as a first generation young girl

growing up in a border town. Thus, Ibarra's work is very much influenced by her family history and cultural identity.

The Creative Process

It is clear from above that Ibarra's and Garcia's stories grow out of their uniqueness as individuals and their interaction with people and circumstances in their lives. As creative artists, they use their knowledge and skills of the visual arts, media production and writing to create an original and unique tangible product, whether it is a film or telenovela. In the case of Ibarra, she made new combinations out of existing film clips in order to create the novel product *Dirty Laundry*.

> **Ibarra:** My creative process is different every time. I'm always looking for a new approach, depending on what I'm trying to do. I do so many different things. I feel like a split-personality kind of person, because I have so many genres I work in. I have fiction, documentary, and then I have satire. They all require these different approaches. I work individually and then I work collectively.

Ibarra places her creative process in two different modes, that is, individually and collectively. Regarding her creative process as a team effort, Ibarra mentions that she belongs to a collective called "Fulana," ("anybody" in Spanish). The collective is made of four Latina women, a Dominican, a Chilean, a Puerto Rican, and herself a Chicana. In addition, they all come from different backgrounds and disciplines: a graphic artist and poet, a performer, a playwright, and a filmmaker. As a true collective they do everything together, from the conceptualization of shots and scriptwriting to editing.

> **Ibarra:** It's a collaborative medium, so what I depend on is someone that understands how to translate my story and we cooperate on the visual, so we shoot with a storyboard, or somewhat of a storyboard, sometimes it's loose. Then I take it into the edit room, and the ideas are always there to do the mixing and that's kind of where the magic happens for me. There is some treatment happening, not to the image itself, but maybe the way they are put next to each other.

García, on the other hand, places his creative process within two different environments: in his role as an executive producer of telenovelas in the media entertainment industry and his own personal creative agenda as a filmmaker.

> **García:** Television networks are organized according to a programming schedule and each of those spaces ought to have specific characteristics. It has budgetary conditions, so we see that each time segment of the programming grid has an assigned budget that depends on its potential for commercial revenues. It has

audience characteristics; for, historically there is a specific audience that is connected to a specific time slot and there is also a history and genres and themes that belong in that slot...From there we begin to conceive what sort of dramatized piece can adjust to those three conditions.

Regarding his creative process as a personal endeavor, especially as a filmmaker, García tells us that his process begins with something obsessive, like the need to tell a story. He has recurrent ideas that are always trying to come afloat and need to be expressed. Any attempt to create something without attending to that inner prompting and only having a commercial contextual frame could result in a well structured novel or story. However, it will be a story without a "heart." He adds that the first referent he has when creating something is himself. As an author he must be the first one satisfied with the story, the first one that is entertained by it, and the first one to become emotional when watching it.

In light of the above, it can be determined that Ibarra's and García's creative processes are influenced and determined by three main factors. The first one is knowledge and skills in the specific creative activity. The second is the artist's background and personal interactions. The third factor is the environment in which they perform their creative endeavors. The next section explores the way in which these two artists conceptualize and envisage the identities of the characters they bring to life in their works.

The Issue of Identity

For Ibarra, the identity issue is not something that needs to be made explicit. Rather it is something that is always present in her narrative. She does not predetermine whether a character will be white, black, American or Chicano, because her stories are always set on the border and they are always Latino stories. However, according to her, being labeled a Chicano has been a controversial issue for Mexican immigrants in the border. For some time, she says, it was used as a pejorative term for those who fell into that "tertium quid" category or who never fit the traditional cultural and social image of neither a Mexican nor an American. Moreover, Ibarra says, it was always difficult, while growing up, to understand the "constructed border," those types of barriers that society created at the border. Why was it that her grandmother, living so close, would need a passport to come and visit the family? The answer would not come easily until years later, during her awakening years at the University of Texas at Austin.

> **Ibarra:** To me the border is, I don't know, a rich way to explore these metaphors of separation and displacement, you know, and this kind of identity: Who am I? Who are we? So, for me, the center of the world is El Paso, Chicano, you know. Again, that word Chicano, we had complicated discussions about it in my house, about using that word. It's an immigrant family, so Chicano, isn't the best thing that you can call yourself. It was looked down upon and I know it's more accepted now than it used to be, but still.

Thus, the conflict over identity is ever-present. According to Ibarra, for many Mexicans, the Chicano was the traitor who gave up the homeland to become Americanized. Historically, Chicano identity was dismissed. However, the reality of the economics of labor migration, such as remittances, and the cultural crossing over of people like Selena (the music artist), helped create a better understanding and acceptance of the Chicano identity on both sides of the border. Ibarra has not attempted or intended to project a specific national identity. Rather, she believes in telling stories about issues and themes using matters of daily life and embedding certain socio-cultural characteristics within geographical confines. Furthermore, these stories as finished products should serve as tools for social change. As stated previously, Ibarra's stories are always set on the U.S.-Mexican border and they are about Latinos. Such is the case of Sandra in *Dirty Laundry*.

> **Ibarra:** She is a 12 year-old Mexican American growing up in an immigrant family along the border. So to create her I just had to go into my diary. It was a lot of fun actually, you know heart-breaking a little bit but mostly fun. I would put myself in the mind of a 12 year-old child. I would always write scenes thinking about these home-movies and thinking about my own childhood. It was a very personal process, very intimate.

Despite its intimate nature, the story may provide viewers across national borders with a connection to their daily life experiences. The creative treatment and representation of issues are usually charged with universal values that transcend geographical borders. This point is well illustrated by Ibarra's anecdote about something that happened to her at an African American Women in Cinema Conference after showing *Dirty Laundry*.

> **Ibarra:**…there was a woman that came up to me, an African American Woman and she said: "Oh my God, that was me up in the screen, that's exactly what I went through." That's amazing because she didn't grow up along the border and I don't know her but maybe she knows what is like growing up speaking Spanish. I don't think so, but it was really surprising to me and when that happened, I just understood something about film and the power behind it.

In this case Ibarra's creative treatment and representation of her childhood memories was the vehicle she used to explain the culture clash she grew up in: a cultural collision between an immigrant family and their U.S.-born child. Nevertheless, the fact that someone who grew up in Washington Heights in New York could identify with a character who is a twelve-year old girl living with an immigrant family in El Paso evidenced to her that the culture clash portrayed in the film was emotionally appealing and truthfully depicted. Is this the case with traditional telenovelas?

For Garcia, the appeal and representation of national identity in telenovelas is dependent on two factors. First are the genre structural characteristics. That is, how a playwright uses a theatrical form to construct meaning. Second are the economic needs and competition within the media entertainment industry. Both factors include a realistic style story telling which means that they focus on everyday happenings and characters with whom the audience can identify.

In general, García explains, telenovelas include the following seven characters that are fundamental in constructing a melodramatic story and who also fulfill key dramaturgy characteristic. There is a hunk or male sexy star: the hero, a heroine, a villain, a listener, an accomplice, a mother, and a buffoon. If any of these characters are absent in the story or deviate from their expected role then there is the risk of having an incomplete story, one that does not fulfill the audience expectations.

For instance, in the classic melodrama the heroine represents an ethical paradigm that must be kept throughout the story. The hero is someone that is not clear about what he wants in life and who only through the contact with the heroine begins to mature. García claims that now the Mexican and other Latin American telenovelas are changing the role given to their heroines because they are consuming the Colombian product. Virginity is no longer an issue in the marriage venue as a commodity that can be exchanged for a social position or financial gains. Rather is just a simple factor of life and sexuality.

Conclusion

Increasingly, telenovelas are dealing with social issues that only two decades ago were considered taboo by many Latin American producers and writers. Similarly, Ibarra's everyday life and telenovela experiences as a young girl are the cultural and identity framework in which she encases all her creative work. Her emergence as a successful writer and producer has a direct, emotional link to her family life at the U.S.-Mexico border. Telenovelas thus help her make sense of the cultural dialectical environment in which she grew up and also provide context for her ongoing daily life routines. Therefore, Ibarra's work con-

tinues to focus on stories that project her passion for themes that relate to her cultural and ethnic background. Ibarra's work, with its highly charged emotional appeal, has in many instances, served as a vehicle for promoting third-space identity, understanding particular behaviors and as an advocacy forum for social change.

García's experiences, on the other hand, focuses mainly on his creative process and identity construction as an executive producer of telenovelas in the Colombian entertaining television industry. The criteria for creating successful telenovelas or a personal media product do not always collide but rather remain common in many cases. Overall, for García, the construction of both industry and personal driven media products require a high dose of creativity that can be thrown into a melting pot in which visions, emotions and needs mix to create drama, melodrama or documentary.

In the crossing over of national borders, the Latin American telenovela, once a highly melodramatic fictional event, is now becoming another venue for identifying reality. These televised serials have begun to depict identities that, depending on the country of origin, can be considered to be native to that region even though their emotional appeal and the universality of their themes make them appealing to audiences throughout the world.

References

Anzaldua, G., & Keating, A. L. (Eds.). (2000). *Interviews/Entrevistas.* NY: Routledge.

Aparicio, F. (1997). On sub-versive signifiers: Tropicalizing language in the United States. In F. R. Aparicio & S. Chavez-Silverman (Eds.), *Tropicalizations: Transcultural representations of Latinidad.* (pp. 194–212). Hanover, NH: University Press of New England.

Anzaldua, G. (1999). *Borderlands/La Frontera: The new mestiza* (2nd ed.). San Francisco, CA: Aunt Lute Books.

Benavides, O. H. (2008). *Drugs, thugs, and divas: Telenovelas and narco-dramas in Latin America.* Austin, TX: University of Texas Press.

Brunner, J. J. (2002). Traditionalism and modernity in Latin American culture. In E. Volek (Ed.), *Latin America writes back: Postmodernity in the periphery* (pp. 3–31). New York: Routledge.

Cantu, N. (2002). Chicana life-cycle rituals. In N. Cantu & O. Najera-Ramirez (Eds.), *Chicana traditions: Continuity and change* (pp. 15–34). Urbana, IL: University of Illinois Press.

Duran-Cogan, M. F., & Gómez-Moriana, A. (Eds.). (2001). *National identities and sociopolitical changes in Latin America.* NY: Routledge.

Estill, A. (2000). Mapping the minefield: The state of Chicano and U.S. Latino literary and cultural studies. *Latin American Research Review, 35*(3), 241–250.

Flores, J. (1997). The Latino imaginary: Dimensions of community and identity. In F. R. Aparicio, & S. Chavez-Silverman (Eds.), *Tropicalizations: Transcultural representations*

of Latinidad (pp. 183–193). Hanover, NH: University Press of New England.

García-Canclini, N. (1995). *Hybrid cultures: Strategies for entering and leaving modernity.* Minneapolis: University of Minnesota Press.

Hurtado, A. (2003). *Voicing Chicana feminism: Young women speak out on identity and sexuality.* NY: New York University Press.

Hurtado, A., & Gurin, P. (2004). *Chicana/o identity in a changing U.S. society: Quien soy? quienes somos?* Tucson, AZ: The University of Arizona Press.

Martin-Barbero, J. (1987). *De los medios a las mediaciones: Comunicación, cultura, y hegemonía.* Barcelona, Spain: Editora Gustavo Gilí S.A.

Martin-Barbero, J. (1995). Memory and form in the Latin America soap opera. In R. C. Allen (Ed.). *To be continued...soap operas around the world.* (pp. 276–284). New York: Routledge.

Mato, D. (2003). The telenovela industry in the production of markets and representation of transnational identities. *Media International Australia, 106,* 46–56.

Mato, D. (2005). The transnationalization of the telenovela industry, territorial references, and the production of markets and representations of transnational identities. *Television & New Media, 6*(4), 423–444.

Morse, R. M. (1996). The multiverse of Latin American identity, c. 1920–c.1970. In L. Bethel (Ed.), *Ideas and ideologies in twentieth century Latin America.* (pp. 3–129). Cambridge, UK: Cambridge University Press.

Nunca hubo tanta tensión en la región desde la Guerra Fría. (2009). *El Tiempo.* Retrieved from http://www.eltiempo.com/archivo/documento/CMS-6044327

Saldivar, J.D. (1997). *Border matters: Remapping American cultural studies.* Berkeley, CA: University of California Press.

Sinclair, J. (2005). International television channels in the Latin American audiovisual space. In J. K. Chalaby (Ed.), *Trasnational television worldwide: Towards a new media order* (pp.196–215). NY: I. B. Tauris & Co.

Staud, K., & Spener, D. (1998). The view from the frontier: Theoretical perspectives undisciplined. In D. Spener & K. Staud (Eds.), *The U.S.-Mexico border: Transcending divisions, contesting identities* (pp. 3–33). London: Lynne Rienner Publisher.

Vila, P. (1998). The competing meanings of the label "Chicano" in El Paso. In D. Spener, & K. Staud (Eds.), *The U.S.-Mexico border: Transcending divisions, contesting identities* (pp. 185–211). London: Lynne Rienner Publisher.

Waisbord, S. (1998). The ties that bind: Media and national cultures in Latin America. *Canadian Journal of Communication, 23*(3), 381–411.

3. Emergence of Asian Dramas as a Global Melodramatic Genre

The Case of Korean Television Dramas

Sung-Yeon Park, Gi Woong Yun, & Soo Young Lee

Asian television dramas in general and Korean dramas in particular are still largely unfamiliar, if not unknown, to drama fans outside of their native continent. It has also been slow for Western scholars of soap operas and the related genres to recognize the active trade of television dramas taking place amongst many Asian countries. Huat and Iwabuchi (2008) lamented the lack of understanding of Asian dramas based on the fact that a book titled "…Soap operas around the world" (Allen, 1995) covered only one and fairly nascent development of Chinese melodramas while omitting more established and sophisticated drama industries in other Asian countries. Four years later, another book titled *Soap Operas Worldwide* was published (Matelski, 1999). For researchers and fans of Korean dramas, the book was also less than gratifying because it left out South Korea while discussing television dramas in other Asian countries with smaller television drama industries.

Indeed, as Huat and Iwabuchi (2008) argued, this lack of acknowledgement of Asian dramas as a narrative television genre that is comparable to soap operas and telenovelas certainly reflects negligence on the part of Western researchers. However, Asian media scholars needed to share their knowledge with the outside world as well. Limited availability of Asian television drama products and dearth of information about them in the English-speaking part of the world also presents an interesting contrast to the wide availability of Latin American telenovelas and active discussions about them taking place in the same space.

As a response, this essay aims to accomplish two tasks that are urgently needed to relieve these problems. First, Asian television dramas are formally introduced into the discussion of soap operas and telenovelas as yet another major branch of narrative television genre comparable to the latter two. Similarities and differences among these three genres are examined to establish their position in relation to one another. Second, the status of Asian dramas is investigated by focusing on the "Korean Wave," one of the most salient cultural trends in Asia in recent years. Starting in the late 1990s, Korea emerged as a major exporter of cultural products such as television dramas, movies, and popular music in Asia. In particular, television dramas have been in the front and center of the cultural phenomenon, with huge popularity throughout the Asian continent and increasing awareness elsewhere.

After accomplishing these goals, we will examine Korean drama fans and their online activities. Focused attention is given to an online fan community devoted to an actor who became popular through his appearances in several Korean dramas. The particular fan community was chosen for two reasons. First, the Web site exhibited a typical structure of online communities devoted to Korean television dramas and celebrities in them. Second, unlike others, the online fan community became a site of a high-profile conflict between the fans and the actor's talent agency over the issue of managing the celebrity, which is unimaginable were it not for the interactivity and networkability of the Web. This was a level of fan activism beyond the conventional notion of "active audience" and thus deemed to deserve a new label "intervening audience" coined here to specifically refer to the phenomenon. After all, the online activism of the Korean drama fans should be considered as yet another characteristic that Asian dramas share with soap operas and telenovelas.

Soap Operas, Telenovelas, and Asian Dramas: A Taxonomy of Korean Television Dramas

Whereas the commercial origin of the term "soap opera" in the era of radio is widely known, a formal description of what qualifies a narrative television program to be classified as one is not very common. In one rare exception, Brown (1987) provided a list of eight generic characteristics of soap operas:

> . . . soaps are characterized by: 1. serial form which resists narrative closure; 2. multiple characters and plots; 3. use of time which parallels actual time and implies that the action continues to take place whether we watch it or not; 4. abrupt segmentation between parts; 5. emphasis on dialogue, problem solving, and intimate conversation; 6. many of the male characters portrayed as 'sensitive men'; 7. female

characters often professional or otherwise powerful in the world outside the home; 8. the home, or some other place which functions as a home, is the setting for the show (p. 4).

At the same time, we have to be careful in applying this list to include or exclude specific television programs in a scholarly discussion of soap operas because a soap opera text can be experienced differently by individual audiences and also morphed to fit production and programming conventions in different countries (Brown, 1987). The case in point is the telenovela. In spite of common pairings of the two, telenovelas do not share many of the characteristics of soap operas listed above. Except that soap operas and telenovelas have the common origin of being sponsored by the same soap companies in the early days of television, the two were conceived differently from the beginning and continue to differ in many major aspects. For example, telenovelas tend to last less than one year whereas most U.S. soap operas go on for more than a decade. In addition, telenovelas are the mainstay of prime time entertainment whereas soap operas comprise daytime entertainment targeting mostly female, home-bound audiences (see Lopez, 1995 for more detailed comparison of the two). Therefore, it is reasonable to state that their melodramatic root is pretty much the only commonality holding the two genres together.

Rather than expunging telenovelas from the realm of inquiry for soap opera researchers, however, the incompatibilities between soap operas and telenovelas expand their territory by allowing entry of other formerly neglected genres into the same family. One such genre can be a group of Asian television dramas that are, in essence, based on melodramatic development of romantic relationships. Granted, not all Asian dramas belong to the category. Differences in language, culture, and religion across countries participating in production and consumption of the Asian dramas further complicate any effort to sum up the vast genre.

After the Second World War had ended, most Asian countries started broadcasting in the 1960s. Since many of them modelled their broadcast systems after the U.S., they also quickly adopted many program formats popular in the U.S., including dramas. However, it was not until the 1980s that dramas made in one Asian country were exported for enjoyment of audiences in other Asian countries. Due to the lack of resources, talents, and know-how, most dramas made during the first two decades lacked sophistication and thus were not considered for overseas audiences. Nonetheless, they were highly popular domestically and the popularity, in turn, propelled growth of a drama industry in some of the Asian countries that were also riding on the tide of rapid economic development. Cultural affinity of Asian-produced dramas, in comparison to U.S. dramas, was a strong selling point and language

differences were easily overcome by editing technologies such as dubbing and captioning.

According to Huat and Iwabuchi (2008), the first stage of regional circulation took place in 1980s amongst Asian countries with predominantly ethnic Chinese populations such as China, Hong Kong, Taiwan, and Singapore. Supported by mature domestic markets and favored by ethnic and linguistic affinity, many dramas produced in Hong Kong and Taiwan were distributed in the circle with a great success. In the second stage in the 1990s, however, the ethnic and linguistic exclusivity gave a way to a strong preference for Japanese dramas filled with artefacts of a modern capitalistic consumerist society such as luxury cars, designer clothing and accessories, fancy buildings and Western-style restaurants. Referred as "urban trendy" dramas, these Japanese shows were consumed for the pleasure of the eyes as much as of the mind. The beginning of the third stage is characterized by the emergence of South Korean dramas in the late 1990s. By that time, the list of Asian drama exporters extended from the ethnic Chinese countries with advanced economies to include Japan and Korea. At the receiving end, the circle of importers also expanded from East Asia to the whole Asian continent and further to Russia and the Middle East.

In spite of these differences in the origin and details, there are common characteristics observable in most contemporary dramas produced and consumed in Asia. Foremost, many of them are melodramatic love stories, which is also a crucial thread linking these dramas to the soap opera-telenovela lineage. Besides, these Asian dramas share many characteristics of telenovelas: Each drama runs for a limited time, mostly between six months to one year, is aired at various times including primetime for the enjoyment of both men and women side-by-side, is consumed by foreign as well as domestic audiences, and accrues the highest prestige in the regional entertainment industry. Once we clearly understand the connection between soap operas, telenovelas, and the Asian dramas, we can comfortably situate Korean dramas as part of the Asian dramas on the larger map of melodramatic television genres throughout the contemporary world.

Before moving onto Korean dramas, however, it is in order to sort out one nomenclatural issue. Currently, there is no widely accepted term to refer to this particular type of television drama of the Asian origin. Although some (e.g., Rofel, 1995) refer to them as "melodramas," the naming presents two dilemmas. First, being melodramatic is the signature of the bigger global genre encompassing the Asian dramas along with soap operas and telenovelas and thus the name should be reserved to represent all three. Second, somewhat contradictory to the first, there is a stigma in general perceptions attached to

being "melodramas." For the lack of a better alternative, the particular television dramas under discussion are called "Asian television dramas" throughout this essay.

Korean Television Dramas as the Driving Force of "Hollywoo (the Korean Wave)"

Since the end of the Second World War, South Korea has been known to the outside world for several things. There was the Korean War in the 1950s, the fast-paced economic growth known as "the Miracle on Han River" from the 1960s to the 1980s, globally exported cars, home appliances, and personal electronic devices in more recent decades. Also, the world is aware of the dysfunctional behaviors of the North Korean regime and the suffering of North Koreans.

However, what is known about Korea is rapidly changing in many parts of the world due to a new cultural phenomenon called "Hollywoo," also known as the "Korean Wave." "Hollywoo" is the Korean pronunciation of a word composed of two Chinese characters that mean "Korean" and "Wave," respectively. The term broadly refers to the substantial amount of popularity garnered by Korean mass media products such as dramas, movies, and popular songs in overseas markets. It has been utilized as the standard term referring to the cultural phenomenon by the popular media and experts alike. The trend started from two neighboring East Asian countries, China and Japan, but is now spread to South Asia, the Middle East region, Russia and parts of former Soviet Union, and even some Central and South American countries. Although the cultural phenomenon includes many different types of cultural products, the one genre driving the whole trend is television dramas that are collectively referred to as "Hollywoo dramas."

Two most famous examples, by many accounts, are briefly described here: *Winter Sonata* and *Jewel in the Palace*. These two also represent two most common types of Hollywoo drama: The former is set in a contemporary time and driven by a love story whereas the latter is set in a historical period and focused on personal triumph of a heroine against corrupt systems and malevolent individuals.

Winter Sonata was originally broadcast in 2002 on Korean Broadcasting System (KBS), a public television network and also the largest television broadcaster in South Korea with a decent average rating of 23%. However, the real success came when the program was aired in 2003 on NHK-BS (*Nippon Hoso Kyokai* or Japan Broadcasting Corporation—Broadcast Satellite), a satel-

lite channel run by the government-funded and largest television broadcaster in Japan. After broadcasting the complete series twice on the satellite channel, NHK eventually moved the program to its terrestrial channel and aired it one more time in summer 2004, resulting in 15% average rating and spikes in sales of related products such as DVDs and books. Later in the same year, NHK broadcast the complete, original director's-cut version of the series again. The high popularity of *Winter Sonata* was also credited with increased tourism to Korea by Japanese fans (Mōri, 2008).

In terms of the narrative structure, *Winter Sonata* has all typical elements of Korean melodramas: an illegitimate child, secret of birth, half brothers who compete with each other for a woman without knowing their kinship, manipulative mother and unfaithful father, multiple love triangles across two generations, mistaken identity, fatal car accidents, incurable illnesses, disapproving families and friends, and a pure and sacred love. The plot is also sustained by seemingly haphazard moments of separation and reunion that are actually crucial props for the whole storyline. In the end, the narrative of *Winter Sonata* fits perfectly with that of typical telenovelas as Patricio Wills, the Head of Development at Telemundo, described: "…A telenovela is all about a couple who wants to kiss and a scriptwriter who stands in their way for 150 episodes" (Clemens, 2006).

The second exemplar of Hollywoo dramas, *Jewel in the Palace*, deviates from the above archetype. Instead of focusing on a romantic relationship, this drama is centered on trial, tribulation, and triumph of a bright and determined woman who eventually achieves happiness while helping numerous others—both the powerful and the powerless—along the way. The story is loosely based on a historical figure who was mentioned only a few times in the official record of Chosun Dynasty, the last Dynasty in Korea before the Japanese colonization. The only known facts about the person were that she existed in the 16th century and became the first female physician to the King of Chosun.

Based on this sketchy information, the director and writers created a story about a girl whose parents, while working in the royal palace, were dragged into a tragic Royal conspiracy to their annihilation. She grew up with the sole purpose of going back to the palace to restore the reputation of her family by setting the record straight, which she eventually accomplishes after years of hardship and many near-death moments. Although romantic tension appears a few times, that only serves the purpose of glorifying the heroine's exceptional qualities.

In spite of all these differences, *Jewel in the Palace* is considered to be a successor of *Winter Sonata* in terms of keeping the trend of Hollywoo alive and further expanding its reach. The show's final episode generated over a 40%

rating in Hong Kong, making it the most watched television show in its history. Chinese President Hu Jintao was also reportedly an ardent fan of the series (Park, 2005). Besides these two, *Jewel in the Palace* was nationally broadcasted in Japan, Taiwan, Singapore, Malaysia, Brunei, Indonesia, Philippines, Thailand, and Vietnam. Non-Asian counties such as Russia, Australia, Israel, and Iran were also added to the list later on. In North America, the series was run on ethnic Japanese and Korean satellite television channels in 2005.

According to Shim (2008), the first sign of Hollywoo was detected in China in 1997 when China Central Television (CCTV), China's major state-run television broadcaster, aired a Korean drama titled *What Is Love All About*. The show was a huge success to the point of warranting a complete rerun the following year. This discovery of Korean dramas in mainland China and other parts of the "pan-Chinese pop sphere" including Taiwan, Hong Kong, and Chinese communities in Southeast Asia (Huat, 2004) also coincided with explosive increases in broadcasting channels and the devastating downturn of many Asian economies at the late 1990s. In the end, these changes benefited South Korean drama producers by making Korean dramas a much needed alternative to more expensive programs from the U.S., Hong Kong, and Japan for Asian television broadcast outlets (Heo, 2002).

A look at the import/export balance sheet of television programs in South Korea clearly demonstrates a rapid growth of the Korean television program export industry. In 1996, Koreans collectively spent $63.9 million on importing television programs while generating $5.9 million in revenue by exporting theirs. By 2001, however, the import figure had declined to $20.4 million while the export figure rose to $18.9, shrinking the deficit to approximately $1.5 million. In 2004, the balance was completely reversed to reveal $71.4 million in revenue and $31 million in expense (Park, 2005). A separate report further explicates that Hollywoo dramas, among various television genres, accounted for 92–95% of all the revenues created from exporting Korean television programs (Yoon, 2005).

In terms of the geographic dispersion, Hollywoo dramas are now expanding their territory beyond the traditional pan-Chinese pop sphere. Although the core basis of the Hollywoo phenomenon is still comprised of such countries like Japan, China, Hong Kong, Taiwan, Thailand, Singapore, Malaysia, Vietnam, and Indonesia, quite a few other non-Asian countries are also now regarded as increasingly active sites of Hollywoo drama consumption. In the Middle East, an Egyptian-government owned broadcast system that is also the largest broadcaster in the region, ERTU, aired a Hollywoo drama *An Autumn Fable* during primetime in 2004 with a great success, prompting other Middle Eastern countries such as Jordan and Algeria to follow the suit (Yoon, 2005).

Hollywoo dramas are also highly popular in Central Asia with Uzbekistan as the epicenter of the trend. Mexico (part of North America) serves a similar function as a foothold of the cultural promulgation for Central and South America (Radio Free Asia, 2005). In 2007, Russia also joined the roll by having a state-owned broadcaster, DVTRK, air a Hollywoo drama on a terrestrial channel (Kang, 2007).

Among ethnic Koreans in the U.S. and Canada, there had been a beloved tradition of watching Korean dramas recorded on videotapes (VHS) that were usually rented from ethnic Korean grocery stores (Lee & Cho, 1990). With advances in media technology and increasing popularity, however, the tradition is in the process of being gradually replaced by watching Korean dramas via satellite television channels, Internet Web sites, video/DVDs at Blockbuster stores, and Netflix home delivery. The increased availability and choice, in turn, transformed the consumption pattern of Hollywoo dramas in North America. Whereas regular viewers of Korean dramas used to be largely concentrated in big cities on the East and West coasts, the viewing area has now been expanded. There are a number of online Korean drama fan communities in Midwest cities like Chicago (e.g., http://deiner.proboards.com). The composition of the fan base has also become more inclusive of people outside of the ethnic Korean community (Hua, 2005). In one survey of randomly selected 270 Hawaii residents, it was revealed that 56% of them watch Hollywoo dramas once or twice a week and 18% watch everyday (Cho & Agrusa, 2007).

Korean Television Drama Fandom in Online Communities

The energy and time invested by fans of Korean dramas should be understood in the context of surging pan-Asian popularity of Hollywoo dramas and the stars featured in them. In Korea, until mid-1990s, celebrity fan clubs were virtually unheard of outside a small circle of teenage girls. The emergence of South Korea as a hotbed of a new information revolution in the new millennium (Ha & Ganahl, 2004), however, presented new venues such as Internet Web sites, online fan clubs, and discussion boards to drama fans who were eager to express their enthusiasm for their shows and stars. Frequent news coverage of overseas trips of Korean Hollywoo stars who were greeted by a wild crowd often characterized as "Japanese fan club members for (a star's name)" or "Diehard fans of (a star's name) in Hong Kong" further motivated Korean fans to organize themselves and claim their "original ownership" over the celebrities.

Indeed, some of the most active online communities in South Korea are the ones devoted to television dramas and celebrities in them. These fan communities exist aside from program Web sites created and maintained by the broadcast networks. A typical Hollywoo star has multiple online communities devoted to him or her, but it is usually the one operated by his or her management company that enjoys the prestige of being the "official" Web site. The vast majority of online fan communities are inhabited by people who identify themselves to be "sickly in love with" or "incapacitated" to carry out anything other than watching their favorite shows and talking about it with others.

Fans of popular culture have always been searching for ways that satisfy their desire for access to their favorite content and performers. For Korean television drama fans, many characteristics of the Internet made an online fan community the ultimate resource for everything about their favorite shows and stars. Unlike other traditional means of fan activities, online communities empower them in multiple fronts. First, the interactive nature of online communities allows fans to become an active participant of communication taking place on the platform. Second, as a networked environment, the online communities enable users to exchange information and opinions with one another, which also opens up the possibility of collective action by the fans, if necessary. Third, the fast pace of open online communication means that fans are constantly updated with news from diverse sources about upcoming episodes and celebrity-related gossip that are also confirmed or debunked in a matter of a few hours to a few days. Fourth, the work of producing and maintaining content of online fan communities is widely shared by whoever is willing to put in their time and skills to the Web site, resulting in equal participation privileges (Flanagin et al., 2002; Jessup, Connolly, & Tansik, 1990). Finally, multimedia functions of the Internet facilitate sharing of content in various forms including text, picture, drawing, audio, and video among participants of the communities.

To illustrate these characteristics, an online fan community and the fans on the Web sites were closely examined. It was the official fan community dedicated to Kim Rae Won, a young idol star who was best known through his title role in *A Cat in a Rooftop Shack*. The drama was first broadcasted in Korea in 2003 with an average rating of 26% and later aired in Thailand and the Philippines. The fan community was created by the actor's management company and went public in December 2000 and reached approximately 60,000 members by May of 2004.

Anatomy of the online fan community

The homepage of the online community had four tabs. The first tab was "Display boards," which was composed of three distinct areas. One of them was designed for communication between the actor and fans. Since the actor, unfortunately but expectedly, hardly used the display boards to correspond with his fans, this sub-section of display boards was eventually occupied by fans themselves who filled the space with messages about the star such as sightings and scheduled media/event appearances and other miscellaneous daily activities of fans and fan groups.

The second area could be considered a creative commons where fans' creative works were displayed to be appreciated by others. Some fans wrote text reviews for drama episodes and acting while others uploaded visual materials featuring the actor. Photographs in the space were digitally altered to reflect the creators' interpretation of the drama and the actor while drama episodes were often heavily edited from a 60-minute full length to a 10/20-minute highlight. Furthermore, some fans even created music videos—complete with the drama theme songs—by boiling down the whole series into a few minutes of summary highlights. The debate of copyright infringement aside, these audio-visual artifacts clearly demonstrated the command of media production techniques and technologies possessed by the fans and their dedication to the drama, the actor, and the fan community.

The third area was a clearinghouse for any news related to the actor. Although this place also contained some photographs and videos, its primary function was for the community members to update each other on current developments occurring to the actor and his drama. Since the amount of information, either text or A/V, deposited in the section became quite substantial over time, the Web page also featured a search function to help users locate information easily. "Library" was the second tab next to the "Display boards." Unlike others in the Web site, this area did not require registration and log-in for access. Instead, anyone could visit and download the actor/drama-related information made available by the management company.

The third tab was "Small group discussion boards," under which three small groups were formed based on the gender and age of participants: (in comparison to the actor's age) Older female fans' discussion board; Male fans' discussion board; and Younger/same age (female) fans' discussion board. Considering that homogeneous groups perform better than heterogeneous groups in online communication (Valacich et als., 1995; Wright, 2002), the partitions certainly helped to build stronger ties amongst the members of each group.

The last tab read "Chat rooms." In the chat rooms, fans were able to participate in both open and closed chats. The former allowed anyone to participate in an instant chat any time a chat session was active. The latter, on the other hand, was limited to people who were invited to join. The chat functions were utilized by the fans to make new friends in real time or to have meetings with established friends on the online community.

The users

Users of online fan communities can be classified into two broad categories. In an analysis of an international fan community for a Japanese actor/singer, Darling-Wolf (2004) noted that a disproportionate amount of posts were generated by a handful of highly active participants while the majority of members played the role of vigilant, yet mostly silent observers.

For the most part, this description was applicable to the users of the fan community under discussion as well. Some of them utilized the online community in a manner that they used to deploy when consuming traditional mass media. They came to the Web site, accessed their desired content, and then left. The content that they typically utilized included the actor's drama videos, photographs, and clips of news and other media appearances. Since they participated in the community as audiences for the most part, their presence was only traceable by the frequency of access to the content or downloads.

The other category of community members, on the other hand, behaved in a way that took a full advantage of interactivity afforded by the Internet medium. They posted messages on the small group message boards and exchanged ideas with one another through the instant chat functions. As was the case with other online fan communities (e.g., Darling-Wolf, 2004), there was a strong sense of camaraderie among the participants because they shared a passion for the star and his dramas. The mutual encouragement and reinforcement amongst the participants was clearly manifested in their posts.

Besides these two types of users, however, an existence of yet another small class of users was noted. There were a relatively small number of users who served as producers of content in the creative commons and information clearinghouse located under the "Display boards" tab. Whereas most of the news updates found in the clearinghouse were merely transferred from other sources and thus users who participated in the dissemination of news were simple information gatherers, the text reviews and video materials in the creative commons were certainly products of artistic activities. In particular, a few drama reviewers enjoyed the status of mini-celebrity within the online community as was clear from the access frequency and the number of replies to their reviews. Similarly, a limited number of users who were equipped with both resources

and skills produced the vast majority of highly sophisticated multimedia content and thus they were revered by other users and sometimes even referred to as "Director" so and so.

In sum, the above observations present a picture of a three-tier structure of the online fan community members. As already identified by Darling-Wolf (2004), the first two tiers were comprised of majority lurkers and minority active participants. At the same time, this probe revealed a third tier that had not been formally introduced into the literature: a few elite members who were producers of highly prized content on the online community. Whether it was articulate reviews of drama episodes borne out of literary skills or seamlessly edited clips of drama footages enabled by technical skills, producers of the high value content sat on top of the fan structure and enjoyed a little fame of their own in a community built around their passion for a real drama celebrity.

At the same time, it should also be noted that the user structure within the fan community was not a hierarchy commonly found in traditional organizations. The membership was open to anyone and it was absolutely voluntary to remain lurkers or become active participants. Although an entry into the third tier of highly respected producers was restricted by each individual's literary or technical ability, it was still highly egalitarian because the entry was determined by personal merits rather than inherited status or material wealth. Furthermore, the elite members facilitated the rest to join them by providing lectures on editing techniques and other technical matters on the community Web site. They also did not garner any personal gain other than purely psychological satisfaction of getting respected within the community. Based on these characteristics, one may conclude that this community fits better with a new organizational model called "commons-based peer production" that a lot of collaborative online projects such as LINUX have successfully adopted since the emergence of the Internet (Benkler, 2006).

New Intervening Audiences: Fan-Management Conflict in an Online Community

Whereas this online fan community was typical in the Web site structure and the composition of users, it was very unique in terms of what happened between the users and the management company of the Hollywoo star in early 2004. It started with a few outspoken criticisms posted on the online community about the way the management company handled the actor. One persistent complaint was about frequent appearances of the actor at promotional events. There is a common, but increasingly criticized practice in Korea that forces celebrities to make short appearances at store openings or other pro-

motional events in exchange for payments to the management company. Since the actor was discovered by the company and still in an early stage of his acting career, in the eyes of the fans, he was seen to be beholden to his managers. In addition, many community members started to voice other concerns once they saw the criticisms.

After a period of responding to these increasing criticisms by simply deleting the critical messages on the online community, the management company took a more drastic action. In January 2004, the management company filed an official complaint against approximately 30 members of the online community to an investigative police unit that specialized in Internet crimes for "Sexual Harassment on the Internet." In addition, the company removed the accused members from the online fan community by deleting their usernames and banned their future access to the Web site while distributing press releases to all major news outlets that described the evicted fans as dangerous stalkers who excessively invaded the actor's private life and abused the freedom of expression by posting messages that sexually harassed the actor on the online community.

Against these tough measures by the management company, the fans on the community swiftly responded in four ways. First, many of the remaining users of the online community continued to post messages criticizing the management company. More than 70% of new messages on the community (118 out of 167 postings) posted during the one month since the incident expressed dissatisfaction with the way the company handled the situation and concerns about censorship rampant on the Web site.

Second, the evicted fans tried to restore their reputation by demanding equal access to media outlets that originally ran the story provided by the management company. They followed an official protocol by making the request to a central governmental agency that was in charge of negotiating conflicts originating from skewed media coverage. Within a month, the request was granted and thus the fans' counterarguments appeared on February 4th, 2004 in all media that published the management company's version of the story.

Third, the fans also filed a libel lawsuit against the management company. In the suit, the fans maintained that the press release distributed by the management company made false claims about the conduct of the fans and it was created with a malignant intention to smear the reputation of the fans who had not done any wrongdoing. The lawsuit dragged on, but most of the fans managed to stick around to see a day of justice in court. After about a year, however, the fans and the management company reached an agreement and the fans dropped the lawsuit. Among others, the most compelling reason for

the fans to drop the lawsuit was the consensus that the lawsuit and ensuing negative publicity was hurting their beloved star more than punishing the management company.

Last but not least, many from the original online community, while waging the legal battle, created an alternative Web community and named it "Meeting (the actor's name) again outside (the original community name)." Within the first four months of the launch, the new community recruited 1,400 members. But the real strength of the new community was in the level of activity. Although the 3-year old original community, which was also the "official" online fan community of the actor, had more than 60,000 members, the original community was surpassed by the new community in terms of the activity level. *Daum.net*, a Web community hosting company that hosted both the fan sites regularly surveyed and published ranking of online communities with 10 or more members based on the these major criteria: number of postings and visits, members' activity consistency, number of flaming messages, and penalties given to the community due to its unethical activities. Based on the tally, all the communities hosted by the company were ranked. A higher rank meant that more active and positive interaction was taking place in the community. And according to the list, the new community ranked at 119 and the original community at 142.

What stands out most from this saga between highly active fans of a Korean drama star and his management company is the capacity of fans to intervene in an affair between the actor and his management team and further pursue proper recourses when they recieved retaliation for the intervention. Resistance was well expected, but the continued demand for freedom of expression within the system and the ingenuity of creating a totally new space of their own respectively embodied the philosophy of liberal and radical feminism, whether the participants were aware of the political significance of their actions or not. In the legal and publicity battles with the management company, the competency and resourcefulness of the fans was also quite surprising, given the common scornful characterizations of fans and their behaviors that were also especially more harshly implicated on female fans (Jenkins, 1992).

Besides these strengths of fans themselves, the nature of the Internet as a venue for fan activities should be credited as another crucial facilitator of the subversion. In particular, the first three of the five characteristics of the Internet as the technological foundation of online fan community activities discussed earlier—interactivity, networkability, speed, shared content production responsibilities and privileges, and multimedia functions—immensely empowered the fans.

Due to the interactivity, they were able to voice their complaints against the management company, exchange opinions about the issue amongst them-

selves, and keep the rest, less active but nonetheless involved fans informed about their conflict with the management company, all within the online community Web site. The fans were also enabled by networkability of the Internet to form such a large community in the first place and also to take actions as a unified collective when later confronting the management company. For individuals in a capitalistic society vis-à-vis a well-financed commercial organization, the strength is in numbers. Although the official fan site of the drama actor was created by the management company to exploit the wide reach and emotional attachment amongst users of the medium, the fans recruited to serve the commercial interest also found a way to take advantage of the size and cohesion of the community against its own creator. It is easy to imagine how the story would have been different if the fans acted as isolated individuals and thus a few troublesome ones were shut out of the community by the management company and simply never heard from again. Instead, the networkability of the Internet kept them in touch with the remaining users of the online community and further enabled them to recruit more defectors. The speed of the Internet also enabled the fans to respond to the management company's publicity campaign to smear their reputation in a rapid-fire pace.

Conclusion

The major purpose of this essay was to introduce Asian dramas as the third leg, along with soap operas and telenovelas, of the global melodramatic television genre. Once a space for Asian dramas was created through a comparative analysis of the characteristics of soap operas and telenovelas, a brief history of television drama trade across Pan-Asian cultural sphere was illustrated. A focus was given to the recent trend of "Hollywoo dramas," the high popularity of South Korean television dramas in many Asian countries and beyond.

The latter half of this essay concentrated on how fans of a Hollywood drama star used an online fan community. In the community, a three-tier structure was observed that included silent majority lurkers, minority active participants, and a few elite producers of highly prized content. What distinguished the particular online community, however, was a high profile conflict that took place between fans on the community and the management company of the drama star. Although the legal and public action involved a few dozen members, far more members supported them throughout the ordeal and also migrated to a new alternative online community. Fans morphed from quiet consumers to active content producers to vigilant protectors of their star.

This essay also leaves a few tasks to be taken up by researchers interested in global melodramatic television genres and metamorphoses of fans with advances in communication technology. This essay was only able to examine

select issues. The relationship between soap operas, telenovelas, and Asian dramas is one of them. A more detailed comparison of the three genres will certainly enrich our understanding of their relationships. To facilitate this and other comparative studies, it is also urgent to increase accessibility of existing research on Asian television dramas to the researchers of soap operas and telenovelas.

Last but not least, the fan-management conflict on the online fan community of a Hollywoo drama star points to a new possibility that fans can become a force as powerful as other traditional participants in the production-distribution-consumption cycle of television dramas. Albeit rarely, producers of television shows had incorporated their fans' opinions into the plot in the past (D'acci, 1992). Today, with the proliferation of program Web sites and online communities, it has become much easier to engage fans in order to keep them captivated. This symbiotic relationship goes on as long as fan participation is not considered a threat to industry interest. The notion of audiences who can intervene on behalf of the less powerful—whether they be performers, writers, producers, or staff—and make a noise to be heard by the wider society, can be empowering fans who are victimized by unfair descriptions and prejudices. There lies the responsibility of researchers to bring people's attention to the vigilant, not merely subversive, actions of fans.

References

Allen, R. C. (Ed.). (1995). *To be continued...: Soap operas around the world*. NY: Routledge.

Benkler, Y. (2006). *The wealth of networks: How social production transforms markets and freedom*. New Haven, CT: Yale University Press.

Brown, M. E. (1987). The politics of soaps: Pleasure and feminine empowerment. *Australian Journal of Cultural Studies, 4*(2), 1–25.

Cho, Y. C., & Agrusa, J. (2007). How the media is a significant promotional tool to deliver marketing messages to audiences? *International Business & Economic Research Journal, 6*(10), 61–74.

Clemens, L. (2006, October 15). Plot twists for genre: Novelas make English-language inroads, but will appeal get lost in translation? *Multichannel News*. Retrieved from http://www.multichannel.com/article/81696-Plot_Twists_for_Genre.php.

D'acci, J. (1992). Defining women: The case of Cagney and Lacey. In L. Spigel & D. Mann (Eds.), *Private screenings: Television and the female consumer*. Minneapolis, MN: University of Minnesota Press.

Darling-Wolf, F. (2004). Virtually multicultural: Trans-Asian identity and gender in an international fan community of a Japanese star. *New Media & Society, 6*(4), 507–528.

Flanagin, A. J., Tiyaamornwong, V., O'connor, J., & Seibold, D. R. (2002). Computer mediated group work: The interaction of member sex and anonymity. *Communication Research, 29*(1), 66–93.

Ha, L., & Ganahl, R. (2004). Webcasting business models of clicks-and-bricks and pure-play media: A comparative study of leading Webcasters in South Korea and the United States. *The International Journal on Media Management, 6*(1&2), 75–88.

Heo, J. (2002). [The "Korean Wave" phenomenon and audience reception of Korean television dramas in China]. *Korean Broadcasting and Telecommunications Studies Journal, 16*(1), 496–529.

Hua, V. (2005, August 28). South Korea soap operas find large audiences: Exported television dramas improving nation's image around Asia—and beyond. *San Francisco Chronicles.*

Huat, C. B. (2004). Conceptualizing an East Asian popular culture, *Inter-Asia Cultural Studies, 5,* 200–221.

Huat, C. B., & Iwabuchi, K. (2008). Introduction: East Asian television dramas: Identifications, sentiments and effects. In C. B. Huat & K. Iwabuchi (Eds.), *East Asian pop culture: Analysing the Korean wave* (pp. 1–12). Hong Kong, China: Hong Kong University Press.

Jenkins, H. (1992). *Textual poachers: Television fans and participatory culture.* New York: Routledge.

Jessup, L. M., Connolly, T., & Tansik, D. A. (1990). Toward a theory of automated group work: The deindividuating effects of anonymity. *Small Group Research, 21,* 333–348.

Kang, J. (2007, February 9). Russia will broadcast *Jewel in the palace. Hankyoreh Newspaper.* Seoul, South Korea.

Lee, M., & Cho, C. H. (1990). Women watching together: An ethnographic study of Korean soap opera fans in the United States. *Cultural Studies, 4*(1), 30–44.

Lopez, A. M. (1995). Our welcomed guests: Telenovelas in Latin America. In R. C. Allen (Ed.), *To be continued...: Soap operas around the world* (pp. 256–275). NY: Routledge.

Matelski, M. J. (1999). *Soap operas worldwide: Cultural and serial realities.* Jefferson, NC: McFarland & Company, Inc.

Mōri, Y. (2008). *Winter sonata* and cultural practices of active fans in Japan: Considering middle-aged women as cultural agents. In C. B. Huat & K. Iwabuchi (Eds.), *East Asian pop culture: Analysing the Korean wave* (pp. 127–141). Hong Kong, China: Hong Kong University Press.

Park, C. (2005, October 27). The power of Korean drama. *The Korea Times.*

Radio Free Asia (2005, June 5). Weekly special: The fervor of Korean Wave throughout the world (4), Retrieved June 4, 2009, from http://www.rfa.org/korean/week-ly_program/korean_wave/korean_wave-20050605.html

Rofel, L. (1995). The melodrama of national identity in post-Tiananmen China. In R. C. Allen (Ed.), *To be continued...: Soap operas around the world* (pp. 301–320). NY: Routledge.

Shim, D. (2008). The growth of Korean cultural industries and the Korean Wave. In C. B. Huat & K. Iwabuchi (Eds.), *East Asian pop culture: Analysing the Korean wave* (pp. 15–31). Hong Kong, China: Hong Kong University Press.

Valacich, J. S., Wheeler, B. C., Mennecke, B. E., & Wachter, R. (1995). The effects of numerical and logical group size on computer-mediated idea generation. *Organizational behavior and human decision processes, 62*(3), 318–329.

Wright, K. (2002). Social support within an on-line cancer community: An assessment of emotional support, perceptions of advantages and disadvantages, and motives for using the community from a communication perspective. *Journal of Applied Communication Research, 30*(3), 195–209.

Yoon, H. (2005). The present and future of television dramas in the age of digital: From the "Korean Wave" to HD (Report No. 05–18). Seoul, Republic of Korea: Korean Broadcasting Institute.

4. Media Globalization and "The Secondary Flow"

Telenovelas in Israel

Tamar Ginossar

The hegemony of the West, and especially of the United States as a global entertainment-media provider, led to public and scholarly concerns regarding the cultural sovereignty of countries in the periphery. Since the 1960s, scholars described this one-directional flow of entertainment as cultural imperialism (Schiller, 1992; Straubhaar, 1991). In the 1990s, with the simultaneous processes of television privatization and globalization, importing television programs and channels became an economic imperative for most countries. The rise in imports increased the concerns over foreign television content further weakening local cultures (Cohen, 2008). At the same time, the increase in production and export of telenovelas in some Latin American countries during these years rendered previous models of unilateral cultural flow and media imperialism too simplistic. Instead, some global media scholars claimed, this new flow represented the potential of the South for resistance, alternatives, and even contra-flow of communication (Biltereyst & Meers, 2000). The complexity of this new phenomenon in media globalization led to what Biltereyst and Meers (2000) referred as "an international telenovelas debate" about whether it truly represented a "contra-flow" to media imperialism. A more recent phenomenon is that of "a secondary flow," the import of telenovelas from Latin American countries to other developing countries and countries in economic transition from socialism or communism to capitalistic economies. Despite the growing scholarly attention to the flow of telenovelas from Latin America, this secondary flow was largely overlooked. For instance, most of the

studies and scholarly debate focused on the flow of telenovelas within Latin America, or between developing and developed countries (e.g., Antola & Rogers, 1984; La Pastina & Straubhaar, 2005; Mato, 2002; Rogers & Antola, 1985). Other studies focused on their reception among Latino audiences (e.g., Mayer, 2003; Rios, 2003). Anecdotal data and media coverage of this relatively new phenomenon included vivid descriptions of countries that shut down any activity when certain telenovelas were broadcast. A few publicized examples include the success of the Mexican production *Los Ricos Tambien Lloran* (*The Rich Cry Too*) in Russia (Stan, 2003). Similarly, *Marimar*, a Mexican telenovela that captivated audiences in Indonesia and the Philippines, was reported to attract more viewers in Côte d'Ivoire than the 1998 World Cup, and forced some of the mosques in Abidjan to change the prayer time during the month of Ramadan of 1999, so as not to conflict with its broadcast (Ortiz de Urbina & López, 1999). In Bulgaria, the Venezuelan telenovela *Kassandra* was running ten episodes ahead of Yugoslav television, which allowed some viewers to charge their neighbors in return to information about the coming episodes (Stan, 2003). In Israel, the stars of a popular Argentinean telenovela for youth had to change hotels during their first visit after their young fans crowded the first hotel, managed to bypass security, and disturbed the peace of other hotel guests.

This international fascination with this distinct Latin American genre demonstrates the emergence of some Latin American countries as global centers of export of telenovelas. Telenovelas have been consumed across Latin America for the last 40 years, with Mexico, Brazil, Venezuela and Argentina as the main producers. The processes of economic transformation and privatization in countries across the world, as well as technological development like the cable television and satellite dishes, expanded the regional distribution of telenovelas to a global diffusion, challenging the monopoly of the U.S. as a global entertainment-media provider (Antola & Rogers, 1984; Mato, 1999). In view of the potential of this "secondary flow" to provide an alternative to previous models, it is important to examine its processes of production, export, and cultural influence.

Previous analyses of the globalization of television typically concentrated on the developed West and/or on developing countries, but not on transitional economies (Thomas, 2002). In contrast, in this chapter, I describe the processes of production and consumption of telenovelas in Israel, a country that in the 1990s experienced privatization of formerly state-owned institutions, including a transition from a one-channel, government-controlled television to a multi-channel system. This examination can aid in moving away from investigating media globalization using only binary definitions of center/ periphery, and include research of the *hybridity*, or the mixture of global/local

and of center/periphery that is inherent to globalization (Kraidy, 2005). As cultural products, telenovelas provide a prime example of hybridity (Garcia-Canclini, 1995) and a departure from the linear diffusion model of "the West to the rest." This analysis is based on interviews with cultural informants in Israel, including children and adults from different socio-economic backgrounds about their consumption of telenovelas; my personal experience as a scriptwriter writing a pilot of an Israeli telenovela; a content analysis of telenovela websites, including those of fans and producers; and of Israeli and other national newspaper stories related to telenovelas that were identified using Lexis Nexis Academic, Internet searches, and print newspaper archives in Israel.

This chapter opens with an overview of the Israeli television system and its transformation. It then describes the processes through which telenovelas were imported to Israel, their production, and their impact on the local market. Specifically, following previous studies of "the flow" of television content (e.g., Antola & Rogers, 1984; La Pastina & Straubhaar, 2005; Mato, 2002; Rogers & Antola, 1985), I analyze the structural and cultural aspects of this flow. I propose that this flow led to processes of cultural learning, in which audiences adopted elements of Latino culture, most notably expressed by Israeli fans learning to speak Spanish, and of cultural resistance, manifested in a public debate over the impact of Argentinean telenovelas aimed at children and adolescents. Structurally, I depict how this flow began with importing telenovelas and proceeded to production of local Israeli telenovelas, as well as to the founding of an internationally-traded company owned by Israelis that co-produces and distributes Latin American telenovelas to more than 50 countries. The chapter concludes with a discussion of the implications of these processes of the "secondary flow" to the future of media globalization in "peripheral" countries. I argue that this "secondary flow" manifested new forms of cultural and production and global distribution hybrids. However, as telenovelas operate from the mainstream media and are produced with financial motives, they do not resist the status quo and only create messages that attempt to increase consumption.

Context: Israeli Television

Although the country was established in 1948, Israel's first television broadcast took place in 1968 with the historic broadcast of its 20th Independence Day's military parade. In the two decades prior to this symbolic broadcast, Israeli leaders resisted television. They perceived it as a vehicle for promotion of capitalistic messages that would threaten the young country's core socialist values and its efforts to establish a unique national culture (Cohen, 2005; Lemish, 2003). Following the 1967 war, leaders became concerned over the

potential influence of Israelis' consumption of television broadcasts from neighboring Arab nations, which included overt anti-Israeli propaganda. Consequently, they decided to counteract this programming by embracing this previously resisted medium. The Israeli television was therefore created as a tool to develop national identity and counter Arab propaganda (Almog, 2004 cited in Cohen, 2005), but the debate over the merit of commercial television and the resistance to it never completely abated (Lemish, 2003). Until the early 1990s, Israel maintained one public broadcast channel, modeled after the BBC. The broadcast time in this one channel was divided between the educational television, the Arab-Israeli television, and the "Israeli Television." The latter broadcast locally produced newscasts and shows and dramas imported mostly from the U.S. and other English speaking countries.

In the 1990s, cable television and the first commercial channel were established. This major regulatory change was part of a larger transition to increase "free market" competition in Israel, similar to other countries (International Monetary Fund, 2000). By 2003, 99 channels were available in Israel through broadcast, cable, and satellite. These included two public, commercial, broadcast stations; one public noncommercial station; and cable and satellite systems. Regulated by the Ministry of Communications, the different broadcasters are required to meet a certain quota of locally produced shows (Cohen, 2008), but are permitted to import a large majority of their programming, in view of the various barriers to local television production. Expansion of the scale of the local television production is constrained by a few factors. First, Israel constitutes a small market with about 6 million potential viewers, which limits television advertising revenue to less than 250 million U.S. dollars. Thus, advertising support for commercial channels is limited, which increases its reliance on foreign content (Cohen, 2008). Additionally, Hebrew is a unique language that inhibits export of television programs. Furthermore, Israel lacks a natural region with cultural affinity with which it can exchange programming. Finally, Israel is culturally heterogeneous. Its society is comprised of Jews from European and Eastern origins, Arabs, religious and secular communities, foreign workers, and recent immigrants, especially large numbers from the former Soviet Republics who have strong ties to their home countries. This cultural heterogeneity leads to a wide array of imported national channels, as opposed to global channels broadcast by cable and satellite operators. Consequently, the Israeli television system uses a variety of programming strategies. In 2008, there were 32 Israeli channels, including a Russian-language channel. Some of these channels rely heavily on foreign content, but their schedules are constructed in Israel and foreign programs are translated using subtitles. In addition, 35 foreign national channels broadcast

in a dozen different languages, and 19 global or local channels (e.g., CNN, Al Jazeera, and MTV) were available to Israeli viewers. Finally, 13 global channels are run by local companies (e.g., National Geographic, The History Channel) (Cohen, 2008).

Thus, the Israeli television today has a well-developed infrastructure of communication, and is situated in a structural-cultural context of what Lemish describes as "a thriving print industry and a flourishing market for imported products, such as books and magazines, computer and video games, films, music compact discs and tapes" (2003, p. 126). In contrast to the attention on Israeli audiences' consumption of English-language television content among adults and children (Lemish, 1999; Liebes & Katz, 1990), including media globalization influence on children (Lemish et al., 1998), the consumption of Latin American content, on the other hand, has received no scholarly attention. Two exceptions are a study that examined perceptions of parents and third person effects as they relate to the influence of *Rebelde Way*, an Argentinean telenovela, on children (Tsfati, Ribak, & Cohen, 2005), and an analysis (López-Pumarejo, 2007) of the reasons for the success of the genre in Israel. López-Pumarejo argued that four primary factors can explain this popularity: the centrality of cable to opening the television industry, the limited television programming before the 1990s, the cultural and political climate in Israel, and the telenovelas' compatibility with Israel's narrative traditions, particularly its popular cinema. However, this previous research did not examine the consumption of telenovelas in Israel as a special case in globalization of television. Consequently, little is known about the different facets of consumption and productions of telenovelas in Israel.

The Secondary Flow: Exporting Telenovelas to Israel and Their Consumption

Like soap operas, telenovelas are serial melodramatic genres that according to Matelski (1999) share the ambiguity of being successful and disdained at the same time. Telenovelas differ from the soap opera four major ways. First, they have a finite number of episodes (120–200), therefore viewers expect a definitive conclusion to the story; second, they are financed by television networks and are broadcast both in primetime and in the afternoon block. In addition, whereas in the U.S. it is Hollywood that determines the stardom system, in Latin America it is telenovelas. Finally, the television careers of actors are not tied to the characters they portray as is the case in the American soap opera system. Instead, Latin American actors perform in various telenovelas (Acosta-Alzuru, 2003).

Whereas American soaps and super-soaps were broadcast in Israel since the early 1980s (Liebes & Katz, 1990), telenovelas did not enter the Israeli market in a significant way until the 1990s. The first telenovelas to air in Israel was *Los Ricos También Lloran* in 1989. It did not receive media coverage and its viewership and consumption is largely unknown. The significant introduction of telenovelas to Israeli audiences centered on the efforts of one man, Yair Dori. Born in Argentina, Dori immigrated to Israel when he was 21. His familiarity with both Argentinean and Israeli cultures allowed him to identify the potential attractiveness of the genre to Israeli audiences. Furthermore, he was well immersed in media industries, and his social connections facilitated his active role in promoting the success of the telenovelas. Following the relative success of the Venezuelan telenovelas *La Extraña Dama, Topcio*, and *Cristal* in Israel in the early 1990s, Dori imported in 1994 the Argentinean telenovela *Antonella*, which was an immediate hit. Contrary to other television content importers/distributers, Dori did not limit his role to buying the rights and selling the serials to local television. Instead, he utilized his personal connections in Argentina's large studios, previous experience in importing sports and concerts from Latin America, and natural marketing skills (Dori's formal education includes a B.A. in philosophy) to promote the diffusion of telenovelas in Israel.

One of the most important means that Dori utilized to increase the popularity of these imported serials and to secure fans' loyalty was well-organized and publicized visits of the telenovela stars, Andrea Del Boca and Gustavo Bermúdez to Israel. The enthusiastic reaction from Israeli telenovelas' fans was described by López-Pumarejo (2007), a telenovela scholar who happened to participate in an academic panel attended by Argentinean telenovela star Gustavo Bermúdez:

> A screaming crowd pushed its way into a Tel Aviv University auditorium. As armed security guards did their best to contain those who were shoving me against the officer at the door [...] The frantic mob consisted primarily of young Hebrew-speaking women who, in Spanish, yelled from the door: "¡Te quieRRo!...¡Te amo!" which meant something significantly more passionate than what "I love you" means (normally) in English (p. 197).

López-Pumarejo's experience demonstrates the unprecedented success of telenovelas in Israel, as well as some of the cultural processes that characterized this success. First, the local mass media provided much coverage of the telenovelas and especially of their stars' visits. Such media coverage was previously reserved for the visit of "super soaps" stars like those in *Dallas* and *Dynasty* and to mainstream Hollywood movie stars. However, in contrast to these visits of U.S. stars, in which fans and even media access to the stars was

carefully restricted, the Latin American stars' visits presented a much more immediate image of these actors. They allowed journalists, photographers, and fans to follow them constantly, and gave frequent interviews to written and broadcast media, in which they expressed their emotional connection to Israel and Israelis. For example, a few years following the success of Andrea Del Boca and Gustavo Bermudez in *Antonella* and *Celeste*, the telenovela *Muñeca Brava* (*Ferocious Doll*) captured the hearts of telenovela audiences and became one of the most successful telenovelas in Israel. Its star, Natalia Oreiro, appeared on one the most popular prime time evening talk shows. The host, David Topaz, complemented her on air about her charms, and said that she was "so cute, he could eat her." To demonstrate his seriousness, he literally bit her arm. This incident received much public attention as on-camera sexual harassment. The public uproar was such that the story in the online newspaper *Y-net* received over a thousand comments from readers, most of them enraged by his behavior. This story received more attention than any other news story that occurred at the time. This public response demonstrated both the magnitude of the mass media coverage of telenovelas' stars in Israel, and the extent to which local audiences identified with them and their stars. In the case of Oreiro, Israelis overwhelmingly sided with the foreign star, and were offended on her behalf at the sight of inappropriate behavior by a local male media personality.

As these previous examples demonstrate, audience consumption of telenovelas in Israel included (a) much media coverage, indicating its relative centrality in the cultural discourse in the country, (b) audience attention to this coverage, as evident in response to news stories about telenovelas and their stars, and (c) individual's identification with the stars and the protagonists they portrayed. This intense identification is manifested in different "fandom" behaviors, such as following the Latin American stars during their visits to Israel, readership of their magazine as well as other media coverage, consumption of music, participation in online email lists and "forums" dedicated to the topic of telenovelas and other behaviors as described above. Much of this "fandom" behavior demonstrates cultural-learning. Although Israel has a large community of Latin American, and particularly Argentinean-born Jews, they are not believed to be a big fraction of the telenovela fans (Lerner, 2006). Therefore, telenovela fans often learn Spanish from watching the subtitled shows. Some of them even take Spanish classes. In addition, some fans travel to Argentina to visit the studios producing the telenovelas.

Both the structural and the cultural characteristics of telenovela imports to Israel are most notable in the telenovelas targeting children and adolescents. In 2000, Dori imported to Israel *Chiquititas* (the show was named *Tiny Angels* in English), an Argentinean telenovela for children written by Cris

Moreno and produced by Telefe. The show depicted a girls' orphanage in Buenos Aires called Rincón de Luz. In the first season, it centered on the girls' first loves and their struggles with the evil owner of the orphanage. In the following seasons boys were added to the cast and integrated into the plot. Similar to Argentina, where the show aired from 1995–2001, the Israeli young audience received the show with much enthusiasm. The distributers released a line of merchandise for Israeli children, and members of the cast visited Israel to promote the show

Following this production, Cris Morena and Yair Dori collaborated on the production of a show that targeted adolescents, *Rebelde Way* (*The Rebels*). This show was important in two major ways. Culturally, its distribution was accompanied by immense popularity among children and teenagers that led to intense public debate and unprecedented institutional reaction. Structurally, it manifested a shift in the production of Argentinean telenovelas imported to Israel. Whereas *Chiquititas* was produced by Telefe, an Argentinean television channel, Cris Moreno collaborated with Yair Dori on *Rebelde Way*, thus moving away from the previous model of Argentinean telenovela production in which the big television channels were also the shows' producers. Moreover, this collaboration between the Argentinean Moreno and the Israeli-Argentinean Dori created a new global hybrid of production, of international collaboration between media content producers of the "secondary flow." This hybridism also had some cultural implications. Although the production was conducted just like other Argentinean-made telenovelas in Buenos Aires, that is in Spanish by an Argentinean cast and production crew, the fact that one of the producers was an Israeli allowed him to adapt some of the messages to the Israeli audience.

The show portrayed teenagers in a prestigious Argentinean boarding school. The "rebellion" that the name of the show alluded to consisted of the students rebelling against their career-driven, neglectful parents and school personnel by misbehaving. The show depicted them using foul language, dressing provocatively, being rude to parents and teachers, stealing, having sex, consuming alcohol, and harassing other students. Following the broadcast of the first episodes of the show in Israel, two interrelated processes ensued. First, the show became extremely popular among children and teens (Tsfati et al., 2005). This popularity manifested itself not only in high ratings among this age group, but also in media coverage of a number of reported "copy cat" cases in which children imitated some of the transgressions depicted in the show. Tsfati and colleagues (2005) reported recurrent coverage in the Israeli media about violent incidents that were reportedly inspired by *The Rebels*. Although

the actual number and prevalence of these incidences was unknown, they received widespread media and public attention. For example, on February 17th 2003, *Maariv* (Israel's second largest newspaper) published a story about a violent attack on a seventh grader that reportedly imitated an episode in the show, where a talented and good-looking character was beaten up because he was too popular with the girls. The authors indicated that two days later, the newspaper proclaimed that "this is already a very worrying phenomenon: As more episodes of *The Rebels* are aired, more and more incidents of harassment and violence, inspired by the show, are reported" (Zelinger & Greilsmer 2003, cited in Tsfati et al., 2005, p. 4). The perceptions of many parents, teachers, and politicians that considered the show harmful (Tsfati et al., 2005) led to an intense public debate and unprecedented institutional response. The director general of the Israeli Ministry of Education requested the channels broadcasting the show to edit out offensive content prior to airing the program, and to label the show as inappropriate for young viewers. In an uncommon step, Israeli parliament's committee for children's rights held a special hearing about the show.

In view of these extreme institutional responses and intense public concerns, it is important to note that Israeli communication researchers (Tsfati et al., 2005) described the content as "not much more graphic than many of the other shows and movies broadcast on Israeli cable channels (many of which are U.S. productions), including those targeted at young audiences" (p. 4). They attributed this attention and public criticism to what they described as the show's extreme popularity. Other possible explanations for both the show's popularity with youth and the resistance to it among adults can be attributed to cultural factors associated with the origin of the show. Contrary to the U.S. programs that children and adults in Israel have been accustomed to, Argentenean telenovelas pose different cultural influences and thus lead to different perceptions. Previous scholars noted that the strong presence of U.S. cultural products in different media over the years has created a sense of familiarity or proximity with them (La Pastina & Straubhaar, 2005). In view of this long-standing tradition of North American cultural influences on Israel, it is possible that many Israeli adults perceive the "familiar" U.S. cultural influences as unavoidable or even desirable, whereas they might perceive the "novel" influences of South American culture as more threatening, and thus resist them. Future analyses of the content of these shows, as well as more in-depth audience analyses, should further explore the reasons behind this resistence.

Paradoxically, although the Latin American serials present Israeli audiences with new cultural influences, they perceive them as more similar to Israeli cul-

ture than U.S.-produced shows. Whereas both my interviews and prior audience research revealed that Israeli audiences perceive the U.S. soaps and dramas as fulfilling fantasies, and its stars/protagonists as very different from the viewers (Liebes & Katz, 1990; Lemish, 1999), the stars/protagonists in the telenovelas are considered to be more similar to Israeli audiences. For example, taxi driver Nissim Wizgan said to a reporter, " The American soap operas are good as well, but the characters are too high class and don't have anything in common with the Israeli public. The Telenovela characters, on the other hand, do" (Lemor, 1998). The producers' marketing efforts, as described above, promoted these perceptions of similarity and immediacy.

This perceived similarity might have led to more explicit imitation of the behaviors depicted in the show among young viewers, compared to cultural assimilation inspired by U.S. media. At the same time, this imitation might have led to concerns among parents and other adults about the behavioral consequences of watching the show. Alternatively, it is possible that the show did not actually create more "copy cat" cases than any other popular television show, but that because the Latin American cultural influence was new, it received more public (and media) attention than U.S. influences that became "transparent" over years of consumption of its television content (Weinman, 1984), cultural products, as well as other cultural exchanges.

This perceived similarity of Latin American culture as depicted in the telenovelas also support cultural proximity theory, which advances the idea that audiences prefer media which reflect their own culture, and thus television broadcasters will import programming from the most culturally similar exporters, not the most powerful ones (Straubhaar, 1991). In the case of Israeli audiences, both fans and television importers and producers view telenovelas as culturally congruent with Israeli culture. These perceptions were based on nonverbal behavior of telenovela characters and actors that reflected immediacy, including physical appearance, body language, clothes, and collectivistic cultural values that center on the importance of family and friends.

Structural Features of the Secondary Flow: The Dori Media Group

The marketing efforts that arguably increased the cultural influences on Israeli audiences were orchestrated by Yair Dori, who did not suffice by simply importing programs to existing channels. In 1999, Dori established a cable channel dedicated to telenovelas, called Viva. In the next year, he established

VIVA Platinum, which broadcasts telenovelas on weekends. This move proved to be financially successful. According to his company, Dori Media group (DMG), Israel imports more telenovelas than any other country. The Viva channel both benefits from this popularity and promotes it. The success of the channel demonstrates the stronghold of telenovelas in audience's hearts in Israel. One of the reasons for this success is related to the loyalty of telenovelas' fans. About 80% of viewers of a telenovela show at the beginning of the week will watch all the episodes through the end of the week.

Today, Dori Media Group (DMG) is an international media group traded on the London Stock Exchange. It is controlled by Mapal Communications Ltd., one of the largest media companies in Israel. In 2008, the company had subsidiaries and bases in 5 different countries (Argentina, U.S.A., Israel, Switzerland, and Philippines). Its model includes production in Argentina and in Israel, an international distribution division, selling to approximately 65 territories and 400 TV channels worldwide, operating 15 television channels and a website for telenovelas, as well as an ancillary business of merchandising, live shows, CD, DVD, and advertising and a technical lab in which translating, dubbing, duplicating and other technical services are provided. In Israel, DMG owns Dori Media Paran and Dori Media Darset, which produce daily series and telenovelas for the Israeli market. It also owns and operates the two telenovela channels described above, Viva and Viva Platinum. In addition, it packages, produces and operates all of the movie channels on HOT cable television and the series channel on HOT Extra. In Indonesia, the company operates the Televiva Vision 2 channel that is devoted to telenovelas and Baby TV Vision 3 for toddlers.

In addition to the obvious financial success of telenovelas in Israel and other countries at the periphery, this extensive international activity of DMG manifests the economics of hybrid production of television content in the era of globalization. This hybrid production includes international co-productions that are produced with the intent to be distributed internationally. For example, in 2004 alone, DMG co-produced *Padre Coraje* with Pol-ka, *Jesus el Heredero* with Central Park, *Floricienta* with Cris Morena, and the film version of *Rebelde Way*, also with Cris Morena (López-Pumarejo, 2007). However, I argue that the greatest influence of telenovelas on Israeli television and culture was exhibited through the production of local telenovelas produced in Israel. In the following section, I will describe this local production and its main cultural and structural characteristics.

Local Production of Telenovelas and Soap Operas

Despite the popularity of telenovelas in Israel in the 1990s, it was not until 2001 that the first Israeli-made telenovela was produced. On the other hand, one of the first and most popular local productions to air on the new commercial channel (Channel 2) was an Israeli drama modeled after U.S. soap operas. Consistent with this genre, it focused on the life of rich people. This serial drama, called *Ramat Aviv Gimel* (the name of an upscale northern Tel Aviv neighborhood) depicted the fictitious life and dramas of a wealthy family who owned a fashion house and lived in this neighborhood. Its 150 episodes aired from 1995–2001. The production was not only modeled after U.S. soap operas in terms of its content and story line, but also marketed as such. However, it departed from the genre in three important ways. First, it was broadcast during prime time. Second, it received much media coverage, indicating its cultural significance to local audiences. Finally, the actors' reputation was not based solely on their role in this show. Instead, many of them were already established actors before their participation in the serial, and most of the lead actors participated in other television productions, including other genres, following the show. In these respects, this serial was similar to the telenovela, rather than to the soap opera.

Kessef Katlani (*Killer Money*) was another soap opera that aired concurrently. It differed from *Ramat Aviv Gimel* in a few ways. First, it adhered more precisely to the "U.S. soap conventions," by highlighting the value of money and materialism more than Ramat Aviv Gimel did. It focused on adult characters only, whereas *Ramat Aviv Gimel* also depicted teenagers, a feature that was more consistent with Australian telenovelas (Crofts, 1995). Finally, it was shot only in the studio, whereas *Ramat Aviv Gimel* included outdoor locations as well, in another cultural influence of Australian soaps (Balas, n.d.). Whereas *Ramat Aviv Gimel* was scrutinized by television critics but was very popular with the audience, *Kessef Katlani* by and large failed in receiving either critique or popular acclaim. I argue that whereas *Ramat Aviv Gimel* succeeded in providing cultural relevancy to Israeli viewers through its focus on a family, providing likeable characters/actors, and depictions of actual location, in *Kessef Katlani* the strict adherence to the U.S. genre's conventions, combined with very low production values and lack of experience in production of this genre resulted in a serial that was unintentionally campy in its style. It failed in competing with the original soap operas, as well as in providing local cultural relevancy to the audience.

Lagaat Baosher (*Touching Happiness*), the "first Zionist telenovela" as it

was known, was produced by Yair Dori and broadcast in 2001. It followed the classic, conservative model of the telenovela, with 50 minute episodes, and a "Cinderella" story. The storyline focused on a poor, fatherless young woman who, in an attempt to pay for her mother's surgery, agreed to be a surrogate mother to a wealthy woman. Unknowingly, she fell in love with the woman's husband (who was the father of her unborn baby). The serial was produced during one year, with 119 episodes that were later broadcast as re-runs by different channels.

Whereas the first productions of Israeli soap and telenovela followed the respective genres' conventions, in the years following the production of the first two Israeli telenovelas the boundaries between Israeli-produced serials modeled after soap operas and telenovelas were not always clear. For example, the serial *Ahava Meever Lapina* (*Love around the Corner*) aired in 2003 as a soap opera modeled after the Australian soap opera *Neighbors*, which portrayed ordinary people's lives. Following low ratings, the Australian-inspired story line that originally centered on mundane events from the characters' daily life was turned into a "telenovela" rich with conniving individuals. This change indeed led to an increase in popularity of the show.

These "diffused boundaries" between the two genres are also manifested, and potentially created, by the participants in these productions. Israeli writers, producers, and actors often participate in production of both soap operas and telenovelas, as well as other genres. It is perhaps this fluidity of both cast and content creators between different genres that leads to some flexibility in adhering to the foreign conventions of either genre. This phenomenon should be considered in view of the economic realities of the Israeli television and other media industries. Consequently, unlike American soap operas, and to a greater extent than Latin American telenovelas, Israeli telenovela actors and creators' careers are not limited to the genre. Young actors often perceive participation in telenovelas as a stepping stone to more meaningful roles, or to the public eye, depending on the aspiring actors' ambitions. However, not only do young actors participate in telenovela, but also some of the most established Israeli theater and movie actors. Participation in telenovelas is a financial necessity even to many acclaimed actors. Most actors and artists in Israel, including those with successful television, movie, or theatrical careers, still struggle financially and often prefer to play in telenovelas than work in odd jobs. One agent of an actress that won the Israeli Oscar in 2002, but worked as a waitress in the following years explained in a media interview: "it is not that uncommon that actors in Israel work in other jobs to supplement their income. What is an Oscar in Israel? It is not like the actor is going to receive

a million dollars in his next movie. Sometimes he does not have enough money to take a taxi home from the ceremony" (Chalutz, 2009).

Local and Political Themes in Israeli-Produced Telenovelas

For the most part, Israeli telenovelas exhibit what Lee (2003) defined as "delocalization," or the minimization of local elements to create content that is "least objectionable" to different audiences. Their portrayal of non-local themes and locations is a common feature of television productions that are produced with the intention to be distributed internationally (Wang & Yeh, 2005). Contrary to the role of some telenovelas in Latin America (La Pastina, 2004), where telenovelas were often active players in the national political and social discourse, the Israeli telenovela never served to deliver political, social justice, or social change messages. Thus, following its primary role as an escapist pleasure, Israeli telenovelas have never depicted Arabs; any mention of the political dispute with Palestinians and Arab countries, terrorism, or any overt discussion of the major political and social problems that plagued the nation. Of the major social and ethnic tensions in Israel, only two were depicted on telenovelas. The few examples of integrating local and cultural elements into telenovelas produced in Israel was a telenovela about an ultraorthodox family, produced originally for a specialized channel, and the identity of a protagonist in a few telenovelas as transitioning from being an observant, orthodox Jew to a secular, non-observant one. In addition, the first telenovelas followed the classic narrative of the telenovela with the classist tension manifested between Jews from Ashkenazi (European origin) and Jews from Sephardic (Eastern origin). More recent tensions, like those between Russian immigrants and other Israelis, Ethiopians immigrants, and of course between Jews and Arabs were never included in the telenovelas. By ignoring other, arguably more threatening social frictions, Israeli telenovelas follow the tradition of a certain Israeli film genre ("Burekas") (Shohat, 1991), maintain their role as providers of escapism, and avoid any expression of social criticism.

Conclusion

In this chapter, I attempted to describe and analyze the consumption of telenovelas in Israel as a case study of a particular global media phenomenon. Although previous researchers who analyzed the production, distribution, and consumption of telenovelas pointed at this genre as demonstrating the

potential of "Third World culture industry for resistance, alternatives, and even contra-flow" (Biltereyst & Meers, 2000, p. 394), to my knowledge this is the first attempt to examine the secondary flow of telenovelas between peripheral countries. The complex pattern of telenovelas' production and import/export to and from Israel described in this chapter demonstrates that perhaps even the term "flow" (Biltereyst & Meers, 2000) as it relates to production, distribution, and consumption of this television genre might not completely capture the complicated relationship and international influences on production. Whereas the term "flow" assumes a definite direction of origin and destination, the reality of production and of distribution of telenovelas points out that these "directions" might not be so clear and definite. In this new global era, not only is the content of television often hybrid, but also the nationality and cultural influences of production and distribution. For example, in the case of Yair Dori's production of *Rebelde Way* and other telenovelas, an Argentinean born Israeli co-produced a telenovela in Argentina, with an Argentinean cast, but at the same time planning on exporting the serial internationally. Therefore, it is not easy to discern the cultural and the financial considerations that were involved in this production, from the write up of the content and the messages, to the choice of cast. All of these decisions might have been impacted by different cultural, structural, and economic factors. Moreover, all of these have the potential to influence consumption of these telenovelas internationally in unknown ways. Clearly, further analyses of the consumption of telenovelas in Israel are needed. In particular, in this chapter I focused on the processes of production and consumption, but did not provide a detailed-analysis of the content of different telenovelas. A closer analysis of plot, style, sense of humor, mis-en-scène, and other elements has the potential to answer the questions regarding the telenovelas' unprecedented success as well as involved resistance in Israel. In addition, incorporating feminist and film theories in this analysis could lead to more nuanced conclusions regarding the cultural influences of Israeli-produced telenovelas and their critical functions in Israeli public discourse compared to my current conclusions.

This analysis also exemplifies the importance of distribution of telenovelas, as opposed to considering only the production/consumption dichotomy. For example, DMG is managed by an Israeli CEO (Nadav Palti) and was financially owned by other Israeli companies. However, it is traded on the London stock exchange, and much of its operation includes trade of telenovelas produced in Latin America and distributed to other countries around the world. Some of the countries that import the telenovelas are European and other developed countries, and others are developing or transitioning from com-

munist regimes. In addition, some countries bought the rights to produce certain telenovelas locally, such as Mexico re-producing *Rebelde Way*, whereas others imported the serials.

It is important not to overstate the importance of this secondary flow and to understand its relative marginality. International television productions are still dominated by Western production, mostly U.S. imported shows (Biltereyst & Meers, 2000). For additional contra/secondary flow of television content from peripheral national cultures to occur, non-central television industries should create new genres that would provide a similar experience of narratives that would be accepted by different audiences.

References

Acosta-Alzuru, C. (2003). "I'm not a feminist…I only defend women as human beings": The production, representation, and consumption of feminism in a telenovela. *Critical Studies in Media Communication, 20,* 269–294.

Antola, L., & Rogers, E. M. (1984). Television flows in Latin America. *Communication Research, 11,* 83–202.

Balas, T. (n.d.). Another opera—from Dallas to Antonella to Ramat Aviv Gimel. Retrieved from http://www.amalnet.k12.il/sites/commun/library/tv/frm_janerim.htm

Biltereyst, D., & Meers, P. H. (2000). The international telenovela debate and the contra-flow argument: A reappraisal. *Media, Culture & Society, 22,* 393–413.

Chalutz, D. (2009, May, 8). Maya Maron Mathila Lehafnim Shehi Beemet Sahkanit (Maya Maron begins to internalize that she is indeed, an actress). *Haaretz.* Retrieved from http://www.haaretz.co.il/hasite/spages/1083800.html?more=1

Cohen, J. (2005). Global and local viewing experiences in the age of multi-channel television: The Israeli experience. *Communication Theory, 15*(4), 437–455.

Cohen, J. (2008). What I watch and who I am: National pride and the viewing of local and foreign television in Israel. *Journal of Communication, 58,* 149–167.

Crofts, S. (1995). Global neighbours? In Allen, R. (ed.) *To Be Continued…*London: Routledge pp.89–121.

Garcia-Canclini, N. (1995). *Hybrid cultures: Strategies for entering and leaving modernity.* Minneapolis, MN: University of Minnesota Press.

International Monetary Fund (2000, November 30). *Transition Economies: An IMF Perspective on Progress and Prospects.* Retrieved from http://www.imf.org/external/np/exr/ib/2000/110300.htm

Kraidi, M., (2005). *Hybridity, or, the cultural logic of globalization.* Philadelphia: Temple University.

La Pastina, A. (2004). Selling political integrity: Telenovelas, intertextuality and local elections in Brazil. *Journal of Broadcasting and Electronic Media, 48,* 302–325.

La Pastina, A., & Straubhaar, J. (2005). Multiple proximities between genres and audiences: The schism between telenovelas' global distribution and local consumption. *Gazette, 67,* 271–288.

Lee, C.C. (2003). Media business strategies in the global era: From a "connectivity" perspective. *Mass Communication Research 75*, 1–36.

Lemish, D. (1999). "America, The Beautiful": Israeli children's perception of the U.S. through a wrestling television series. In Y.R. Kamalipour (Ed.), *Images of the U.S. around the world: A multicultural perspective* (pp. 295–308). New York, NY: SUNY Press.

Lemish, D. (2003). Spice world: Constructing femininity the popular way. *Popular Music and Society, 26* (1), 17–29.

Lemish, D., Drotner, K., Liebes, T., Maigret, E., & Stald, G. (1998). Global culture in practice: A look at children and adolescents in Denmark, France and Israel. *European Journal of Communication 13*(4), 539–556.

Lemor, S. (1998, June, 12). The Bermudas Triangle. *The Jerusalem Post*, Arts, p.3.

Lerner, I. (2006, April, 27). El lugar de la Lengua Española en Israel (the role of Spanish Language in Israel). *Real Instituto Elcano.* Retrieved from http://www.realinstitutoelcano.org/analisis/961/LermerPDF.pdf

Liebes, T., & Katz, E., (1990). *The Export of Meaning: Cross-Cultural Readings of 'Dallas.'* New York: Oxford University Press.

López-Pumarejo, T. (2007). Telenovelas and the Israeli Television Market. *Television and New Media, 8*, 197–212.

Matelski, M. (1999). *Soap Operas Worldwide: Cultural and Serial Realities.* Jefferson, NC: McFarland Publishing.

Mato, D. (1999). Telenovelas: Transnacionalización de la industria y transformaciones del género." ("Telenovelas: Transnationalization of the industry and trasnformation of the genre") in N. García Canclini (ed.), *Industrias culturales e integración latinoamericana* ("Cultural industries and Latin American integration"). Retrieved from http://www.gp.cnti.ve/

Mato, D. (2002). Miami in the transnationalization of the telenovela industry: On territoriality and globalization, *Journal of Latin American Cultural Studies, 11*(2), 195–212.

Mayer, V. (2003). Living telenovelas/telenovelizing life: Mexican American girls' identities and transnational telenovelas. *Journal of Communication, 53,* 479–495.

Ortiz de Urbina, A., & López, A. (1999). *Soaps with a Latin Accent,* Retrieved from: www.unesco.org/1999_05/uk/connex/txt1.htm

Rios, D. I. (2003). U.S. Latino Audiences of "Telenovelas." *Latinos and Education, 2,* 59–65.

Rogers, E.M. & Antola, L. (1985). Telenovelas: A Latin American Success Story. *Journal of Communication, 35,* 24–36.

Schiller, H. I. (1992). *Mass Communications and American Empire.* Second Edition. Boulder, CO: Westview Press.

Shohat, E. H. (1991). *Hakolnoa Hayisraeli: Historia Veideologia (The Israeli Cinema: History and Ideology).* Tel Aviv, Israel: Breirot.

Stan, L. (2003). Living La Vida Loca: Telenovelas and postcommunist transition. *The Sphere of Politics (Sfera Politicii), 105,* 50–54. Retrieved from www.ceeol.com

Straubhaar, J. D., (1991). Beyond media imperialism: Asymmetrical interdependence and

cultural proximity. *Critical Studies in Mass Communication, 8, 39–59*.

Thomas, A. O. (2002). Review of the book "The Global and the National: Media and Communications in Post-Communist Russia." *Transnational Broadcasting Studies, 9*. Retrieved from http://www.tbsjournal.com/Archives/Fall02/Thomas.html

Tsfati, Y., Ribak, R., & Cohen, J., (2005). Rebelde Way in Israel: Parental perceptions of television influence and monitoring of children's social and media activities. *Mass Communication & Society, 8*, 3–22.

Wang, G., & Yeh, E. Y. (2005). Globalization and hybridization in cultural products: The cases of Mulan and Crouching Tiger, Hidden Dragon. *International Journal of Cultural Studies, 8*(2), 175–193.

Weinman, G. (1984). Images of life in America: The impact of American TV in Israel. *International Journal of Intercultural Relations, 8*, 185–197.

Section II

Global Case Studies of Serial Television Dramas and the Emergence of New Audiences

5. *From Humble Beginnings to International Prominence*

The History and Development of Brazilian Telenovelas

Cacilda M. Rêgo

Telenovelas or serialized novels have been part of Brazilian television since its inception. Before the invention of television, radio was the medium for novelas. Millions of loyal fans throughout the country listened to live broadcasts aired every weekday afternoon. Radionovelas, however, died out as soon as the genre moved to television. Telenovelas began with the production format of radionovelas, but through trial and error soon adapted to the new medium, ultimately developing a format that remains in place today. In this essay, I look at the history and development of the Brazilian telenovela. My intent is to show how the Brazilian telenovela, while remaining faithful to the traditions of the genre, has modernized itself in both its thematic content and the quality of its technical and artistic production. For this purpose, I first look briefly at the earliest novelas, both in their radio and television forms, and then discuss the several variations of the genre within television itself. Discussion of all aspects of telenovela production in Brazil is beyond the scope of this essay, as is an in-depth discussion of how telenovelas are received and used by viewers. I confine my discussion to developments within the telenovela industry that have influenced the history of the genre in Brazil. Special attention is given to contemporary telenovelas, whose characteristics are distinctly Brazilian (Straubhaar, 1982). The importance of Globo TV Network in the development of the genre is also discussed. This essay begins with a brief look at how Brazilian telenov-

elas developed and rose into their prominent role in Brazilian popular culture. This essay then moves on to show how the genre evolved from radio to television and, more recently, to the Internet. It ends with a brief look at the future of televised Brazilian telenovelas in the new digital era.

Brazilian Telenovelas and Society

Besides being the most popular television programming genre among Brazilian viewers, telenovelas are the main pillar of broadcast television in Brazil. Broadcast television is the dominant medium of communication in Brazil, and its role in shaping the attitudes and values of Brazilians is both profound and far-reaching. As Reis (1999) notes, television is a very important information resource for Brazilians of every socio-economic level. Brazilians of all socio-economical backgrounds refer to the latest news broadcast in the daily newscast *Jornal Nacional*, or talk about the latest plot twist in one of the telenovelas (p. 402).

The strong audience appeal of telenovelas partly rests on their ability to cross socio-economic, genre, and age barriers. As Page (1995) points out:

> The addictive appeal of the telenovelas has become a kind of glue that binds the disparate elements of Brazilian society. Residents of shacks in frontier towns in Amazonia and high-rise apartments in São Paulo, wealthy matrons and humble maids, children and their grandparents, attorneys and janitors (and even intellectuals who insist that they despise television) all share a common fascination with the characters and the plot convolutions of hit novelas...Brazilians everywhere have made the characters of the telenovelas a major source of their daily gossip. (p. 447)

According to Hamburger (2005), viewers take telenovela plots and characters as references to that which they share with fellow viewers. Hamburger states, "Because they have well-known, cross-class, cross-gender, cross-age, and cross-regional viewers, and because of their references to national symbols and repertoires, viewers understand telenovelas as displays of models of behavior" (p. 144). This is not to say that viewers agree with or assume these models. Rather, by displaying given models of behavior, telenovelas provide an intelligible context for thinking and talking about the national reality. In other words, viewers take topics that telenovelas address as legitimate topics for public discussion. However, Hamburger notes, "beyond simply inspiring opinions about polemic issues," such as political corruption, urban violence, drug addiction, disability, racism, and homosexuality, "telenovelas provide a repertoire through which viewers engage their personal experiences in public terms,

that is, in terms that are recognized as legitimate by fellow viewers" (p. 145).

Hamburger's analysis contributes to wider debates about the telenovela as "a cultural forum" (Newcomb & Hirsch, 2000), whereby important issues faced by society are discussed openly. Although this form of analysis does not concern us here, it gives us the opportunity to briefly reflect on the central presence of the telenovela in Brazilian culture and society. In this regard, Lopes (2009) notes that "Nowadays, to speak of culture in Brazil is to speak necessarily about the 'Brazilian telenovela.'" Fifty-eight years "after its introduction, it is possible to state that the telenovela conquered the public recognition as an aesthetic and cultural product, becoming a central figure in the country's culture and identity" (p. 2).

Moreover, the introduction of digital television in Brazil in 2007 not only became a very lucrative opportunity for Brazilian networks to showcase telenovelas on the new high definition television (HDTV) channels, but also allowed for streaming any telenovela video content online, through both personal computers and cellular phones (Rêgo, 2009). Globo, which had already produced a number of its miniseries and external scenes in high definition (HD) in the early 2000s, launched that same year *Duas Caras/Two Faces* (aired 2007–2008, written by Aguinaldo Silva), the first ever-full HD telenovela to reach the Brazilian public via the then newly launched Brazilian Digital TV System (SBTVD in the Portuguese acronym).

While it is difficult to predict the future of the telenovela industry in Brazil, Globo's dedication to making HD telenovelas is likely to continue as the network makes further inroads into the digital media realm with its programs. The network, which has the distinction of being one of the largest telenovela producers in the world, announced that it is developing new strategies for the new digital media and is distributing an array of digital services, including video and music downloads, as well as interactive blogs. Attracting close to 2 million visitors a year, the network's website not only provides telenovela video content along with other media products such as magazines, newspapers, and live radio, but also access to telenovela blogs. In the case of the 2009 Emmy Award-winning program for Best International Telenovela *Caminho das Indias/The Times of India* (aired 2009, written by Gloria Perez), Globo offered several forums for discussing the telenovela, including *Twitter Caminho das Indias*, further engendering audience loyalty for the serial.

In short, whether on television or the Internet, Brazilian viewers have easy access to the telenovela of their choice every day. In addition to watching novelas on television, viewers—some of whom already purchase or subscribe to fan magazines, write letters to directors, writers, stars, or to fan publications—

now have the opportunity to not only follow their favorite shows on Twitter, but exchange messages with other fans as well as directors, writers, and stars on electronic bulletin boards provided by the network. While there has been no research on message boards for telenovela audiences in Brazil, this new trend will likely have an impact on how traditional Brazilian telenovelas will be produced and consumed in the future. The rest of this essay takes us through the evolution of Brazilian telenovela to the present-day industry boom that has held the whole of Brazil enthralled.

Beginnings: Early 1950s-Early 1960s

Radionovelas arrived in Brazil in 1941 in the form of an Argentine production sponsored by the Colgate-Palmolive company of the U.S. Transmitted by Rádio São Paulo, this first broadcast rapidly caught listeners' interest, and soon radionovelas were a staple of Brazilian broadcasting. Like radio in the U.S., and later television soap operas, these first radionovelas followed the classic melodramatic tradition of the 19th-century serialized novel, the *feuilleton* (Portugese: *folhetim*), which had newspaper readers captivated for decades with stories of love, murder, betrayal, deception, mistaken identity, inheritance, disinheritance and so forth. With women as their main audience, radionovelas thrived on afternoon radio during the 1940s (Belli, 1980). Their introduction to television came a decade later with *Sua Vida Me Pertence/Your Life Belongs to Me*. Aired by Tupi, the first Brazilian television network, in 1951, this earliest telenovela caused great commotion among viewers by featuring Brazil's first on-screen kiss (Borelli, 2000, p. 139).

Early 1950s Brazilian television ran many adaptations of radionovelas. By rule, these were produced locally from Argentine, Cuban, and Mexican scripts. Whether broadcast on radio or television, novelas from this period drew on a variety of literary and dramatic sources for their story elements, including French and English classic dramas such as those found in Moliére, Racine, and Shakespeare. Because they were shot live, the first telenovelas were a laboratory for improvisation. Not infrequently, slips in action and dialogue occurred during those years, and technicians, actors, and cameramen became adept at covering mistakes. Having simpler storylines than today's serials, the early telenovelas were also less sophisticated in appearance. Given budget limitations, they were shot in poor lighting, and sets were small, simple, often improvised, and few in number. With limited rehearsal time, telenovelas carried on the radio tradition of short episodes of 15 minutes, aired live twice a week (Filho,

2001; Lorêdo, 2000; Klagsbrunn & Resende, 1991; Ortiz & Ramos, 1988; Fernandes, 1987). The advent of videotaping in the early 1960s significantly influenced the overall format, and raised the quality and style of Brazilian telenovelas, which have since become the most popular and profitable product of Brazilian television. The story of a female prisoner, *2.5499 Ocupado/2.5499 is Busy* (aired by Excelsior Network in 1963) by Argentine writer Alberto Migré was the first live-to-tape recorded novela on Brazilian television. Lasting 43 episodes and aired daily, it enjoyed considerable popularity among viewers. The popularity of the genre was further confirmed by *O Direito de Nascer/The Right to Be Born* (aired by Tupi in 1965) by Cuban writer Felix Caignet, the first telenovela to achieve a mass audience in Brazil.

It was against this background of ongoing technical development and a massive television audience that the genre consolidated itself in Brazil. With the advent of videotaping, telenovelas could be recorded and edited, hence leading to marked improvement in their technical quality as well as to changes in format and presentation style. Today's telenovelas air six days a week, and are one hour long, which would have been virtually impossible before the advent of the videotape technology. Also, increased budgets for sets as well as new camera and lighting equipment in the 1970s made for a more sophisticated look. Needless to say, today's telenovelas bear little resemblance to the earliest ones.

As discussed elsewhere (Rêgo, 2003a), up to the late 1960s, Brazilian telenovelas adhered to the melodramatic formula that made the genre so successful. A survey of early telenovelas indicate that during the 1960s, the most popular telenovelas were *dramalhões* (of excessively dramatic style) written by women writers, such as the Cuban-exiled Glória Magadan, who worked for Tupi and later Globo. Far-flung locations, such as Morocco, Russia and Japan, provided the settings for most of her stories. It goes without saying, nevertheless, that Magadan's style had its detractors, especially among the more intellectual telenovela writers like Geraldo Vietri, Mário Lago and others, who favored less melodramatic storylines and themes that dealt with distinctively Brazilian social and political realities. This is what critics call the "Brazilianization" of telenovelas (Herold, 1988; Straubhaar, 1982). As Fernandes (1987) argues, by gesturing toward realism, telenovelas like *Beto Rockfeller* (aired 1968, written by Bráulio Pedroso) and *Antonio Maria* (aired by Tupi during 1968–1969, written by Geraldo Vietri), among others, set a new (i.e., realist) dramatic style of representation that paved the way for the modern Brazilian telenovela (p. 85).

Time of Transition: Late 1960s-Early 1970s

Broadcast by Tupi, *Beto Rockfeller* was a decisive moment in the transition of telenovelas into a format with a more distinctly Brazilian content and a more modern feel. The significance of *Beto Rockfeller* lay in the fact that without completely breaking with the melodramatic nature of the genre, it introduced modern dramatic elements into Brazilian television: it used colloquial language instead of the traditional theatrical speech prevalent in previous telenovelas, relied on film techniques for its shooting, and employed an irreverent style of acting, all the while featuring a parade of characters from different social classes, including a typical Brazilian *malandro* (rogue) as personified by Beto Rockfeller, a São Paulo shoe salesman who used "all his wits to climb the social scale" (Mattelart & Mattelart, 1990, p. 15). With *Beto Rockfeller*, the Brazilian telenovela began to enjoy higher status, that of *novela-verdade* (realist novela), being also the first of the kind to confer upon the writer—an inflated expression by today's standard since his/her job consisted solely of adapting the script and directing the actors—the status of author, to date the least theorized category in studies of telenovela production in Brazil (Nogueira, 2002; Vink, 1988). After *Beto Rockfeller*, telenovela fans began to expect greater realism from Brazilian telenovelas—and that is what they have gotten.

In her most recent examination of Brazilian telenovelas, Lopes (2009) notes that the conventions adopted after *Beto Rockfeller* are based in the concept that each telenovela should offer a "novelty," a subject that would differentiate it from its predecessors and that it is capable of provoking interest, commentaries and debates, as well as the consumption of products such as, for example, books, records, and clothes (p. 5).

At any rate, with the smashing success of *Beto Rockfeller*, Tupi showed that it was possible to make a witty telenovela based on Brazilian contemporary reality without failing the Brazilian Institute of Public Opinion (IBOPE) rating litmus test. Comparable to Nielsen in the U.S., IBOPE has performed measurement research in Brazil since 1954. If a telenovela fails to obtain a good IBOPE rating (above 40%) after a certain number of episodes, it can be either terminated or modified, whereas a telenovela that maintains a high rating (70% and above) may see its life span increased. That said, the formula put in effect by Bráulio Pedroso, and soon repeated by telenovela authors Geraldo Vietri and Walter Negrão in *Nino, O Italianinho* (aired by Tupi during 1969–1970), demonstrated above all that the era of the *dramalhões* was over. Proof of this came when, after running *Simplesmente Maria* (aired 1970–1971) for a few weeks, the network realized that it had failed to replicate its past success with

previous *dramalhões* (Fernandes, p. 141). By then, Globo—which, after firing Glória Magadan, had wholeheartedly started the process of "Brazilianization" of its telenovelas—had already stolen Tupi's audience. This was done with the help of Janete Clair, whose *Véu de Noiva/Bridal Veil* (aired 1969–1970) was advertised as the network's first *novela-verdade*.

Considered the grand doyenne of telenovelas, Janete Clair created radionovelas and later telenovelas, among them Globo's *Irmãos Coragem/Brothers Courage*. Originally aired during 1970–1971, and remade in 1995, the serial celebrated soccer and virility, attracting the men to telenovela-watching (Xexéo, 2005; Ferreira & Coelho, 2003). In terms of formal innovations, Clair's new style was a long way from the overly melodramatic, theatrical mode of the first telenovelas and much closer to the realistic style of the telenovelas produced today. Other innovations of a technical order, including better lighting, smaller microphones, portable cameras and videotapes, made it further possible for Globo to create its own styles of telenovelas all the while nudging aside the multinational advertising agencies that had until then controlled telenovela production in Brazil.

The rise of Globo TV Network has been described in detail elsewhere (Rêgo 2009; 2003b) but it became a network in 1969. Within the following decade (1969–1979), it not only outdistanced its rivals, but also began to export its telenovelas (Melo, 1995). Suffice it to note here that Globo's professionalism and production capabilities made it stand apart from the other Brazilian networks. Of course, not every Globo telenovela of this period succeeded in appealing to viewers, but the variety and quality of the network's output in the 1970s and 1980s meant new developments for the Brazilian telenovela.

Since the 1970s, the telenovela has assumed a tremendous level of importance and widened its appeal. In the more intellectual sphere of academia, telenovelas were not taken seriously until the late 1970s-early 1980s, a trend that continues today (Lopes, 2009; Hamburger, 2005; Almeida, 2003; Lopes, Borelli & Resende, 2002; Resende, 2001; Costa, 2000; Borelli, 2000; Borelli & Priolli, 2000; Araújo, 2000; Tufte, 2000; Pallottini, 1998; Távola, 1996; Melo, 1988; Ortiz & Ramos, 1988; Leal, 1986; Ramos, 1986; Campedelli, 1985; Carvalho, Kehl & Ribeiro, 1979–1980, to mention only a few). And yet, when compared to other telenovelas, Globo telenovelas have received a wider share of research and publicity. This was not by accident. Globo converted the genre into a sophisticated Brazilian commodity for internal consumption and export, ultimately setting the model for other Brazilian networks. In fact, some successful Globo telenovelas have generated clones on other net-

works, all hoping, of course, for the same success. Written by Brazil's leading dramatists and performed by television stars, the Globo telenovelas began to air in the 1970s at 6, 7, 8, and 10 in the evening, each with its own style and thematic emphasis, and directed to different audience segments. As Fernandes (1987) writes, "[it is] enough to say '7 o'clock novela' and everybody knows that it refers to a Globo telenovela, shown at 7 P.M., with fixed characteristics" (p. 131). The rest of this essay looks at some of the different telenovela styles, and the savvy moves by Brazilian networks to beat Globo in the competition for audiences.

Telenovelas' Progress: Late 1970s-Early 1980s

Between 1975 and 1982, Globo dedicated the 6 P.M. slot to lavish and costly telenovelas *de época* (epic telenovelas). These dealt with historical themes, such as slavery, derived from classics of Brazilian literature. One such telenovela was *Escrava Isaura/Slave Isaura* (aired 1977). Adapted by Gilberto Braga from a 19th-century anti-slavery novel by Bernardo Guimarães, it became one of the most successful telenovelas of the period. The 6 P.M. telenovelas inspired Globo's miniseries, first produced by the network in 1979 for the 10 P.M. slot. Beginning in 1983, the telenovelas *de época* began to slowly disappear. Telenovelas made for that time slot became, instead, increasingly more adventurous and outgoing in their settings, and their stories included "landowners, ranchers, farmers, mayors, priests, physicians, local businesspeople, and at least a romantic teenaged couple" (Kottak, 1990, p. 40). Although aimed at urbanites, the 6 P.M. telenovelas (actually aired at 6:10 P.M.) became increasingly popular in rural areas as well.

In turn, the network always dedicated the 7 P.M. slot for the so-called *telenovelas leves* (telenovelas light), a mixture of light comedy, romance, and glamour especially geared for the teen audience, and this practice continues today. Whether or not explicit in their titles, the 7 P.M. telenovelas (actually aired at 7:15 P.M.) are irreverent, and tend to comment on current issues (*Da cor do pecado/The Color of Sin*, aired 2004, written by João E. Carneiro), trends (*Tempos Modernos/Modern Times*, aired 2009–2010, written by Bosco Brasil) and fads (*Desejo de Mulher/A Woman's Desire*, aired 2002, written by Euclydes Marinho).

Since the 1970s, dramatic telenovelas have been reserved for the 8 P.M. slot. As Kottak (1990) writes, the 8 o'clock telenovela (actually aired at 8:55 P.M.) "Is a mystery, usually with a few murders. Several times during [that] decade [and well into the 1980s], the entire nation...watched as a murderer is revealed

in the last episode" (p. 40). Two such telenovelas were *O Astro/The Star* (aired 1977–1978, written by Janete Clair) and *Vale Tudo/Anything Goes* (aired 1988–1989, written by Gilberto Braga); the latter was remade in Spanish in 2002 for the U.S. Latino market. More recently, *A Favorita/The Favorite One* (aired 2008–2009, written by João E. Carneiro), which garnished a daily average audience share of between 50 and 60%, became a popular and award-winning telenovela. The Brazilian media attributed its success to its innovative approach to television drama (viewers learned who the murderer was early on), which culminated with the bold turn-around in the life of the apparent heroine.

Yet it was during this period, between 1964 and 1985, that Brazilian theater underwent heavy censorship under the military dictatorship. The pressure and, ultimately, the "scissors" of the censors made several directors, actors, and playwrights like Dias Gomes, Gianfrancesco Guarnieri, Plínio Marcos, and others abandon the stage and seek exile in television, a medium that offered them better salaries and, however slight, greater creative freedom at the time. More effective than any sermon, the 10 o'clock telenovela became in these years a powerful political tool used to criticize social reality. While not overtly political in the militant sense, telenovelas such as *O Bofe* (aired by Globo during 1972–1973, written by Bráulio Pedroso and Lauro Cesar Muniz), *O Bem Amado* (aired by Globo in 1973) and *Saramandaia* (aired by Globo in 1976) both by Dias Gomes, as well as *Os Ossos do Barão* (aired by Globo during 1973–1974, written by Jorge Andrade) and *O Rebu* (aired by Globo during 1974–1975, written by Bráulio Pedroso), made use of fantastic realism to depict daily life, politics, corruption, and hypocrisy in contemporary Brazilian society (Borelli, 2000, p. 130). Typical to the industry, sometimes these 10 o'clock telenovelas succeeded with the broad Brazilian audience, and sometimes they did not. As a consequence, telenovela fans began to migrate to other networks, and for the first time, Globo's monopoly on telenovelas was challenged by less "noble" rivals like the Sistema Brasileiro de Televisão (SBT) and the now defunct Manchete Network, both set up with the remains of Tupi, extinct in 1980.

When Globo Telenovelas Went Global: Mid-1980s On

The first Globo telenovela in color was, incidentally, the first telenovela exported by the network: *O Bem Amado*. This telenovela took the Brazilian accent

to Portugal, where the genre began to affect the former colonizer's speech pat-
terns, in what Mader (1993) calls "a sweet historical revenge" (p. 83). Since
the 1980s, Globo telenovelas have been exported to over 100 countries,
where they achieve large audiences (Rede Globo Website, 2009). Globo's most
important markets are Portugal and its former colonies, Russia, Romania, the
U.S. Latino market, Chile, Peru, Uruguay and Argentina, followed by China,
Indonesia, Malaysia, the Philippines, and more recently India and Japan.
Telenovelas represent 90% of the network's sales abroad. Movies and televi-
sion documentaries account for the remaining 10% of sales in the international
market (Rêgo & La Pastina, 2007, pp. 99–100). The network, however, does
more than export telenovelas to other countries. Beginning in 2002 with *Vale
Todo*, which was co-produced with Telemundo, the network has sold its telen-
ovela format (including scripts, and set and costume descriptions) to several
countries. In May 2009, the network, which is currently co-producing a
Spanish version of *O Clone/The Clone* (aired 2002, written by Glória Perez)
with NBD Universal-owned Telemundo for the U.S. Latino market,
announced that it was also teaming up with Mexico's Azteca to co-produce a
Spanish version of *Louco Amor/Crazy Love* (aired 1983–1984, written by
Gilberto Braga). Azteca and its affiliate Azteca America as well as TV Globo
International will share distribution rights to the telenovela in the Mexican and
U.S. Latino markets (Rede Globo Website, 2009).

 In the process of expanding its products globally, apart from acquiring
channels in Italy and Portugal during the 1980s, Globo launched TV Globo
International in 1999, which is available by cable/satellite to audiences in Latin
America, North America, Europe, Australia, Africa, and Asia (TV Globo
International Website, 2009). Several other Brazilian television networks have
also expanded globally, among them, Bandeirantes (Band International) and
Record (Record International), thus increasing the penetration of Brazilian
telenovelas in a myriad of new markets like Japan, where they have also
become very popular. Significantly, this international presence challenges the
traditional debate about cultural imperialism and the North-South flow of
media productions (Sinclair, 2003). Evans (2005) has gone as far as to say that
the export of Brazilian telenovelas across the globe can be viewed as an exten-
sion of cultural imperialism "with Brazil surrepetitiously spreading the United
States culture to its audiences worldwide" (n.p.). I would like to point out,
however, that another way to look at the flow from Brazil (as well as other Latin
American countries) is to consider its increasing international presence as a
challenge to Hollywood's hegemony of cultural software (see, for further

discussion, Tunstall, 2008; Straubhaar, 2007; Rêgo & LaPastina, 2007). In the final analysis, Globo, which has continued to maintain the high artistic and technical standards set in the previous decades, enjoys an enormous national and global popularity despite increasing competition in both the national and international television markets (Rêgo, 2009; Straubhaar, 2007).

Competition in Telenovela Production: Late 1980s-Early 1990s

The rise and consolidation of Globo as Brazil's leading network in the late 1970s-early 1980s coincided with the demise of several networks, including Tupi, which was the pioneer of telenovelas in Brazil. Globo reigned supreme for much of the 1980s at home. Abroad, as discussed above, it began to substantially intensify the export of its telenovelas in a fierce competition with Mexico's Televisa and Venezuela's Venevision, as well as with Brazil's Bandeirantes and Manchete, which had also been exporting telenovelas to Europe and Latin America with great success since 1987.

Owned by Adolpho Bloch, founder of the Editora Bloch, a prominent news magazine group, Manchete had also become one of Globo's strongest adversaries at home. By not skimping on expenses, the network was able to buy directors, scriptwriters, and actors from Globo, and consequently challenge the leader in the telenovela arena. Manchete's first move in this direction came in 1986 with *Dona Beija,* written by Wilson Aguiar Filho, a historical telenovela based on the life of a 19th-century courtesan of the state of Minas Gerais. The success of *Dona Beija* helped Manchete consolidate its position as Brazil's second largest network (in ratings), second only to Globo.

Although Manchete increasingly challenged Globo's hegemony in the late 1980s with its telenovelas, it was not until the early 1990s that the network gave the leader real cause for concern. In 1990, Manchete launched *Pantantal,* written by Benedito Ruy Barbosa, a telenovela awash in nudity and eroticism that earned audience ratings that surpassed those of Globo. Shaken by *Pantantal*'s success, that same year Globo responded by launching a program on ecology (which was the telenovela's theme), *Globo Ecologia/Globo Ecology,* and by infusing its own telenovelas with equal doses of eroticism and nudity. The large investment required to produce first-rate telenovelas ultimately led Manchete to its demise. In 1999, it was sold to TeleTV!

By then SBT, owned by *Paulista* impresario Silvio Santos, had also become a strong competitor to Globo. With popular programming aimed at the lower

classes, SBT established itself as a solid network in the 1980s. For economic reasons, SBT initially imported rather than produced telenovelas. Between 1982 and 1990, the network broadcast 30 telenovelas, 13 of which were Mexican. The trend, which was limited to SBT, ultimately generated fears of "Mexicanization" of Brazilian television. Considered tacky and overly dramatic by national standards, Mexican telenovelas, nevertheless, enjoyed massive popularity among Brazil's lower classes, who also had their eyes on the prizes (houses, cars, etc.) offered by Santos during his Sunday variety program, *Sílvio Santos' Show* (Rêgo 2003b, pp. 173–175).

While debate raged in 1991 about whether Globo was losing its edge (as hard as it tried, the network seemed unable to replicate the success of former telenovelas), SBT scored a mega hit with the Mexican production *Carrosel*. Although poorly dubbed into Portuguese and unsophisticated in style, the serial scored ratings that cut deeply into Globo's *Jornal Nacional,* which had customarily dominated the prime time 8 P.M. slot. While Mexican productions were immensely popular in Brazil, no other Mexican telenovela had had such an impact before, especially on Globo, which lost US$17 million in advertising revenue in the first quarter of 1991 as SBT began to lure advertisers away from it (Rêgo 2003b, p. 177). With the popularity of Mexican productions declining since the late 1990s, the network has increasingly produced its own telenovelas. Most of them have been remakes of old shows, such as *As Pupilas do Senhor Reitor* (aired 1994–1995) based on the homonymous novel by Júlio Dinis and originally adapted to video by telenovela writer Lauro Cesar Muniz and aired by Record Netwwork in 1970–1971; *Os Ossos do Barão* (aired 1997), adapted by telenovela writer Walter G. Durst from Jorge Andrade's original story and aired by Globo during 1973–1974; and *O Direito de Nascer* (aired 2001, adapted by telenovela writers Aziz Bajur and Jayme Camargo). During this period, SBT also remade several old Mexican telenovelas in partnership with Mexico's Televisa (currently partner of Record), and re-aired original telenovelas from other networks, such as *Pantanal,* which was recently shown (2008–2009) by the network (SBT Website, 2009). In any case, as Matelski (1999) notes, "With SBT's rising success, Rede Globo began to change its novela direction to better attract new viewers and to keep its old ones" (p. 81). As with SBT, Bandeirantes and Record (owned by the Universal Church of the Kingdom of God) grew steadily during the 1980s and 1990s, during which time these networks began to produce their own telenovelas.

Looking Toward the Future:
Late 1990s to the Present

Since 2000, telenovela fans in Brazil and around the world can turn to the Internet to watch the most popular prime time serials from Globo. The network, which pioneered the trend in Brazil, makes daily segments of its telenovelas available at no charge in its website: a strategy that has helped rather than hindered broadcast viewership at home, while increasing the network's marketing and promotion ability of its products worldwide. Globo.Com subscribers can watch entire episodes of Globo telenovelas. Other networks like Record and SBT have followed suit by placing highlights of their telenovelas online in an attempt to drive the growth and support of online viewers for their shows. If the advent of the Internet ever instigated fears of a decline in viewership of telenovelas, the viewing of telenovelas online may indicate, in fact, that there is a Web-savvy audience for them. Besides enjoying the added Web-exclusive materials (Globo, for instance, sells telenovela-related merchandise on the homepages of its telenovelas), cyberviewers can read about and discuss what is going on with the telenovelas they watch, as well as interact online with their favorite actors, directors, and writers. Daily updates of episodes can be followed by cyberviewers, who can also participate in online chats or vote on their private computers for how the show should continue or what should be the fate of characters. Although a fertile area for analysis, the worldwide spread of Brazilian telenovelas via online and cyberspace fandoms of these telenovelas have yet to be investigated within and outside academia.

The Rise and (Fall?) of a Genre

With ratings that outstrip other television programs and the highest cost for advertisement slots, prime time Globo telenovelas are entitled to the biggest production budgets, with the cost of one single episode sometimes exceeding $100,000 (Jambeiro, 2001, p. 119). In order to defray costs, the network makes use of commercial merchandising (product advertisement in story form), which serves a validating function to new consumer products introduced into the market. Commercial merchandising has become so important that Globo created its own spinoff company (Central Globo de Comunicação) to handle its commercial merchandise enterprises.

However, like the characters they portray, Brazilian telenovelas have also had their own ups and downs. Daniel Filho (2001), director of Central Globo

de Criação, an in-house creation center within PROJAC, has admitted that despite the international success of its telenovelas, Globo has begun to lose its hold in the Latin American and U.S. Latino markets due to increasing competition from Mexican and Venezuelan telenovelas (pp. 341–348). As if this were not enough, Borelli and Priolli indicate that, despite its undisputed supremacy in the field, Globo has also been loosing its edge at home. They interpret the decline of audience ratings—from 70–100% in the 1970s and 1980s to 30–45% since the early 1990s—as a crisis in the genre (pp. 33–41). This trend, according to Borelli and Priolli as well as other analysts (Filho, 2001, p. 71; Mattelart & Mattelart, 1990, pp. 56–58), is partly due to the network's repeated use of well-worn plot lines and characters in its prime time telenovelas, making it difficult for them to maintain the interest of loyal viewers and to attract new ones. But the truth is the telenovela market has been experiencing growth for a good while now. There has never been such a large number of telenovelas being produced in Brazil. Consequently, Globo is not only facing a much more mature market but fiercer competition from other networks as well.

Conclusion

This essay discusses the development of the telenovela genre in Brazil, tracing from its early history of borrowing and adapting from foreign sources to its decisive entrée as a uniquely Brazilian, sophisticated art form into international markets. Distinct from American soap operas, Brazilian telenovelas have a tremendous cultural impact, "both nationally and internationally, far beyond anything the U.S. soap opera have been able to effect" (Page, 1995, p. 446). According to Dias Gomes (in Klagsbrunn & Resende, 1991), there is a difference between the fascination a telenovela exerts in Brazil and abroad. In Brazil, he notes, the genre enjoys greater popularity because it is an open work. As a consequence,

> The viewer knows that the story he [sic] is watching is unfinished and therefore it has a special charm for him. The viewer has even the impression that his reaction will in some way affect the plot. The characters start to come to life; to be real citizens involved in the daily life when a telenovela is successful. And the viewer includes them in his life and shares in the uncertainties of their fate because the novel is in the process of being written as it is being produced. The art form is completely open. (p. 23)

Needless to say, the Brazilian telenovela is recognized today as its own art form. Having attained the level of a national institution in the 1960s, the genre has evolved away from the general Latin American model since the 1970s. Globo, in particular, invested heavily in higher quality productions, increasing, for instance, the use of external shots that had been previously avoided due to costs. The network also promoted a modernization of telenovela themes, giving priority to scripts written by Brazilian authors. Changes in style and format have led Brazilian telenovelas to become more realistic and dynamic as well as closely associated with contemporary events in the life of the nation. In fact, it is the norm to thematically include current events, such as elections, strikes, and political scandals, in prime time telenovelas, as these events occur in "real" life (Rêgo & La Pastina, 2007, p. 107).

Although researchers have interpreted the decline of telenovela ratings since the 1990s as a crisis in the genre, it remains a fact that the genre continues to be a massive presence in the lives of millions of Brazilians, perhaps more than ever before as networks make their serials available through new technologies such as the web and mobile phones. Data available for 2006–2007 show that the number of Internet users in Brazil jumped from 32.2 million to 42.6 million in the period, indicating a rapid growth in the sector (Internet World Stats Website, 2007). That said, it must be noted that "The link between the telenovela and its audience is perhaps better described as interactive, since the impact of the novela on viewers is matched by the impact of viewers on the novela" (Page, 1995, p. 448). Even though still limited, especially considering that close to 150 million Brazilians have access to television sets, the use of new technologies such as the Internet has become instrumental in how networks currently showcase their serials and how viewers interact with them. While further research about online interactivity between viewers and telenovelas (and vice versa) is still much needed, it will not be surprising that new developments in telenovela production and viewership will soon lead researchers not only to continue writing about the enduring popularity of the genre, but offer a richer history of the genre than that which this article is able to offer to the reader at present.

References

Almeida, H. B. de. (2003). *Telenovela, consumo e gênero* [Telenovela, consumption and genre]. Bauru (São Paulo): EDUSC/ANPOCS.

Araújo, J. Z. (2000). *A negação do Brasil: O negro na telenovela Brasileira* [The negation

of Brazil: Blacks in the Brazilian telenovela]. São Paulo: SENAC.

Belli, Z. P. B. (1980). *Radionovelas.* São Paulo: SENAC.

Borelli, S. H. (2000). Telenovelas Brasileiras [Brazilian telenovelas]. In L. Dowbor (Ed.), *Desafios da comunicação* [The challenges of communication] (pp. 127–141). Petrópolis: Vozes.

Borelli, S. H., & Priolli, G. (2000). *A deusa ferida* [The wounded goddess]. São Paulo: Summus.

Campedelli, S. (1985). *A telenovela* [The telenovela] São Paulo: Atica.

Carvalho, E., Kehl, M., & Ribeiro, S. (Eds.). (1979–1980). *Anos 70: Televisão* [Television: The 1970s] Rio de Janeiro: Europa.

Costa, C. (2000). *Eu compro essa mulher: Romance e consumo nas telenovelas brasileiras e mexicanas* [I will buy this woman: Romance and consumption in Brazilian and Mexican telenovelas]. Rio de Janeiro: Zahar.

Evans, R. (2005). Research: TV Globo. *Media Matters.* Retrieved from http://journalism.cf.ac.uk/2005/MAJS/sjore/research1.html

Fernandes, I. (1987). *Telenovela Brasileira* [Brazilian telenovela]. São Paulo: Brasiliense.

Ferreira, M., & Coelho, C. (2003). *Nossa senhora das oito: Janete Clair e a evolução da telenovela no Brasil* [Janete Clair and the evolution of the telenovela genre in Brazil]. Rio de Janeiro: MAUAD.

Filho, D. (2001). *O Circo Eletrônico* [The Electronic Circus]. Rio de Janeiro: Zahar.

Hambuger, E. (2005). *O Brasil Antenado: A sociedade da novela* [Brazil: Telenovela and society]. Rio de Janeiro: Zahar.

Herold, C. M. (1988). The 'Brazilianization' of Brazilian television: A critical review. *Studies in Latin American Popular Culture, 7,* 41–57.

Internet World Stats. (2007). *Usage and population statistics, South America.* Retrieved from http://www.internetworldstats.com/south.htm

Jambeiro, O. (2001). *A TV no Brasil do Século XX.* [20th Century Brazilian Television]. Salvador: EDUFBA.

Klagsbrunn, M., & Resende, B. (1991). *A telenovela no Rio de Janeiro: 1950–1953* [The telenovela in Rio de Janeiro: 1950–1953]. Rio de Janeiro: CIEC.

Kottak, C. (1990). *Prime-time society.* Belmont, CA: Wadsworth.

Leal, O. F. (1986). *A leitura social das Novelas das Oito* [A social reading of the 8 O'Clock Telenovelas]. Petrópolis: Vozes.

Lopes, M. I. V. de. (2009). Telenovelas as a communicative resource. *Matrizes, 3*(1), 1–23.

Lopes, M. I. V. de, Borelli, S.H.S, & Resende, V. da R. (Eds.). (2002). *Vivendo com a telenovela* [Living with the telenovela]. São Paulo: Summus.

Lorêdo, J. (2000). *Era uma vez...a televisão* [Once upon a time...The television]. São Paulo: Alegro.

Mader, R. (1993). Globo village: Television in Brazil. In T. Dowmunt (Ed.), *Channels of resistance* (pp. 67–89). London: BFI Publishing.

Matelski, M. J. (1999). *Soap operas worldwide.* Jefferson, NC: McFarland.

Mattelart, A., & Mattelart, M. (1990). *The carnival of images: Brazilian television fiction.* New York: Gergin & Garvey.

Melo, J. M. de. (1995). Development of the audiovisual industry in Brazil from importer to exporter of television programming. *Canadian Journal of Communications, 20*(3), n.p. Retrieved January 7, 2006, from http://info.wlu.ca/~wwwpress/jrls/cjc/BackIssues/20.3/demelo.html

Melo, J. M. de. (1988). *As telenovelas da globo: Produção e exportação* [Globo's telenovelas: Production and export]. São Paulo: Summus.

Newcomb, H., & Hirsch, P. M. (2000). Television as a cultural forum. In H. Newcomb (Ed.), *Television: the critical view* (6th edition). New York: Oxford University Press.

Nogueira, L. (2002). *O autor na televisão* [Authorship in television]. Goiânia: UFG.

Ortiz, R., Borelli, S., & Ramos, J. (1988). *Telenovela: História e produção* [Telenovela: History and production]. São Paulo: Brasiliense.

Page, J. (1995). *The Brazilians.* New York: Addisson-Wesley.

Pallottini, R. (1998). *Dramaturgia de televisão* [Television's dramaturgy]. São Paulo: Moderna.

Population Media Center (2003). Retrieved from http://www.populationmedia.org/programs/brazil.html.

Ramos, R. (1986). *Grã-finos na globo: Cultura e merchandising nas Novelas* [The rich according to Globo: Culture and merchandising in *Novelas*]. Petrópolis: Vozes. Retrieved from http://redeglobo.globo.com/TVG/0,3916,00.html

Rede Globo Website (2009). Retrieved from http://redeglobo.globo.com/TVG/0,3916,00.html

Rêgo, C. M. (2003a). Novelas, novelinhas, novelões: The evolution of the *(tele)novela* in Brazil. *Global Media Journal, 2*(2). Retrieved from http://lass.calumet.purdue.edu/cca.gmj/sp03/gmj-sp03-rego.htm

Rêgo, C. M. (2003b). 'Era uma vez...a rede Globo de Televisão' [Once upon a time...Globo TV network]. *Studies in Latin American Popular Culture, 22,* 165–180.

Rêgo, C. M. (2009). Beyond Globo: The history and development of Brazilian television. *Journal of International Communication, 15*(1), 37–55.

Rêgo, C. M., & La Pastina, A. (2007). Brazil and the globalization of *telenovelas*. In D. Thussu (Ed.), *Media on the move: Global flow and contra-flow* (pp. 99–115). New York: Routledge.

Reis, R. (1999). What prevents cable TV from taking off in Brazil. *Journal of Broadcasting and Electronic Media, 43,* 399–415.

Resende, V. da R. (2001). A vida em capítulos [Life in Installments]. In L. Dowbor (Ed.), *Desafios da comunicação* [Challenges of communication] (pp. 166–172). Petrópolis: Vozes.

SBT Website (2009). Retrieved from http://www.sbt.com/br/institucional.asp?cs=5

Sinclair, J. (2003). The Hollywood of Latin America: Miami as a regional center of television trade. *Television & New Media, 3*(4), 211–229.

Straubhaar, J. (1982). The development of the *telenovela* as the pre-eminent form of popular culture in Brazil. *Studies in Latin American Popular Culture, 1,* 138–150.

Straubhaar, J. (2007). *World Television.* Los Angeles: Sage.

Távola, A. (1996). *A telenovela Brasileira* [The Brazilian telenovela]. Rio de Janeiro: Globo.

Tufte, T. (2000). *Living with the Rubbish Queen: Telenovelas, culture and modernity in Brazil*. Luton: University of Luton Press.

Tunstall, J. (2008). *The media were American: U.S. mass media in decline*. New York: Oxford University Press.

TV Globo International Website (2009). Retrieved from http://tvglobointer nacional.globo.com/

Vink, N. (1988). *The telenovela and emancipation: A study on TV and social change in Brazil*. The Netherlands: Royal Tropical Institute.

Xexéo, A. (2005). *Janete Clair*. Rio de Janeiro: Relume.

6. The Cultural and Political Economy of the Mexican Telenovela, 1950–1970

Melixa Abad-Izquierdo

Introduction

Over the course of the 1950s and 1960s, Mexican telenovelas secured their place as the most popular form of entertainment in Mexican society while simultaneously evolving a series of successful narrative tropes and character archetypes. Studying telenovelas sheds fresh light on the relationship between politics and popular culture in post-revolutionary Mexico. More than a generation of intellectuals in Mexico dismissed the television industry as an evil empire that was at all times allied with the interests of the one party state system that ruled Mexico from 1946 to 2000. However, examining telenovelas such as *Senda Prohibida* (*Forbidden Path*) and *María Isabel*, which were broadcasted during the 1950s and 1960s, reveals that the situation was much more complicated. The television producers creating telenovelas had to strike a complex balance between the demands of their patron, the PRI (Institutional Revolutionary Party), and the demands of urban, middle class viewers that were their growing and vital consumers. The founders of the Mexican television, Emilio Azcárraga Vidaurreta, Rómulo O'Farril Sr., and Guillermo González

Camarena were given permits to start their respective television stations because of their connections in the PRI. Azcárraga Vidaurreta was an important radio entrepreneur that boosted Mexican nationalism in its radio network. Rómulo O'Farril Sr. was a close collaborator and friend of the Mexican President Miguel Aleman (1946–1952). Guillermo González Camarena was an engineer who served as a consultant to the Mexican state since the 1940s. In 1955, the channels founded by Azcárraga Vidaurreta, O'Farril and González Camarena merged, creating Telesistema Mexicano (TSM) (Televisa S.A. de C.V., 1972). Later, in 1973, TSM went through another merger with channel 8, changing its name to Televisa. To this day this televison network dominates the Mexican television industry. As well, for long periods, from 1955 to 1968 and later from 1973 until 1996, Televisa was the only network in Mexico. The telenovelas produced by Telesistema had a dual purpose. First, it was to appeal to urban, middle class viewers, while at the same time playing with the PRI's nationalistic messages in complex ways. Telesistema created a product that complied at times with the PRI's discourse but was marketable as well.

Paying attention to cultural issues and the role of nationalism in Mexican media during the mid-twentieth century helps explain the rise of telenovelas as the staple of Mexican television. Like radio, television was the center of controversies about what constituted the appropriate role of the medium in Mexican society. Should it be a tool to transmit culture? If so, what should that culture look like? Should television follow the path of radio, becoming commercial and focusing on entertainment? Nationalism played an important role in these controversies (Knight, 1994). The PRI viewed almost all questions of culture, including the role of television, through the lens of nationalism. Like the situation in the United States, in Mexico, the state and intellectual elites were concerned that the new medium could spread foreign values. This concern grew from the legacy of the Mexican Revolution (1910–1920) and the government that emerged from it. The post-revolutionary Mexican state created educational policies that "sought to inculcate literacy, nationalism, notions of citizenship, sobriety, hygiene and hard work. Art, rhetoric, and (by the 1930s) radio were enlisted for the same purposes" (Knight, 1994). The Mexican state used radio to build national identity. It allowed for commercial broadcasters, but they had to comply with the state's nationalistic discourse. Broadcasting pioneers like Emilio Azcárraga Vidaurreta worked out a successful and profitable way to incorporate the state's requirements of nationalist content and no religious or political discussion on the airwaves into his national radio network while also appeasing his listening audience (Hayes, 2000).

The political goals for incorporating nationalism into popular culture, however, changed with the advent of television. By the time television appeared, the one party state was under the control of a technocratic generation that retained the nationalist and revolutionary rhetoric of the founding revolutionaries. Azcárraga Vidaurreta was the owner of XEW, a radio station that by the 1940s covered the entire Mexican Republic and exported scripts and tapes of its programming to many Latin American countries ("Horizontes Continentales," 1945). From the 1950s until the 1970s, his expansion into television, with the creation of Telesistema Mexicano, followed a similar growing pattern. However, the political, social and economic environment of the 1950s—when television started—was different from that of the 1930s. Owners like Azcárraga Vidaurreta, in cooperation with government officials, used radio for nation building and unifying national culture. Television continued this task, but with a twist. During the 1950s, technocratic government officials began to develop a national identity that insisted Mexico was modern, middle class, and urban. Indeed, for most of Azcárraga Vidaurreta's tenure— he started channel two in 1951 and did not stop working until his death in 1972—the main television audience was the urban middle class. Telesistemas' focus on the urban middle class meant that other social sectors such as the lower class, those living in rural areas and even the upper class were ignored (Burke, 1967).

In response to the changing audience within Mexican society, television producers gradually shifted program formats in prime time over the course of the 1950s and 1960s. In the 1950s, the main staple of television drama was *teleteatro* (teletheater). These were plays adapted for television. Teleteatro was live and the stories were not serialized thus every week there would be a different story often with different performers. Azcárraga Vidaurreta's network, TSM, showed three or four dramas a week. These productions were expensive and labor intensive. Producing and staging a teleteatro required a great degree of theatrical craftsmanship to create the desired sets and ambience. They also required rehearsals and performances that, true to the theater tradition, had to be live (De María y Campos, 1957). These requirements were very difficult to fulfill in television due to time, money, and space constraints. On the other hand, telenovelas did not have any of these troubles. These were serialized stories that were very inexpensive to produce. For one, many of the writers such as Fernanda Villeli and Estela Calderón began their careers writing for radio. Some of these writers were already working for Colgate Palmolive, which usually paid them a fee for the script (Calderón, 1955; Villeli, 1959). In addition, performing in telenovelas did not require the same skill as teleteatros. Beginning in the early 1960s, directors adopted the *apun-*

tador, an earpiece that fed actors the lines during filming. Thus, actors did not need to learn all the lines and the acting was often done without previous rehearsal (Burke, 1967). The adoption of this earpiece—that is still in use—remains an object of criticism, especially from scholars who compare the Mexican telenovelas, which are overtly melodramatic and Manichean, with the more realistic Brazilian telenovelas where the earpiece is not used (Mazziotti, 1996). Telenovelas were a cheap and efficient form of entertainment that slowly but surely displaced teleteatros during the 1960s and became a staple of Mexican and Latin American television. The next section explores the relationship between national politics and the content of some of these dramas in more detail.

Politics, Economics, and the Rise of Serialized Drama

Despite political anxiety about importing American programming, Mexican television producers wanted to transplant the commercial success of soap operas in the U.S. to Mexico. Serialized dramas already existed in Mexico as *radionovelas* (radio soap operas) and were, as in the U.S., sponsored by detergent companies ("La radio es," 1945). The first attempt at the serialization of a drama occurred in 1951 when channel four broadcast *Angeles de la Calle* (*Street Angels*). The series depicted the drama of kids living in the streets. Each week featured the story of a different homeless child. The series had a total of 50 episodes ("Cronica del . . . IX," 1963). However, despite the serialization of the story line and the presence of the famous Cuban writer Felix B. Caignet, *Angeles de la Calle* was not truly a telenovela. It did not feature the same set of recurring characters. According to the official account of TSM, the first true telenovela was *Senda Prohibida*, (*Forbiden Path*) in 1958 ("Banquells dirigirá," 1958).

During the first decade of television in Mexico, almost all of the programming was produced domestically and only two percent were imported, filmed series. This was the result of both limited broadcast hours and the political pressure of the PRI to produce national programs. With the advent of videotape and the extension of broadcasting hours in the early 1960s, the need for content increased dramatically. By the end of the decade, U.S. programming accounted for about 45% of all Mexican broadcasts (Burke, 1967). This situation was a contradiction to the nationalistic discourse of the Mexican state and created tension between Telesistema and the government.

Originally, American series offered TSM a cheap method to fill programming hours with an alluring product that appealed to middle class audiences. The inclusion of already successful American programming also meant that more sponsors would be willing to invest in television. With this newfound investment capital, TSM started a quest for original programming that was cheap to create and easy to export during the 1960s. In order to counteract the flood of imported programs, the Mexican government encouraged TSM to increase its production and export of television (Burke, 1967). However, teleteatros started to lose their appeal for a variety of reasons. As outlined above, they were expensive to produce. More importantly, these productions were problematic because of their elitist character. In order to enjoy them, viewers needed certain cultural capital that some middle class families did not possess. In addition, as a tool for commercial promotion, they were not as effective because it was difficult to retain an audience with a different story every week. Critics and collaborators in the genre complained that the crew and actors in teleteatros varied from week to week, making it difficult to create a personal connection to the show and keep a stable audience. An audience did not have much incentive to tune in next week to a program that might be better or worse than last week's episode. Ultimately, there was a necessity to produce television that would attract a wide audience.

Meanwhile, members at all levels of the entertainment industry regarded soap operas as popular entertainment with little or no cultural value. This contempt rested partly on gendered assumptions because soap operas were intended for a female audience and were a mere vehicle to sell cleaning products. The network even reinforced this assumption in an article about telenovelas that appeared in its monthly bulletin. The article noted, "The daily soap operas produced by Channel 2 under the direction of Luis de Llano are part of the sentimental life of millions of women in Mexico, the south of the United States as well as Central and South America where they are the backbone of the programming" ("Una aportación," 1966). Despite this reputation, telenovelas offered one of the few national alternatives to American series, providing a source of employment for local performers at a time when the movie industry was declining, and a profitable product that attracted sponsors and was exportable to other Latin American countries ("Informe de," 1970). As an important alternative to American series, telenovelas had to evolve and change. The genre became so important in Mexican television that a great number were created with a wide variety of styles. The next section turns to the newly triumphant telenovela format, analyzing the diversity that emerged within this genre and the continuing efforts of producers to balance competing political pressures.

Gender and Class Tensions
in Early Telenovela Plots

Examining series like *Senda Prohibida* and *Gutierritos*, which were broadcast
in the afternoon and prime time productions such as *La Tormenta* demon-
strates the diverse genres that emerged among telenovelas during the 1960s.
When most people think of Mexican telenovelas, the usual plot that comes to
mind is the Cinderella story. Yet that was not the only plot in the telenovelas
of the 1960s. Looking at the television guides of the period reveals a wide range
of stories that were made into telenovelas, including family dramas, suspense,
medical dramas, historical telenovelas, and, of course, the Cinderella story
everyone is so familiar with. An important source of telenovela stories in the
1960s were comic book plots. The use of successful comic books stories
offered diverse themes and sponsors were more willing to invest in an already
popular story. Television producers worked with these diverse plot structures
and characters to satisfy competing audiences and influences throughout this
period.

Most of the telenovelas discussed here kept a *puta/virgen* dichotomy
(Anzaldúa, 1987). This dichotomy resulted from the contentious and violent
encounter of the main cultural influences that composed Mexico. The *puta* was
represented by *La Malinche*, Cortés's translator, who later became his mistress
and even gave birth to a son. Malinche was seen as a traitor to her people due
to her collaboration in the campaigns that resulted in the fall of the Aztec
Confederation (Franco, 1989). The virgin was a reference to the Virgin of
Guadalupe who appeared in 1531 to Juan Diego, a Chichimec Indian that con-
verted to Catholicism. This apparition happened at Tepeyac hill where prior
to the Spanish invasion the goddess *Tonantsi* (which means our lady Mother)
was worshiped (Anzaldúa, 1987). These two icons played important roles in
the Mexican national identity and provided the national base for the *puta/vir-
gen* dichotomy that appears in Mexican telenovelas.

The depiction of female roles in many telenovelas from 1958 to the early
1970s was stereotypical of a traditional Latin American society. Characters were
Manichean with female roles constantly replicating the *puta/virgen* dichoto-
my, while male characters were very masculine in appearance but often weak
in character and easy to manipulate. Often the plots revolved around a love
triangle. This triangle featured either two male suitors competing for a woman
or two women competing for the love of a man. In the latter triangle, the
women were represented either as the "good" virginal maid or the "bad"
femme fatale. The "bad" woman tried to use her sexuality to seduce the man,
while the "good" woman tried to connect with him emotionally and spiritu-

ally, and rarely sexually. In the end, the "good" and "love" triumphed over evil and the good woman always got the man. The women in these *puta/virgen* dramas reinforced the role of women according to the postrevolutionary political discourse. Under the PRI government, the state attempted to expand women's rights in the domestic sphere and the public sector without disturbing the patriarchal order (Fernández Aceves, 2006). Characters like María Isabel depicted the idealized female role of Mexican women, while the characters of Rosa in *Gutierritos*, and Nora in *Senda Prohibida* challenged patriarchy. At the end of most Mexican telenovelas the characters that challenged patriarchy were punished while those that reinforced it were rewarded.

The first Mexican telenovela was *Senda Prohibida* in 1958. This drama was broadcast live at 6:30 P.M., with 60 episodes sponsored by Colgate-Palmolive (Reyes de la Maza, 1999; Iglesias Martel, 2007). The story had an ensemble cast and featured a series of intertwining storylines that revolved around one family. A young woman named Nora immigrated to Mexico City from the countryside. In the city, she fell in love with Federico, an older married man. The victim in this drama was Irene, the stay at home wife of the man at the center of the love triangle. Nora was a young temptress that aggressively pursued a married man until they became lovers. The actor Silvia Derbez, a young woman that already had some success in films, played Nora. Viewers responded wildly to the character. After the first few episodes, security guards had to escort Derbez when she left the television station because she received threats from audience members, mainly older women who would even wait for her outside the station to insult her or even try to beat her (Reyes de la Maza, 1999). Federico was head over heels for Nora and separated from his wife. The lovers moved in together to a luxurious apartment. Federico was transgressing the norms of the petite bourgeois Latin American family by abandoning his wife and family. This aspect of the story line played with gender norms in interesting ways. In the cultural context of the 1950s, it was not unusual for an older married man to have an affair. However, Federico's abandonment of his family home was not acceptable. The plot was complicated when Federico, a business executive, lost his fortune and Nora refused to aid him. Federico's mother was the only one that helped him to resolve his economic troubles. This situation served as a lesson, punishing him for his wrongdoing. Penitent, he decided to reunite with his wife. In the end, the wife and children forgave Federico and the family was reunited, thus reaffirming traditional petite bourgeois values.

Telesistema followed up on the success of *Senda Prohibida* with *Gutierritos*. The network aired *Gutierritos*, written by Estela Calderón, right after the finale of *Senda Prohibida* and in the same 6:30 P.M. time slot. *Gutierritos* had high

ratings during its broadcast and later was adapted to the big screen and remade as a telenovela in the 1960s. *Gutierritos* reflected the gendered anxieties of the Mexican middle class in even more explicit ways than *Senda Prohibida*. *Gutierritos* featured an emasculated male lead that did not fulfill his wife's economic expectations. The main character was a middle class, white-collar worker that lived in Mexico City. His wife, Rosa, coined the pejorative nickname (a diminutive form of his last name) that doubled as the title for the series. She was the villain of the story as she mistreated and yelled at Mr. Gutierrez, emasculating him repeatedly. Rosa was never satisfied with the salary and the lifestyle that her husband provided for her ("La Novela Colgate," 1958). Her nonconformity went so far that she had a crush on Jorge, a co-worker of her husband. Jorge had a higher position within the company and was a stereotypical womanizing bachelor. Although the relationship never went beyond the platonic realm, she was attracted to his manly behavior. Confronted with the mistreatment and demands of his wife, Gutierritos started to write his memoirs as a medium to relieve his frustrations.

The writers and producers made it clear that Gutierritos was the victim in this situation. In addition to suffering with the emasculation that his wife inflicted upon him, the protagonist also internalized his unhappiness. He was saddened because of his inability to provide his wife's desired lifestyle. The opening credits featured a particularly poignant image. Gutierritos appeared walking on the streets of Mexico City under the rain and crying bitterly with tears of impotence. The informed viewer would conclude that the protagonist was crying in frustration over his emasculated gender identity. Fortunately for Gutierritos, the series afforded him an opportunity to redeem himself and restore his manly identity. Gutierritos vented his frustration by writing a journal. A writer friend read the manuscript and suggested that he publish it under a pseudonym. The memoir became a best seller that even the spiteful wife praised. The family did not learn that the emasculated patriarch was the author of the book until the end of the series. His newfound fame and fortune finally redeemed him in the eyes of his wife (García Riera, 1997).

These first two telenovelas illustrate how concerns about gender and class came together in Mexican society during the late 1950s and 1960s. Even though the period from 1958 to the early 1970s was a formative and experimental one for the genre, some of the characteristics of the telenovela such as recurring characters, began to appear. In particular, gendered stereotypes such as the bad woman, the weak man, and the female victim all appeared in these formative telenovelas (Mazziotti, 1996). Many of these stereotypes also emerged in other cultural venues such as movies and serialized dramas that were broadcast on radio at the time. One of the characteristics of these seri-

alized dramas was their reliance on existing narratives. After all, as discussed above, telenovelas were melodramatic series that owed their modes of narration and organization to previous forms of mass culture (Martin Barbero, 1993). These early telenovelas depicted many of the female characters as ambitious and uncomfortable with their social status. Although these characteristics can be positive, in these stories the women were excessively ambitious and used extreme measures to achieve their goals. In *Senda Prohibida* a young working-class woman seduced an older man from a higher social class. Nora represented the growing number of unmarried women working outside the home or pursuing higher education in Mexico City during the 1950s. A massive migration from rural areas to the cities started during this period. In addition, the National University inaugurated City University, a huge complex south of Mexico City that allowed more people from the countryside to attend the University (Brandenburg, 1967). Anxiety about the behavior of young women in urban settings was a recurring theme in these telenovela stories. Migration in search of work often placed these young women outside paternal control for the first time. Thus, their presence was a threat to the patriarchal establishment and the upper and middle class homemakers that were the original intended audience of these dramas. Married women who feared this, as an audience, might identify as the possible victims of these possible young temptresses.

Rosa, the wife of Gutierritos, was a woman that defied the patriarchal establishment from within while simultaneously reflecting the anxieties that many of her middle class female viewers experienced. As a married woman and homemaker, she questioned the ability of her husband to supply an adequate lifestyle for their family. She aspired to live a middle class lifestyle by participating in the consumer society that was developing in Mexico, and was promoted by television, magazines, and newspapers. Since her goals were material (clothes, jewelry, and modern and newer home appliances), Rosa assumed the villainous role and Gutierrez represented the victim. In this regard, the series conveyed contradictory messages. On the one hand, the creators acknowledged and displayed the commodities that were available to those who could afford them. However, the creators also reprimanded people who were envious or coveted these commodities and tried to obtain them by dubious means such as theft, prostitution, or marrying someone wealthy without being in love. Interestingly, in the end Rosa, was rewarded when her husband started to make more money due to the rights of the book he wrote. Ultimately, he was able to provide her desired lifestyle. Perhaps the creators rewarded her for her respect to the sanctity of marriage, even though she constantly nagged her husband for financial reasons. In the end, she remained faithful to her husband.

Another important gendered aspect of *Gutierritos* was anxiety over the emasculation of the Mexican man in the urban environment and in white-collar jobs. Most of the national images of the macho come from the Mexican Revolution with characters such as Emiliano Zapata and Pancho Villa, rough men that led thousands of rebels and were decisive figures in the war. Although both were assassinated, they became the main icons of masculinity and popular participation in the Mexican Revolution. However, for the generation that came of age in the 1950s, the Revolution was losing significance. Many were born after the end of the conflict, and that was reflected with changes in the political sphere. A new generation of college educated technocrats replaced the revolutionary veterans and local bosses that had previously dominated the PRI. Not coincidentally, 1958, the year that *Senda Prohibida* and *Gutierritos* were broadcast, was the same year that women exercised the right to vote for the first time. These series gave voice to the gendered concerns of the urban middle class, and at the end of each story, the patriarchal family order was restored.

Despite the success of *Senda Prohibida* and *Gutierritos*, most telenovelas during the 1960s stayed in the late afternoon time slot (5:30P.M. to 7:00P.M.) (Tele Guia, 1963). Prime time was still reserved for teleteatro, movies, variety shows, and American series. Series like *Bonanza* and *Dr. Kildare* were favorites of the Mexican audience. The wide experimentation with the telenovelas suggests that producers were still looking for the formula that was easy and cheap to produce and export. During this period, the stories developed in telenovelas dealt with a diverse range of themes. Some, like *Senda Prohibida*, were family dramas that explored the problems of families. Adaptations of popular nineteenth century *feuilletons* such as *Rocambole* (1967), which told the story of a con man, also appeared as telenovelas (Tele Guia, 1967). TSM also aired a medical drama entitled *Sala de Emergencia* (1964) (Tele Guia, 1964). Another fascinating example, explored in more detail in the next section, were the historical telenovelas where producers serialized the history of Mexico and intertwined it with fictional characters. The Cinderella story that we now associate with telenovelas, discussed below, was not the dominant plot device but rather one of many.

One of the first telenovelas that successfully exploited the Cinderalla story was *María Isabel* (1966). Yolanda Vargas Dulche, a prolific comic strip writer, created the story. She originally published the plotline as an episodic story in *Lagrimas y Risas*, a comic strip that her husband owned. This was the first comic book character to be adapted for telenovelas (Reyes de la Maza, 1999). *María Isabel* was broadcast from April 6, 1966 to June 13, 1966 and it had

just forty-eight episodes (Televisa S.A., 2007). It was the story of an indigenous girl—María Isabel—who befriends Graciela, the daughter of a wealthy landowner named Don Félix. María Isabel's father toiled as a field worker for Don Félix. Consequently, Don Félix disapproved of the friendship and sent Graciela to a girl's school in Mexico City. Years later, Graciela graduated and went back to her father's hacienda, and the friendship with María Isabel continued. Things became complicated for María Isabel when Graciela got pregnant and fled to Mexico City with her. Tragically, Graciela died in labor. Beforehand, she asked María Isabel to take care of her daughter, Rosa Isela, to save the child from the unhappy childhood she had with her father Don Félix. María Isabel began working as a maid in various houses, where she was often looked down upon for being Indian and the single mother of a white, blonde baby. After a couple of years, María Isabel found work at the house of Ricardo, a rich, handsome and widowed lawyer.

Mexico's relation to the indigenous population and its indigenous past is filled with contradictions. This complex relation was further complicated after the Revolution of 1910 and the state that came out of it under the PRI. The post-revolutionary Mexican state celebrated *mestizaje* (mixed race) and indigenous peoples as primordial to their national identity (Vaughan & Lewis, 2006). During the 1920s and 1930s intellectuals such as José Vasconcelos (1925) praised mestizaje and Indian heritage in his celebrated essay *La Raza Cósmica (The Cosmic Race)* while artists like Diego Rivera celebrated them in his murals. However, by the 1960s Mexico was a different country whose government and elite were struggling to turn their nation into a modern and developed country. The indigenous population that lived mostly in rural areas was a contradiction to the national identity that the PRI was developing. Indians like María Isabel did not fit the modern, middle class, and urban characteristics of the national identity that the Mexican state was trying to pursue. During the first half of the twentieth century the population in the urban areas of Mexico rose steadily. Migration from the countryside, many of them Indians, was one of the main factors besides high fertility rates. The reasons for migration were the job opportunities and higher wages that the cities offered (Meyer, Sherman, & Deeds, 2007). It is within this historical context that we have to understand the racial and ethnic issues in 1960s Mexico.

María Isabel fell in love with her boss but this love was impossible due to their class differences. Interestingly, race was never mentioned as an obstacle. The "real" obstacle was class, not race or ethnicity, or so the show's creators implied. However, the relationship between María Isabel and her daughter Rosa Isela highlighted the issue of race and ethnicity. The latter started attend-

ing a fancy private school and as she grew older, and she resented being poor and having an Indian mother. A second plot was developed when Rosa Isela met her wealthy grandfather, Don Félix, and left her mother María Isabel. Eventually after Ricardo had his heart broken by another woman, he realized that María Isabel had all he wanted. In "the end love triumphs and María Isabel is happy and gets married" (Televisa S.A., 2007). In addition, she resolved her issues with Rosa Isela in a rather superficial way but lived happily ever after.

This soap opera followed almost all the stereotypes of what we now understand as a conventional telenovela. The main female character was a chaste woman who did not have sex until she got married. María Isabel was obligated to immigrate to the city where, despite humiliations and necessities, she remained an honest woman, a loving mother, and a loyal servant. During this process, she also undergoes a transformation from a little Indian girl to a modern urban woman. Most of the change occurred with the help of Ricardo. One of his first orders to María was to start wearing a uniform, so she would not be seen in her Indian dresses that revealed her as a migrant. He also encouraged her to speak a better Spanish and often complimented her for her effort "to progress." Significantly, María Isabel was wooed by other men but she was never interested in them. She only had eyes for Ricardo, the man that was helping her "to progress."

The story can be interpreted as being instructional for the generation of young, Indian women who migrated to urban settings. The show demonstrated that, as Indians, they would be discriminated against and mistreated. Despite this, they should stay proud, work hard, and be honest. In the process, the immigrant would leave behind the cultural signifiers of his/her ethnic origins, most notably clothing and speech. Despite many temptations, María Isabel never stole anything, panhandled, or practiced prostitution. She was efficient in her work as a maid, she obeyed orders, and rarely contradicted her bosses. After all of this sacrifice she was rewarded. She married a perfect, wealthy man that helped her "to progress." In Mexico, as in other Latin American countries, Indians were often considered an obstacle to modernity (Knight, 1990). By migrating and doing all the right things "to progress," María Isabel represented Mexicans (especially indigenous Mexicans) having the ability to adapt to modern, urban life. Moreover, the fact that someone like María Isabel was able to adapt to urban living gave hope to the country. The story represented the possibility of Mexico overcoming its obstacle and becoming an urban, modern and industrialize nation.

Politics, Memory, and Culture:
Historical Telenovelas

At the same time that TSM worked to attract urban, middle class viewers, it had to be careful not to alienate the PRI. The case of historical telenovelas exemplifies the versatility of the genre and provides a concrete instance where politics, nationalism, and telenovelas converged. The circumstances under which these stories were developed illustrate the complicated relationship between the one party state and TSM. In 1965, the network produced a telenovela that presented Benito Juárez, one of the most venerable presidents in Mexican history, as a villain. The story was a historical fantasy that idealized the French intervention in Mexico (1864–1866). A big part of the appeal of the telenovela was displays of the luxury and glamour of the court headed by the Archduchy Maximilian and his wife Charlotte. This positive representation got the network into trouble with the PRI. In an effort to amend its situation, the network produced a series of historical telenovelas that were loyal to the party's official story.

Carlota y Maximiliano (1965) was a story that claimed historical accuracy because it was filmed on location, the costumes were done following the style of the period, and the producers had the collaboration of the Department of Education and the National Institute of Anthropology and History ("Los controles remotos," 1965). The story revolved around the French intervention and the short-lived reign of the Austrian Archduchy Maximilian and his wife Charlotte (Televisa Internacional, n.d.). The love story was between Maximilian and Charlotte, and thus converted Benito Juárez and his allies into the main obstacle for the young couple to fully enjoy their love. The author of the series, Margarita Dueñas, based it on the memoir of one of her ancestors that was part of Charlotte's entourage. The vilification of Juárez, combined with the romanticized representation of foreign forces in Mexico, was a scandal. Historians, intellectuals and even the government strongly criticized the series' artistic liberties. The Secretariat of Governance (Mexican equivalent to the Department of the Interior) demanded that the story be changed. Although this was not possible, the network cut the telenovela from the 80 planned episodes to 51 (Reyes de la Maza, 1999). The idealization of a foreign occupation was too unpatriotic for the highly nationalistic PRI regime, who at the time was promoting an agenda of national unity. The PRI's reputation had suffered after the violent suppression of the railroad strike in 1958. In addition after the Cuban Revolution the Mexican left was highly critical of the government (Zolov, 2008).

Interestingly, from the beginning, TSM sold *Carlota y Maximiliano* as a realistic portrayal of the period. The producers bragged about their collaboration with the National Institute of History and Anthropology as well as the Department of Public Education ("El público y," 1965). Of course, the interest in authenticity and realism only applied to the costumes and locations. The producers freely sacrificed historical facts to glorify romantic love. In this case, the glorified romance was between the invading monarchs of a European empire that challenged the power of the legitimately elected Mexican President. The network intended this drama to be part of their effort to incorporate cultural television into their commercial network. The effort backfired and resulted in the indignation of intellectuals as well as politicians. In part due to this historical/political faux pas, the networks started to develop historical telenovelas with storylines that stayed close to the narrative of the PRI's official history.

The telenovelas *La Tormenta* (1967), *Los Caudillos* (1968), and *La Constitución* (1970) were landmarks in television broadcasting. The network produced these stories with the help of the Mexican Institute of Social Service. The writers, Miguel Sabido and Eduardo Lizalde, were widely respected and were advised by historians. The narrative of *La Tormenta* started in 1855 when the country was in the middle of a series of political instabilities: the end of one Santa Anna's many presidencies, conflicts among Liberals and Conservatives, the rise to power of Benito Juárez, and the French Invasion. The plot intertwined a fictional character into these political events. This fictional character was a peasant who learned to read and write. He later joined Juárez' Army against the French occupation. After the historical liberties that the writers and producers took with *Carlota y Maximiliano*, this new production was meant to tell the official story and clear the names of both TSM and Ernesto Alonso, the producer of both series. The next series was *Los Caudillos*, which served as a prequel, narrating the history of the Independence wars (1810–1820) ("Con la mejor," 1968). As in the first story, Sabido and Lizalde intertwined a common Mexican family with the historical narrative. This particular production did not receive the same favorable reviews as its predecessor. In comparison, critics held up *La Tormenta* as an example of the good quality that was possible in Mexican television.

The historical dramas continued with *La Constitución*, which narrated the events that led to the Revolution of 1910. In this story, the common citizen involved in the historical drama was Guadalupe (played by María Félix, the famous Mexican actress) a woman from the northern state of Sonora that was affected by the military campaigns that the dictator Porfirio Díaz launched against the Yaqui Indians. In one of those military campaigns, federal soldiers

attacked the ranch where she lived with her husband. He was killed and, although she survived, she suffered a miscarriage. After that tragic incident, she swore to kill Porfirio Díaz, the one responsible for her tragedy. The formula told the history of Mexico while inserting fictional characters that had dual purposes. Guadalupe and her husband were the characters with whom the audience identified. Thus, the story of the fictional characters was the story with the real emotional drama.

Unlike *Carlota y Maximiliano*, the historical figures in these telenovelas were not central to the emotional dramas that anchored the shows. Producers certainly represented historical figures as complex humans in order to make them sympathetic, but they still did this within the official history. These stories combined real historical characters with fictional characters that were minor participants or witnesses of the historical drama. The third installment ended with the Constitution of 1917, a moment when the Mexican revolution of 1910 was not over yet and the assassinations of many important leaders such as Emiliano Zapata, Pancho Villa, and Venustiano Carranza had not yet occurred. Ending the narrative at that point of the revolution avoided the controversies that surrounded the death of those leaders. It was not convenient in the late-1960s and early-1970s to stir up discussions about the revolution (Charlois, 2008). What became known as the Tlatelolco Massacre occurred in 1968 when the riot police open fired against student demonstrators. Hundreds were wounded or dead and the precise numbers of those injured or killed are still unclear. This tragic event sparked a crisis of legitimation for the PRI and the party justified its power by claiming to be the heir of the Mexican Revolution (Joseph, Rubenstein, & Zolov, 2001). Against this backdrop, TSM could not conceivably create another telenovela like *Carlota y Maximiliano*.

Conclusion

The analysis of telenovelas from the late 1950s to the early 1970s illuminates the social and political changes and tensions of post-revolutionary Mexico. In this period, telenovelas were not mere mindless conservative entertainment, but a cultural industry product at a time when the realities of a developing economy and an uneven modernity affected the country. The recurring themes of these series highlight many of the issues that caused anxieties for the urban middle class and the PRI. Problems such as massive migration from the countryside to the city, the dangers of unmarried young women joining the work force, and challenges to racial categories left middle class Mexicans anxious

about the social order. Mexican telenovelas presented conservative values because they were the product of a very contentious period when the middle class was challenging the power of the PRI at a moment when the party was strenuously trying to guard its power. Producing mythologized historical dramas and feel good stories about modernizing country peasants allowed TSM to avoid censorship and any potentially threatening discussion. At the same time, these formulas worked perfectly to create products that were suitable for exportation. The strong intervention of the Mexican state in television production during the late 1960s and early 1970s influenced the production of telenovelas for years to come. After this experience the owners of TSM, as well as producers, preferred the production of telenovelas that revolved around a romantic story and reused the Cinderella story countless times. This model allowed the network to portray, within the context of a conservative and nationalistic Mexico, an image that pleased the state, satisfied urban audiences, particularly the working class and various segments of the middle class, and that was palatable and exportable to other Latin American countries.

References

Anzaldúa, G. (1987). *Borderlands/La frontera: The new mestiza* (1st ed.). San Francisco, CA: Aunt Lute.

Banquells dirigirá un nuevo programa en Junio a base de novelas folletinescas lo patrocinara Palmolive. (1958). *T.V. 58 la revista de la televisión mexicana*, p. 28.

Brandenburg, F. (1967). *The making of modern Mexico*. Englewood Cliffs, NJ: Prentice Hall.

Burke, J. P. (1967). *The history and development of telesistema Mexicano: A descriptive study*. Unpublished master's thesis. San Diego State Collage, San Diego, CA.

Calderón, E. (1955). *Entre la vida y la muerte. Archivo General de la Nación (AGN)* Propiedad Artística y Literaria (PAL) Caja 1226 Reg. 28445.

Charlois, A. J. (2008). *Ficciones de la historia e historias en ficción. El tramado de la historia en el formato de la telenovela mexicana. El caso de Senda de Gloria*. Unpublished master's thesis. Universidad de Guadalajara.

Con la mejor intención.(1968, September 19). Los caudillos. *Tele Guia*, Issue 841, p. 63.

Cronica del teatro televisado mexicano IX. (1963, July 4). Cronica del teatro televisado mexicano IX. *Tele Guia*, Issue 569, pp. 36–37.

De María y Campos, A. (1957). *El teleteatro en México*. Mexico City: Compañía de ediciones populares.

El público y la critica aplauden Carlota y Maximiliano. (1965). *Televicentro: Boletin mensual de Telesistema Mexicano S.A.*, p. 10.

Fernández Aceves, M.T. (2006). Guadalajaran women and the construction of national identity. In Vaughan, M.K. & Lewis, S.E. (Eds) *The eagle and the virgin: Nation and cultural revolution in Mexico, 1920–1940* (pp. 297–313). Durham, NC: Duke

University Press.

Franco, J. (1989). *Plotting women: Gender and representation in Mexico* (p. 131). New York: Columbia University Press.

García Riera, E. (1997) *Historia documental del cine Mexicano* (Vol. 10). Guadalajara, Jalisco: Universidad de Guadalajara.

Hayes, J. (2000). *Radio nation: Communication, popular culture, and nationalism in Mexico, 1920–1950*. Tucson: University of Arizona Press.

Horizontes Continentales. (1945, October 15). *Radiopolis*, p.15.

Iglesias Martel, I. (ed.) (2007). El gran libro de las telenovelas. *50 años de historia*. Mexico City: Editorial Televisa.

Informe de la labor del comité ejecutivo en 1969. (1970, February 7). *La Voz del actor. Boletín de la asociación nacional de actores*, p.18.

Joseph, G., Rubenstein, A. & Zolov, E. (2001). Assembling the fragments: Writing a cultural history of Mexico since 1940. In Joseph, G., Rubenstein, A. & Zolov, E. (Eds.), *Fragments of a golden age: The politics of culture in Mexico since 194.* (pp. 3–22). Durham, NC: Duke University Press.

Knight, A. (1994). Popular culture and the revolutionary state in Mexico, 1910–1940. *The Hispanic American Historical Review, 74,* 395.

Knight, A. (1990) Racism, revolution, and *indigenismo*: Mexico, 1910–1940. In Graham, R. (ed.) *The idea of race in Latin America, 1870–1940* (pp. 71–113). Austin: University of Texas Press.

La novela Colgate de las 6:30, el hit del año 1958, en televisión. (1958, December). *TV-58 la revista de la televisión mexicana.* p.12.

La radio es un magnífico mostrador. (1945, October). *Radiopolis*, pp. 23–25.

Los controles remotos de telesistema contribuyen a divulgar y mantener nuestras costumbres regionales. (1965). *Televicentro: Boletin mensual de Telesistema Mexicano S.A.*, p. 2.

Martin Barbero, J. (1993). *Communication, culture and hegemony. From the media to the mediations.* (E. Fox & R.A. White, Trans.). London: Sage Publications.

Meyer, M. C., Sherman, W. L. & Deeds, S. (2007). *The course of Mexican history* (8th ed.). New York: Oxford University Press

Mazziotti, N. (1996). *La industria de la telenovela: La producción de ficción en America Latina*. Argentina: Paidós.

Reyes de la Maza, L. (1999). *Crónica de la telenovela. México sentimental.* Mexico City: Editorial Clío.

Tele Guia. (1967, March 9) issue 761, pp. 66–68.

Televisa Internacional. (n.d.). Carlota y Maximiliano. *Catalogo de telenovelas.* file no. 2, Protele private archive. Mexico, Mexico City.

Televisa S.A. de C.V. (1972). *Surgimiento de la televisión mexicana (1950–1972).* Visión anecdótica.

Televisa S.A. de C.V. *Catalogo de títulos (detallado).* Televisa private archive. Mexico, Mexico City

Una aportación de Telesistema Mexicano al tele auditorio de América. (1966, August). *Televicentro: Boletín mensual de Telesistema Mexicano S.A.* p. 3.

Vaughan, M. K. & Lewis S. (Eds.). (2006) *The eagle and the virgin: Nation and cultural*

revolution in Mexico, 1920–1940. Durham, NC: Duke University Press.

Vasconcelos, J. (1925/1997). *The cosmic race.* (D.T. Jaen, Trans.). Baltimore: The John Hopkins University Press.

Villeli, F. (1959). *Cuando se va el amor. Archivo General de la Nacion.* Propiedad Artistica y Literaria Caja 1244 Exp. 29330.

Zolov, E. (2008). ¡Cuba sí, Yanquis no! The sacking of the Instituto México-Norteamericano in Morelia, Michoacán, 1961. In Joseph, G. & Spenser, D. (Eds.) *In from the cold: Latin America's new encounter with the Cold War* (pp. 214–252). Durham, NC: Duke University Press.

7. *Looking for 'A Place in the Sun'?*

The Italian Way To Soap Opera

Daniela Cardini

In the 1980s the soap opera became an up-to-date television genre in Europe, both in academic interest (Allen, 1985, 1995; Ang, 1985; Dyer et al., 1981; Geraghty, 1991; Modleski, 1984; Radway, 1984; Silj, 1988), and in television program production. During those years several local soap operas were aired in many countries, and television programming schedules were already filled with United States-imported serials belonging to the so-called "second golden age" (Thompson, 1996). In contrast, in Italy neither the public service television RAI (Radiotelevisione Italiana) nor the newly-born commercial television network Mediaset produced any soap operas until the second half of the 1990's, therefore scholarship about this topic was minimal. However, within a span of five years the situation changed radically for television in Italy. From 1996 to 2001 three soap operas were produced: *Un posto al sole* (*A place in the sun*, 1996), *Vivere* (*Living*, 1999), and *CentoVetrine* (*The Mall*, 2000). Moreover, in 2008 the Italian "soapscape" was enriched by a new RAI production called *Agrodolce* (*Bittersweet*).

The first Italian soap opera project was the result of a risky adaptation process based on an Australian format. In the 1990s, imported formats in Italy were not so common. Furthermore, television drama is considered the less amenable genre to the global nature of formats because of its tendency to deal with local issues and to appeal to a mostly national audience (Bignell & Lacey, 2005; Brunsdon, 1997, 2000; Caughie, 2000; Hobson, 2002; Moran & Malbon, 2006). This chapter will discuss key moments in the history of the Italian soap opera as a new television genre as well as present the unique char-

acteristics of the local Italian television system. Ultimately, the chapter argues that the birth of an Italian soap opera style was late in comparison with the rest of Europe and the United States, mostly because of a peculiar Italian television scenario.

The Italian Television Scenario (1980-1995)

In the early 1980s the newborn commercial television group Fininvest owned by Silvio Berlusconi brought the monopoly of the public service television network RAI to an end. Raiuno was founded in 1954, Raidue in 1961, and Raitre in 1979. Until then, the three channels of RAI followed the pedagogic rules upon which John Reith's BBC (British Broadcasting Television) was built in the 1950s: to educate, to inform, and to entertain.

Silvio Berlusconi, an Italian tycoon who began his career in the real estate business, built an entire new town in the hinterland of Milano that was named Milano 2. Thanks to the huge economic success of the enterprise, he entered the media market in 1978 by buying a local television station called Telemilano. Two years after, due to a joint venture with four other big local stations in northern Italy, Telemilano became the most important Italian local network and its name was changed to Canale 5. The birth of Canale 5 was the first step in the building of a media (and political) empire. The new channel was followed in a very short time by the acquisition of two other important television stations: Italia 1 (1983), previously owned by the publisher Rusconi, and Retequattro (1984), formerly owned by the publisher Mondadori. The three stations merged into the Fininvest Group, which in 1994 was renamed the Mediaset group. In a little more than a decade, the commercial network built by Berlusconi became a powerful and very popular alternative to the government-owned television network RAI. Until the advent of the Fininvest-Mediaset group, Italian public television was financed by a tax and advertising provided a small source of income for RAI. Yet the harsh competition with Mediaset forced RAI to radically change its policy. Instead of strengthening its public service mission by differentiating itself from its competitor, RAI decided to dramatically increase the number of commercials but not to abolish the tax.

Until then, the three Italian television channels were deeply linked to the political forces that led the country. Raiuno was ruled by the Democrazia Cristiana, the most popular political party that was strictly linked to the Catholic Church. Raidue was influenced by the Socialist Party whose leader was Bettino Craxi, an important and powerful politician. Finally, Raitre, the smallest and youngest channel, was influenced by the left-wing Communist

Party. The birth of Berlusconi's commercial network was made possible by many political agreements and in particular by his friendship with Bettino Craxi, who at that time was Italy's Prime Minister. It is difficult to sum up a very complicated and sometimes obscure period of Italian history. Here it can be useful to remember that the particular political climate gave birth to what was called a television "duopoly," where RAI and Mediaset had the same economic, political and social relevance. This relevance was that both of them owned three channels, both of them had political protection and both of them were financed by advertising (even if RAI was, and is, also financed by a tax). The Italian situation was very different from that of other European countries such as Great Britain, for instance, where the birth of a commercial television network (ITV—Independent Television) followed different rules from those of public service television. This was especially so with regard to the distribution of advertising and social and cultural missions.

In this peculiar and all-Italian setting, it was not surprising that in 1994 Silvio Berlusconi decided to enter the political arena. Thanks to the huge popularity of his television stations and due to the enormous size of his expanding media empire (real estate, publishing, newspapers, film production and distribution, radio stations) and to the strong support of the most influent politicians of the time, he founded his own right-wing party called 'Forza Italia.' He won the elections and became Italy's Prime Minister, (a position he still holds as of this writing).

In the early 1980s, the unexpected opening in a previously closed government-owned market shook up the whole television system, produced significant consequences at economic and political levels, and dramatically changed the daily television schedules. The competition between the new television entrants and the well-established public company largely rested on program ratings. The need to quantify how much a single minute of television time could cost was vital for a commercial television station, whose aim was to sell audiences to the firms that inserted their commercials into television programs. In 1986 the Auditel system was introduced in the Italian television market. It was originally created to measure the cost of advertising, but it remains the only way to measure the "success" of a television program. This continues to be the only measurement. RAI was forced to agree to adopt this system for evaluating its programs as well. Quality and appreciation in terms of program contents were replaced by figures and rates.

In this new landscape, it became necessary for television organizations to schedule blockbuster television programs. Whereas the newly-born Mediaset lacked the expertise to produce its own competitive programs, the RAI had the skills and the experience that stemmed from thirty years of monopoly. On the other hand, Mediaset did not lack financial resources and therefore its strat-

egy became the purchase and import of foreign shows, especially from the United States. The imports were proven to be successful programs in the U.S. that guaranteed good ratings, good savings, and a lower cost than locally produced programs. Starting in 1981, Silvio Berlusconi began to buy a huge number of television dramas produced by the three major American networks, CBS (Columbia Broadcasting System), NBC (National Broadcasting Company) and ABC (American Broadcasting Company), while RAI persevered in its traditional strategy of declining the inclusion of foreign shows.

The Face-Off between RAI and Mediaset

RAI and Mediaset faced each other as competitors throughout the eighties, thus allowing their different strategies to emerge, especially in their attitudes toward television dramas. American shows were aired only occasionally by RAI and prime time slots were reserved for nationally produced dramas. As a form of public television, RAI preferred the production of short-running series that focused on social and politically charged themes with a strong national identity.

Until the advent of commercial television, RAI's serial production was focused on one peculiar genre, the "sceneggiato," that is the television adaptation of classic novels (e.g. Dickens' *David Copperfield*, Manzoni's *I Promessi sposi*, Tolstoy's *War and Peace*). This peculiar genre represented the pride of RAI's pedagogic goals that aimed at popularizing the masterpieces of national and international literary fiction to a vast audience. The sceneggiato remained the most appreciated genre by the Italian audience until the end of the 1970s.

In order to understand the role played by RAI in Italian television history, it is useful to remember that during the early years of Italian television history (that was born in 1954), RAI played a major role in rebuilding Italy's social and cultural identity. The country was very slowly recovering from the disaster of World War II. Big cities such as Rome, Milan, and Turin had been bombed during the war and had to be totally rebuilt. A vast majority of the population lived in small villages. Because literacy was not widely diffused among adults at that time, leading toward a reliance on broadcast media, the role of television (and therefore of RAI) became important. By translating a novel into a visual story it was possible to help people learn about world literature that they could not read about. Television became a teacher for those who could not go to school and a much appreciated storyteller for children and adults. Only at the end of the seventies did a few American television dramas enter RAI's schedules, though in secondary time slots. For instance:

Kojak (1976), *Happy Days* (1977), *Fury* (1977), *Roots* (1978), *Eight is Enough* (1978), *Columbo* (1979), *Starsky and Hutch* (1979), *Charlie's Angels* (1979), and *M.A.S.H.* (1979).

On the contrary, Berlusconi's newborn Mediaset (Canale 5 was founded in 1980) used American television dramas as the keystone for building an alternative model to RAI's programming during these same years. Instead of the pedagogic mission that, until then, was typical of the public service, they adopted a clear strategy that focused on marketing and on creating media "events" that were advertised and sold to the audience long before their actual broadcasting. The prime time soap opera *Dallas* (1981) can be taken as the turning point that marked the real birth of Mediaset's programming strategy. The story of how *Dallas* was broadcast in Italy clearly shows how much television was changing in those years, and how hard the competitive struggle between the two main players became.

Dallas was already a big success in the U.S. (Liebes & Katz, 1990) when the first season of the show was imported by RAI in 1981. However, the network decided to schedule it late at night and not in prime time. Moreover, the original sequencing of the episodes was not respected, thus completely changing the narrative structure of the show. Quite predictably, this nonstandard strategy resulted in very low ratings and the show was canceled. A few months later, Canale 5 purchased *Dallas* directly from CBS. The series was broadcast anew in prime time, with the correct sequencing and launched by a strong marketing campaign. It was a very big success. Canale 5 not only gained high ratings, but also huge visibility and credibility (Cardini, 2010).

RAI's reaction was the production of a new prime time show called *La Piovra* (*The Octopus*, 1984–2001), a dark series focused on the war with the mafia led by the main character, Inspector Cattani. It quickly became RAI's most representative program of the decade. It was such a big success that the production was renewed for ten seasons, surviving even the death of its hero who was killed by the mafia at the end of the fourth season. *La Piovra* was a hybrid between the serial and the series form. A serial is composed of long-running storylines that continue from one episode to another, while a series is characterized by storylines that end in each episode (e.g. *Columbo* is a series, while *Guiding Light* is a serial). From 1984 to 1995 each season was composed of seven long episodes, while in the remaining three seasons only two episodes were produced and aired. Moreover, the seasons were irregularly produced and broadcasted. So the audience, in some cases, had to wait even three years for the new episodes. Helped by its mix of crime, action, and melodrama, *La Piovra* still remains the only example of Italian serial drama exported to foreign countries. Despite its possible controversial impact on the nation's image, the mafia stereotype worked well abroad.

In the meantime, Mediaset continued importing American television shows. Canale 5's schedules were primarily based on Hollywood movies and daytime soap operas such as *General Hospital* (1980) and *Guiding Light* (1982), while Italia 1 focused almost exclusively on American serials and Retequattro focused on "telenovelas." Until then, Latin American telenovelas like *Escrava Isaura* (1982) and *Dancin' Days* (1982) were completely ignored by Italian television, but their unexpected success started a flood of Brazilian and Mexican productions.

However, neither RAI nor Mediaset seemed to understand or use the standard rules of the serial form. On the one hand, there was the unwillingness to respect regularity and continuity in broadcasting, and therefore the audience was often confused by changes of time, if not of channel. For instance, RAI bought the show *E.R.* in 1996 and it broadcast two episodes in one slot per week because Italian schedules are not structured around one-hour slots, but prefer one and a half-hour shows as a minimum. On the other hand, there was impatience for not immediately gaining substantial ratings, though generally long-running serials need some weeks or even months to build up a solid audience following. Thus, American serials were often cancelled not because of audience dislike, but too many confusing scheduling decisions that were the result of a deep misunderstanding of serial form rules.

The Soap Opera Genre in Italian Television (1990-1996)

In 1990 the Italian landscape of imported serials was enriched by a very important newcomer called *The Bold and the Beautiful*. It was RAI's second channel Raidue that bought and broadcast the famous U.S. soap opera. The channel was already airing the soap opera *Loving*, which scored good ratings, and during its summer hiatus, *The Bold and the Beautiful* was intended to be nothing more than a substitute. However, the intriguing love stories of the Forrester family soon overcame *Loving*'s ratings and in a few weeks the new soap opera became a huge success, which obviously gave way to some scheduling experiments. The channel aired one episode per day, following the traditional scheduling for soap operas, but also decided to edit three episodes together, in order to get a single 90-minute show that was suitable for prime time slots, and Sunday evenings. *The Bold and the Beautiful* soon became a real phenomenon. Audience members discussed it in pubs and classrooms, and its actors were on the covers of gossip magazines. Once its popularity became really strong, the

show was scheduled during prime time hours. In Italy, prime time goes from 8:30 P.M. to 11:30 P.M. It is the most important slot of the whole television day. From 8:00 to 8:30 P.M. the main news editions of the day are aired by Raiuno and Canale 5. Almost a decade after the great success of *Dallas* another soap opera conquered the most precious schedule slot of the week, the Sunday prime time.

After four years of great audience ratings, RAI was forced to back down when Berlusconi fought to obtain the broadcasting rights. The Italian tycoon's highest economic offer brought *The Bold and the Beautiful* to Canale 5 schedules, where it is still being aired today with average ratings reaching 5 million viewers every day. *The Bold and the Beautiful* was actually created for the foreign market (Simon, 1997), as its creator Bradley Bell says:

> When I write the storylines of *The Bold and the Beautiful* I am perfectly aware of its international audience. Love stories—that are the narrative focus of the show—speak an international language. Everyone can relate to this topic, and everyone is attracted by it. I do not write about legal storylines because I think that international audiences can get bored by the endless details of the American legal system . . . and I think that comic stories cannot work either in different cultures, while if I stick to love stories, love triangles and love matters I know I can reach a wide international audience (p. 161).

For these reasons and without any strong competitors, *The Bold and the Beautiful* became the very synonym of "soap opera" in the Italian television landscape in the 1990s. Slow narrative rhythm, complicated and unrealistic love relationships, and handsome "tabloid-style" characters became the main features of the genre in the perception both of the Italian audience and of Italian television scholars.

This was the Italian cultural mood in the middle of the nineties when the project of the first Italian soap opera, *Un posto al sole*, was born. Because of strong internal contradictions and seemingly suicidal production and scheduling strategies, the genesis of this Italian soap opera is particularly interesting.

At the very beginning of the project, RAI did not have any technical skills for producing a soap opera. The project was planned by Raitre, the third channel of Italian public television, whose identity was based upon cultural content such as news, talk shows about political issues, and documentaries. Raitre had very few self-produced television dramas, very few imported shows, and absolutely no soap operas. The creative team that produced *Un posto al sole* chose to rely on the realistic but totally unknown British serial model, thus dis-

carding the successful and much appreciated melodramatic path shown by *The Bold and the Beautiful*. The chosen production location was Naples, one of the most charming cities in southern Italy, appreciated for its naturalistic and architectural beauties but also one of the most difficult places to live in because of high social conflicts and criminality. Its difficult cultural and political climate would surely make things more difficult when it came to the practical needs of any television production. The soap opera style that was chosen was a difficult but successful adaptation of a British-Australian format, just when the Italian television market was far from starting the process of localization of foreign shows. Thus, from its very beginning, *Un posto al sole* seemed doomed to fail. Surprisingly, it survived all odds and is currently running its 13th season and has a wide and faithful audience despite its unusual and difficult slot in the schedule. The fascinating case of *Un posto al sole* gave fuel for a national school of soap opera production.

Thus, in 1996 there appeared two different styles of the soap opera genre in Italian television schedules. On the one hand, there was the American style represented by *The Bold and the Beautiful* aired by Canale 5. Luxury locations, fashionable and glossy characters, complicated and unrealistic love stories developed on the screen at a very slow rhythm. Long and slow conversations between two characters at a time took place in interiors—mainly the characters' rich houses located in a most elegant neighborhood in Los Angeles. On the other hand, Rai was airing the first Italian soap opera by adapting a completely different style taken from the British soap opera. The main features of *EastEnders*, *Coronation Street*, or *Brookside*—the most successful British soap operas, never aired in Italy. These were completely unknown to the Italian audience and so was the stylistic element of "realism." The action takes place in real locations such as pubs, shops, squares and streets, classrooms, and workplaces; characters are real-looking people, far from the glamour of the American soap opera. The narrative focus is on social and cultural themes such as alcoholism, abortion, divorce, and drugs, rather than on love affairs, marriages and adultery.

The British soap opera's realistic style is appreciated in those countries that share a cultural proximity with Great Britain, such as Australia. That's why *Neighbours*, the Australian soap opera upon which *Un posto al sole* is based, has the same structure as *EastEnders*, *Coronation Street*, or *Brookside*. That is why it scored great audience ratings in Great Britain but not in the United States (Crofts, 1995). Below is further discussion about how the first Italian soap opera project developed.

The Difficult Beginnings of the Italian Soap Opera: *Un posto al sole* (1996)

In 1996 a joint venture between Raitre and Grundy Productions, an Australian-based television production company, gave birth to the first Italian soap opera. The terms of the deal were based on the purchase of the format of a successful Australian soap opera *Neighbours*, already exported to 25 countries.

The purchase of the format was quite peculiar (Moran & Malbon, 2006). Unlike what would happen in many of the markets where the program had been sold, such as the U.S., Britain or France, RAI did not ask Grundy for the rights of *Neighbours* to be aired in its original form and dubbed, nor was RAI interested in the strict adaptation of the narrative format. What RAI needed at that time were the skills and knowledge to "produce" such a difficult and complex show. So they bought all the skills from Grundy (and the professionals) that were needed to create a soap opera. Italian storyliners, or writers who write the storylines, were not used to coping with so many characters and interwoven storylines at a time. Therefore they learned to manage long-running stories that involved many characters from head writers from Australia. Furthermore, actors, who were mostly experienced in theatre or movies, were trained by Australian teachers about how to play multiple scenes per day, as is demanded of the soap opera production schedule. A daily 25-minute episode is made up of an average of 18 scenes that can involve up to 15 characters each. This kind of fast-paced production is why a good soap opera actor must learn how to get the most out of every second. Italian directors were trained by those from Australia about how to film in a very short time, coordinate many actors at a time, and manage everyone and everything else that was needed. This included working with the head writers, costumes, and hairstyling. As well, every single production step had to be understood, learned, and "Italianised." With its eventful atmosphere, the Naples setting contributed a strong uniqueness to the plots. Stories and characters were infused with a distinct Mediterranean flavor. This learning process was obviously very difficult. For instance, some rigid guidelines established by Grundy from a narrative and productive point of view had to be deeply re-discussed and changed in order to fit the Italian culture. In the original *Neighbours* format there were three sets of guidelines.

The first guideline involved "the need for a distinctive location." In the original Australian format, the relationships between the characters developed mostly in the neighborhood, as noted in the title of the soap opera. In Italy however, space does not serve the same social aggregation function as it

does in British or Australian pubs, blocks, or streets. These particular spaces serve major social functions in *EastEnders* and *Coronation Street*. In Italy, the neighborhood equivalent can be squares in very small villages or single buildings in bigger towns. That was the case of Naples, and that is why the main characters of the soap opera were gathered in a single building (a beautiful aristocratic old mansion in front of the sea) instead of being placed in the different houses that form a specific city neighborhood.

The second guideline emphasized that the stories should keep the audience engaged, or keep interest among "the target audience in relation to the storylines." Grundy aimed at focusing the storylines on younger characters in order to reach the core younger audience target, just as it happens to be with the original *Neighbours* in Australia and in Great Britain. In these two countries, however, the show is aired during the daytime. By contrast Italian young people are generally not interested in daytime soap operas. For this reason, Raitre decided to schedule the soap opera in a very peculiar slot: in the first season, it was aired in the late afternoon (6:30 P.M.) for the first three months, and then it was shifted to prime time (8:30 P.M.). Instead of building up a young audience, this peculiar scheduling contributed to create an adult male audience, since many men were at home watching television. This was different from the usual female soap opera audience. That is why many storylines that were originally focused on younger characters had to be changed in favor of stories that could appeal to adult male audiences as well (crime, social issues, action etc.).

The last guideline was to have a "narrative focus on class struggle." Grundy explicitly requested that class struggle was the narrative main point, and that stories were to have a realistic tone and be focused on social issues. It was not simply to be a melodrama that was typical of U.S. soap operas. This guideline was strictly respected only in the first seasons of *Un posto al sole*, but soon the most realistic storylines (linked to news stories or to the harsh Neapolitan daily life) were replaced by more appealing love stories, which were often put in the forefront of the narration. Therefore, *Un posto al sole* was the result of a constant mediation process between the format's production guidelines and the need to localize.

A useful way to highlight the differences and similarities between the two soap opera styles aired in Italy during the mid-1990s—the American and the Italian one (adapted from the British soap opera)—is textual ethnography (Liebes & Livingstone, 1994). Instead of analyzing audiences with ethnographic tools (Ang, 1985; Morley, 1992), Liebes & Livingstone tried to apply the same approach to soap opera characters, with the aim of drawing a map of their relationship structures (Newcomb & Hirsch, 1984). It is possible to

compare two soap operas by mapping their "family trees" and friendship relations on the basis of past or present weddings between characters, on past or present love relations, and past or present friendship relations. Each character is linked to others by one or more relational dimensions, whose intersections retrace the narrative lines and highlight social conventions, ethic rules, causes of deviancy, and so on in the soap community. The map as a whole can reveal at a glance the presence of one—or more—main elements (i.e. past or present marriages, inter-generational friendships, past or present love stories) and so it can describe the main relational patterns upon which the soap opera community is based. The next step is to compare the soap opera relationship map to the structure of the society where it belongs. Furthermore, by mapping two different soap operas and then by comparing them, it is possible to detect which of them is more similar to its audience's culture, described by drawing on the same variables (i.e. past or present marriages, inter-generational friendships, past or present love relations).

The parallel between *The Bold and the Beautiful* and *Un posto al sole* in relation to the Italian culture shows many relevant differences between the two soap opera styles. For instance, the main feature of *Un posto al sole* coming from the ethnographic mapping is the prevalence of friendship relations, which are almost absent in *The Bold and the Beautiful*. As far as love relationships are concerned, *The Bold and the Beautiful* shows a prevalance for new weddings and many divorces, while in *Un posto al sole* marriages are solid and romantic relationships are loving and strong. These two features are enough to outline the deeper similarity of *Un posto al sole* to the Italian family and relational structure, compared with the American one.

From a British research perspective, Liebes & Livingstone (1998) compared *The Bold and the Beautiful* with *EastEnders* and *Coronation Street*, highlighting that in the British serial drama the love plots are less relevant than the community relationships or the complex friendly-lovely texture that binds the families starring in the stories. Therefore, it can be said that *Un posto al sole* stands in a middle ground since the friendly component is an important alternative to love stories, which, nonetheless, play an important role in the narration. Equal to the British model and opposite to the American one, story themes in *Un posto al sole* are often realistic and rooted in the Italian cultural context, sometimes even anchored on the issues of the day: homosexuality, prostitution, and crime. Nevertheless, *Un posto al sole* has a minor focus on the community dimension compared to the British soap opera style. Family relations and friendships shift the tone towards the private dimension, and the comedy storyline, which must always be present in each episode, helps to "soften" the most serious social issues. This last feature was another rule imposed

by the original Australian format. At first, it seemed a problem for the producers of *Un posto al sole*, but nowadays it stands as one of its most peculiar features and as the most evident outcome of the success in the localization process, with its references to the "commedia all'italiana" (Italian comedy).

Into the Soap Opera Factory:
Vivere, CentoVetrine, Agrodolce (1998-2008)

Two years after *Un posto al sole* premiered in RAI, Mediaset responded with a strong-starting soap opera that was produced with a precise strategy. A soap opera, in Mediaset's view, was a perfectly fitting product for commercial television, and for the network's intense competition with RAI. Indeed, the creative and productive staff hired for *Vivere* (*Living*) was recruited from the crew of *Un posto al sole*. Creative and writing work on Canale 5's first soap opera began in 1998, while the first episode premiered on March 1, 1999. Mediaset's strategy in launching the product was focused on two main tools: scheduling techniques and promotion. The new program was placed between the channel's classic soap opera *The Bold and the Beautiful*, with its five million daily average viewers, and the popular show called *Uomini e donne* (*Men and Women*). This very popular reality show focused on love affairs and dating with an audience mainly composed of women and young people. In this way, the viewer was led from one program to another in a compact flow that covered all the first part of the afternoon. This scheduling technique also guaranteed effective marketing strategies, with many ads announcing "Canale 5's new soap opera" aimed directly at the right audience.

For the producers of *Vivere*, the soap opera's themes had to stand between *The Bold and The Beautiful* and *Un posto al sole*. The program should focus on love and private matters, but it should keep a realistic flavor and characters should be "normal" people. A strong difference from *Un posto al sole* was the location, which was very far from the sunny Naples. Vivere is located in Como, a town on the lakeside in northern Italy: a foggy land, very different from the warm Mediterranean flavor of Neapolitan atmospheres. This choice for the location was aimed at stressing crime and mystery storylines, thus underlining the hidden secrets of the community. *Vivere* was produced in Milano, but filming was performed on the Lake of Como. From the author's perspective, this was a perfect setting to give stories and relationships a dark edge, and to depict a community that is quiet and still only on the surface and tumultuous beneath, exactly like the lake's waters. So, beyond romance and drama, Canale 5's soap opera had a third and new typical storyline of crime.

The show was such a big success that Mediaset was convinced to start another new soap opera project immediately.

CentoVetrine (*The Mall*, 2001) was born thanks to another bold production move: a brand new unit was set up, located in an all-new television center near Turin which was built exclusively for producing this show. The location was Turin, a typical Italian industrial and working class city. With its blue-collar image, this town was the ideal set for storylines that were focused on class struggles and on the quest for power and success. But the city itself always remains on the backdrop, unlike the heavily location-influenced stories of *Un posto al sole* and *Vivere*. The heart of the narrative of *CentoVetrine* is located in a big new mall where most of the professional settings of the episodes take place. To this day, the soap opera airs every afternoon at 2 P.M., right after *The Bold and the Beautiful*, and scores very good ratings.

RAI's response to the second Mediaset soap opera came after a very long time; almost ten years after the first season of *Un posto al sole*. The new show, called *Agrodolce* (*Bittersweet*) was aired in 2006 amidst many controversies. The "think tank" of the soap opera was led by Giovanni Minoli, the same RAI's executive who purchased *Neighbours'* format from Grundy in order to create *Un posto al sole*. The new project is located in Sicily, in a fictitious small town named Lumera (which in real life is Porticello, a little village on the seaside near Palermo). The storyline is based upon six families with different economic and cultural backgrounds, from aristocrats to working-class people.

The project resulted from a joint venture between RAI, Einstein Multimedia (an Italian production company), and Sicily's regional government. *Agrodolce*'s first season was financed drawing on European Union funds, which unfortunately were not renewed at the end of the first year of production. The show was therefore suspended by July 2009 and actors and workers were not paid. RAI is now airing repeats from the first season. Some recent rumors speak about a possible recommencement of the production in order to complete the two-season deal that was originally planned; if not so, the program will be canceled.

This show represented a big production effort aimed at creating a television industry in Sicily, a region where it is usually difficult to establish business because of political and cultural reasons. The strong criminal power of mafia, whose organization is deeply rooted in the Sicilian socio-cultural background, influences all aspects of daily life and makes the Sicilian way of life quite different from the rest of Italy. The daily struggle between Sicilian citizens and the subterranean but always present mafia rules can be difficult to imagine for non-Italians, and often for non-Sicilians as well. Obviously, the political and economic life of the region is strongly affected by the presence of mafia.

However, in spite of many obstacles, a real "television town" similar to that of *CentoVetrine* was created in Termini Imerese, a small town near Palermo. The stakes for this project were high. Not only were hopes pinned on the creation of a "television town," which was a challenge due to limited professional knowledge and media production. The effects of such a big creation (2,000 square feet studios, high technology facilities such as the HDTV technique, many jobs created anew) produced positive effects on the general economic and working conditions of the region. After a long preparatory phase, the first season (230 episodes) of the Sicilian soap opera was completed. In the first weeks, the show scored fairly poor ratings, but this is the case for every new soap opera that needs a lot of time to build its own faithful audience. The audience share only reached 5%, with 1 million viewers on average, but after a few months those figures rose up to 9%, which fulfilled the channel forecasts in a very difficult schedule slot (8 P.M., against all the primetime news editions of RAI and Mediaset).

For its producers, *Agrodolce* had two main goals. It aimed at giving Sicily a real television factory that could produce quality television shows. It would stand for a "great Italian popular novel," drawing on the themes of national literary production and traditional neorealism of Italian film, thus distinguishing itself from the stereotypes of the American soap opera. Love stories are important, but political, civil, and ethics issues were by far more interesting for the producers. As a consequence, this soap opera was characterized by many location scenes that show the beauty and the harshness of the Sicilian land. This soap opera also had strong real-life storylines about struggles with mafia, immigration, unemployment, and education.

Conclusion: An Italian Soap Opera Style?

More than a decade after its birth, it is now possible to review the existence of an Italian sop opera style, the existence of a "soap opera factory," and focus on its peculiarities (Cardini, 2004). From a production and technical point of view, Italian soap opera does not rely on a single episode but on the so-called "block," which is a unit composed by five weekly episodes which share some storylines. This strategy is aimed at boosting the writing and production efforts in order to maximize the results and to reduce costs to a minimum.

The ongoing localization process of the Italian soap opera is clearly represented by an apparently meaningless detail: the credits. In 1996, *Un posto al sole's* final closing credits used English words to describe all the professional roles involved in the production process, at least in the first seasons. Five years later, *CentoVetrine* translated them into Italian. This detail shows that the whole

genre of the soap opera is no more perceived as a foreign format, but has been transformed into an important piece of Italian television culture.

The four Italian soaps previously discussed in this chapter stick to reality in the way they deal with human relations, in their portrayal of characters which are never put on a pedestal but always depicted as plausible and real, and in their distance from the narrative strategy of *The Bold and The Beautiful*.

A main difference among the four shows is the nature of the two television institutions out of which they are born. *Un posto al sole* was the answer to Mediaset's aggressive import strategy of American television dramas. Its debut had to overcome many difficulties, not only on the industrial side but also, and mainly on the cultural side. A passive resistance, motivated by RAI's mission as a public service, threatened the possibility of success, confining the program's airing first in an unusual late afternoon slot, then in prime time. Both slots were very far from the early afternoon times that were usually reserved for soap operas. The program was forced to overcome another bias: the creation of a brand new audience in that particular schedule slot traditionally used for game shows and news segments but not for soap operas.

Based on the contextual, stylistic, and other significant developments of soap opera style programming, we can now state that there is an Italian soap opera style, even though its birth is late in comparison with other European and U.S. experiences. The Italian style is the result of a combination among different production and content elements that stem from both the U.S. soap opera and the British serial drama. Its key features can be traced to the strong presence of the local setting, realism in stories, and character representation, a good mix of love stories, and real-life themes such as crime, news and social issues.

From the soap factory many other factors also emerged related to the two main competitors in the Italian television market: RAI and Mediaset, and their different strategies. One could expect that the first try at soap opera production would come from commercial television, since this genre is deeply linked to marketing strategies. On the contrary, the starter of the race was public service television. Public service television took a great risk in choosing a new path in its adaptation of a format that came from a distant culture such as Australia. As a consequence, commercial television's reaction was immediate and competitive. Only one year after *Un posto al sole* premiered, Mediaset "stole" a good portion of RAI's think tank to produce *Vivere*, which was aired by Canale 5 after an aggressive marketing campaign and an accurate scheduling technique. Mediaset raised the stakes three years later, not only by producing another soap opera, *CentoVetrine*, but also by devoting a whole new and huge production structure solely to the soap opera genre, with the intention to produce more shows by lowering costs and maximizing outputs. Something along the way

went wrong. Mediaset partially dropped its initial plans and *Vivere* was shut down among controversies; *CentoVetrine* lived on, but there are currently no plans for future new soap operas coming out of that factory. Against all odds, RAI's plan continued and *Agrodolce* was born with big ambitions, both on the narrative and on the production side, but had—and still has—a harder life than initially expected. Its ratings were low, but not enough to be totally canceled. The struggle now is on the financial side and on the politics of funding. The soap opera genre is born in commercial television but in Italy it seems to work better in public television, which has shown a stronger belief in direct production strategies.

In this perspective, what is the future of the soap opera in the Italian broadcasting television system? A decrease in the interest in soap opera direct production can be found in the strategy shift derived from commercial television's recent moves, which were almost immediately mirrored by RAI and the programming schedule. The recently ended decade was dominated by the advent of a new genre, the reality show. Reality shows target the same audience as soap operas but cost less and score higher ratings and higher productivity. *Big Brother*'s first edition introduced the genre in Italy in 2000. Since then, Canale 5 rode the wave in many ways, leaving aside other big projects, such as the soap opera production. RAI, on the other hand, produced its own reality shows without leaving soap operas. As we have seen before, many difficulties and uncertainties pave RAI's new soap opera path. We can sum up the whole question by underlining how the Italian television system of the 1990s, which initially led to the birth and growth of the genre, moved rapidly towards less engaging and less expensive production goals.

At this point, there are different possible scenarios, all of them linked to the structural changes that the whole system has been going through in the last few years. The two big corner stones around which the new scenario and the debate about its future revolves are represented by the new competitor called Sky and the slow affirmation of DTTV (digital terrestrial television). Sky entered the scene in 2003 as a satellite provider and producer. Broadcast television still has solid ratings but satellite television gains bigger and bigger share figures. A richer, younger, more cultivated audience that is attracted to satellite thanks to new American television drama programming and football games are desired by advertising companies. This new audience is also fleeing from traditional television to new forms of consumption that takes place outside the medium and on the computer screen. Broadcast television cannot fight this already lost battle, but it can adjust its strategies and its content by looking at the main core of its audience. In this perspective, soap opera could become a high quality content for elder, less cultivated audiences. National

drama (Allen, 1985)—which soap opera belongs to—is a key element in broadcast schedules. The soap opera is the language of a grown-up medium, able to speak to a broad and varied audience. It is possible that in this peculiar moment for the Italian television system, the soap opera form will be able to find its suitable new recipe in order to cope with the transforming mediascape on the global stage.

References

Allen, R. C. (1985). *Speaking of soap operas.* Chapel Hill, NC: University of North Carolina Press.

Allen, R. C. (ed.) (1995). *To be continued . . . Soap operas around the world.* London, England-New York, NY: Routledge.

Ang, I. (1985). *Watching 'Dallas': Soap opera and the melodramatic imagination.* New York, NY: Methuen.

Bignell, J., & Lacey, S. (2005). *Popular television drama. Critical perspectives.* Manchester, England-New York, NY: Manchester University Press.

Brunsdon C. (1997). *Screen tastes: From soap opera to satellite dishes,* London, England-New York, NY: Routledge.

Brunsdon, C. (2000). *The feminist, the housewife and the soap opera.* Oxford, England: Oxford University Press.

Cardini, D. (2004). *La lunga serialità televisiva: Origini e modelli.* Roma, Italy: Carocci.

Cardini, D. (2010). *Blockbuster television. Come la tv ha sconfitto il cinema.* Roma-Bari, Italy: Laterza.

Caughie, J. (2000). *Television drama. Realism, modernism, and British culture.* NY: Oxford University Press.

Crofts, S. (1995). Global *Neighbours?* In R. C. Allen (ed.), *To be continued . . . Soap operas around the world.* New York, NY: Routledge.

Dyer, R., Geraghty, C., Jordan, M., Lovell, T., Paterson, R., & Stewart, J. (1981). *Coronation Street.* London: British Film Institute.

Geraghty, C. (1991). *Women and soap opera: A study of prime time soaps.* Cambridge, MA: Polity Press.

Hobson, D. (2002). *Soap opera.* Cambridge, MA: Polity Press.

Liebes, T., & Katz, E. (1990). *The export of meaning. Cross-cultural readings of 'Dallas'* Cambridge, MA: Polity Press.

Liebes, T., & Livingstone, S. (1994). The structure of family and romantic ties in the soap opera: An ethnographic approach. *Communication Research, 21,* 717–41.

Liebes T., & Livingstone, S. (1998). European soap operas: The diversification of a genre. *European Journal of Communication, 13,* 147–80.

Modleski, T. (1984). *Loving with a vengeance: Mass-produced fantasies for women.* New York, NY: Routledge.

Moran, A., & Malbon, J. (2006). *Understanding the global TV format.* Portland, OR: Intellect Books.

Morley, D. (1992). *Television, audiences and cultural studies.* New York, NY: Routledge.

Newcomb, H. M., & Hirsch, P. M. (1984). Television as a cultural forum. Implications for

research. In Rowland, W. D., & Watkins, B. (Eds.) *Interpreting television. Current research perspectives*, Beverly Hills, CA: Sage.

Radway, J. (1984). *Reading the romance. Women, patriarchy and popular literature.* Chapel Hill, NC: University of North Carolina Press.

Silj, A. (ed.) (1988). *East of 'Dallas.' The European challenge to American television.* London, England: British Film Institute.

Simon, R. (1997). *Worlds without an end. The art and history of the soap opera.* New York, NY: Harry Abram.

Thompson, R. J. (1996). *Television's second golden age. From 'Hill Street Blues' to 'E.R..'* New York, NY: Syracuse University Press.

8. Kenyan Soap Operas as Functional Entertainment

Redefining the Role of Television Melodrama for an Active Audience

George Ngugi King' ara

Television viewing "is a purposeful act, one laden with intent, guided by rationale, and fraught with the search for personal gratifications that need to be satisfied" (Abelman & Atkin, 2002, p. 72). One such gratification is the viewers' need for entertainment value. Television production too is motivated by the rationale and purpose of producing and reproducing socially constructed texts whose intents are meaningful. One of the 'meaningfulness' of such texts is their utilitarian value as entertainment for audiences in return for accomplishing desired institutional objectives. The most important objective for producers is to make television an asset in the lives of the viewers. Hence, the relationship that develops between television viewers and the producers of television programs in this context is one of mutual utilitarian interdependence.

This chapter explores some of the general conceptual and theoretical issues relating to soap operas as entertainment television programs, their functions, and their possible implications on the real lives of their viewers. The chapter draws from my current field research that examines how Kenyan producers conceptualize the audiences of television entertainment programs. In the research, I participated in the production processes of a commercial television soap opera entitled *Uhondo (Feast)* (shown on Nation TV between 2003 and 2006) but also considered the dynamics of other soap operas produced in Kenya and the African region in relation to their audience appeal. Using examples concerning the institutional and cultural dynamics surrounding the

production and viewing of *Uhondo, Wingu La Moto (Cloud of Fire)* and *Heart and Soul* (shown on Kenya Broadcasting Corporation TV in 2002), the chapter aims to illustrate the multi-facetedness of the relationships that exist between the audience and the entertainment element embedded in soap operas. It also shows that the entertainment function of soap operas is related to roles such as fulfilling audience's needs in mood repair and imparting socio-cultural education to audiences. Furthermore, soap operas' socio-cultural relevancy promotes audiences' social interactivity by locating them within their socio-cultural-political networks. In this respect, soap operas facilitate the audiences' self-reflexivity by enabling viewers to negotiate socially ascribed subjectivities, hence allowing them to view their world from more personalized perspectives. The chapter concludes that the production and viewing of soap operas in Kenya are far from mundane affairs. Indeed, soap operas now constitute important narratives that many people are looking to in order to make sense of the social world they live in; they are the stories that authenticate the audience's world by reflecting that world back to the audience.

According to the many cultural traditions thriving in Kenya, stories have a role to play as each story can be said to have a moral value to be garnered from it (Ligaga, 2005). Storytelling, therefore, is never vain entertainment. In this context, the value of production and viewing of soap operas might be predicated by the quest for lessons worth teaching or learning from the programs. Indeed, field data used for this current research reveals that Kenyan television producers and audiences alike felt that soap operas had lessons to teach, or that they were teaching wrong ways of behavior. This expectation for lessons from the soap operas points to 'a given' presumption that these programs had a purpose, to teach a lesson of some kind. This quality as perceived by the producers and audiences of these soap operas also points to a Kenyan tradition of storytelling for the purposes of teaching. It can be argued that producers of soap operas in Kenya went about conceptualizing their audiences based on the ideal that these dramas are indeed stories serving the same purposes as do folk narratives. In this respect, they expected these television stories to pass on values and traditions of the Kenyan culture to the audience using universal cultural codes. These codes have significant impact on how audiences understand messages in soap operas, irrespective of Kenya's diversity in cultural traditions.

In order to better understand the producers' perspectives regarding the role of soap operas as propagators of ideal Kenyan socio-cultural values, it is important to comprehend the contexts within which soap operas have been produced and viewed in Kenya. For this reason, the next section briefly highlights the political, economic and cultural dynamics surrounding overall television programming and the popularity of soap operas as entertainment

offerings. Subsequently, a discussion on the characteristics of soap operas illustrates how these dramas may become part of the audience's everyday lives. The chapter concludes that soap operas in Kenya can be considered a new form of folk tale. They are functional narratives that are useful not only for entertainment but for imparting social education.

Contexts of Soap Opera Production and Viewing in Kenya

Beginning in 2003, the percentage of local soap operas on Kenyan television screens was destined to increase. In August of that year, Tourism and Information Minister Raphael Tuju announced that radio must broadcast at least 20% local content, while television should dedicate at least 30% of programming time to local content. These quotas were expected to rise to 60% in the coming years (Maubert, 2006). The Media Owners Association and the Kenya Union of Journalists opposed the minister's move claiming that it went against the provisions of media liberalisation, and could even force television stations to close down due to the high cost of producing local programs. The minister defended his ultimatum and stated that he wanted to guarantee that Kenyans enjoyed the economic benefits inherent in broadcasting as a national resource. He complained that foreign programs are detrimental to the creation of jobs for Kenyans (Apsattv.com, 2010).

Whether the minister's ultimatum would have any effect on the number of soap operas that viewers in Kenya would continue to watch was not clear at the time. However, by the end of 2004, Nation TV, arguably the most successful commercial media house in East Africa, was airing three local soap operas for the first time since the station opened in 1999. According to the directors of *Uhondo* and Nation TV's production manager, *Uhondo* was the first true local soap opera to be aired on commercial television in Kenya. Hence, it became the pioneer in a new brand of Kenyan television melodrama (Field Notes, 2005). In advertisements featured in *Daily Nation*, the sister newspaper of Nation TV, the show was described as "a soap opera about life though 75% of the characters live a life of utopia. Deceit is a main weapon which causes a lot of trouble and havoc in everyone's life. For the young and old with language that's light and easy to understand" ("Wonderful Wednesday," 2005). Like its predecessor, *Wingu La Moto* (shown on Nation TV, 2003—2006) was initially very popular. It was described in newspaper promotions as a soap opera that featured "the story of three bosom friends . . . sharing an apartment in the suburb and are very good friends though totally

different in character. As the story unfolds, their bonds of friendship will be betrayed and totally shattered" ("Wonderful Wednesday," 2005).

The success of *Uhondo* and *Wingu La Moto* controverted the notion that only foreign soap operas could garner high ratings on Kenyan television. The two shows competed well with the ever-popular brand of telenovelas imported from Mexico. A former programming manager at Nation TV, Wavinya Mwanzia, attributed the popularity of the local soap operas to the fact that in some way they reflect ideals in Kenyan society. She noted, "It is reassuring to the viewer to know that in the soap operas, the bad guys get caught and punished and good eventually triumphs over evil, which is not always the case in real life. But that is what most of us would want to have in an ideal world" (*Saturday Nation*, July 30 2005). This quality of idealism and relevance of soap operas to viewers' lives emerges from the dynamic characteristics of these dramas. The next section explores these characteristics and highlights some interesting relationships that viewers have had with soap operas.

What's In a Soap Opera, Really?

Characteristically, soap operas are set in central environments where ordinary people across the world spend a significant amount of time. For example, the home, the work place, the hospital and the social/public place such as the bar or restaurant commonly feature in soap operas because they also provide familiar spaces where people tend to congregate. Furthermore, such environments enhance the social interactivity necessary for dramatic relationships between soap opera characters. Since the soap opera is also underpinned on conflict, these gathering environments catalyse the actions of the characters in that direction. Also, the struggles of the villains and their allies against the heroes and their allies unravel slowly in many short scenes over an extended period of time (Mittel, 2007). Indeed, *Uhondo* and *Wingu La Moto* ran for at least three years while soap operas produced at Kenya Broadcasting Corporation (KBC) have tended to run for at least five years (Field Notes, 2005). Although there are many reasons why soap operas are popular, many studies emphasize that identification with soap opera characters or their situations is central to the attraction many people find in them (Ang, 1985; Geraghty, 1991; Hobson, 1982; Liebes & Katz, 1990; Miller, 1992). This identification can range from the viewer's recognition of the familiar in the characters' predicaments, attitudes toward life, morals, cultural values, and even fashion (Miller, 1992).

Ang (1985) notes that "what appeals to audiences in a serial is connected to their social situations, histories, aesthetics and cultural preferences" (p.

46). In addition, the mythical realism of soap operas is a meta-commentary on the nature of truth itself. The melodramatic representations in soap operas of characters dealing with the mundane and quotidian serve this purpose. In so far as these representations involve the psychological conflicts of characters as their lives are unsettled by their estrangement from core social institutions, particularly the family, church, school etc., they become meaningful to many viewers. The depiction of characters' movements within these institutions in soap operas represents a reality that viewers recognise as it reminds them of the responsibility of living within institutions that epitomize and consolidate their sense of community. Furthermore, in Third World post-colonial countries (such as Kenya) where the socio-national community belongingness has been overemphasized by government through patriotically themed television programming (Bourgault, 1995), the audience finds a means of realizing postmodern sensibilities of the personal in the melodramatic orientation of soap operas (Abu-Lughod, 2002). As the audience becomes intimately familiar with soap opera characters and their lives at an emotional level, the experience of 'feeling with the characters' personalizes and individualizes the social world, and provides the audience with a new way of knowing their own (Kenyan) social world (Hobson, 1982). Thus, the soap opera ceaselessly offers the audience dramas of recognition and re-cognition by locating social and political issues in personal, familial-social terms, therefore allowing the audience to make sense of an increasingly complex world (Lopez, 1995). According to Mazziotti (1993), soaps also "allow for the viewers an emotional participation in a set of fictitious powers that play with elemental human questions: honor, goodness, love, badness, treason, life, death, virtue and sin, that in certain ways has something to do with the viewer" (as cited in Gonzales, 1998, p. 11).

Furthermore, researchers have found that there is a possibility that many a social interaction have grown from the shared experiences of watching soap operas (Cantor & Pingree, 1983). Once formed, the ritual of 'soap watching' is never an empty or hopeless endeavour as individuals carry this experience to the social space throughout their day. The next section illustrates that when 'soap opera watching' becomes part of the viewers' 'routine of life' it can have significant impact in their emotional wellbeing as well as their social interactions.

Attending to the Habit of Viewing Soap Operas

Habits are derived from experience, from first engaging in an activity upon which a tradition of repeating the same practices develops because the initial experience in the activity fulfilled a certain need (Abelman & Atkin, 2002, p.

75). The consistent growth of the soap opera audience in Kenya since the 1990s when KBC television first introduced foreign soaps lends support to the foregoing point. According to social critics, many Kenyan viewers have confessed that they often rushed home from work to watch soap operas, because the dramas are entertaining and realize the viewers' dreams (Kang'ong'oi, 2005).

Routinized, the practice of viewing soap operas, for example, becomes 'living,' at which point it transforms into a habit that is hard to break (Miller, 1992). When viewing soap operas becomes such an intense habit, its entertainment value for the audience reaches the greatest degree and it changes into something more intimate—a sort of the audience's 'beingness' or identity. It can be argued that watching television in this context could be considered a valued cultural activity. Therefore, terminating the habit when it has reached this level is like *cutting off limbs* (Kubey & Csikszentmihalyi, 2003). When this happens, there are implications in the lives of individual audience members, ranging from the emotional, psychological to physical ones, all of which can be felt by people who share the same socio-cultural spaces with the afflicted audience members. The example below concerning a tragedy resultant of a 'television viewing' related incident attempts to support the above contention.

Recently in Nairobi a young Kenyan girl was reported to have stabbed her step-father to death because he would not allow her to watch a favorite television soap opera. The step-father had insisted on watching a football match in which the national team was playing a key qualifier match for the World Cup/African Nations Cup that afternoon. An argument ensued, at which point the girl fetched a knife from the kitchen and stabbed the step-father repeatedly in the chest as he sat on the couch watching the match (Mukinda & Issa, 2008; Ombati, 2008). This incident points to the fact that watching their favorite television program was very significant for both the girl and her step-father. Although the tragedy could have been triggered by previous antagonism between the two viewers, the fact is that 'soap opera viewing' had become a discernible part of their lives to quarrel over. It also supports that they attached great value to watching these programs at the exact time they needed to, otherwise they would not have fought over the remote control that afternoon. The international match between Kenya and Namibia could have provoked in the step-father a desire to engage in a patriotic (social and empathic) activity, and therefore his need to watch the match on television that afternoon. The girl may have desired to keep track of the undertakings of characters in an on-going soap opera story, and therefore did not want to be left behind in the journey she 'shared' with them. Whichever the case, the experience of watching (for the step-father) and not being able to watch (for the girl) a

favorite entertainment program provoked such strong feelings in the two viewers that attending to their television viewing related needs resulted in the death of one of them.

Interestingly, online newspaper readers who reacted to the above story (see their comments below) focused little on the issue of 'watching television' per se. They saw the incident as an extension of the problems of a culture that is permissive for allowing children to gratify their needs through television. In addition, they pointed to the irresponsibility of parents in allowing their children to make choices for themselves too often in ways that have significant impact on their lives. The readers' comments on the aforementioned story seem to suggest that habits formed in the process of making decisions for themselves result in the delinquency in children, and by default these are reflected in instances such as the television viewing killing incident. While this point of view may seem to resurrect the direct impact of television debate, it is not what is intended here. Instead, it is suggested that the meaningfulness of television viewing has become a grantedly valuable asset in the lives of people who have a habit of engaging in it. Thus, as discussed above, motives for seeking entertainment in soap operas, for example, relate to deeply felt convictions that it is capable of enriching life in meaningful ways. Indeed, the two viewers in the tragedy cited above might have attached such value to watching their favorite program. Viewing must have seemed a necessary activity 'to do' since it was something worth fighting for.

When television entertainment viewing becomes 'something worth fighting for,' it is elevated in the hierarchy of things a society's cultural tradition includes as part and parcel of what constitutes its structure. It is seen as part of society's meaning-making systems or as a cultural institution. This notion is reflected in comments featured in the *Saturday Nation* (on line newspaper) where readers reacted to the story on the television related killing. The comments are presented below without alteration:

1. Submitted by MUTAIELARY
Posted September 08, 2008 01:44 PM

This does not amaze. I am not a prophet, I must reiterate, but this are the signs of the end times. If you have been keen enough to observe how the Nairobi kids are brought up,you should never be troubled by such incidents. From their upbringing Nrb kids can do such acts of atrocities or even worse. We have let the media to be our children's parents. How many hrs does your child spend on the TV? We have shred the family bond so loose that we even fight in front of our kids.

2. Submitted by MichaOlga
Posted September 08, 2008 01:15 PM

Hey, don't blame it all on the girl. Aren't the parents the ones who allowed her to become addicted to these nonesensical soaps? Heh! Halafu, they sent her to a baording school where they have no Idea what kind of people, things or behaviors she's exposed. Parents nowadays are just careless and dump their children in highschool

3. Submitted by Lilyen
Posted September 08, 2008 06:27 AM

This is not an isolated case but one that points to the deep rot our youth are in now. It is a reality check on how our children have developed an I-have-to-get-what-I-want-when-I-want-how-I-want-no-matter-what attitude. It is no different from a group of students burning a dormitory [or the headmistress's house] because they have told there'll be evening preps when some don't want to miss 'cuando seas mia' [a Mexican soap opera]. Seriously a massive social disaster is looming in our country like hoary, amorphous clouds; I think we need to integrate some 'mitigative' psychosocial support activities in our syllabi—something is deeply wrong!

The *Saturday Standard* on line newspaper (September 7th, 2008) also carried the story under the heading 'Girl Kills Father After They Disagree Over TV.' Below is a reader's commentary on the story:

User comments(1)

1. On Monday September 8, 2008, 8:15 AM, Chesley Harvey, Kenya wrote:

Ridiculous what our young have become They ignore parents' advice. There is also lack of good parenting—Think the article on Mums who love to party! Marriages are breaking & ppl take on new partners who have children. Shocking that many Kenyans don't go to church! This reminds me of when I taught at schools in UK where a lot of students in sec schools don't live with their biological fathers. At one sch we were told not to ask students about their dad unless student volunteers such info. Many live with single mums others are in care. Such kids are wild & abusive to teachers! One day a student said: "Why don't you go back to Africa you black bitch!" Our gov needs to ensure society's fabric isn't eroded. Teenage girls & the-morning-after pill is reminiscent of the West. It was suggested that this pill be offered @ UK schs! I used to see teenage girls at FP clinics in the UK, where FP pills are NOT available over th counter! Yourblood pressure is monitored when u're on the pill. The Kibera girl who killed her father might have been acting a Ninja movie scene! She & her step-dad

Overall, the above comments seem to universalise watching television as a socio-culturally integrated activity. They suggest that people's experiences with television are defined 'elsewhere' (socio-cultural arena) before they enter the 'television arena' either as programs that are said to have an impact on the audience or as the activity of viewing per se. Therefore, it appears that when the audience regards entertainment programs as extremely valuable, such programs become transformative. At this level, the distinction between use of entertainment television for gratification of certain individual needs and use of television as prosthesis for facilitating 'good living' considerably blurs. Nevertheless, despite extremes such as those that unraveled in the above incident, motives that bring the audience to the viewing of soap operas are linked to the audience's desire to alter not only their mood but also to change their lives, most preferably in positive ways.

In light of the above, it is worthwhile to note that nearly all of the 15 television drama producers interviewed for the current research mentioned that the youth is the most vulnerable audience group to media content. They believed that as impressionable as the youth are, they could be negatively swayed by the foreign programming aired on commercial stations. For this reason, even *Uhondo*'s producers, who considered the show as 'all entertainment,' indicated that they had the responsibility to embed lessons in its content cautioning the youth about immoral influences. To the producers, the youth as audience needed lessons about sexual behaviour, drug abuse and social responsibility (Field Notes, 2005). Indeed, it appears that Channel 1, KBC's Youth, Education, Women and Children Department had been set up for this reason, and as a matter of government policy (Onyango, 2005). *Reflections*, a soaplike drama targeted at the youth, was a product of this educational initiative. The program's success was an indication that non-conventional entertainment-education (E-E) drama can also be effective in imparting social education to the audience. Below is an explication of the foundation of this claim.

Soap Operas as a Resource for Social Education

In the African context, soap operas have been found to influence cultural attitudes about education, disease, poverty, family planning and prejudice (Oosthuysen, 1997; Pitout, 1996). In South Africa, the oldest local soap opera, called *Egoli* (1992), was considered 'impactful' in this respect. Since the drama attracts a large number of viewers, Pitout (1996) said that it is in "a powerful position in terms of incorporating context-specific events and utilising these to supply the audience with sufficient information. [It's] storyline regarding prejudices against AIDS, for example, heightened awareness amongst the *Egoli* viewers and so helped to conscientise viewers" (as cited in

Oosthuysen, 1997, p. 1). *Soul City* (1994), another South African production, has been strategically employed as an entertainment-educational (E-E) drama to raise consciousness in troubled youths. It provides a forum for exhibiting a televisual engagement with topics often ignored by the conventional soap opera, such as HIV/AIDS, domestic hygiene, nutrition, alcoholism, teenage pregnancy and crime (Singhal & Rogers, 1999).

In East Africa, the role of the soap opera in social education has been applauded. In mid-May 1987, Kenya Broadcasting Corporation (KBC), then known as Voice of Kenya (VOK), utilized Miguel Sabido's social education-al soap opera method to develop the television series *Tushauriane (Let's Discuss It)* (1987) and a radio series entitled *Ushikwapo Shikamana* (*When Assisted, Join In*) (1987). Otherwise stated, the title means that when one is offered support by benevolent 'neighbors' s/he should join them in improv-ing his/her and their overall well-being. Both dramas aimed at 'opening the minds of men' so that they could allow their wives to seek family planning counselling. Greg Adambo, the original producer of *Tushauriane* (1987), attributed the popularity of the program to its realism. Although the program was designed to promote specific types of behaviour change, it appealed to the audience in a wholesome way by representing a familiar, 'local' situation to which the audience could easily relate (Singhal & Roger, 1999). This facet is a primary strength of the entertainment-education soap opera because it invites audience involvement. In this context, "Audience involvement is the degree to which audience members engage in reflection upon, and parasocial interaction with, certain media programs thus resulting in overt behaviour change" (Sood, 2002, p. 156). In reflection, the audience members consid-er the message in the soap opera and integrate it in their own lives (Liebes & Katz, 1986). In referential reflection, the audience relates the soap content to their personal experiences, usually by discussing it with others in the context of their own lives and problems. Hence, audience involvement in soap operas not only influences personal behaviour but also facilitates the audience's understanding of past experiences in a social perspective. When audience members disagree with the depictions in the soap opera content, it shows that they have critically reflected on the content of the drama and found it inac-curate or unfamiliar (Sood, 2002, p. 157).

Indeed, seen as 'out of place,' the educational Kenyan soap opera *Heart and Soul* (2000) was not well received despite its highly acclaimed production values and apparent relevance in featuring topical social issues. Some viewers, claimed the *Daily Nation* media critic John Kariuki, felt it had "serious omis-sions and violations from a cultural point of view which, to a large extent, [made] it irrelevant to an African audience" (BBC News World Edition,

2010). According to Kariuki, one such cultural inaccuracy in *Heart and Soul* appears in a scene where a wealthy landowner who died of AIDS is buried in the middle of a coffee plantation. This scene misappropriates some facts relating to the Kenyan practice of burying the dead "always within the homestead" and covering the grave with a lot of flowers (BBC News World Edition, 2010). Ostensibly, *Heart* did not fit the reality of its target audience. Unlike conventional soap operas, entertainment-education soap operas have to be culturally coherent, and must project clear moral distinctions between the good and bad behaviour. Indeed, unlike conventional soaps operas, E-E dramas always attempt to address any inconsistencies that might arise in the depictions of characters' actions and dialogue (Singhal & Roger, 1999).

When conventional 'soap-like-serials' (dramas that feature the same characters, and delve deeply into topics, which may take several episodes to conclude) are encoded with content that reflects a high degree of social responsibility, the distinction between them and E-E soap operas narrows. *Reflections*, for example, was created for the purpose of addressing the gap between the information the youth needed for their overall development and what they were getting from media and society (Wamuyu, 2005). Unlike E-E soap operas, the program was not theory based, nor did the producer/director, whose personal input was mostly responsible for the success of this programme, engage in intensive research to identify specific lessons that had to be addressed in each episode. Nevertheless, the program did address critical issues that members of a family may face in their relationships inside and outside of the home. For example, it featured the tribulations the youth may face when dealing with puberty with regards to their sexual conduct and overall social subjectivity (Field notes, August 2005). Thus, conventional soaps undoubtedly serve as commentary that possibly helps viewers to "resolve the contradictions in the contemporary [Kenyan] culture . . . between aspirations of modernity [exercise of newly found freedom of expression, thought, assembly, sexuality] and nostalgia for tradition" (Miller, 1992, p. 176).

In relation to the above, audiences of *Uhondo* seemed to view the show for a representation of moral and cultural values, though according to Stan Darius and Stephano Ngunyi, the director and executive producer of *Uhondo* respectively, the show was primarily created for entertainment. Audiences also criticized this drama for lack of authenticity in depicting 'African-ness.' Some viewers felt the soap opera failed in representing 'the Kenyan culture,' for example in characters' behaviour and their dress codes. During one viewing session organised for the research that inspired this chapter, a discussion between audience members about whether the 'right' Kenyan language and dress were featured in *Uhondo* became heated. One member of the audience

asked: "Do you think that the author of the show wants the viewer to think of the people in the play as normal Africans? Have we been brainwashed?" (Field Notes, 2005). Ostensibly, the connotation in this viewer's questions is that *Uhondo* did not represent African-ness. To this viewer, the soap opera denoted a kind of space where the society's undertakings are projected back to itself for evaluation. Hence, *Uhondo* and *Reflections* as televisual social commentary are expected to proclaim what is 'Kenyan values' and African-ness. Nevertheless, these soap operas revealed the existing contradiction in the lives of Kenyans (viewers) who aspire to be 'purely' Kenyan in their cultural attitudes (as expressed through dress, song and dance, language etc.) without ever compromising traditions that are regarded as indigenous or 'un-imperialised.' Yet, these same people live in a modern, constantly evolving world. In this category are the audience members who questioned why characters in *Uhondo* had to mix English and Kiswahili in their dialogue, "why the characters don't wear our clothes," or why the local soap operas are copying everything Western (Viewer Commentary, October 2005).

When a focus group evaluated, analysed or discussed matters about Kenyan soap operas, the issue of what it is to be Kenyan and modern surfaced as an enigma. It was evident that there exists a dilemma regarding how 'natural' 'Kenyan-ness' today looks like. Some audiences said it did not look like what they had seen on *Uhondo* (Field notes, 2005), even though they could not precisely define the 'natural' Kenyan look. Perhaps the roots of this ambivalence in how a Kenyan television audience feels about character portrayals in a local soap opera is symptomatic, suggesting that other aspects of Kenyan life are also tied to its colonial history and its experience with what could be considered 'cultural imperialism' through the media. The mere existence of commercial television in Kenya is a representation of this enigma and the ambivalence that the audience of commercial television in particular might feel about what is truly theirs. To this audience, local content seems Westernized (foreign), and so does commercial television in general. The ownership of the major commercial media houses, the foremost being Nation Media Group (owner of Nation TV, producer of *Uhondo*) has always been foreign, hence begging the question: Just whose agenda are these media representing? (Ochieng, 1992). In this context, the Kenyan conventional soap operas can be viewed as laden with a lot of baggage relating to the foundation of the agencies of their production. This phenomenon is manifested in story content which, in turn, is sending particular signals that the audience perceives. Whatever the case, it appears that soap operas are occupying an ever more meaningful place in the development of Kenyan culture, because they now constitute the narrative tools that are indispensable in the propagation of a Kenyan socio-cultural heritage.

In other words, through soap operas viewers are able to engage at a personal level with the numerous quotidian issues represented in the programs. This engagement empowers the viewers to feel as if they are actively involved in 'dealing with' the said issues. Thus, soap operas are practical narratives rich in utility value. The next section discusses this phenomenon and soap operas' role as generators and disseminators of relevant knowledge.

Soap Operas as Folk and/or Functional Narratives

In the absence of the grand oral narratives of old, which in many African traditional societies contained and archived dominant philosophical teachings about 'how to live,' broadcast media narratives could be seen as important tools for generating knowledge about how life is and should be morally lived (Okigbo, 1998; Bourgault, 1995,1996). For instance, "television melodramas offer distinctive constructions of the world" (Abu-Lughod, 2002, p. 122), some of which are no doubt based on stories that disseminate, circulate moral teachings, norms and values of a society within itself. Today, soap operas seem to be playing this role of defining the grand narratives of the day which people look to for insight on how to be or not to be. For instance, "In keeping with ideologies in post colonial nations, television drama is viewed by most of its producers in Egypt not simply as entertainment but as a means to mold the national community. Viewers, whether ordinary television watchers or critics, recognize to varying degrees the ideologies informing these melodramas and react to them—either sympathetically or with hostility, depending on their own situations and political visions" (Abu-Lughod, 2002, p. 117). Thus, soap opera drama always provided social commentary and the 'passing on' of the moral traditions from the cultural spaces within which it is set, always close to 'home' and 'family' (Kamwiri, 2005).

In Kenya, a country that was previously low-literate (meaning, it was primarily an oral culture), the new orality in television, through television drama "has striking resemblances to the old in its participatory mystique, its fostering of a communal sense, its concentration on the present moment, and even its use of the [orality] formulas" (Ong, 1982, p. 136). It easily appeals to audiences as functional storytelling. In this context, soap operas are symbolic stories capable of reflecting on human actions within specified frames of culture and socio-political networks. Thus, these stories "store, organize, and communicate much of what [people] know . . .," and have become particularly important because they "can bond a great deal of lore in relatively substantial, lengthy forms that are reasonably durable" (Ong, 1982, p. 140–141). Indeed, according to Okigbo (1998), television in Africa is primarily an entertainment

medium with characteristics of traditional forums as the village square, the community market and the age-grade gathering. All of these are community situations that facilitate the common exchange of information and sharing of values.

Conclusion

This chapter has illustrated the multifaceted relationships that exist between the audience and the entertainment element inherently embedded in soap operas. It has suggested that soap operas may have dynamic impact on their audience's emotional 'dispositions' and they are also capable of imparting socio-cultural education to audiences. Indeed, soap operas' socio-cultural relevancy promotes audiences' social interactivity by locating them within their socio-cultural-political networks. Hence, as functional narratives they facilitate the audiences' self-reflexivity by enabling them to negotiate socially ascribed subjectivities. In doing so, soap operas enable the audience to view their world from more personalized perspectives. In the Kenyan context, the viewing of soap operas appears to be a highly valued cultural engagement. Viewers seem to attend to soap operas in order to make sense of the social world they live in. Indeed, it can be argued that soap operas authenticate the audience's world by reflecting that world back to the audience. Ultimately, these narratives are agents of culture that can be used to comment on and assess the 'realities' of life in terms of how they could be lived. For this reason, the soap operas' capacity to generate and propagate relevant cultural knowledge applicable to the improvement of the well-being of the society of viewers should be taken seriously.

References

Abelman, R. & Atkin, D. J. (2002). *The televiewing audience: The art and science of watching TV*. Cresskill, New Jersey: Hampton Press.

Abu-Lughod, L. (2002). Egyptian melodrama—technology of the modern subject? In F. D. Ginsburg, L. Abu-Lughod & B. Larkin. (Eds.), *Media worlds: Anthropology on new terrain* (pp. 115–133). Berkeley and Los Angeles: University of California Press.

Adambo, G. (1987). (Producer) Tushauriane [Television Serial]. Nairobi: Voice of Kenya.

Ang, I. (1985). *Watching Dallas: Soap opera and the melodramatic imagination*. London: Methuen.

Apsattv.com (2010). New law could hurt TV stations. Retrieved from http://www.access-mylibrary.com/coms2/summary_0286–24081182_ITM. Original retrieval from http://www.apsattv.com/history/august2003.html.

BBC News World Edition (2010). UN Aids drama 'not realistic enough.' [2002, August 15]. Retrieved from http://news.bbc.co.uk/2/hi/africa/2195252.stm

Bourgault, L. M. (1996). Television drama in Hausaland: The search for a new aesthetic and a new ethic. *Critical Arts, 10*(1), 61–84.

Bourgault, L. M. (1995). *Mass media in Sub-Saharan Africa.* Bloomington, IN: Indiana University Press.

Cantor, M. & Pingree, S. (1983). *The soap opera.* Berverly Hills, CA: Sage.

Field Notes (2005). Research data for author's PhD study (Ethnography of production practices in Kenyan television entertainment programmes: imagining audiences), in progress.

Geraghty, C. (1991). *Women and soap operas.* Cambridge, U.K: Polity Press.

Gonzales, J (Ed.). (1998). *La cofrodia de las emociones (In)terminables: Miradas sobre telenovelas en Mexico.* Guadalajara: Universidad de Guadalajara.

Hobson, D. (1982). *Crossroads: The drama of a soap opera.* London: Methuen.

Kamwiri, E. (2005). Interview with the author on in February 2005. Nairobi, Kenya [CD recording in possession of author].

Kang'ong'oi, B. (2005, July). Riding the wave of romance. *Saturday Nation,* 12—13.

Kazungu, T. (1987). (Director) Ushikwapo Shikamana [Radio Serial]. Nairobi: Kenya Broadcasting Corporation.

Kubey, R. & Csikszentmihalyi, M. (2003). Television addiction is no mere metaphor. Retrieved from http://www.simpletoremember.com/vitals/TVaddictionIsNoMere Metaphor.pdf

Liebes, T. & Katz, E. (1990). *The export of meaning: Cross-cultural readings of "Dallas."* New York: Oxford University Press.

Liebes, T. & Katz, E. (1986). Patterns of involvement in television fiction: A comparative analysis. *European Journal of Communication, 1*(2), 151–171.

Ligaga, D. (2005). Enacting the quotidian in Kenyan radio drama: 'Not Now' and the narrative of forced marriage. *The Radio Journal—International Studies in Broadcast and Audio Media, 3*(2), 107–119.

Lopez, A. M. (1995). Our welcomed guests: Telenovelas in Latin America. In R. C. Allen (Ed.). *To be continued: soap operas around the world* (pp. 256–275). New York: Routledge.

Maubert, P. (2006). *Television in Kenya: Regulation and programming.* Nairobi: Transafrica Press.

Mazziotti, N. (1993). *El especta'culo de passion: Las telenovelas Latino Americanos.* Buenos Aires, Argentina: Colihue.

Miller, D. (1992). The Young and the Restless in Trinidad: A case of the local and the global in mass consumption. In R. Silverstone & E. Hirsch (Eds.) *Consuming technologies: Media and information in domestic spaces* (pp. 163- 182). London: Routledge.

Mittel, J. (2007). Soap operas and primetime seriality. Retrieved from http://justtv.wordpress.com/2007/07/29/soap-operas-and-primetime-seriality/ 31 August 2009

Mukinda, F. & Issa, H. I . (2008, September 7). Girl kills step-father over Harambee Stars match. Retrieved from http://www.nation.co.ke/News/-/1056/468290/-/tkcdv8/-/index.html

Ngunyi, S. (Executive Producer). (2003). Uhondo [Television Serial]. Nairobi: Nation Media Group, Kenya.

Ochieng, P. (1992). *I accuse the press: An insider's view of the media and politics in Africa.* Nairobi: Initiatives Publishers.

Okigbo, C. (1998). Africa. In A. Smith & R. Paterson (Eds.) *Television: An international history* (pp. 234–246). Oxford: Oxford University Press.

Ombati, C. (2008, September 8). Girl kills father after they disagree over TV. Retrieved from http://africanpress.wordpress.com/2008/09/08/kenya-a-tv-set-causes-death-in-family-dispute-over-a-remote-control/

Ong, W. J. (1982). *Orality and literacy: The technologizing of the word*. London: Routledge.

Onyango, M. (2005). Interview with the author 18 February 2005. Nairobi. [Interview transcript in possession of author].

Oosthusyen, C. (1997). *Intertextuality in the soap opera Egoli: Culture and consumption* (Master's thesis, University of Natal, Durban).

Pitout, M. (1996). *Televisie en resepsiestudie: 'n analise van kykersinterpretasie van die seep-opera Egoli—Plek van Goud* (Television and reception study: an analysis of viewers' interpretations of the soap opera Egoli—place of gold). Pretoria: University of South Africa.

Singhal, A. & Rogers, E. M. (1999). *Entertainment-education: a communication strategy for social change*. Mahwah, N.J. & London: Lawrence Erlbaum Associates.

Sood, S. (2002). Audience involvement and entertainment-education. *Communication Theory, 12*(2), 153–172.

Viewer Commentary (2005). Research data for PhD study (Ethnography of production practices in Kenyan television entertainment programmes: Imagining audiences), in progress.

Wamuyu, C. (2005). Interview with the author 15 February 2005. Nairobi. [Interview transcript in possession of author].

Wonderful Wednesday. (2005, May 25). *Daily Nation*, p. 2.

Section III

Sexuality and Gender as Powerful Forces in Telenovelas and Soap Operas

9. *Fuego en la Sangre Fires Risky Behaviors*

A Critique of a Top-Rated Telenovela and Its Sexual Content

Petra Guerra, Diana I. Rios, & Robert Forbus

Telenovela audiences are well acquainted with the passion and romantic intrigue that are typical of this television genre. Similar in format to United States daytime soap operas, telenovelas are serialized melodramas. However, they differ from U.S. soap operas in that telenovelas are broadcast heavily in the evenings, in the Spanish language, and typically end within one year's time (Lopez, 1995). Telenovelas are an important form of entertainment in Latin American and U.S. Latino popular culture and command large audiences by promising vicarious involvement in a virtual social network of friends, lovers, relatives, and communities. Some telenovelas such as *Fuego en La Sangre* (*Fire in the Blood* or *Burning for Revenge*, 2008), *Sin Tetas No Hay Paraíso* (*Without Tits There Is No Paradise*, 2008), *Amor Real* (*True Love*, 2003), *La Mujer de Lorenzo* (*Lorenzo's Wife*, 2003) feature attractive performers in tangled romantic plots that contain highly sexualized content. More specifically, these telenovelas present characters' high-risk sexual activities, such as unprotected sex, without realistic portrayals of the negative consequences. While high ratings of these programs indicate that sexuality contributes to attracting viewers, the effects of these Spanish-language telenovela stories upon viewers are not yet firmly established. However, research based on television viewer exposure to sexualized content in general market (mainstream) mass media

suggests that media can support false realities in the minds of its consumers including misconceptions of behavioral outcomes (Morgan, Shanahan & Signorelli, 2009).

Similar to other popular media shown in the U.S., soap operas and tele-novelas do not typically address the truth that risky sexual behaviors can result in serious life-long challenges and problems. These problems include teenage pregnancy and poverty, sexually transmitted diseases and infections, and even death (Center for Disease Control Fact Sheet, 2008). Telenovela programming in particular serves social and cultural functions as part of multi-generational female and male family entertainment among U.S. Latinos, while U.S. day-time soap operas have historically catered to women (Mayer, 2003; Rios, 2003; Wilkin et al., 2007). So, in addition to adults, younger people such as teenagers gain exposure to telenovela content messages. These younger view-ers are in a certain life stage where they are forming ideas and opinions about their roles and sexuality in society (Rich, 2008). This essay addresses a con-cern about the impact of highly sexualized telenovela content on viewers who consume these programs as part of their mass media diet.

This chapter examines an internationally distributed and highly viewed telenovela called *Fuego en La Sangre*. This Mexican-made telenovela debuted in Mexico during 2008, was shown in Slovenia during 2008–2009, and aired in the U.S. during 2008–2009 (Univision.com Press Release, 2008). *Fuego* continues to be available in 2011 through selected scenes on YouTube.com and by purchasing the digital video disc (DVD) set through online retailers. Furthermore, with entertainment-education (Singhal et al., 2004) in mind, this chapter will also describe how commercial telenovela producers have integrated pro-social behavior messages into telenovelas while still maintaining audience appeal. Overall, this essay supports the idea that ratings-worthy entertainment and education can co-exist by providing audiences with entertainment, escape, as well as accurate information about sexual health and other important social issues.

In order to better understand television's role as an informal educator, the chapter will begin with a discussion on social learning, cultivation, sexual media content, and sex roles. Second, the essay will present how television can be a pro-social agent through purposive "entertainment-education." Third, a background description of *Fuego* illustrates how *Fuego* appeals to audiences. Last, this chapter offers a critique of *Fuego en la Sangre*.

Television Influences, Sexual Media Content, and Sex Roles

This section will touch on how television influences viewers and can have impact on attitudes and behaviors about sexuality. Two theories that describe the effects of television on its viewers are social learning and cultivation. Sexual content in media can also influence viewer's learning about sex roles.

Television has been argued to impact social learning. Some scholars posit that one way that people learn about their surroundings is through the content of television programs, and that television helps viewers create their own reality (Bandura, 1977, 1986, 1989; Rich, 2008). This kind of reality construction, or social learning through television, can be especially true among individuals who are high media consumers. Learning is done vicariously and the characters they watch are perceived as role models. Also, characters whom viewers see often on television become "friends," especially if viewers are isolated and alone, and viewers tend to identify with television characters that they find intriguing (Rubin, 1985). Furthermore, Bandura describes how individuals learn from observing the behaviors of others and the rewards these other people receive. If an individual sees that a behavior is rewarded, the individual will emulate the rewarded behavior, based on the expectation that the rewarded behavior will continue to garner similar results for them as well.

Many scholars have posited television cultivates consumers' worldviews. According to Morgan, Shanahan, and Signorelli (2009) television continues to be a cultivator of heavy viewers' culture and the development of their values. Even when viewers are considered to be active consumers of media, that is viewers practicing varying kinds of discernment with the media messages they receive, these viewers are not exempt from cultivation. Gerbner and colleagues (1994) explain how cultivation is part of an insidious process whereby media is a powerful social agent in our world, ". . .cultivation means the specific independent (though not isolated) contribution that a particular consistent and compelling symbolic stream makes to the complex process of socialization and enculturation" (p. 249). Young viewers who consume sexualized media images are thus socialized in part through these messages (Shrum, 2009). For adolescents, the characters presented in television programs such as telenovelas may be among the most prevalent role models that television offers.

Sexual media content and influences on sex roles has been a long time concern. Since the Payne Fund Studies of the early 20th century, researchers have investigated the effect of mass communication on young people (Rodman,

2009). Both broadcast and print media have elevated public concern that mass media messages could negatively influence the attitudes, behaviors, and beliefs of adolescents. In the 1970s, research moved from media-channel effects to media-genre investigations, with scholars looking into the impact that television soap operas' sexualized content were having on viewers (Baran, 1976a & b; Greenberg, Abelman & Neuendorf, 1981; Greenberg & Busselle, 1996; Heintz-Knowles, 1996; Haferkamp, 1999).

More recently, Kunkle et al. (2001, 2003) examined sex on television and found that most depictions of sexual intercourse involved older adults, yet younger people are consuming these images and messages. Empirical evidence supports the notion that television can have positive as well as negative effects on young people (Bandura, 1986; Gerbner et al., 1994). Ward and Rivadeneyra (1999) explain that an attribute of having sex on television is that this medium provides convenient information, "TV's accessibility, frankness, and popular appeal make it an excellent instructor, offering a convenient way to learn about sex without embarrassment. While TV's sexual messages are not necessarily visually explicit, they are abundant, and often provide information youth do not get elsewhere" (p. 237). In a more cautious vein regarding the development of gender role and sexual expectations, Brown and Engle (2009) state that, ". . .frequent exposure to consistent themes about gender and sexual behavior can effect a young person's developing sense of what is expected sexually for males and females" (p. 132). Brown and Engle further explain that media contribute to one's construction, or creation of "scripts," "...through observation of relevant and attractive models in both real life and the media, people create and store 'scripts' that guide social behavior" (p. 132). So, mass-mediated messages have influence on gendered, sexual "scripts" and can influence social behavior overall.

Related to the learning and storing of scripts that support sex roles, in research with young people, Eggermont (2005) found that greater exposure to sexualized content on television related to more support for sexual stereotypes and higher assumptions about peer's sexual experiences. This research suggests that sexualized content on television could contribute toward the formation of perceptions about sex and sex roles among young people.

Furthermore, in their study on sex and prime time television, Kim and colleagues (2007) examined the "heterosexual script," as the basis for sexual and romantic encounters. They argue that roles, or heterosexual script " . . . compels girls/women to deny or devalue their own sexual desires, to seek to please boys/men, to 'wish and wait' to be chosen, and to trade their own sexuality as a commodity" (p. 146). They posit,

"not only that the Heterosexual Script is a form of sexual content that saturates television programs targeting teens. . ." but that ". . .adolescents who are engaging in their first relational and sexual experiences may seek such scripts that orient them to how boys/men and girls/women think, feel, and behave in relationships until they develop a body of experience of their own." (p.146)

In other words, Kim et al. describe that sexuality in television programming presents guidelines, however distorted, about what heterosexual or "normal" sexuality should be in relationships. This kind of sexual script is common throughout *Fuego en la Sangre*. The concern here is that television presents a distorted vision of sexuality. Ward and Rivadeneyra (1999) state, "television provides a one dimensional picture of sexual relations, one in which sex is only for the young, single and beautiful, and sexual encounters are spontaneous, romantic and risk free" (p. 237).

Television as a Pro-social Agent

Research suggests that networks can be both profitable and socially responsible (Singhal et al., 2004). The marriage between profit and education, between high ratings and positive social impact has been supported by evaluation research on entertainment-education in different countries. According to Sabido (2004), television ratings do not suffer from the content of an educational entertainment telenovela. He would argue that the "informational bits need not hamper the emotional nature of a telenovela"(p.71). This reinforces the idea that unlike education-only soaps, Education-Entertainment soaps maintain the excitement and drama that make a soap opera interesting and entertaining, thus more attractive to viewers.

Television programs can incorporate messages to be catalysts for pro-social behaviors among young people and other segments of the viewing audience. According to Barker (2007) there are many components to the Sabido approach to planning and constructing a soap opera. The Sabido methodology combines his theory of dramatic "tone" (tension or energy) with additional cross-disciplinary theories from Bentley, Jung, Bandura, and MacLean (described more thoroughly in Sabido, 2004). According to Barker (2007), Sabido's work was successful because he tapped into the cultural myths, archetypes and stereotypes held by the target population. According to Sabido, the theory of tone was developed through his experiments with the use of communication "tones," or theatrical energy flows that are subjectively perceived among audience members. Not only did he carefully consider the

actors' body movements, but the use of voice; changing the voice to promote anger, humility and force. These theoretical approaches, as well as other considerations have been valuable in the creation of soap operas that are both appealing and perform a social good. Below are some examples of entertainment-education telenovelas.

Simplemente Maria (*Simply Maria*, 1967) is an early telenovela that provided inspiration for the production of other programs that would target social problems. This is a Peruvian rags-to-riches tale that presented a positive role model for young maids, domestic workers, who saw constructive ways in which they could improve their lots through adult education (Singhal, Rogers & Brown, 1993). At the request of the Mexican government, Sabido developed several telenovelas for Televisa. Televisa, Mexico's national television network, intended for these telenovelas to deliver pro-social messages to viewers (Poindexter, 2004).

After analyzing *Simplemente Maria*, Sabido utilized telenovelas to promote Mexico's literacy program through a popular 1975 telenovela called *Ven Conmigo* (*Come With Me*) (Barker, 2007). The telenovela utilized humor, conflict, and real life situations. It showed the characters attending an actual literacy center to pick up materials (Bandura, 2004). *Acompañame* (*Accompany Me*, 1977) encouraged family planning and was said to have contributed to a birthrate decline in Mexico (Adaló, 2003). Furthermore, the telenovela called *Vamos Juntos (Let's Go Together)* shown in 1979–1980 promoted the importance of being a good parent and for children to stay in school. This program was sponsored by the United States Department of Education and was hosted by Maria Elena Salinas (co-anchor for Univisión). *Caminemos (Let's Walk)* shown during 1980–1981 advocated sexual responsibility such as using condoms and preventing unplanned pregnancy. Also in 1980 *Nosotras las Mujeres (We Women)*, extolled equal status for women, creating an awareness that women had rights. Sabido's handiwork was demonstrated again in 1997 with *Los Hijos de Nadie (Nobody's Children)*. This telenovela, sponsored by Televisa and the United Nations Children's Fund (UNICEF), aimed to create consciousness about the homeless children living on the streets of Mexico.

As a result of Latin American success, the Sabido Method migrated to other countries. In 1984, the Indian soap opera called *Hum Log* (*People Like Us* or *We People*) advocated family planning, while elevating women's education levels and promoting equal opportunities (Polston, 2005). In 1987 a Kenyan television series named *Tushauriane* (*Come with Me*), and a radio series called *Ushikwapo Shikamana* (*When Assisted Assist Yourself*), encouraged

using contraceptives and family planning (Brown, 2008, 2009; Poindexter, 2004). Also, in 1993 *Twende na Wakati* (*Let's Go with the Times*) was a radio drama that was planned to increase condom use in Tanzania (Rosin, 2006).

Some scholars use a social learning framework for their analysis on the impact of television programs such as telenovelas. La Pastina (2004) analyzed how telenovelas influenced changes toward gender equality in Brazil's rural communities. He observed how telenovelas such as *Rei do Gado* (*Cattle King*, 1996) appeared to influence and change gender roles within families in the location of Macambira.

Wilkin and colleagues (2007) conducted a study to test the impact of entertainment-education (the Sabido model) on Latina women in the U.S. They used *Ladrón de Corazones* (*Heart Thief*, 2003), a Spanish-language telenovela, and added a message targeting pregnant women and cancer.

Other television programs outside the telenovela or soap opera genres, in mainstream U.S. television, have been successful with embedding health messages into their storylines (Kunkel et al., 2001, 2003). Recent examples include, *Grey's Anatomy* on the ABC television network, which include a plot addressing HIV transmission, and other sexually transmitted diseases (STDs) (Kaiser Family Foundation, 2008). On ABC daytime television, the soap opera *All My Children* included a transgender character, with issues of sexuality and mental health as part of a subplot in 2007. Though the long-term success of incorporating pro-social messages during evening or daytime programming has yet to be determined, this is a step in the right direction. Below is a section that presents background information on *Fuego*.

Fuego en la Sangre: Background

This section provides a description of *Fuego*'s storyline, the creative legacy, its unique style and its high audience ratings. This will be followed by a section that critiques the telenovela.

In this story the main protagonists in Fuego include three Reyes brothers named Juan, Oscar, and Franco. These are played by Jorge Salinas, Eduardo Yanez, and Pablo Montero respectively. The trio seeks to avenge the death of their pregnant sister, Libia (portrayed by performing artist "Sherlyn") who dies tragically. Libia's death occurs after she attends the funeral of her much older fiancé Bernardo Elizondo (played by Carlos Bracho). Later, the brothers proceed to the Elizondo homestead with an elaborate plan of romantic deception

that targets the three daughters of the late Elizondo. To their surprise, the brothers fall in love with the young women: Sofia, Ximena, and Sarita (played by Adela Noriega, Elizabeth Alvarez, and Nora Salinas respectively). What the Reyes brothers do not expect are confrontations with Gabriela Elizondo (the famous telenovela star Diana Bracho) the widow and matriarch.

Fuego is part of a creative legacy. It is the Mexican re-creation of the Colombian soap operas called *Las Aguas Mansas* (*Passive Waters*, 1994) directed by Aurelio Valcárcel Carrol, and *Pasión de Gavilanes* (*Passion of Hawks*, 2002). Both of these aired in Latin America and the U.S. The existence of a multi-generation remake such as *Fuego*, may seem to be redundant at first blush, especially since *Pasión de Gavilanes* a Colombian telenovela shown in Mexico in 2002 and the U.S. in 2004, is a close contemporary. However, audiences have seen different versions of telenovela stories before. For example, *Betty La Fea* the Colombian soap opera was later re-created in Mexico and shown in Mexico and the U.S. as *La Fea Mas Bella* (Straubhaar, 2003). *Fuego* incorporates unique aesthetic qualities and showcases a different combination of well-recognized telenovela actors that appeal to the audiences. Well-known telenovela actors are part of a larger Latin American star system that consumers expect to see "reincarnated" in additional programs (Lopez, 1995). As Lopez describes, "In nations that are continuously struggling to sustain cinematic production (and often fail to do so), telenovelas produce indigenous star systems of great cultural (and economic) significance, for the great mass media icons are not movie stars but telenovela stars" (p. 258).

Fuego has a unique style. The era in which the story takes place is not easy to decipher because of intentional anachronisms in men's and women's clothing styles, technological innovations and other usual time markers that are intentionally mixed or diluted by the script writers. *Fuego* is a lavish production, set in the beautiful rural countryside of the state of Puebla in Mexico. Puebla's renowned open spaces, mountains and important historic locations are presented often. This anachronistic aesthetic makes for interesting viewing because unexpected combinations of dress, settings and modes of transportation build constant intrigue. For example, male characters often dress as "charros" (horsemen) complete with elaborate Mexican charro hats. This suiting and crowning, especially of the lead male characters, evoke a colonial ranch or "hacienda" style. This costuming nostalgia makes the characters symbolic of the traditional Mexican man since the charro figure is one representation of Mexico's "manhood/nationhood" (Limon, 1984; Najera-Ramirez, 1994). Periodically, the lead characters will break out of their conservative clothing restrictions to bare their sculpted chests and display

their ample, muscular limbs. The display of the physical body, both male and female, is a notable part of *Fuego's* style since sexualized, partial nudity contrasts with traditional, colonial features of the telenovela.

Women's fashion in *Fuego* offers viewers a large array of anachronistic styles. Some of the women wear very snug, revealing clothes such as low and tight jeans topped by halter blousing. This style is typical of the wardrobe one would find among women in contemporary, sexualized, music videos and popular media that use women's bodies to sell products. For example, the popular young actress Ninel Conde's (who plays Rosario the exotic dancer in *Fuego*) costumes are typically contemporary and sexually provocative. Some of the costumes the female actors wear are "raunchy" (Levy, 2005). For example, raunchy styling includes tight and revealing black leather outfits, low cut blouses that expose much of the breast area, low-waist pants that expose midriff, hips and upper abdomen, and "booty shorts," or short pants that reveal the lower part of the buttocks. Yet, still, characters portrayed as peasant-class women wear traditional "huipiles" (blouses with embroidered Maya textiles) and wear braided hair. Also, the characters who work as domestic staff report to wealthy patronesses wearing clothing evocative of the colonial period.

Not only do the costumes in Fuego vacillate between modern and antiquated, but the technological innovations used by the characters also fluctuate. The contrasts between material objects draw attention to the old and highlight the new. For example transportation ranges from horseback, horse and buggy, to new trucks and sports utility vehicles. Surprisingly, telephone service is either rare or nonexistent on the program. Still, Univisión's website advertising for the telenovela depicts the female character Rosario in sexy, red, revealing clothing with an enlarged cellular phone image in the foreground. The ad carries a statement in Spanish that customers may obtain exclusive content from *Fuego en la Sangre*. A listing beckons, "photos, exclusive images, be in the cellular phone club, see the entire catalog here." Other photos of lead characters have carried noticeable phone-device symbols placed on the outer areas of the photo, linking the characters with the idea of fashionable cellular phone service. No doubt, if an audience member looks further, Verizon is the phone company that is connected to *Fuego* publicity.

The intentional obfuscation of communication technologies, inconsistent modes of transportation, and other incongruous or missing innovations in *Fuego* puts this telenovela in an ambiguous temporal-location of dream-fantasy for the viewer. At the same time, the incongruities create a type of curious style because it directs viewer attention to the newer items (e.g. vehicles, contemporary fashions, music, and cellular phone services) that are obtainable

through purchase. Fans can daydream about the sensual and glamorous aspects of the *Fuego* mini-world and support their connections with the program by consuming *Fuego* featured products.

Music plays an important role stylistically, setting the story's mood and tone, keeping the audience engaged while they watch the program over a period of months. Music also commands social attention and holds important commercial value (Univisión, 2009). The practice of integrating popular music has been common among both telenovelas (Benavides, 2008) and other soap operas around the world (Hobson, 2003). Furthermore, as Benavides points out, the Colombian telenovela that preceded Fuego, *Pasión de Gavilanes*, used Mexican "rancheras" and "Tex-Mex" music to create transnational linkages between Colombia, Mexico, and U.S. Latino consumers. Pasión's music was planned with an eye toward global market appeal. Fuego also uses different types of music, seemingly to engage different markets and generations of viewers. Music includes rancheras, Latino pop, and rock 'n' roll. The theme song called *Para Siempre* is performed by Vicente Fernandez. His music is available for purchase through Verizon's VCAST menu of MP3 songs and cellular phone rings (Verizonwireless.com, 2010).

Further evidence of the importance of music and its socio-cultural as well as commercial value is a concert tour that promoters scheduled for the actors who portrayed the three brothers. These concerts were co-promoted with Verizon, the mobile phone company featured prominently on Univisión's Web pages. According to a commercial Web portal catering to Latino consumers, these concerts were marketing events for Verizon. Several descriptions of the concerts are variations of the following press release, "Soap stars warm cold fans—Nearly 1,500 wait for hours to see Mexican actors—Eduardo Yañez, Pablo Montero and Jorge Salinas from Fuego en la Sangre in Yakima, Washington for a Verizon marketing event" (News Blaze, 2008). The three "Reyes brothers," as they are known, performed together in the concerts along with singer Ninel Conde (who plays the role of Rosario). The concerts were in Yakima, Washington, Los Angeles, California, and Hidalgo, Texas, among other locations where Latino heritage communities are concentrated.

Regarding the audience, *Fuego* commanded a great deal of attention from viewers in the U.S. *Fuego*'s premiere on April 28, 2008 was the highest-rated in Univisión history. This program was shown at prime time from 8:00 to 9:00 PM (Central Time) Monday through Friday. During the first three weeks, according to the Nielsen Media Research list of top-10 Hispanic weekly programs, *Fuego* held the top audience position. Additionally, for the 2008–2009 television season through January 2009, Nielsen showed Univisión in the num-

ber-five position in terms of total viewing audience (Seidman, 2008). According to the Nielsen report (Nielsenwire, 2008), on Tuesday, December 30, 2008, 145,000 viewers tuned-in to watch *Fuego*. For the period of May 30, 2008 through September 28, 2008, the National Television Index (NTI) showed Univisión as the number-three network among viewers ages 18 to 34. Univisión was also rated as the number one network in the country in overall primetime, on Wednesday and Friday nights among all Adults 18 to 34 (1.4 million), regardless of language (Univision.com Press Release, 2008). Even though *Fuego* was such a success with high numbers of viewers and record-breaking reviews, an educational tool for health it was not. Following is a critique.

Fuego en la Sangre: Critique

Fuego is a telenovela that garnered large viewership, high ratings, and advertising revenues. Unfortunately, *Fuego* still sends distorted sexualized content to viewers who can still purchase the condensed version of *Fuego* on DVD and watch lovemaking segments on YouTube.com. This message might be nothing more than an amusing fantasy for some. However, 60 years of empirical research suggests that media effects, for some people, are weak to non-existent and for a few people, media effects can be much more profound (Shrum, 2009). Youth may be among the individuals most susceptible to media effects (Shrum, 2009; Kim et al., 2007; Brown & Engle, 2009), and thus the group who concern researchers most regarding the possible negative effect of *Fuego's* media messages.

Health studies have revealed that teen birth rates are on the rise for the first time in 15 years (National Center for Birth Statistics, 2007). Latinas had the highest teen birthrate of all major racial/ethnic groups in the United States, 83 births per 1000 teenage women ages 15–19 in 2002 (Dickson & McNamara, 2004). It appears that Latinas are less likely to engage in safer-sex practices or that Latinas have less accessibility to birth control than other groups. They also state that Mexican American teens are at a higher risk of pregnancy followed by Puerto Rican teens. The *human immunodeficiency virus*, HIV/AIDS, is also on the rise among Latinos. Latinos represent only 14% of the U.S. population, yet Latinos represent 22% of the newly diagnosed HIV positive population (Kaiser Family Foundation, 2006).

The previous trends are important in relation to *Fuego* and other telenovelas with sexual content, because telenovelas like *Fuego* contain storylines that suggest that sex is part of love and romance yet sex carries no responsi-

bilities. The storyline does not include topics about sexual health, condoms or family planning. Romantic subplots also ignore that HIV-AIDS and other diseases or infections are spread through sexual contact. Unfortunately, sex is portrayed as a tool that both men and women can use or abuse to achieve larger goals. Violence coexists with sex naturally throughout the telenovela story, without clear negative mental or physical consequences. More critique and discussion follow below.

Unplanned pregnancies among the female characters are a common result of any type of sexual involvement whether consensual or forced, due to romance or violence/rape. For example, while married, Gabriela Elizondo, the matriarch, had an affair with Ricardo Uribe, which resulted in a daughter she never wanted. Gabriela's husband, Bernardo Elizondo, impregnated Libia Reyes, who was under the impression that he was a single man and was going to marry her. Bernardo also fathered a daughter with the family's housekeeper, Eva. To impose her power, Gabriela sold Eva's baby to Raquel Uribe, her lover's wife. Raquel of course kept this a secret since the baby was used as an attempt to keep her marriage together. Another unplanned pregnancy resulted when Sofia Elizondo, Gabriela's daughter unexpectedly meets Juan Reyes in the woods and has a romantic sexual encounter with him. Sex and violence are common combinations, as the following examples illustrate. The kindly and beautiful Sophia was forced to marry Fernando whom she does not know was her rapist. In addition to Sofia, Fernando also raped Rosario, the exotic dancer, at a local entertainment venue that he owns. Rosario has a son by her rapist, who steals away the child. Fernando abuses Rosario persistently through sex and threats that she would never see the child. After Sofia divorces Fernando, he marries Gabriela Elizondo, Sofia's mother. Fernando is very violent with Gabriela, and uses sex to manipulate her into making him her heir. Fernando is also involved in an affair with Raquel Uribe, the wife of Gabriela's lover, Ricardo Uribe. Ultimately, sex and violence are used by Fernando to achieve his own twisted versions of romance without realistic emotional or physical consequences. However, sex and violence are not tools of power for only men.

Women also practice sex and violence. Ruth Uribe (played by Susana Zabaleta) uses sex to obtain what she wants. Like her father Ruth uses violent sex to obtain the lands she assumes belongs to her family. Ruth attempts to use both sex and violence with Fernando, and those scenes end up in violent sex. Fernando slaps her around, even restraining her with ties before sexually assaulting her. Even though she thinks she is controlling Fernando with her sexuality, she is the less powerful and she is under his control. The scheming

Ruth also forces herself sexually on Juan, Sofia's boyfriend. These scenes typically turn into violent passion. That is, the men and women appear to enjoy their sexual passion mixed with violent behavior.

Depictions of sexual activity, both with violence and without, are pervasive in *Fuego*. Issues such as aggression and control problems in relationships, safer sex practices, negotiating for safer sex or birth control are absent. As a reminder of *Fuego's* vast popularity, Neilsenwire (2008) noted that on December 30, 2008, more than 5 million viewers saw intimate encounters of heavy petting and kissing. It is of concern that viewers may interpret the problematic romantic relationships portrayed in programs such as *Fuego*, as acceptable behaviors to model (Bandura, 1986). Social learning theory argues that individuals learn vicariously, and that the actions of others are influential, even if they are fictional, mediated characters (Bandura, 1977, 1986).

Returning to the ideas of Bandura (1977, 1986), self-efficacy is the ability to exercise control over one's behaviors. This is a missing element among some of *Fuego's* key female characters. There are many chances to include issues of family planning or the practice of safe sex in the storyline; after all, sex seems to be a main issue in a telenovela such as *Fuego*. A character such as Eva the housekeeper would have been an effective kind of character to create awareness about practicing safe sex and family planning. She helped the daughters when they were in trouble, mothered them, and could have been used as an advocate for sexually responsible behavior. However, the women characters appear to lack the self-efficacy needed to negotiate sexual practices, whether in a romantic relationship, and much less when sex was utilized as a power tool and in the case of rape.

Most recently in 2008, Univisión broadcasted a telenovela called *Las Tontas No Van Al Cielo* (*Dumb Women Don't Go to Heaven*), a production by Rosy Ocampo. This telenovela is an example of how a commercial telenovela can weave pro-social messages among subplots. Below is a comment by a fan:

This novela not only has a wonderful and realistic story of love, it also includes controversial subplots such as plastic surgery, feminism, HIV in teenagers, drug abuse, sexual abuse, homosexuality, abortion, safe sex procedures, obesity, anorexia, bulimia, sterilization, leukemia, alcoholism and mental illnesses. Not only does this novela entertain, it informs and educates and really opens your eyes to the dangers of the real world. Over all, it promotes the dignity of woman and how being female does not mean being dominated by man. It promotes the capacity a woman has to become her own person without letting herself be stepped on by anyone (IMDb, 2008).

In *Las Tontas No Van Al Cielo*, the characters deal with several issues that average viewers could encounter, such as issues of sexuality, HIV, adoption, obesity, anorexia, and older women realizing they had the right to fall in love.

Conclusion

This chapter examined an internationally distributed and highly viewed telenovela. In the U.S., families watch telenovelas, and teenagers are among the younger viewers. Unfortunately, *Fuego en la Sangre*, like many others shown in the U.S. and distributed widely, contains highly sexualized content but does not address the facts that risky sexual behaviors can result in serious physical and mental challenges and problems. These serious social problems include teenage pregnancy, and sexually transmitted diseases and infections. The younger viewers in particular are forming attitudes and values about their sexuality and their gender roles. According to theories of television impact, viewers can learn about sexuality from television. With regard to entertainment-education approaches this chapter described how telenovela producers have integrated pro-social messages into telenovelas while still keeping audience attention.

Beyond the examination of content, the next steps for research would include an empirical audience study with young Latino consumers of telenovelas and their sexual attitudes and behaviors. Since teen birthrates are on the rise among young Latinas, the researchers could measure the presence or absence of socially responsible messages and correlations could be drawn between the consumption of telenovelas and the incidence of unplanned pregnancy. Telenovelas, as we have discussed using *Fuego* as an example, send messages that are confusing and contradictory to viewers overall, and adolescents who consume the telenovela cultural product are exposed to misleading information. This essay explains that programs such as telenovelas can be harnassed to educate and inform audiences. Just as Sabido and others have created popular telenovelas that changed viewers' lives, there is an opportunity for more pro-social media work to continue.

References

Adaló, P. (2003). Love, tears, betrayal and health messages. *Perspectives in Health, 8*(2), 1–9.

Bandura, A. (1977). *Social learning theory*. Englewood Cliffs, NJ: Prentice Hall.

Bandura, A. (1986). *Social foundations of thought and action: A social cognitive*

theory. Englewood Cliffs, NJ: Prentice-Hall.

Bandura, A. (1989). Social cognitive theory. In R. Vasta (Ed.), *Annals of Child Development, 6*, pp. 1–60. Greenwich, CT: JAI Press.

Bandura, A. (2004). The social cognitive theory for personal and social change by enabling media. In Arvind Singhal, Michael J. Cody, Everett M. Rogers, and Miguel Sabido (Eds.) *Entertainment Education and social change: History, research, and practice*. Mahwa, NJ: Lawrence Erlbaum Associates, Publishers.

Baran, S. J. (1976a). How TV and film portrayals affect sexual satisfaction in college students. *Journalism Quarterly, 53*, 468–473.

Baran, S. J. (1976b). Sex on TV and adolescent sexual self-image. *Journal of Broadcasting*, 20(1), 61–68.

Barker, K. (2007). Sex, Soap & Social Change: The Sabido methodology. *AIDSLink*. 104. Retrieved from http://www.populationmedia.org/2007/08/09/sex-soap-social-change-the-sabido-methodology/

Benavides, O.H. (2008). *Drug, thugs and divas: Telenovelas and narco-dramas in Latin America*. Austin, TX: University of Texas Press.

Brown, J.D. and Engle, K.L. (2009). X-Rated: Sexual attitudes and behaviors associated with U.S. early adolescents' exposure to sexually explicit media. *Communication Research, 36*, 129–151.

Brown, L.R. (2008). Eradicating poverty, stabilizing population. *Plan B 3.0: Mobilizing to Save Civilization*. New York, NY: W.W. Norton & Co.

Brown, L.R. (2009). Moving to a stable world population. *Population Media Center*. Retrieved from http://www.populationmedia.org/2009/02/04/moving-to-a-stable-world-population-2/

Center for Disease Control. (2008). HIV among youth. CDC HIV/Aids Fact Sheet. Retrieved from http://www.cdc.gov/hiv/resources/Factsheets/PDF/youth.pdf

Dickson M. C. and McNamara, M. (2004). Latina teen pregnancy: Problems and prevention. Retrieved from http://www.prcdc.org/files/Latina_Teen_Pregnancy.pdf

Eggermont, S. (2005). *Conference Papers—International Communication Association*, 2005 Annual Meeting, New York, NY, 1–32.

Gerbner, G., Gross, L. Morgan, M., and Signorielli, N. (1994). Growing up with television: The cultivation perspective. In Jennings Bryant and Dolf Zillman (Eds.) *Media Effects: Advances in theory and research* (17–41). Hilsdale, NJ: Lawrence Erlbaum Associates.

Greenberg, B.S., Abelman, R. and Neuendorf, K. (1981). Sex on the soap operas: afternoon delight, *Journal of Communication, 31*, 83–89.

Greenberg, B.S. & Busselle, R.W. (1996) Soap operas and sexual activity: a decade later. *Journal of Communication, 46*, 153–160.

Haferkamp, C. J. (1999). Beliefs about relationships in relation to television viewing, soap opera viewing, and self-monitoring. *Current Psychology, 18*(2), 193–205.

Heintz-Knowles, K. E. (1996). *Sexual activity in daytime soap operas: A content analysis of five weeks of television programming*. Menlo, CA: The Henry J. Kaiser Family Foundation.

Hobson, D. (2003). *Soap opera*. Cambridge, UK: Polity Press.

IMDb (2008). An entertaining look at how love makes people do stupid things. Retrieved from http://www.imdb.com/title/tt1149586/

Kaiser Family Foundation (2006). Latinos and HIV/AIDS. HIV/AIDS policy fact sheet. Retrieved from http://www.kff.org/hivaids/upload/6007–03.pdf

Kaiser Family Foundation (2008). Television as a health educator: A case study of Grey's Anatomy. *Retrieved from* http://www.kff.org/entmedia/7803.cfm

Kim, J.L., Sorsoli, C.L., Collins, K., Zylbergold, B.A., Schooler, D., and Tolman, D.L. (2007). From sex to sexuality: Exposing the heterosexual script on primetime network television. *Journal of Sex Research*, 44(2), 145–157.

Kunkel, D., Cope-Farrar, K., Biely, E., Farinola, W. J., Donnerstein, E. (2001) *Sex on TV 2*. Menlo, CA: The Henry J. Kaiser Family Foundation.

Kunkel, D., Cope-Farrar, K., Biely, E., Farinola, W. J., Donnerstein, E. (2003) *Sex on TV 3*. Menlo, CA: The Henry J. Kaiser Family Foundation.

La Pastina, A. (2004). Telenovela reception in rural Brazil: Gendered readings and sexual mores. *Critical Studies in Media Communication*, 21(2), 162–181.

Levy, A. (2005). *Female chauvinist pig: Women and the rise of raunchy culture*. New York: Free Press.

Limon, J. E. (1984). La Llorona, the third of greater Mexico: Cultural symbols, Women and the political unconscious. *Renato Rosaldo Lecture Series 2*.

Lopez, A. (1995). Our welcomed guests: Telenovelas in Latin America. In Robert C. Allen (Ed.) *To be continued: Soap operas around the world* (256–275). NY: Routledge.

Mayer, V. (2003). Living telenovelas/televelizing life: Mexican American girls' identities and transnational telenovelas. *Journal of Communication*, 53(3), p. 479–95

Morgan, M., Shanahan, J., and Signorelli, N. (2009). Growing up with television: The cultivation effect. In Jennings Bryant and Mary Beth Oliver (Ed.) *Media effects: Advances in theory and research*. NY: Routledge.

Najera-Ramirez, O. (1994). Engendering nationalism: Identity, discourse, and the Mexican charros. *Anthropological Quarterly*, 67(1), 1–14.

National Center for Birth Statistics (2007). Teen birth rate rises for first time in 15 years. Retrieved from http://www.cdc.gov/nchs/pressroom/07newsreleases/teenbirth.htm

News Blaze (2008). Fans of Fuego en La Sangre compete for private concert tickets. Retrieved from http://newsblaze.com/story/2008120410430300003.pnw/top-story.html

Nielsenwire (2008). Primetime Broadcast Ratings, December 30, 2008. Retrieved from http://blog.nielsen.com/nielsenwire/media_entertainment/primetime-broadcast-ratings-december-30–2008/

Poindexter, D.O. (2004). A history of entertainment education, 1958–2000. In Arvind Singhal, Michael J. Cody, Everett M. Rogers, and Miguel Sabido (Eds.) *Entertainment Education and social change: History, research, and practice*. Mahwa, NJ: Lawrence Erlbaum Associates, Publishers.

Polston, P. (2005). Lowering the boom: Population activist Bill Ryerson is saving the world—one 'soap' at a time. Retrieved from http://www.populationmedia.org/2005/08/21/lowering-the-boom-population-activist-bill-ryerson-is-saving-the-world-one-soap-at-a-time/

Rich, M. (2008). Virtual sexual reality: The influence of entertainment media on sexual attitudes and behavior. In Brown, J. (Ed.) *Managing the media monster: The influence of media (from television to text messages) on teen sexual behavior and attitudes.* Washington, D.C.: National Campaign to Prevent Teen and Unplanned Pregnancy.

Rios, D. I. (2003). U.S. Latino audiences of telenovelas. *Journal of Latinos in Education, 2*(1), pages 59–65.

Rodman, G. (2009) *Mass Media in a Changing World: History, Industry, Controversy,* 2nd ed., New York, NY: McGraw Hill.

Rosin, H. (2006). Life Lessons: Annals of broadcasting. *The New Yorker, 82*(16), 40–45.

Rubin, A.M. (1985). Uses of daytime television soap operas by college students. *Journal of Broadcasting & Electronic Media, 29*(3), 281–258.

Sabido, M. (2004). The origins of entertainment-education. In Arvind Singhal, Michael Cody, Everett M. Rogers, and Miguel Sabido (Eds) *Entertainment-education and social change,* 61–74. Mahwah, NJ: Lawrence Erlbaum.

Seidman, R. (2008). Tuesday Nielsen ratings: House and Fringe dominate age demos for Fox. Retrieved from http://tvbythenumbers.com/2008/11/12/tuesday-nielsen-ratings-house-and-fringe-dominate-age-demos-for-fox/7996

Shrum, L.J. (2009). Media consumption and perceptions of social reality: Effects and underlying process. In Jennings Bryant and Mary Beth Oliver (Eds.) *Media effects: Advances in theory and research.* NY: Routledge.

Singhal, A., Rogers, E.M., and Brown, W. J. (1993). Harnessing the potential of entertainment-education telenovelas. *Gazene, 51,* 1–18. The Netherlands: Kluwer Academic Publishers.

Singhal, A., Cody, M.J., Rogers, E.M., and Sabido, M. (2004). *Entertainment-education and social change: History, research, and practice.* Mahwah, NJ: Lawrence Erlbaum Associates.

Straubhaar, J. (2003). Choosing national television: Cultural capital, language, and cultural proximity in Brazil. In Michael G. Elasmar (Ed.) *The impact of international television: A paradigm shift.* Mahwah, NJ: Lawrence Erlbaum Associates.

Univisión (2009). Investor Relations Web site. Retrieved from http://files.shareholder.com/downloads/UVN/522889448x0x249684/172a18f3-e83f-4b3a-be0b-82d3f20c3fc5/249684.pdf

Univision.com Press Release (2008). Univision outdelivers ABC, NBC, CBS, or FOX nearly every night during May sweep. Retrieved from http://u.univision.com/contentroot/uol/10portada/sp/pdf/prospect/NOMETA_20080521.pdf.

Verizonwireless.com (2010). Verizon Media Store. Retrieved from http://medias-

tore.verizonwireless.com/onlineContentStore/index.html#searchTerm=Para%20S iempre&selectedMedia=ALLMEDIA.

Ward, L.M. & Rivadeneyra, R. (1999). Contributions of entertainment television to adolescents' sexual attitudes and expectations: The role of viewing amount versus viewer involvement. *The Journal of Sex Research, 36,*(3), 237–249.

Wilkin, H.A., Valente, T., Murphy, S., Cody, M.J., Huang, G., and Beck, V. (2007). Does entertainment-education work with Latinos in the United States? Identification and the effects of telenovela breast cancer storyline. *Journal of Health Communication, 12*(5), 455–469.

10. Gender, Drugs, and the Global Telenovela

Pimping Sin Tetas No Hay Paraíso

Héctor Fernández L'Hoeste

Released in fall of 2006 and based on the novel by journalist Gustavo Bolívar Moreno, the Colombian soap opera *Sin Tetas No Hay Paraíso* (*Without Tits There Is No Paradise*) narrates the story of working-class teenagers moonlighting as prostitutes for rising drug kingpins. The series chronicles the story of Catalina, a schoolgirl from Pereira, a city in the heart of the country's entrepreneurial coffee region, who views breast implants as her ticket out of poverty. Along the way, she becomes a *prepago* (a prepaid woman, like phone cards), fully convinced that a powerful lover will bankroll her wishes. Like other Colombian hit soap operas (e.g., *Betty la Fea*, which spawned a United States version) *Sin Tetas* was marketed heavily around the world. It was broadcast all over Latin America and reached places as far as Bulgaria (Nova Television), Greece (Alpha Television), and Spain (Telecinco), where a local version was produced. Currently, the National Broadcasting Company (NBC) is developing a U.S. version. Telemundo, NBC's Spanish-language network, broadcast a new Colombian adaptation, titled *Sin Senos No Hay Paraíso* (*Without Breasts There Is No Paradise*), in an effort to appeal to a wider audience and comply with Federal Communications Commission (FCC) regulations, which prohibit the usage of the word "tits." A Colombian production company called Radio Televisión Interamericana (RTI) developed this new "modest" version for Caracol Television, the creator of the original series; like its forerunner, it was picked by a number of networks in Eastern Europe (Serbia, Macedonia),

contributing to the popularity of Colombia's television industry. *Sin Tetas* exemplifies the global telenovela, bent on crossing borders and expanding notions of Latin American identity. At first glance, it poses a harsh critique of gender, disapproving society's endorsement of extensive cosmetic surgery and its corresponding implications for female individuality. At times, though, it validates this construction of gender, rather than indicting it. Overall, *Sin Tetas* occasionally contributes to the popularity of breast implants as tools of social ascent. In Argentina, for instance, nurtured by the soap opera's popularity, nightclub establishments started raffling breast augmentations (Gabino, 2008). Therefore, my contention is that, within the context of their dramatic structures and the grasps of global circuits, soap operas may embody unpredictable vehicles for critiques of gender. Rather than focusing exclusively on the depiction of cultural milieus, they may perform better by advancing more effective assessments of the origins of disconcerting trends. In this sense, *Sin Tetas* represents a pertinent case study.

Fascism, Aesthetics, and Seguridad Democrática: On the Cultural Implications of a Political Model

German critic Walter Benjamin advances a critique of the impact of the cultural industry on the perception and assessment of the aesthetic experience (Benjamin, 1969, pp. 217–251). While Benjamin generally argued that mass entertainment was generating a new type of public, able to deal critically with content (in contrast to other cultural critics of this period, like Horkheimer and Adorno, who repeatedly reviled mass culture, Benjamin's criticism on this topic was more benevolent) the overall arc of his writings points at the risks resulting from the rise of Fascism and the assimilation of ever greater social and cultural territory by the machinery of capitalism. In this sense, Benjamin identifies a link between right-wing ideology and the dynamics of an economic system bent on the glorification of individualism and private property. In their most extreme forms, Benjamin seems to suggest, Fascism and capitalism will not only meet, but will also coalesce into a greater body politic with potentially perilous implications. After all, Benjamin asserts, Fascism will try to organize the masses without affecting the property structure. Fascism's salvation, he assures us at the end of the essay, lies in giving the masses a chance to express themselves. Within this framework, the logical consequence to the rise of Fascism is the introduction of aesthetics, never mind how distorted, into political life. Thus, for the German critic, the violation of the masses has its counterpart in the violation of an apparatus that is pressed into the production of ritual values.

Benjamin's argument is thoroughly determined by his times. After all, he was keenly conscious of the implications of the rise of the Third Reich and died tragically while trying to flee Europe. To Benjamin, Fascism was far from being an abstraction; it was an explicit, palpable reality, an order with the potential to conceive and enact cultural imperatives, such as a typology of perfection, both physical and theoretical. In his writings Benjamin's (1969) concern is, most patently, the possibility of the co-optation of the political and cultural moment by right-wing imperatives, so compatible with an intensive application of capitalist directives. In plain terms, Fascism's introduction of an aesthetic norm provided the opportunity for the popularization of an idea of perfection, embodied, in the case of the Nazis, in a particular set of physical features and traits. Within a Latin American context, the acceleration of capitalism at the end of the twentieth century, resulting from the extensive application of neoliberal imperatives, with the corresponding exacerbation of cultural differences, social inequality, and superficial macroeconomic booms, provides circumstances propitious for the application of Benjamin's theories. In the realm of gender, in particular, the late 1990s and early 2000s have witnessed a dramatic increase in the degree of social acceptance of cosmetic medical procedures, enforcing and popularizing a specific view of the human body, especially in the case of women.

Additional insight into how a particular norm of the human physique comes into play might prove handy. In her essay on the work by Riefenstahl, U.S. critic Susan Sontag examines and describes the aesthetics of the German filmmaker's work (Sontag, 1982, pp. 305–325). Sontag dissects the ways in which Riefenstahl represents the human body, clearly motivated by the grasp of bodily "perfection." Sontag's essay is divided into two parts. In the first, dedicated to a brief review and discussion of Riefenstahl's career, Sontag addresses the German director's concern for form. In the second, she explores the relationship between Fascism and sex. For Sontag, a great deal of the attraction of a Fascist aesthetics comes from its meditation on power. At times, it is about vertigo, as in the earlier films of Riefenstahl's career. At others, it involves self-control and submission, as in the Nazi films. However, for this concern over form to be effective, according to Sontag, it must combine the notions of power and sex. In the article, a central theme is criticism of a new book by Riefenstahl, *The Last of The Nuba*, a photography volume on a tribe of fighters from the Sudan, which Sontag argues represents a continuation of Riefenstahl's work for Hitler. According to the writer, "Although the Nuba are black, not Aryan, Riefenstahl's portrait of them evokes some of the larger themes of Nazi ideology: the contrast between the clean and the impure, the incorruptible and the defiled, the physical and the mental, the joyful and

the critical" (Sontag, 1982, p. 314). In short, as contained in this book, Riefenstahl's fascination with the Noble Savage preserves many of the cues from her work in propaganda, specifically, contempt for anything reflective, critical, and pluralistic. In this sense, textual analysis provides Sontag an opportunity to bring forth an expanded definition of the aesthetics of Fascism.

Fascist aesthetics include but go far beyond the rather special celebration of the primitive to be found in *The Last of the Nuba*. More generally, they flow from (and justify) a preoccupation with situations of control, submissive behavior, extravagant effort, and the endurance of pain; they endorse two seemingly opposite states, egomania and servitude. The relations of domination and enslavement take the form of a characteristic pageantry. The Fascist dramaturgy centers on the orgiastic transactions between mighty forces and their puppets, uniformly garbed and shown in ever swelling numbers. Its choreography alternates between ceaseless motion and a congealed, static, "virile" posing. Fascist art glorifies surrender, it exalts mindlessness, and glamorizes death (Sontag, 1982, p. 316).

At one point, Sontag clarifies that, when it comes to taste for the monumental and mass obeisance, there are points in common to both Fascism and Communism. However, while Communism tends to reinforce morality, Sontag clarifies, Fascism emphasizes aesthetics, in special, physical perfection, whether it be in the human body or in surrounding structures (Sontag, 1982, p. 317). From this viewpoint, nothing stands as thoroughly Fascist as the imposition of the theoretical norm of the "beautiful," since it implies an ideal eroticism: sexuality as the superlative channel for tension between leaders and their followers, between masters and their slaves. This is a view materialized at the collective level in Riefenstahl's work; individually, it is evident in works like Liliani Cavani's *The Night Porter*. As Sontag explains, "The expression of the crowds in *Triumph of the Will* is one of ecstasy; the leader makes the crowd come" (Sontag, 1982, p. 323), hinting at a dual reading of the term, both in an ambulatory and sexual way. Thus, the cult for the "beautiful," charged with eroticism—in the case of Nazism, through a penchant for well-polished surfaces, stylish, well-cut uniforms, stunningly angular profiles, and taut, firm bodies—entails a key example of the aesthetics of Fascism. For Sontag, this explains the relation between Fascism and sexuality (sadomasochism). Given Nazism's heavy ritualization and aestheticization of the relations of domination and enslavement, it is only logical then that many of the visual cues of Nazi culture percolated into the sadomasochism (S&M) scene.

All things considered, Sontag takes the implications of the introduction of aesthetics into politics one step farther than Benjamin. While the German critic is busy rationalizing the change witnessed in European culture, in fact,

issuing a warning on the potentially calamitous consequences of this shift, Sontag, aided by history, effectively explains the mechanics of the cultural phenomenon. In her critique, the object of manipulation, the concept of what stands as "beautiful," is not discussed at length; i.e., Sontag is more interested in the dynamics of manipulation than in the actual vehicle of the process. In this way, she highlights the malleability, according to politics, of an object of desire. "Beauty" becomes a construct that may be associated with a variety of objects—for example, the graceful divers at the end of *Olympia* or the hardened physique of Nuba warriors—and each one is designated with a particular intent in a fixed context. Ultimately, the notion of "beauty" is merely a very effective device for political manipulation. What truly interests the critic is how aesthetics can be used as a political tool, how it is implemented in a way compatible with political interests. In this sense, the evolution of the political scene in Colombia may provide a suitable example for the clarification of Sontag's ideas. While the impact of political violence in Colombia can be assessed in many ways, recent developments have triggered societal reactions supportive of notions that, in aesthetics terms, may be employed as political devices. The rise of right-wing nationalism, personified by the current administration, is just one of them.

When it comes to *Sin Tetas*, it is important to note that its hypothetical critique of a social trend (the increased popularity of breast implants) while endorsing a particular construct of identity, might seem detached from political circumstances. Nevertheless, one should consider the implications of successful cultural production in an environment as politically charged as Colombia, where the drug trade has affected the very fabric of everyday culture and, most visibly, the evolution of national policies. To a great extent, the aspect that determined the bloodiest clash between the Colombian government and the drug cartels was the possibility of extradition. In their recurrent messages to the overall population under the moniker of "Los Extraditables," drug kingpins like Pablo Escobar and José Gonzalo Rodríguez Gacha habitually declared they'd rather have a tomb in Colombia than a life behind bars in the U.S. As a result, Colombia's police and armed forces received heavy investment from the local government and the U.S., increasing the military's already high degree of relevance and profile within national society. Years of bloodshed ensued. The rise of current president Álvaro Uribe Vélez (2002–2006, 2006–2010), who embraces a government model rooted in a hardened security policy—the so-called *seguridad democrática* (democratic safety)—is, for the most part, a consequence of the evincing of the weaknesses of the Colombian state during its prolonged struggle with the drug cartels, and later, with subversive groups and paramilitary organizations. In other words, in a country

where the drug trade has given way to the evolution of politics in an autocratic fashion—in a manner diametrically opposed to shifts in surrounding areas of the region, making Mr. Uribe an ideological anomaly—it is not realistic to disassociate a particular cultural practice, with its corresponding endorsement of a certain norm for the human body, from the political culture of the nation. Within the region, Colombia stands out as the place where political matters have experienced a sharp shift to the right. Thus, it is only logical that we probe into the influences of this political realignment on the actual construction of identity suggested by *Sin Tetas*. Taking in consideration our previous examination of Benjamin and Sontag's arguments, which evinces the link between Fascism and aesthetics, some cultural implications of Mr. Uribe's political model become evident: in the end, a policy based on a construction of citizenship that emphasizes security, rather than democracy, engenders a citizenry more prone to obedience in exchange for protection, along the lines of a relation structured on domination and subservience (Rojas, 2009, pp. 227–245). Within this context, 'obedience' takes many shapes, underlining certain norms for the human body, bent on social regulation (the growing masculinization of society) and economic imperatives (an overall increase of the private sphere). In Colombia, the popularity of breast implants is, undoubtedly, linked closely to the increased circulation of capital within segments of society that were previously indiscernible to the state. Quite literally, the government did not see them, as it overlooked social inequality. Violence and rampant wealth brought these segments to the public eye. And with them, came a certain construct of female anatomy—that of a full-bosomed, thin-waisted shape—habitually celebrated by media and society. In the case of drug cartels, beauty queens and models, so ubiquitous in Colombian society and so connected to this body type, became strongly associated with the rise of a new social order—in fact, emerging from the margins. Many models and *reinas de belleza* (beauty queens) surfaced from the lower middle class, exuding appeal though lacking economic resources. This new-fangled construct of female identity gained such popularity that, eventually, it was even embraced by upper middle-class sectors (Rutter-Jensen, 2005). In this way, the body becomes a brand new, "perfect" figure that is easily attainable thanks to recently gained financial capability. It also becomes a means to reassert political presence in an acceptable manner, duly sanctioned by the male gaze of the administration that is so bent on obedience and servitude. In a nutshell, cosmetic surgery is a symptom, a cultural practice intimately associated with the evolution of society responding to the negligent and unyielding ways of the state. In this sense, the soap opera, as an outstanding chronicler of popular narratives, reproduces cultural codes and collective memories; along the way, it benefits from any misuse.

Sin Tetas, Sin Senos: Two Approaches to Colombian Reality

A brief look at the official abstract for *Sin Tetas* at the Web site of Caracol Television, the Colombian network owned by Julio Mario Santo Domingo hints at the telenovela's claim that it is based on good intentions. While the abstract alludes to the new adaptation produced for Telemundo, which follows a more conventional format (the original series comprised twenty-three hour-long episodes) and was broadcast by Caracol in the late-night slot, the narrative replicates faithfully the argument for the original series' critical intent and also appears along many products (books, videos, etc.) associated with the earlier version. According to the company's Web site, the series intends "to bring general attention to the unsupervised proliferation of breasts implants and the proven case of 'prepaid girls,' where [*sic*] lack of education, ignorance and the need to procure money bring about a fall into a context in which the body becomes the only option to attain goals" (translated from *La novela basada*, 2009).

As disingenuous as it may sound, the narrative touts the official line of the Colombian television network. With its hyper-sexualized content and its array of starlets surrounded by kingpins and tough guys, the series does not fare well as a critique at the objectification of young women. To succeed at the disapproving representation involves aesthetics that portray characters in a negative light, a characteristic that, for the most part, is ambiguous in both versions of the telenovela. Moreover, a good deal of the appeal of *Sin Tetas* as a successful articulation of image comes from the fashionable portrayal by its actors, who dramatize the conflicts between the girls from the working-class districts and the narco-traffickers in a cheery, almost sanitized manner. While the characters evince greed and evil in many of their decisions, they usually do so in a stylish manner. Overall, the morbid yearning to watch a group of starlets playing the role of prostitutes is the main rationale behind lucrative ratings for the series. In this sense, *Sin Tetas* plays to the notion that, to faithfully recreate the conditions of the "prepaid girls," it must rely on good looks and superficiality, thus embracing the cues of a culture based on glitz and glamour. This degree of flamboyance has been tamed a bit in the new adaptation, with its more generic aesthetics, although the bodies of women continue to figure as the ultimate attraction in the storyline. In comparison to *Sin Tetas*, the revamped telenovela *Sin Senos* has a more polished look. It is more in line with the editing pace and cinematography that average spectators have come to expect from mainstream telenovelas. Also, a slower rhythm of narrative devel-

opment and a thoroughly protracted storyline contributes to greater financial profit, which makes its critical aspirations even harder to sustain. In contrast to *Sin Tetas*, which embraced exteriors repeatedly, emphasizing the grittiness of city life and, at times, mimicking a quasi-ethnographic feel, *Sin Senos* conveniently relies on studios and makeup to depict a more sanitized, cleansed version of events.

Sin Tetas's most blatant claim to sincerity comes, indisputably, from each episode's introductory segment, which Caracol manufactured carefully, so its alleged good intentions would be clear from the start. The beginning scenes show a pair of men in what could be construed as the typical exchange of drugs for money, with one of the men stating, "Aquí está el dinero. ¿Dónde está lo mío?" (Here's the money. Where's my stuff?). A large white bar code is superimposed on the wall behind the men, emphasizing the commercial nature of the transaction. Immediately, a series of images flash before the audience, showing dismembered dolls and pieces of plastic body parts. When the man who has received a pair of metallic suitcases comes to a table and opens one of them, surprisingly, what we see are not drugs, but a kit to build a Barbie-like doll. The bearded man, wearing gaudy sunglasses associated with up-and-coming kingpins, smiles malignantly. The camera then shifts to the barred windows of the room, through which a streak of light comes in, and the bar code appears once again on the wall. The images then show the man gathering (and caressing) the body parts from the kit and beginning to assemble the body of a doll. Suddenly, the bar code appears on the side of the suitcase, viewed from the top, clarifying that the product of the deal has not been a load of drugs, as expected, but the joyous possibility of manufacturing a custom-made female doll.

Once the man is finished, the camera focuses on the doll's face, which comes alive, and a teardrop falls from her sobbing eyes. In the back of the room, the messy interior of an old, abandoned warehouse, a number of regular doll heads pile up in disarray. When the man again smiles, he chooses the pieces for his dolls. Prominent among them, we recognize the set of bulges that stands for a pair of breasts, which are carefully lined up inside the foam of the second suitcase; in fact, that is all it contains: the molded pieces of plastic that stand as breasts. The images then show not one, but three living female dolls by a pool, playing with a beach ball, sun-tanning, and smiling candidly, followed by an assortment of flashy vehicles, from a tricked-up (custom enhanced) motorbike to the customary sports utility vehicle. The doll the man is assembling, a good-looking brunette, appears at the wheel of a vehicle. When the camera turns, we notice a white wire coming across her neck, her waist, her legs, and, once again, a teardrop surfaces; we thus realize that the man is

reaching the final point of the process and packaging his doll.

The images then show an assembly line, rolling a number of packaged female dolls; a hand carefully applies a sticker with the name of the doll—Vanesa (in the case of the main doll, with Spanish spelling), Jessica, etc.—on the corner of a box. To our amazement, through a series of narrowly edited zooming shots paced to the sound of closing doors, we then see the bearded man walking past a string of aisles inside a store, all packed with Barbie-like dolls, culminating the chain of events with a bluntly commercial air. The marketable implications for the creation of a bosomy female identity could not be more explicit. Caracol manages to save face by distancing itself from the literal endorsement of a Barbie-like enactment of female identity by feigning irony.

During the entire duration of the opening sequence, the soundtrack plays a song called "El Agujero" (The Hole), a fashionable mix of accordion notes, electric guitar riffs, and electronic loops, composed by José Ricardo Torres. The song's lyrics are performed by a duo, in which a female voice starts "Agujero/ Quiero salir de este agujero/ Quiero tomarme el mundo entero/ Y conquistarlo de verdad, de verdad" (Hole/ I want to leave this hole/ and take over the world/ and really, really conquer it) and a male voice answers "Mi dinero/ Quiero tener mucho dinero/ Para gastarlo en lo que quiero/ Y si me sobra, pues gastar mucho más" (My money/ I want to have lots of money/ To spend it as I wish/ And if some is left, to spend even more). At the end of this exchange, the voices join and sing at unison, "La verdad/ Yo sé que quieres que te diga la verdad/ Pues la verdad/ Yo sólo quisiera que te fijaras un poco más/ En mí/ Agujero" (The truth/ I know you want me to tell you the truth/ Well the truth [is]/ I'd only like you to look closer/ At me/ Hole). Thus, while the images evolve in a way in which the commodified nature of female identity becomes explicit, the soundtrack appeals to the public in terms of an exchange between a man and a woman, in which money and looks play a meaningful part of the story. The mention of a "hole" underscores the tragic quality of the exchange, through which characters are evidently trying to improve their situation and hinting at their travails, related to love, sexuality, and money. Under this reading, the "hole" acquires emotional (emptiness), bodily (genitalia), and financial (insolvency) connotations, duly validated by a clear-cut construct of beauty, closely linked to the image of "prepaid girls."

Altogether, the sound and images of the opening sequence make a hip statement, with an evident emphasis on high production values—a techno-infused soundtrack, proper of nightclubs; flashy, dazzling textures, evocative of kitsch and the glamorous world of fashion—about the commercial exploita-

tion of women thanks to the trade of breast implants. As an exculpatory measure, however, the whole sequence appears limited; after all, the eye-catching appeal of the introductory segment is an additional reason for the narrative's success, as it provides a story from the start, unlike other telenovelas, which simply use the opening sequence to flaunt their repertoire of stars. Nevertheless, the forethought of this allegedly exculpatory statement is watered down in the new version, more compatible with the conventional format of a telenovela (given the structure of its episodes).

In *Sin Senos*, the opening sequence focuses on a woman's naked body. Through the entire sequence of images, and in open allusion to the global nature of the drug trade—and self-reference to the telenovela's distribution—portions of maps appear on the woman's skin, tracing the places—Colombia, Mexico, the U.S.—that drugs, and the telenovela, will engage in its commercial journey. The whole sequence, which borders on the risqué, has landed the series in late-night slots in the U.S. and throughout the world. Even the soundtrack has been altered. While the formula of an exchange between male and female voices has been preserved, the music now lacks an accordion. This lack hints at a wider, less nationally centered audience and sounds like a mainstream Latin pop theme. The lyrics, on the other hand, state, "Yo sólo quiero ponérmelas bien buenas para así salir de este lugar/ Yo sólo quiero que usted me dé un poco de dinero y volverme una actriz de verdad/ Sin ellas no hay paraíso" (I just want to make them really great to get out of this place/ I just want you to give me some money and become a real actress/ Without them, there's no paradise). The degree of anxiety has been lessened, as there is no mention of a "hole." It is substituted by a generic "place." Also, the singer's demand to become a "real actress," is a narrative twist of the new version that breaks away from Bolívar Moreno's novel in which the young women were prostitutes. This sends the story in a new direction. In comparison, the original telenovela was a close adaptation of Moreno's novel. Moreover, the whole idea of opening a soap opera with a camera detailing every angle of a naked female body is, to say the least, a dramatic concession to the coveter's gaze. Thus, in *Sin Senos* the exploitation of the female physique is quite deliberate and the assertion of a certain type of aesthetic standard, that is, the body of a thin, white woman, is very affirmative.

In *Sin Tetas*, in contrast, in addition to the opening sequence, it appears Caracol's only other concession are summarized in a brief segment at the end of the story that was prepared for the exported version of the series. In the exported version Catalina Santana (played by María Adelaida Puerta) and Byron (played by Andrés Toro), Catalina's brother, appeal to the public with

the following message as they walk together:

> One may think that just by being pretty, or by holding a gun, you can reach paradise. That money makes you somebody, a kiss is a coin, and a checkbook is a hug. That to study is a waste of time. As if being a prostitute and becoming someone else's merchandise, or living from killing others, were better than finding an honest job. The truth is, to be somebody in life, you don't have to be rich. To be somebody is to be, everyday more, owner of your own fate; to read, to write, to subtract, and to add, to study so we may understand; to be able to fly. To be proud of ourselves, of the struggles and triumphs we have endured without damaging others. The truth is, to be somebody in life, you need to love someone, to love yourself, and to be loved. It's not about eliciting envy because you have money. No, really, to be somebody is to be able to walk with your head up high; to be able to hang around without having to hide anything; to live without nightmares; to sleep soundly. The truth is one can come to believe that just by being pretty, or by holding a gun, you can reach paradise. But money isn't paradise. And there are no shortcuts to paradise. (Translated from *Mensaje Final,* 2009)

Though the segment demands greater responsibility from the audience, through a rejection of violence and materialism, it is a rather tardy response to the charges of manipulation against Caracol, and even Bolívar Moreno. And to advise prudence at the end of the show, when the audience has consumed and enjoyed hours of imagery glorifying superficiality, seems nonsensical. In addition, it is certainly not included in the video set distributed in the Colombian market. Thus, it appears more as a concession to foreign sensibilities. At the very least, it appears to be an afterthought, once Colombians had consumed the original version.

A Matter of Reception:
Responses throughout Latin America

The reaction to *Sin Tetas* throughout the Americas is a better proof of the risks of toying around with gender constructs than any theoretical imputations. By late 2008, it had been broadcast by many Latin American networks and the impact of its careless approach to gender matters was beginning to come to light. In Argentina, the Latin American country with the highest rate of breast implant surgeries and the fifth one worldwide, the consequences were soon evident (Gabino, 2008). The response to *Sin Tetas* was compounded by a dramatic increase in the rate of breast implants and augmentations. According to the Argentine Society of Plastic, Aesthetic, and Cosmetic Surgery (SACPER), in 1998, there were 25 surgeries per day. By 2008, the number

had surged, with booming figures of up to 100 surgeries per day (SACPER, 2009; Román, 2009). The trend was not only evident in Argentina. At a broader scale, in many corners of Latin America, a growing trend was revealing troubling patterns of societal abuse: among the upper middle-class, it was now relatively common for teenagers to receive breast implants as a token from their parents. In fact, the way I became aware of these troubling dynamics was rather circumstantial. In the early 2000s, during a visit to a Colombian relative, I met the daughter of a childhood friend, who dropped in to say hi, as she was now attending college at a local university. When the girl left, my relative observed the girl would soon return to our provincial hometown, as her parents were giving her breast implants as a gift. Initially, I was appalled, since I had little knowledge of procedures of this kind at such an early age. In addition, I found the implications of unnecessary medical interventions to be rather problematic. My relative dispelled my doubts, informing me that, though she disagreed with such procedures, they were becoming increasingly common and were now beginning to trickle down to impoverished sectors of society, where they were perceived as a suitable measure for the attainment of social mobility.

It is relatively easy to find Latin American media coverage validating the resilience of this dynamics, in many cases, linking it closely to the Colombian soap opera. In Chile, for instance, an online article dated September 7, 2008 from the Web site of nationally-owned daily *La Nación* links the trend directly to *Sin Tetas No Hay Paraíso*, seizing its title, even at a time prior to the release of the television adaptation in the Chilean market, when only Bolívar Moreno's novel was known to locals and sat at the top of the list of bestselling titles in the national publishing industry (Rojas, 2008). The allusion to the novel rather than the soap opera makes sense, since the Colombian telenovela's arrival to Chile was rather tardy in comparison to other Latin American markets. Admittedly, its broadcasting started a day after the article was published (Reyes, n.d.). In any case, the article quotes two women, Andrea and Marisa, explaining the importance of breast implants as a tool for economic success and social mobility. In Andrea's case, the procedure signifies improved wages and eventual access to education. As a measure of proof, the article quotes the owner of the establishment where Andrea works, who suggests "a girl with breast implants earns more than one without them; her tips increase 80% (up to fifty thousand pesos per day, or $90)." The owner even explains how his business has secured financing for the operations of its employees, who come from working-class communities of the Chilean capital, like San Ramón, Quilicura, and Peñalolén.

Ironically, Andrea's experience represents the presumably "positive" side

of things. In turn, Marisa is a 40-year-old escort who got her breast implants in Buenos Aires for two thousand dollars and charges seventy thousand pesos per hour (about $130) for her services. Facing an infection, she immediately realizes she will have to undergo surgery and get rid of the implants; Marisa claims the lack of breast implants will cut her fee in half. The article also includes the comments of a doctor on the escalating size of implants, in an effort to show how the popularity of breast augmentations cuts across classes and occupations. Finally, it mentions the case of a popular Argentine model in Chile, Pamela Sosa, who has just increased the size of her implants from 350 cubic centimeters to 500 cubic centimeters, thanks to the advice of her boyfriend, a plastic surgeon. By then, it becomes pretty obvious that, in terms of the construction of female identity, the implications of media criticism of breast implants are rather mixed, regardless of social and national context. All in all, breast augmentation is a practice that cuts across classes and nationalities, bringing about multiple scenarios.

Nevertheless, the magnitude of the response to the soap opera in Argentina stands in a league of its own, perhaps because of the greater economic well-being of its population when compared to other Latin American latitudes. In Buenos Aires, in the exclusive sector of Olivos, where the presidential residence is located, a discoteque called Sunset celebrated a contest called "Quiero mis lolas" (I want my jugs) in October 2008. In order to attract a female audience, which brought along spendthrift male patronage, clubs habitually offered shows with strippers or lotteries with cars or travel packages as prize. Having run out of gimmicks, the clubs were now resorting to more extreme alternatives: they would raffle breast implant surgeries to the tune of $4 to $10 tickets. According to Fernando Maldonado, Sunset's public relations representative, the popularity of the Colombian soap opera contributed to the contest's success, "Creo que nos ayudo mucho la novela colombiana *Sin Tetas No Hay Paraíso*" (I think the Colombian soap helped us a lot) (Gabino, 2008). Around the same time, clubs and rave production companies in major cities in the interior of the country developed similar events with fashionable names like "Bailando por mis gomas" (Dancing for my jugs) or "Sin gomas no hay paraíso" (Without jugs there's no paradise). These included Amnesia in San Juan, Acqua in La Rioja (held at La Rioja Golf Club), and Montecristo in Córdoba, Recórcholis in Tucumán. In La Rioja press coverage even boasted of the generosity of a local winner, a twenty-two-year-old called Martín Palacios, who generously gave the prize to his girlfriend, a twenty-year-old called Romina Castillo. Press coverage included comments by bystanders like Abi Sidders (18) or Ana Belén Modarelli (23), who claimed, respectively, "I'm

dying to have some good jugs" and "with new jugs I'd feel more secure, my husband would be really pleased" (Irigaray, 2008). In San Juan, a local company even organized a rave at a nearby hacienda, La Cabaña, with the same title as in Buenos Aires, "Quiero mis lolas," opening a Web site and loading advertising on YouTube (Quiero mis lolas, 2009). In Córdoba, Casa Babylon celebrated an event called "El poder de las tetas" (The power of tits), including shows by Lía Crucet, a well endowed popular cumbia singer; Actitud María Marta, a trendy hip-hop ensemble; and Princesa, a favorite of the Argentine reggaetón crowd, thus shielding the celebration with musical genres well-suited for the exploitation of the female image. In Santa Fe, the representative of the local version of the event assured the press that, prior to any surgery, the winner would have to be examined by doctors. However, she would have the freedom to choose a surgeon and clinic from among the five most prestigious ones in the city (Causa revuelo, 2008). Generally speaking, most events followed a similar pattern, with organizers trying to reassure the press and local critics that the celebrations were organized in good faith, hoping to provide a "fun" choice for the public.

Almost immediately, Argentina's National Institute Against Discrimination, Xenophobia, and Racism (INADI) declared that, though it celebrated the right of individuals to do as they pleased with their bodies, it was pretty clear these sorts of events had a negative impact on women's social image. In fact, by the end of the year, largely motivated by the popularity of these kinds of events and the growing number of television series following *Sin Tetas*'s thematic approach, the INADI announced the preparation of a report on the treatment of the image of women in Argentine television. The Colombian soap opera is the first title in the long list of television programs mentioned by the INADI as targets of this project, which includes Argentine staples like Jorge Rial's *Intrusos* (Intruders), the local equivalent of *Entertainment Tonight* or *Inside Edition*, and the telenovela *Casi Ángeles* (Almost Angels) (La discriminación, 2009).

Within a week, the capital province's government declared the lotteries illegal. A number of rationales stood behind this prompt reaction. Officially, the statement by Buenos Aires Health Minister Claudio Zin highlighted the inherent risks of this type of medical procedures. In addition, the authorities were battling the possibility that, as a cost-cutting move, many clubs would endorse surgical procedures with unqualified personnel. Felisa Senderovsky, the head of the Association of Psychologists of Buenos Aires drew attention to the misreading of these surgeries as self-esteem-boosting measures. Senderovsky was not a voice to be taken lightly in a country like Argentina, where psy-

chological treatment is viewed as a right of the middle-class. By the time of the announcement, though, Maldonado claimed over two thousand tickets were sold for the coming raffle during the following weekend. The public relations representative even argued against the measure, declaring it was not correct to prohibit the celebration of an event in which people won a prize in a democratic fashion. Nonetheless, while Buenos Aires tried to end the string of raves with lotteries, governments in the interior of the country displayed a more relaxed attitude. In La Rioja, a political candidate even announced he would finance his campaign raffling a breast implant operation. In Córdoba, however, local government emulated Buenos Aires after a woman died, following surgery at a clinic lacking proper facilities (Quiero mis lolas, 2008; Polémica por sorteos, 2008). Claudio Zin's expectations, it turns out, were well founded.

On the whole, the uproar generated by the raffling of breast implants demonstrates the degree of popularity of practices based on the image of women popularized by sensationalist media. The fact that many linked *Sin Tetas*, a soap opera allegedly produced to criticize the manipulation of women within drug-related circles, to the celebration of these events is a strong indication of the degree of independence of the message in the process of consumption of an audiovisual text. As a matter of fact, when the soap opera was released in Mexico via cable, official releases proudly stated its support by the United Nations Educational, Scientific, and Cultural Organization (UNESCO) (*Sin Tetas*, 2007). Regardless of the truth of this statement, it seems misleading to argue that a soap opera, a cultural product based on the very idea of the physical appeal of its dramatic repertoire, will contribute to the critical evaluation of a troubling societal trend, particularly when the foundations of the charisma of its actors undermine the narrative's alleged premise. In this sense, beyond any potential indictment of a hidden agenda of the Colombian production team, this kind of response emphasizes the relevance of reception within the communication process. Cultural products may be oriented at a certain premise from their point of inception, but, amid individualized decodification of particular messages and private negotiation of meanings, audiences tend to develop their own set of conclusions. Thus, whether this set of conclusions agrees with the hypothetical object of the product is a matter of personal interpretation. What happened with *Sin Tetas* in Argentina brings to light the distance between potential readings and a cultural product's alleged critical intent, not discounting any latent cynicism.

Conclusion

In her study of Riefenstahl's work, Sontag points out commonalities between Left-wing and Right-wing ideologies. In the context of the telenovela text discussed in this chapter, despite the connection delineated between gender constructs and certain ideological leanings, my object has not been to argue that endorsement of chauvinist views is an exclusive privilege of a particular segment of the political spectrum. Rather, what I find intriguing is the role played by a certain contemplation of the human body within the elaboration of narratives of gender, with conclusively alarming implications. As new, authoritative forms of political visibility gain traction throughout the subcontinent, regardless of ideological orientation, they seek to assert themselves with forms of identity closely identified with the aesthetics of the cultural moment. Thus, Benjamin's warning with respect to the political appropriation of aesthetics and Sontag's analysis of the dynamics of this process gain increasing relevance. The fact that the telenovela turns out to be the ideal vehicle for this kind of manipulation makes it even more fascinating. When it comes to benefiting from ideological manipulation, political platforms routinely stand on equal footing. Thus, it comes as no surprise that, in early 2007, a councilwoman from the town of Mariño on the island of Margarita, Venezuela, proposed a program called "Sin Tetas No Hay Paraíso" to supposedly cover the costs of breast implants for underprivileged youth from the state of Nueva Esparta (Jatar Alonso, 2007). The measure, which was immediately ridiculed as an excess of the Socialist project in Venezuela, shows the degree to which constructs of gender may be internalized and employed as a tool of communicative abuse, even by elected officials. In Latin America, sexism or machismo has never been an exclusively male project. To a fair extent, machismo, with its corresponding constructs of passive ingénues and Barbie-like sexpots, is the result of a lengthy process of internalization of these paradigms by different segments of the entire population. It is only foreseeable that some of this population happens to be female, i.e., women embracing and sharing a thoroughly male construct of their identity. Thus, that the telenovela, a cultural product that targets an eminently female audience, relies heavily on the codes and constructs of these modes of gender does not come as a surprise. If there is a paradise, it is more complex than human anatomy.

References

Benjamin, W. (1969). The work of art in the age of mechanical reproduction. In *Illuminations* (pp. 217–251). New York: Schocken Books.

Causa revuelo un sorteo de lolas que organiza un boliche (2008). Retrieved from http://www.unosantafe.com.ar/21.10.2008/noticias/8044_Causa+revuelo+un+sorteo+de+lolas+que+organiza+un+boliche.html

Gabino, R. (2008). *En Buenos Aires los senos no se rifan.* Retrieved from http://news.bbc.co.uk/hi/spanish/misc/newsid_7664000/7664797.stm

Irigaray, J. I. (2008). *Bailar por unas 'lolas.'* Retrieved Aug. 29, 2009, from http://www.elmundo.es/elmundo/2008/09/30/cronicasdesdelatinoamerica/1222800868.html

Jatar Alonso, B. (2007). *Sin tetas no hay paraíso socialista.* Retrieved from http://www.partidounnuevotiempo.org/cms/index.php?option=com_content&task=view&id=102&Itemid=38

La discriminación de género en la television. (2008) Retrieved from http://www.inadi.gov.ar/inadiweb/index.php?option=com_content&view=article&id=818:la-discriminacion-de-genero-en-la-television-&catid=5:gacetillas&Itemid=130

La novela basada en Sin Tetas No Hay Paraíso. (2009). Retrieved from http://www.caracoltv.com/lanovelabasadaensintetas

Mensaje final (Sin Tetas No Hay Paraíso). (2009). Retrieved from http://www.youtube.com/watch?v=67R-SWvnVjM

Polémica por sorteos de implantes mamarios en discotecas en la Argentina. (2008) Retrieved from http://www.latercera.cl/contenido/24_64487_9.shtml

Quiero mis lolas. (2009) Retrieved from http://www.youtube.com/watch?v=XE3HCqy2aCM

Quiero mis lolas sin sorteo de cirugía. (2008) Retrieved from http://www.noticiasnoa.com.ar/index.php?option=com_content&task=view&id=6472&Itemid=109

Reyes, S. (n.d.). *María Adelaida Puerta, protagonista de Sin Tetas No Hay Paraíso: No me parece que 'teta' sea una palabra para censurar.* Retrieved Aug. 29, 2009, from: http://www.terra.cl/entretencion/index.cfm?id_cat=114&id_reg=1028979

Rojas, C. (2008) *Las razones del boom de la silicona en Chile. Sin tetas no hay paraíso.* Retrieved Aug. 29, 2009, from http://www.lanacion.cl/prontus_noticias_v2/site/artic/20080906/pags/20080906183914.html

Rojas, C. (2009). Securing the state and developing social insecurities: The securitisation of citizenship in contemporary Colombia. *Third World Quarterly, 30*(1), 227–245.

Román, V. (2009). *Furor por las "lolas": Ya se hacen en el país 100 implantes por día.* Retrieved from: http://www.clarin.com/diario/2009/03/08/um/m-01873057.htm

Rutter-Jensen, C. (2005). *Pasarela paralela: Escenarios de la estética y el poder en los reinados de belleza.* Bogotá: Editorial Pontificia Universidad Javeriana.

SACPER. (2009). Retrieved from the SACPER Web site: http://www.cirplastica.org.ar/

Sin Tetas No Hay Paraíso, telenovela de la vida real. (2007). Retrieved from
http://www.oem.com.mx/elmexicano/notas/n420122.htm

Sontag, S. (1982). Fascinating fascism. In *A Susan Sontag Reader* (pp. 305–325). New York:
Farrar, Strauss and Giroux.

11. *The Third Subplot*

Soap Operas and Sexual Health Content for African American and Latino Communities

Catherine K. Medina

Much research has discussed the roles of popular culture in society. Indeed, mediated messages, information or visual imagery constitute powerful social, cultural and political forces in communities (Kunkel et al., 2003; Holtzman, 2000; Weimann, 2000). Explicit, repetitive sexual content in daytime and primetime dramas are an important consideration when examining influences on the public about sexual attitudes and behaviors. Soap operas are a melodramatic serial genre that convey powerful messages about sexuality, though these programs seek primarily not to inform but to entertain their consumers. Although sex is a prominent topic in popular media (serials, music videos, advertising), popular media industries do not typically cover sexual risks and sexual responsibility in order to promote sexual health. The lack of media content to promote sexual health and responsible sexual behavior offers an opportunity for the Center for Disease Control and Prevention (CDC) and the television networks to become involved in Human Immunodeficiency Virus (HIV) prevention.

This chapter focuses on an Entertainment-Education approach that encourages African American and Latino Communities to become engaged in HIV/AIDS prevention behaviors. Disproportionate cases of HIV/AIDS among these racial/ethnic groups highlight the continuing need for the public and private sectors to develop alternate preventive strategies. Miguel Sabido, a television producer, and known for the Sabido methodology in entertain-

ment-education, pioneered telenovelas that are serialized melodramatic entertainment with social content. Telenovelas are a format analogous to the United States' soap opera, but have a finite number of episodes in which a central story is told until its conclusion (Kennedy et al., 2004). Sabido best describes entertainment-education as entertainment with a proven social benefit (Barker & Sabido, 2005, p.14). Entertainment-education is the process of purposely designing and implementing a media message to both entertain and educate, in order to increase audience members' knowledge about an educational issue, create favorable attitudes, shift social norms and change overt behavior (Barker & Sabido, 2005; Nairman, 1993; Singhal & Rogers, 2002). In many Latin American countries, telenovelas have been successfully used to inform the public about HIV/AIDS, and to construct cultural alternatives to mainstream social norms in the sexual arena (Barker & Sabido, 2005). Mainly, the first two subplots of the telenovelas are designed to entertain and capture the audience attention through the use of emotionally-charged storylines that portray everyday realities. The third subplot of the storyline contains the social content and educational message. For example, the HIV prevention media strategy can focus on sexual talk (talking about present or past sexual activity) and/or sexual behavior (sexual intimacy, intimate touching and kissing) with health promotion messages woven into familiar, emotion-laden contemporary melodrama such as a love triangle (two men in love with the same woman).

This chapter also argues that similar to Latin American telenovelas, U.S. soap operas and other serialized television programs with dramatic content be used as a public communication tool for social change, and be designed to communicate HIV risk reduction themes. The popularity of soap operas as a suitable vehicle for information on HIV, diabetes, teen pregnancy, contraception and other health and social-related problems has transcended globally in Africa, India, and the United Kingdom (Singhal et al., 2004; Vaughan & Rogers, 2000). In the U.S., the potential of entertainment-education has not been actualized, because no nationally broadcast soap opera has fully employed this approach to promote health messages (Kennedy, O'Leary & Beck, 2004).

By interweaving HIV messages into a variety of popular daytime and prime time serials, media can have cross-cutting impacts that fundamentally improve public awareness and dialogue. Popular media can play a role in promoting sexual health by communicating pro-social norms and behaviors in storylines to prevent HIV transmission. Soap opera melodramas, as an entertainment-education vehicle, can portray an alternative way for men, women, and communities of color to communicate about sexual health and

HIV/AIDS by focusing on speaking openly, acting with respect, and getting involved in the challenge of sustained HIV/AIDS prevention. Soap opera storylines can facilitate sexual talk and sexual behavior dialogue in African American and Latino communities that are disproportionately affected by the HIV/AIDS pandemic.

HIV/AIDS in African American and Latino Communities

In the U.S., the national plan to deal with the human immunodeficiency virus (HIV) and acquired immunodeficiency syndrome (AIDS) pandemic, has primarily focused on individual behaviors—condom use, HIV testing and sexual abstinence. Often, responsibility for HIV prevention has been promoted as an individual concern about personal care and protection, rather than a collective responsibility for public health (Weinberg, 2006). The collective ideal of community responsibility (people caring about and wanting to protect each other) is just beginning to be implemented as a strategy in health promotion efforts within African American and Latino communities through the use of popular media—mainly radio, magazines and newspapers (CDC, 2009a). Yet, there has been little attention on a national strategy to sustain preventive behaviors over time to create a norm of sexual health without stigma, especially in African American and Latino communities where there is disproportionate incidence of HIV/AIDS (CDC, 2009a). Popular media, as a socializing agent, is ideal for conveying positive sexual health messages to large audiences.

A recent Kaiser report (2009) indicates that both African Americans and Latinos are concerned about HIV/AIDS and the ways in which the virus may affect them. However, these two groups currently express less personal concern about the transmission of HIV than they did in the mid 1990s. The CDC (2009a) fears that there is a growing complacency about the epidemic as a result of the medical advances of highly active antiretroviral therapy (HAART). Many HIV-positive individuals are living longer and healthier after their diagnosis. However, since the beginning of the HIV/AIDS epidemic African American and Latino communities have disproportionately been affected, resulting in disparities that have deepened over time. For example, African Americans account for more new HIV infections, AIDS cases, and people estimated to be living with HIV, as well as HIV related deaths, than any other racial/ethnic group (CDC HIV/AIDS Surveillance Report, 2009b). Although African Americans represent 12% of the U.S. population, in 2006 they account-

ed for 45% of new HIV infections (CDC, 2008), and 49% of new AIDS diagnoses in 2007 (Kaiser Family Foundation, 2009c). Similarly, Latinos in the U.S. are heavily impacted by the HIV/AIDS pandemic. According to this same report, Latinos account for higher rates of new HIV infections (17%), new AIDS diagnosis (19%), people estimated to be living with HIV disease (18%), and an estimated AIDS prevalence increase (26%) in comparison to their White counterparts (Kaiser Family Foundation, 2009d). Although African American and Latina women make up 24% of the population in the U.S., they constitute 82% of American women with AIDS (Wiener, 2009). This is an important statistic, since heterosexual transmission of the virus (women having sex with an infected partner without protection) accounts for the greatest exposure category (80%) affecting African American and Latina women (CDC, 2007). While women of color are at risk of HIV infection, they are also strong viewers of daytime soap operas (Kennedy et al., 2004). Therefore, soap operas have great potential to influence women of color in terms of HIV prevention and treatment (Wilson & Beck, 2002).

Media, Sexual Content and HIV/AIDS

Many media scholars agree that media help shape the ways in which society understands the world (Hagen & Wasko, 2000; Livingstone, 1998). Mass media, through content and interpretation, provide parasocial interactions and vicarious experiences through which the viewers can collectively shape meanings about people, norms and life (Weimann, 2000). Mediated messages, particularly from television, inform and help socialize people into society (Sreberny & Van Zoonen, 2000). Some communication theorists argue that popular media uphold current societal values and views by seemingly presenting endless portrayals of reality (Holtzman, 2000; Weimann, 2000). The research literature indicates that the public can vicariously learn healthy and/or unhealthy social behavior through mass media (Aubrey et al., 2003; Bandura, 1977; Vaughan et al., 2000; Wilson, et al., 2002; Jensen & Jensen, 2007). Mass media also have a history of presenting unequal gender roles as well as modeling unsafe sexual practices throughout a person's life cycle—from youth to elder (Shanahan, 1999). This has been a long-standing problem, particularly with the advertising and entertainment media, which are available to millions of audiences on a daily basis (Carstarphen & Zavoina, 1999; Medina & Rios, 2009 submitted for publication; Cortese, 1999). Entertainment media, such as soap operas, have often been criticized for showcasing stereotypical women who wait to be rescued by men from low economic status and romantic predicaments (Galician, 2004). Television programs that feature strong self-

directed women who are not punished or undermined during the narrative are few and far between.

In entertainment television, particularly in soap operas and prime time television shows, the representation of unsafe sexual behaviors are all too common. In the era of HIV/AIDS and other sexually transmitted diseases, one rarely sees television characters behaving responsibly either in the moments before, during or after sexual intimacy. Gurman and Orkis (2006) found that sexual content in African American situation comedies did little to offer information about risky behavior and responsibility. Additionally, longitudinal research has shown that adolescents with high exposure to televised sexual content, in comparison to peers with low exposure, were twice as likely to initiate sexual relations in the upcoming year (Collins et al., 2004). This study suggests that frequent exposure to sexual content in media creates a norm that promotes or accelerates the initiation of intercourse (Jensen & Jensen, 2007). Collins et al.'s study noted that African American adolescents with high exposure to sexual content were less likely to initiate intimate sexual relations if the programs contained sexual risk and personal responsibility messages (2004, p.285–286). This finding suggests that, if audiences are offered a mainstream alternative that combines risk and responsibility, there is less probability of adolescents' initiating sexual relations (Jensen & Jensen, 2007).

Popular media have the unique power to meet the challenge of delivering messages and strategies within cultural contexts that connect the public to information about risk reduction behaviors (Kaiser Family Foundation, 2009b). The Pew Hispanic Center (2008) indicates that an estimated 80% of African Americans and Latinos receive the majority of their health-related information from an alternative source such as television and radio, rather than from a medical provider. Of women who are regular soap opera viewers, 53% of all women, 56% of Latinas, and 69% of African American women stated that they had learned something about disease and prevention from watching soap operas (Beck, Pollard, & Greenberg, 2000). Although soap operas have always included different health problems as a major theme, they have not always addressed sexual health as a social concern. In fact, when topics of safer sex, sexually transmitted diseases (STIs), and consequences of unprotected sex are addressed, they are often underplayed or reduced to individual problems with simple solutions, rather than as a social problem (Larry & Grabe, 2005). When Cope-Farrar & Kunkel (2002) analyzed the sexual content of several popular prime-time sitcoms, they found that 82% of the sample programs contained sexual talk (talking about sexual activity) and/or sexual behavior (sexual intimacy). Within this sample, messages about risks and responsibility occurred 11% of the time when characters engaged in sexual talk and only 3% of the time when characters were involved in sexual behaviors. If media are

going to entertain and educate the public about sexual health, television programs must contain an accurate and honest portrayal of sexuality. To positively influence audiences' attitudes and beliefs concerning sexual health, popular media need to integrate sexual talk, sexual behavior, risks and responsibility in its programs' content.

However, a common criticism is that too often producers of entertainment-education focus on messages without a systematic examination and analysis of their audience, and/or the cultural and societal forces that drive social interactions, concerns or problems (Barker & Sabido, 2005). The research referenced in this chapter thus far suggests a soap opera format that requires both qualitative and quantitative formative research to determine what interests, attributes and needs impact a community or population. For example, formative research defines the populations at greatest risk for HIV to understand what patterns of risk behaviors to address in the mass media for HIV risk reduction. In addition, formative research feeds into the planning stage of health promotion campaigns to ensure that the culturally appropriate educational messages are delivered during the entertainment.

The following is an excellent example of using formative research in a television series to inform the public about HIV risks and prevention. In 2001, *The Bold and the Beautiful (B&B)*, a long-running, televised daytime soap opera, introduced a subplot about HIV after collaborating with CDC scientists. An estimated 4,496,000 households viewed the episode where one of the lead characters, an appealing Latino man, gets tested for HIV and learns that he is HIV-positive. He informs his doctor that he has consistently used condoms with recent heterosexual partners. However, he discloses his positive serostatus to his sexual partners and encourages them to be tested. He also discloses to the woman he is going to marry. The subplot is filled with much melodrama about courage, trust, speaking openly and caring for others. In the soap opera, he faces many challenges, but overcomes obstacles to live a full and satisfying life, while disseminating powerful HIV messages. During two episodes, the National STD and AIDS hotline toll-free numbers were displayed. On both days, the number of attempted calls rose dramatically in the one-hour time slot, and the volume far exceeded the Hotline's surge capacity (for further details see Kennedy et al., 2004).

A more recent example and in response to sexual health and the HIV/AIDS crisis in communities of color, The Black American AIDS Media Partnership (BAMP), in collaboration with United States Center for Disease Control and Prevention (CDC) and the Kaiser Family Foundation (KFF), have recently taken a leadership role by announcing a new media health campaign—*Greater than AIDS* (KFF, 2009a). This multi-faceted initiative includes

targeted public service ads (PSAs) and integrated messages in news, entertainment and community content (mainly radio, magazines and newspapers). The central topic of the campaign is an "internal dialogue" within the African American community. The dominant theme of the media messages is to inspire hope and promote the possibility of change in the AIDS epidemic facing African Americans through the united actions of individuals, families and communities (KFF). At an individual level, the campaign will strive to help people recognize their own risk and take action. According to CDC (2009), at a community level the campaign works to build partnership among agencies, community groups and media to create and sustain norms that are supportive of successful HIV prevention. At a national level, the campaign seeks to remind all Americans of the continued toll of HIV in our nation and the need for collaborative action through leadership initiatives provided by businesses, media industries, government, unions, National Association for the Advancement of Colored People (NAACP) and the National Medical Association (www.cdc.gov/nchhstp/newsroom/docs/A). The campaign will be evaluated and refined over time based on its ability to motivate action, change knowledge and awareness, and ultimately change HIV prevention practices. The message is one of unity, power and the community coming together to fight the HIV crisis by not being silent. Speaking out requires talking about HIV to friends and family members at work, at places of worship, in beauty salons and at barber shops to reduce the stigma of this sexually transmitted disease. Meeting the challenge requires hard work from everyone, and every action counts. *Greater than AIDS* reminds all African Americans that they are greater than any challenge and that they share responsibility in the face of AIDS as well as share in the hope for a HIV-free future (KFF, 2009b). The media campaign focuses on six specific actions that individuals and communities can take in response to the epidemic: becoming informed, using condoms, getting tested and treated as needed, speaking openly, acting with respect and getting involved in the challenge to lower the risks of HIV/AIDS.

Dr. Kevin Fenton, the CDC director, notes "media partnerships are critical to bringing a renewed sense of urgency and resolve to ending the epidemic in the hardest hit communities across our nation" (KFF, 2009). This media campaign reaches out to African Americans with life-saving information about HIV/AIDS, encouraging them to confront the silence and denial surrounding this disease in their communities. Television content for genres, such as soap operas, will be developed for a later phase in this health campaign (CDC, 2009). Soap operas are a health communication vehicle that CDC and media networks can use effectively to integrate consistent and targeted HIV pre-

vention messages to combat complacency about the crisis and raise hope for a HIV-free future in communities of color.

Popular Media: Creating Soap Operas with the Hope for a HIV-Free Future in Communities of Color

As previously discussed, CDC and public officials have urged health and communication research communities to promote new tools and strategies in the fight against the virus. For many communities of color, the effectiveness of rational cognitive base interventions can be limiting, partially due to the lack of cultural and personal relevance of HIV/AIDS prevention messages (Jones & Oliver, 2007). The CDC has indicated that entertainment education is a valuable strategy that may be instrumental, particularly with African Americans and Latinos, because of its effectiveness in delivering health related messages that influence attitudes and behaviors (Wilson & Beck, 2002). Both Kaiser and CDC realize that television prime time dramas are a major source of health information, far more than any other single source including family or health care provider (KFF, 2009b). In fact, African Americans and Latinos report learning and acting on television heath information at higher rates than whites because they often identify with role models (Barker & Sabido, 2005; Beck & Pollard, 1999; Kennedy et al., 2004).

Storylines can be adapted to be personally and culturally relevant to different populations based on formative research (Barker & Sabido, 2005). Because soap operas dramatize compelling stories based on the daily lives of a group of characters with whom an audience can easily engage and identify, health professionals advocate that they be designed to communicate HIV risk reduction themes (Jones, 2008). Keys to the effectiveness of the soap opera to engage audiences are emotion, identification and involvement in the storyline. The audience is captivated through intense, melodramatic emotional tone. Within the viewers' larger social sphere, many individuals faithfully follow the soap opera characters. They feel that their own stories, realities and experiences are being played out. Viewers identify with lead characters, which can motivate them to make meaningful behavior changes. Soap operas spark parasocial interactions, forming relationships between a viewer and a fictional character or prompting viewers to talk to the television (Papa et al., 2000). Davin (2000) notes that viewers assess the pros and cons of various actions, engage with the story and discuss the storylines with friends, family members, and their social networks, thereby feeling more involved and connected.

Papa et al. note that many media messages are processed in a social context. Media stimulate conversations and social interactions among peers and family members that can lead to collective efficacy and increase opportunities for behavior change in communities of color. According to Celsi & Olson (1988), the feeling of involvement increases attention to, and comprehension of, the themes in the soap opera. Therefore, the impact on non-white populations is greater because of the viewers' association with positive modeling by characters. The storyline images and specific information tailored for different racial and ethnic viewers provide cultural norms and values that serve as interest and reference points for communities of color (Barker & Sabido, 2005). For many communities of color, soap operas are credible, attract a large number of people of color and can reinforce motivation for adopting positive behaviors.

As previously stated, the most crucial element of entertainment education is to entertain the audience, which accounts for 70% of the story (Barker & Sabido, 2005). According to the Sabido methodology, two of the three subplots in a long-running soap drama create entertainment through changes of fortune, usage of a diverse range of emotions, cliffhangers and storyline tone (Barker & Sabido, 2005). The other 30% (the third subplot) is devoted to the health-education message. This part of the plot (the main focus of this chapter) contains the social content for the lead characters to enact role-model behaviors that are taught and reinforced. Entertainment scripts are always grounded on various theoretical frameworks. For example, entertainment-education strategies incorporate principles from social learning theory (Bandura, 1986), which posits that people learn behaviors by observing someone else performing and experiencing the consequences of the behavior. Soap opera melodrama sets up the characters in the storyline to be rewarded for pro-social behaviors concerning a health issue (recommended behaviors) with prosperity and happiness, while other characters who do not adopt the behaviors encounter disastrous ends. Thus characters become role models, and can promote the value of community reinforcement of messages about HIV/AIDS risk and responsibility. Viewers live vicariously through the characters that they like and can relate too. The audience is often motivated to adopt certain attitudes and behaviors in their own lives because of their associations with the characters, the realistic plots and portrayals. In fact, some viewers use soap opera websites (see www.cbs.com/daytime/bb) to advocate for a particular plot development to reinforce (Kennedy et al., 2004, p. 289). Often the comments can foster either positive or negative sexual behaviors to keep the audience interested and involved in the evolving storylines.

The third soap opera plot format involves women of color strongly asso-

ciating HIV-risk reduction behaviors with familiar pre-existing risk patterns so that the risk-reduction behaviors may be recalled and enacted in real life situations (Stacy et al., 2000). Ultimately, the health-education subplot depicts sexual content (sexual talk and behavior) and sexual risks and responsibilities (sexual patience, precaution, risk/negative consequences), while embedding a subtle health message into an established entertainment medium to influence personal and or public health (Brown & Walsh-Childers, 2002). For example, a soap opera video developed by Rachel Jones (2008, p. 879), *A Story about Toni, Mike and Valerie,* was deliberately designed to communicate HIV risk-reduction themes. In one of the scripts from the soap opera, Jones describes the following storyline:

> Kayla, an African American woman, has not seen or heard from her partner, Steve, in two weeks. She is anxiously waiting to hear from him. She is outside when she sees him talking to another woman whom she believes he is seeing. That afternoon Kayla comes home to a message from Steve asking if he can come over. The video ends.

Jones (2008, p.879) developed this soap opera script intervention to promote HIV sexual risk reduction in young urban women. The entertainment education storyline was organized to convey a realistic event with some potential for HIV risk taking. To create the soap opera intervention, this scene is based on themes, points, and content from focus groups involving 76 predominantly African American women. The focus groups elicited discussion about sexual pleasure, trust, sensation seeking and power in heterosexual relationships (refer to Jones & Oliver, 2007, p. 877). These concepts are central to understanding sexual behavior that will be used to develop a storyline that promotes unprotected sex. The plot revolves around the pressure women feel to keep their relationship with men, and demonstrating their trust of the relationship by having unprotected sex (Jones, 2006a).

The entertainment-education storyline is most successfully practiced with urban women to approach the subject of unprotected sex using sex script theory (Simon & Gagnon, 1986) and power theory (Barrett, 1998; Carolselli & Barrett, 1998; Jones, 2008). In defining sex script theory Simon and Gagnon (1986, p. 97), note that the scripting of behavior can be examined on three distinct levels: *cultural scenarios* (the collective meanings of a particular behavior to a group); *interpersonal scripts* (the application of specific cultural scenarios by a specific individual within a specific social context) and *intrapsychic scripts* (the management of desire as experienced by the individual). These types of behavior scriptings are applied to sexual behavior to produce a sex-script. In power theory, there is a social conflict between the have and have nots which

refers to a lack of equity (Carolselli & Barrett, 1988). In this case, sex scripts refer to the gender inequalities which some women traditionally experience in gender relationships by having less of a voice in the timing of sex and or less power in negotiating condom use (Gutierrez, Oh, & Gillmore, 2000; Medina, 2009). Power theory states that an individual's sense of power is derived from *participation in change* toward the inequity (Carolselli & Barrett, 1998; Jones, 2008). Contemporary literature supports the existence of a sex script where women knowingly have unprotected sex with a partner they suspect of engaging in HIV risk behaviors (Jones, 2008; Emmers-Sommer & Allen, 2005; Jones & Oliver, 2007). Some women's concern about HIV risk is undermined by their relational needs and desire for emotional closeness in heterosexual relationships (Bell et al., 2007; Sobo, 1995). Such needs include commitment to the relationship, trust and barrier-free intimacy (Diekman et al., 2000; Jones, 2006b). Within different social context, young women and men often view unprotected sex as necessary to secure and maintain the coupling relationship (Bowleg, Lucas, & Tschann, 2004; Jones, 2006b; Jones & Oliver, 2007). The literature verifies the need for emotional closeness in heterosexual relationships as one of the most important challenges in reducing HIV risk (Bell et al., 2007; Sobo, 1995; Diekman et al., 2000; Fromme et al., 1997; Jones, 2006; Medina & Rios, 2009 submitted for publication).

Due to the fact the most prevalent route of HIV transmission for women of color is unprotected sex with an infected partner, a soap opera that focuses on the intimate partner relationship suggests implications for the design and success of the educational message. After showing this video, Jones (2008) asked research participants what they thought would happen next. Does Kayla see Steve? Did they have sex? Did they have unprotected sex?

The sex script below was created by the author and applies Gagnon and Simon's theory. It further demonstrates a soap opera script with a woman validating the need for relational closeness yet using condoms. A popular and likable lead character, Krishana, also African American (Medina & Rios, submitted for publication, 2009) is in the same situation as Kayla. She has not seen her partner, Chris, for a while. However, one evening he shows up at her apartment unexpectedly with some wine and says:

> Baby, I missed you. I have been busy, but now I am here. It's just you and me. (After some more sexual talk and sexual behavior [kissing, moving towards the bedroom]), she looks at him passionately and says, Baby, I missed you too. But remember honey this body is my house. It protects my soul [spiritual dimension] for my children and family. I control it [she waves a condom]. I am serious. We got to protect each other.

This entertainment education storyline supports a sex script and the theory of power that was generated by a Latina in an HIV intervention research study, Project Connect, in New York City. This study tested the efficacy of a relationship based intervention to increase condom use among 217 African American and Latina women with their partners (El-Bassel, et al., 2005). The intervention included a session on condom use and gender power issues. One of the participant's narratives discussed keeping the man, but consistently giving the message of condom use to protect each other (Medina, 2009).

This entertainment-education storyline promotes protected sex while fulfilling several relationship needs: holding on to the relationship, showing romance and intimacy and talking openly about protecting each other. This soap opera script presents an alternative option that can greatly help viewers reduce their HIV risk. Similar to the action fostered by the Greater than AIDS campaign, this woman talks openly and with respect about the portrayal of risks and responsibility in gender relationships and dynamics. According to power theory (Carolselli & Barrett, 1998), the woman expresses power by being aware of her value as a woman (my body is sacred for myself, children and family); by knowing her choices and whether she can pursue these choices intentionally and freely (I control my body and soul), and how the partners can make the choices happen (condom use and protection for all: the couple, children and other family members). By modeling sex scripts like the one described above, women can be influenced to act consistently and take actions that reduce HIV risk while enjoying their relationships with men (Jones, 2006).

Conclusion

Since sexuality is a staple ingredient in television, magazines, and films (Larry & Grabe, 2005), mass media is one viable avenue for public health officials to disseminate sexual health messages about HIV risk reduction. Yet the entertainment industry has been criticized for not adequately covering the risks and responsibilities of sexual intimacy. Sexual content in the media has the potential to affect public sexual health in both negative and positive ways. In order to truly be an effective agent of change, mass media commercial organizations need to commit and increase the amount and quality of different programming formats that would actively connect audiences to information, link them to resources, and challenge the existing gender inequalities in soap operas that increase HIV vulnerabilities.

There is a great need for alternative prevention strategies that offer various options for meeting relational needs for men and women in different social environments. As discussed in this chapter, soap opera styling can be used for

entertainment-education purposes that reach a large targeted audience, and that is perceived by African American and Latino communities as a channel for accessing credible health-related information. Soap operas can be adapted by diverse racial and ethnic communities as a vehicle to open communication about HIV information and HIV risk reduction without stigma. Storylines can portray HIV/AIDS as a challenge that requires openly speaking about sexual behaviors between partners. With communities of color included as an important part of the television audience, plots can also emphasize the collective power to participate in change. The CDC, in partnership with mass media producers and writers, public-health professionals, and leaders in communities of color, may help facilitate an HIV-free future by developing soap opera plots with HIV/AIDS risk-reduction themes for all age-related audiences, especially adolescents and older women of color. There is scant research on the influence of HIV risk-reduction messages in popular media and these two distinct populations.

References

Aubrey, J. S., Harrison, K., Kramer, L., & Yellin, J. (2003). Variety versus: Gender differences in college student's sexual expectations as predicted by exposure to sexually oriented television. *Communication Research, 30,* 432–460.

Bandura, A. (1977). *Social learning theory.* Englewood Cliffs, NJ: Prentice-Hall.

Bandura, A. (1986). *Social foundations of thought and action: A social cognitive theory.* Englewood Cliffs, NJ: Prentice-Hall.

Barker, K., & Sabido, M. (2005). Soap operas for social change to prevent HIV/AIDS: A training guide to journalists and media personnel. Population Media Center.

Barrett, E. A. M. (1998). A Rogerian practice methodology for health patterning. *Nursing Science Quarterly, 11,* 136–138.

Beck, V., Pollard, W., & Greenberg, B. (2000). *Tune in for health: Working with television entertainment shows and partners to deliver health information for at-risk audiences.* Paper presented at the annual meeting of the American Public Health Association, Boston, MA.

Bell, D. C., Atkinson, J. S., Mosier, V., Riley, M., & Brown, V. L. (2007). The HIV transmission gradient: Relationship patterns of protection. *AIDS and Behavior, 11,* 789–811.

Bowleg, L., Lucas, K. J., & Tschann, J. M. (2004). The ball was always in his court: An exploratory analysis of relationship scripts, sexual scripts, and condom use among African American women. *Psychology and Women Quarterly, 28,* 70–82.

Brown, J. D., & Walsh-Childers, K. (2002). Effects of media violence. In J. Bryant & D. Zillman (Eds.), *Media effects: Advances in theory and research* (2nd ed., pp. 453–488). Mahwah, NJ: Erlbaum.

Carolselli, C. & Barrett, E. A. M. (1998). A review of the power as knowing participation in change literature. *Nursing Science Quarterly, 11,* 9–16.

Carstarphen, M., & Zavoina, S. C. (Eds.). (1999). *Sexual rhetoric: Media perspectives on sexuality, gender, and identity.* Westport, CT: Greenwood.

Celsi, R. L., & Olson, J. C. (1988). The role of involvement in attention and comprehension process. *The Journal of Consumer Research, 15,* 210–224.

Centers for Disease Control and Prevention. (2009a). Act!on Newsletter. July.

Centers for Disease Control and Prevention. (2007). HIV/AIDS and women.

Centers for Disease Control and Prevention. (2009b). HIV/AIDS surveillance report. vol. 19

Centers for Disease Control and Prevention. (2008). Fact sheet: Estimates of new HIV infections in the United States. August.

Collins, R. L., Elliot, M. N., Berry, S. H., Kanouse, D. E., Kunkel, D., Hunter, S. B., et al. (2004). Watching sex on television predicts adolescent initiation of sexual behavior. *Pediatrics, 114,* 280–289.

Cope-Farrar, K. M., & Kunkel, D. (2002). Sexual messages in teens' favorite primetime television programs. In J. Brown, J. R. Steele, & K. Walsh-Childers (Eds.), *Sexual teens, sexual media* (pp. 59–78). Mahwah, NJ: Lawrence Erlbaum.

Cortese, A. J. (1999). *Provocateur: Images of women and minorities in advertising.* NY: Rowman and Littlefield.

Davin, S. (2000). Medical dramas as a health promotion resource. *International Journal of Health Promotion and Education, 38*(3), 109–112.

Diekman, A. B., McDonald, M., & Gardner, W. L. (2000). Love means never having to be careful: The relationship between reading romance novels and safe sex behavior. *Psychology of Women Quarterly, 24,* 179–188.

El-Bassel, N., Witte, S. S., Gilbert, L., Wu, E., Chang, M., Hill, J., et al. (2005). Long term effects of an HIV/STI sexual risk reduction intervention for heterosexual couples. *AIDS and Behavior, 9*(1), 1–13.

Emmers-Sommer, T. M., & Allen, M. (2005). *Safer sex in personal relationships: The role of sexual scripts in HIV infection and prevention.* Mahwah, NJ: Lawrence Erlbaum Associates, Publishers.

Fromme, K., Katz, E. C., & Rivet, K. (1997). Outcome expectancies and risk-taking behavior. *Cognitive Therapy and Research, 21,* 421–442.

Galician, M. (2004). *Sex, love, and romance in the mass media: Analysis and criticism of unrealistic portrayals and their influence.* Mahwah, NJ: Lawrence Erlbaum.

Gurman, T. H. & Orkis, J. (2006). Let's get it on: Implications of sexual content in African American situation comedies. *Public Health and Human Rights APHA 134*[th] *Annual Meeting and Exposition.* November 4–8, 2006. Boston, MA. Retrieved December 15, 2008, from http://apha.confex.com/apha/134am/techprogram/paper_133701.htm

Gutierrrez, L., Oh, H. J., & Gillmore, M. R. (2000). Towards in understanding of (em)power(meant) for HIV/AIDS prevention with adolescent women. *Sex Roles, 42* (7/8), 581–611.

Hagen, I. & Wasko, J.(Eds.). (2000). *Consuming audiences? Production and reception in media research.* Cresskill, NJ: Hampton Press.

Holtzman, L. (2000). *Media messages.* Armonk, NY: M.E. Sharpe.

Jensen, R. E., & Jensen, J. D. (2007). Entertainment media and sexual health: A content analysis of sexual talk, behavior, and risks in a popular television series. *Sex Roles, 56,* 275–284.

Jones, R. (2006a). Reliability and validity of the sexual pressure scale. *Research in Nursing & Health, 29,* 281–293.

Jones, R. (2006b). Sex scripts and power: A framework to explain urban women's HIV sexual risk with male partners. *The Nursing Clinics of North America*, 41(3), 425–436.

Jones, R. (2008). Soap opera video on handheld computers to reduce young urban women's HIV sex risk. *AIDS Behavior*, 12, 876–884.

Jones, R., & Oliver, M. (2007). Young urban women's patterns of unprotected sex with men engaging in HIV risk behaviors. *AIDS and Behavior*, 11(6), 812–821.

Kaiser Family Foundation (2009a). *We are greater than AIDS*. Retrieved December 10, 2009, from http://www.kff.org/entpartnerships/BAMP/index.cfm

Kaiser Family Foundation (2009b). *Black AIDS Media Partnership*. Retrieved December 10, 2009, from http://www.kff.org/hivaids/phip062509nr.cfm

Kaiser Family Foundation. (2009c). HIV/AIDS policy fact sheet: Black Americans and HIV/AIDS. September.d

Kaiser Family Foundation. (2009). HIV/AIDS policy fact sheet: Latinos and HIV/AIDS. September.

Kaiser Family Foundation. (2009). Survey of Americans on HIV/AIDS.

Kennedy, M.G., O'Leary, A., Beck, V., Pollard, K., Simpson, P. (2004). Increases in calls to the CDC National STD and AIDS hotline following AIDS-related episodes in a soap opera. *Journal of Communication*, 54(2), 287–301.

Kunkel, D., Biely, E., Eyal, K., Cope-Farrar, K.M., Donnerstein, E., & Fanrich, R. (2003). Sex on TV 3: A biennial report to the Kaiser Family Foundation. Menlo Park, CA: Kaiser Family Foundation.

Larry, A., & Grabe, M. E. (2005, Summer). Media coverage of sexually transmitted infections: A comparison of popular men's and women's magazines. *Journal of Magazine and New Media Research*, 1–23.

Livingstone, S. (1998). Audience research at the crossroads: The "implied audience" in media and cultural theory. *European Journal Cultural Studies*, 1(2), 193–217.

Medina, C. (2009). Beyond routine HIV testing: Beliefs, perceptions, and experiences of low-income women of color. *Journal of HIV/AIDS & Social Services*, 8(3), 219–237.

Medina, C., & Rios, D. (2009). An alternate HIV preventive strategy: Sex scripts in media for women of color. Manuscript in progress.

Nariman, H. N. (1993). *Soap operas for social change: Toward a methodology for entertainment-education television*. Westport, CT: Praeger.

Papa, M.J., Singhal, A., Law, S., Pant, S. Sood, S., Rogers, E.M., et al (2000). Entertainment- education and social change: An analysis of parasocial interaction, social learning, collective efficacy, and paradoxical communication. *Journal of Communication*, 50, 31–55.

Pew Hispanic Center, The (2008). *Quarter of Latinos Get No Health Information from Medical Professionals, New Survey Finds.*

Shanahan, J., & Morgan, M. (1999). *Television and its viewers: Cultivation theory and research*. Cambridge, UK: Cambridge.

Simon, W. & Gagnon, J. H. (1986). Sexual scripts: Performance and change. *Archives of Sexual Behavior*, 15(2), 97–120.

Singhal, A., Cody, M. J., Rogers, S. M., & Santelli, J. S. (Eds.). (2004). *Entertainment-Education and social change: History, research, and practice*. Mahwah, NJ: Lawrence Erlbaum Associates.

Singhal, A., & Rogers, E. M. (2002). A theoretical agenda for entertainment-education. *Communication Theory, 12,* 117–135.

Sobo, E. (1995). Finance, romance, social support, and condom use among impoverished inner-city women. *Human Organization, 54*(2), 115–128.

Sreberny, A., & Van Zoonen, L. (Eds.). (2000). *Gender, politics and communication.* Cresskill, NJ: Hampton Press, Inc.

Stacy, A. W., Newcomb, M. D., & Ames, S. L. (2000). Implicit cognition and HIV risk behavior. *Journal of Behavioral Medicine, 23*(5), 475–499.

Vaughan, P. W., & Rogers, E. M. (2000). A staged model of communication effects: Evidence from an Entertainment-Education radio soap opera in Tanzania. *Journal of Health Communication, 5,* 203–227.

Vaughan, P. W., Rogers, E. M., Singal, A., & Swalehe, R. M. (2000). Entertainment-Education and HIV/AIDS prevention: A field experiment in Tanzania. *Journal of Health Communication, 5,* 81–100.

Weimann, G. (2000). *Communication unreality.* Thousand Oaks, CA: Sage.

Weinberg, C. (2006). This is not a love story: Using soap opera to fight HIV in Nicaragua. *Gender and Development, 14*(1), 37–46.

Weiner, R. (2009, January 15). Project uses soap opera to raise HIV awareness. *New Jersey Jewish News.* Retrieved October 1, 2009, from http://njjewishnews.com/njjn.com/011509/mwProjectUses.html

Wilson, K. E., & Beck, V. H. (2002). Entertainment outreach for women's health at CDC. *Journal of Women's Health and Gender-Based Medicine, 11,* 575–578.

Wilson, B. J., Smith, S. L., Potter, J., Kunkel, D., Linz, D., Colvin, C. M., et al. (2002). Violence in children's television programming: Assessing the risks. *Journal of Communication, 52,* 5–35.

12. Hybridity in Popular Culture

The Influence of Telenovelas on Chicana Literature

Belkys Torres

Telenovelas are the "dominant new cultural form in Latin America today," affirms the Founding Statement of the Latin American Subaltern Studies Group (1993; also see Rodriguez, 2001; Moraña, Dussel & Jáuregui, 2008). Yet, researchers Barrera and Bielby (2001) remind us that Latinas/os in the United States are equally enthralled by these serialized melodramas and watch them daily to maintain their ties to family and culture in Latin America. In fact, the increasing popularity of telenovelas has inspired multiple adaptations of the genre within U.S. English-language television. For example, a number of production companies and television networks raced to create what they named "English-language telenovelas," such as *Desire* (aired 2006), *Fashion House* (aired 2006), and the popular *Ugly Betty* (2006–2010). Currently, "the ownership of the major Spanish language networks . . . instrumental in building a national market of Latinos . . . is by U.S. corporations . . . [who] balance classic Spanish cultural-linguistic programming, like telenovelas, with programmes for those who are English-dominant or bilingual" (Sinclair, 2009, p.35). However, nearly two decades before the telenovela's crossover into English-language television, renowned Latina/o novelists had been experimenting with and adapting the telenovela's form and content into their own narratives. Keenly underscoring the role of daily dramatic serials (their creation, production, and consumption) in women's lives, Latina/o writers like

Sandra Benitez, Ana Castillo, Sandra Cisneros and Eduardo Santiago have blended "high" literature and popular culture in their works to show how migration and the experience of working in the U.S. affects women's relationships with their telenovelas. Some recent narratives either read like telenovelas or parody the genre, creating a hybrid text impossible to define as either "purely" literature or serialized melodrama, and in fact are best referred to as teleNOVELa. I rely upon this particular spelling of the term to visually denote the interconnectedness of the novel and/as telenovelas, since writers' experimentation with the limits between one narrative structure and the other merge, creating a distinct, hybrid genre that is neither solely literature nor "purely" televised melodrama. Sandra Cisneros's reading of Ana Castillo's *So Far From God* (1993), speaks best to this emerging trend in contemporary Latina/o fiction. On the dust cover of Castillo's novel, Cisneros praises this author's innovation, celebrating the work as "a Chicana *telenovela*." That is to say, it is a novel focusing on a humble, marginalized family of five women which aspires to material and social stability while living in a bordertown in the U.S., yet suffer from a number of those implausible situations which form the foundation of any successful telenovela.

According to González's (1992) anthropological research on the topic, to understand the sustained popularity of this global media we must become "more interested in what society *does* with telenovelas, than [in] trying to find out what soaps 'do' to society . . . [Because] understanding the dynamics with which . . . families read television and of the multiple appropriations they make of telenovelas . . . [will provide an] intensive understanding of the relation between familiar everyday experience and its televised dramatization" (p.64). Like González, I analyze the subversive potential of what two renowned Chicana novelists *do* with telenovelas and examine how several characters in their most respected prose narratives engage with serialized melodrama. Sandra Cisneros' *Woman Hollering Creek and Other Stories* (1991) and Ana Castillo's *So Far From God* (1993) both "poach" the content and style of telenovelas to emphasize women's interpretive acts and further a transnational vision of solidarity and community-building amongst Latinas separated by class, language, politics, and/or geography. In each piece, characters' viewing of telenovelas prompts them to perform a tactical manuever, since the serials inspire women to "manipulate [repressive] events in the narrative in order to turn them into opportunities" (de Certeau, 2002, p. xix). Featuring the transgressive power of orality, storytelling, and gossip in women's daily experiences, both texts probe and revel in the potential of women's interpretive acts as savvy, oppositional readers of actual telenovelas in their televisual form.

Woman Hollering Creek and Women's Interpretive Acts

Sandra Cisneros's *Woman Hollering Creek* heeds to Gonzalez's (1992) call when underscoring what her fictional characters do with *las novelas* to suggest that despite linguistic, economic, or political differences, women on both sides of the border (be they fictional or "real") share a similar attraction to them. Her collection of short stories suggests that this connection nurtures egalitarian discussions amongst all women who identify with the global south. Cisneros references telenovelas that traditionally rely on one-dimensional characters and stereotypical plot lines. She deconstructs images of Chicanas/Latinas as passive receivers of information and reveals how telenovela viewers engage in "poaching." This is a "cultural activity of the non-producers of culture" who manipulate otherwise exploitive situations for their own gain, "thus lend[ing] a political dimension to everyday practices" (de Certeau, p.xviii). Acknowledging the popularity and significance of telenovelas in the lives of Mexican women, Cisneros intially depicts women's reaction to and relationship with telenovelas to reveal both the damaging and empowering effects.

Nodding to Hall's (1980) preferred reading model (encoding/decoding), Cisneros's short stories recognize the process of viewing and reading television as negotiation between the viewer and the text. She sees women wanting to break from telenovelas' one-dimensional renderings of social dynamics but there are also passive or dominant readings of storylines. Reading *Woman Hollering Creek* with Hall's theory in mind, then, reveals how Cisneros maps an evolution. She goes from Cleófilas, a character who falls prey to the dominant portrayal of patriarchy, to Chayo's negotiated interpretations (rejects the expected gender roles). Finally, there is Lupe's oppositional understanding of telenovelas. As a result, this mapping demystifies a stereotype of Latina viewers as passive, ignorant, or otherwise complacent.

The title story, "Woman Hollering Creek," is the narrative in which Cisneros most clearly critiques popular culture's hegemonic portrayal of women as ignorant and submissive. However, it is also the story in which Cisneros reveals the process whereby women break with fantasies they have created based on daily melodramatic serials and acknowledges the horrific truths of their domestic lives. Cleófilas, the story's protagonist, interprets and anticipates events in her life in relation to the narrative plots of romance novels and telenovelas. She so desperately desires to live the life of the soap opera star, Lucía Méndez from the 1985 serial, Tú o Nadie, that Cleófilas frequents her "girlfriend's house to watch the latest telenovela episode and try to copy the

way the women comb their hair, wear their makeup" (p.44). Cleófilas so desires her reality to echo the events she sees on the telenovela, that she runs to the drugstore after watching Méndez in Tú o Nadie to dye her hair like the protagonist's. She believes her life will change if she follows the telenovela beauty regimen as embodied by the actress.

Cleófilas is fooled by what Mulvey (2001) calls the "star system, [where] the stars centering both screen presence and screen story . . . act out a complex process of likeness and difference (the glamorous impersonates the ordinary)"(p.397). Cleófilas is convinced that she, too, can achieve the lifetsyle portrayed by Mendez on the small screen, since she sees the telenovela star as a friend, given the character she plays on television. As she is following the plot of "Tú o nadie," Cleófilas is also preparing to marry Juan Pedro and cross the border toward the U.S., where "she would get to wear outfits like the women on the *tele*, like Lucía Méndez. And have a lovely house" (p.45). Believing that the life of a television star is attainable simply by moving to the U.S., Cleófilas visualizes her future with Juan Pedro as a never-ending love scene from a telenovela. She believes material wealth is within her reach, for she has internalized the rags-to-riches stories depicted in her televised melodramas. Moreover, "what Cleófilas has been waiting for, has been whispering and sighing and giggling for, has been anticipating since she was old enough to lean against the window displays of gauze and butterflies and lace, is passion . . . The kind of the books and songs and telenovelas describe when one finds, finally, the great love of one's life, and does whatever one can, must do, at whatever cost"(p.44). She ironically correlates migration with material wealth and social prominence, simply because her melodramatic serials are founded upon such a premise. As Acosta-Alzuru (2010) explains, this is a common symptom of telenovela viewers who do not mind "'unreal' storylines when they involve romance" and who are less prone to critique a serial when they "approve and enjoy these plots that are both like and unlike their own personal love stories" (p.198). Her recent study of a recent Venezuelan telenovela affirms that the telenovela's international success lies in its ability to "elicit identification, recognition, and aspiration, all at the same time" (p.198). Cleófilas's viewing practices emulate the "dominant" interpretation of television audiences who accept the "connoted meaning" of a televised program. They do not question the motive or purpose behind the message and buy into the ideas perpetuated by mainstream culture (Hall, 1980, p. 52).

Cleófilas reveals her dominant reading through her desire to experience the passion of the telenovela's opening song, "You or No One." Yet, when humble and naïve Cleófilas finally marries and crosses the border, her dreams

are shattered as she admits that her marriage in no way compares to those in telenovelas. The first time her abusive husband strikes her, for example, Cleófilas's shock comes not only from the physical blows she receives, but from the realization that she did not react in the way she had imagined: "she didn't fight back, she didn't break into to tears, she didn't run away as she imagined she might when she saw such things in the telenovelas" (p.47). When on another occasion her husband beats her with her romance novel, she notes that "what stung more was the fact that it was *her* book, a love story by Corín Tellado, what she loved most now that she lived in the U.S., without a television set, without the telenovelas" (p.52). Ultimately, these moments of realization lead to Cleófilas's disenchantment with any kind of melodrama. She acknowledges that she "thought her life would have to be like that, like a telenovela, only now the episodes got sadder and sadder. And there were no commercials in between for comic relief. And no happy ending in sight" (pp.52—53). The telenovela initially offers Cleófilas a means whereby she can imagine herself as something more than a woman with a crack in her face when she finds herself struggling, married and living *al otro lado* (p.53). However, the ways in which she relates to such melodrama is drastically changed as she finds no comparison between her lived migratory experience and the "reality" depicted in telenovelas. It is only after Cleófilas realizes that she is dissatisfied with her life in the U.S. and with the illusory depictions of women in telenovelas that she can desire to become more like Felice—her educated, free-spirited, feminist foil who helps a pregnant Cleófilas and her small son escape further domestic abuse. After meeting Felice and realizing that "real" women did not need to depend on abusive husbands to feel fulfilled, Cleófilas begins to aspire for the moment when she too can holler like Felice as they cross the creek and laugh "a long ribbon of laughter, like water" (p. 56).

Phelan's (1998) analysis of this short story, entitled "Sandra Cisneros's 'Woman Hollering Creek': Narrative as Rhetoric and Cultural Practice," argues that its narrative structure posits Cisneros's attempt at writing an "anti-telenovela": "an exposure of their dangerous ideological messages about the value of suffering for love" (p. 225). Phelan explains that Cisneros's story breaks with the basic characteristics of melodramatic serials, since her non-linear narrative blurs geographical borders and offers no change in Cleofilas's situation. He further posits that Cisneros draws attention to her "writerly function . . . announcing the story as high art," which counters the purpose of mass-produced serials (p. 228). In "Women Hollering Transfonteriza Feminisms," Saldívar-Hull (2000) also affirms that Cisneros's story denounces melodramatic serials as masochistic, stereotypical, and illusory. Saldívar-Hull

contends that this story "illustrates how *novelas*, romances and traditional tales of infanticide by disobedient 'wailing women' who are punished for rejecting motherhood join to coerce Cleófilas into accepting patriarchal arrangements" (p.258). While I agree that the content of telenovelas and romance novels do not encourage Cleófilas to think of herself outside of patriarchal systems of power, I argue that it is her primarily dominant interpretation of her serials, and not simply the content of melodramas, that impede Cleófilas resistance toward said oppressive system. In other words, Cleofilas is fooled and mistreated by her husband, not because she enjoyed melodramatic serials, but because she wholeheartedly believed in their hegemonic discourse.

Cisneros is fully aware of said distinction and underscores moments in which Cleófilas, and women like her, not only recognize the deception and frustration inherent in living vicariously through telenovelas, but are also capable of changing their activity as viewers in subversive and empowering ways. In fact, rather than read "Women Hollering Creek" independently, it is important to acknowledge it as *one* narrative within a continuum that slowly dismisses mainstream descriptions of Latina women's social and domestic roles. The continuum contains Cleófilas ("Woman Hollering"), Rosario de Leon ("Little Miracles"), and Lupe's ("*Bien* Pretty") progressive relationship with telenovelas.

Cleófilas cringes when she is finally aware of the difference between her life and the "reality" shown in telenovelas. She works to change her future by planning an escape from her husband's oppressive control. The character Rosario de Morales of "Little Miracles, Kept Promises," on the other hand, embraces this distinction. This story voices the perspectives of numerous Chicanas/os who offer keepsakes, prayers and "milagritos" to La Virgen de Guadalupe either as an offering of thanksgiving or as a means of petitioning a favor. The most powerful of these testimonials is the last one, Rosario Morales's (Chayo) thanksgiving offering. Chayo's narrative reveals that she has broken with family expectations and cultural traditions regarding women's roles and holds a newfound interpretation of and respect for La Virgen. Proud of what she has accomplished, despite her family's vocal disapproval, Chayo cuts her braid and pins it alongside other "milagritos": "I leave my braid here," she tells the Virgin, "and thank you for believing what I do is important. Though no one else in my family, no other woman, neither friend nor relative, no one I know, not even the heroine in the telenovelas, no woman wants to live alone. I do" (p.127). She is proud of her independence and, while embracing this newfound sense of freedom, Chayo compares her situation to those of other women only to celebrate difference. Unlike the deflated

Cleófilas, Chayo takes the first step toward her own independence when differentiating herself from the women in telenovelas. Chayo performs what Hall (1980) refers to as a "negotiated" interpretation of melodramatic serials, accepting some of the mainstream codes while questioning others. Envisioning alternatives to traditional female roles, Chayo builds upon Cleófilas's awakening and rewrites herself as an empowered woman different from telenovela heroines, thus setting the stage for Lupe's (from the story "*Bien* Pretty") own revision of women's voyeuristic reactions to telenovelas. As she cuts off her braid and places it on the altar, Chayo releases the literal cultural tie that was weighing her down. As newly free from pressures of social conformity, Chayo channels her talent as an artist to reimagine the image of La Virgen, representative of everywoman, into an Anzaldúa-like version of the "Mighty Guadalupana Coatlaxopeuh Tonantzín" (p.129). In doing so, Chayo foreshadows the changes she will make in her own understanding and practice of feminity and womanhood.

Like Chayo, Lupe (protagonist of "*Bien* Pretty") also reappropriates icons from Mexican cultural tradition. Since Lupe is also an artist, she recreates the myth of Prince Popo and Princess Ixta on canvas. She uses her lover, Flavio, as a model for Prince Popocatépetl as she paints her "updated version of the Prince Popocatépetl/Princess Ixtaccíhuatl volcano myth" until Flavio eventually leaves her to return to his wife and children in Mexico (p.144). Distraught by Flavio's betrayal, his departure, and her subsequent inability to paint, Lupe resorts to watching telenovelas and reading romance novels to pass the time. She shares in Cleófilas's obsession with the televised romances and confesses to "avoiding board meetings, rushing home from work . . . Just so I could be seated in front of the screen in time to catch *Rosa Salvaje* with Veronica Castro as the savage Rose of the title. Or Daniela Romo in *Balada Por Un Amor*. Or Adela Noriega in *Dulce Desafío*. I watched them all. In the name of research" (p.161). Initially, Lupe mirrors Cleófilas's viewing patterns and believes the world of melodramatic serials will allow her to escape her own tragedy. However, this passive reading of telenovelas does not satisfy Lupe and, like Chayo, she acknowledges her inability to relate to those heroines. Instead, she manipulates the repressive content of her telenovelas and begins to dream up revised versions of them. Rather than discard her telenovelas, Lupe is inspired to resignify the characters, plots and conflicts therein. Lupe imagines different types of female characters in her telenovelas; characters who resemble the "real" women she's grown to respect.

Aware of her love/hate relationship to the telenovelas, Lupe walks into Centeno's grocery store and picks up a magazine with the latest gossip about

her soap stars. As the cashier rings up Lupe's merchandise their shared obses-
sion with the melodramatic serials allows them to speak to each other on com-
mon ground. At the moment when the cashier strikes up a conversation with
Lupe about the magazine, the latter looks at the cashier and notes that they
are the same age and share similar taste in clothing, as well as television pro-
grams. Their conversation is nothing more than mere chit-chat—the cashier
asks Lupe about a Venezuelan telenovela star to which she responds with the
telenovela title "Amar es Vivir"; the cashier then asks what she thinks of the
actress's performance and states that she is rushing home after work to catch
the latest episode, to which Lupe responds that she never misses an episode,
though the series might be coming to an end. However, Lupe's recognition
of the similarities between the cashier and herself allows her to consider the
cashier, a Mexican immigrant of meager income, as her equal and note that
despite differences in class, language, and native origin, they both share their
passion (and frustration) for telenovelas.

Lupe describes what she, the cashier, and other women seek and experi-
ence while watching the telenovela to suggest that what the television programs
can offer is only a limited version of how she envisions women should live.
What is especially telling is her acknowledgement that she and the cashier are
one and the same. She redefines the act of living, not as "the weeks spent writ-
ing grant proposals, not the forty hours standing behind a cash register shov-
ing cans of refried beans into plastic sacks. Hell, no . . . We're going to right
the world and live . . . With rage and desire, and joy and grief, and love till it
hurts, maybe "(p.163). Lupe is inspired by the passion with which telenovela
characters enjoy life. However, she remains dissatisfied with sexist renderings
of passive heroines seeking the upward mobility through marriage. This
dichotomoy leads Lupe to enact what Hall's (1980) interpretive model defines
as an "oppositional reading," where the viewer deconstructs the dominant mes-
sage relayed on the screen "in order to retotalize the message with some alter-
native framework of reference" (p.53). Since she cannot find feminist female
characters in her telenovelas, Lupe returns to her canvas and reconfigures tra-
ditional renderings of the Prince Popocateptel and Princess Ixta myth. Lupe
has the male and femal figures trade places so that the former is "lying on his
back instead of the princess" (p.163). As their roles are reversed, Lupe sub-
verts traditional depictions of women as submissive and resigned; her oppo-
sitional interpretation of telenovelas allows her to question the entire premise
of both genres (telenovelas and myth) and resignify them.

As Lupe describes how women relate to the telenovela she alludes to the
power of collective interpretation and exchange. Lupe suggests that watching

and chatting about telenovelas can jolt women into an awareness of a higher purpose, of what it means to live passionately, with convictions and self-assurance. More importantly, she does not speak of herself from a position of difference, but speaks of her condition as equal to that of the immigrant cashier's and others like her. Lupe's oppositional reading of telenovelas as catalyst for egalitarian conversations and connections suggests a moment in which women can embrace their differences and, through a common cultural referent, speak to each other and "come to realize that we are not alone in our struggles nor autonomous but that we are . . . connected and interdependent"(Moraga & Anzaldua, 1983, p. iv). When Lupe's reaction to telenovelas changes, its value as a cultural product is then resignified; it no longer functions as an obstacle to women's independence, but serves as the driving force behind it. This awareness allows her to envision herself and the cashier as equally entrenched in a fight against traditionally patriarchal expectations of women's social, artistic, and scholarly contributions. Exchanging impressions of her telenovela with the cashier, and acknowledging their connection as women who identify with the global south, inspires Lupe to reconceptualize the traditionally passive and demure renderings of Princess Ixta, placing her instead as the powerful and towering figure on her canvas.

The practice of viewing and gossiping about telenovelas, thus serves as a unifying force, a common ground, that brings women together from both sides of the border and allows them to think of each other as equally entrenched in a fight against traditionally stereotypical depictions of women. Cisneros furthers Hall's (1980) theory to suggest that the kind of reading enacted by Cleófilas, Chayo, and Lupe is only as important as how each character makes her reading a catalyst for change in her everyday life.

So Far From God: An(O)ther English-language Adaptation of Telenovelas

If Cisneros's work underscores the value of women's interpretive readings of telenovelas to reveal what women do after viewing their serialized melodramas, Ana Castillo's *So Far From God* adapts the telenovela's narrative form in ways that extend Cisneros's project. *Woman Hollering Creek* resignifies telenovelas as significant cultural referents that incite positive, even subversive, interactions between women from both sides of the U.S/Mexico border. Yet, *So Far From God* nods to the tradition of serial fiction (both in print and in television) and employs a unique adaptation of telenovelas to engender a hybrid narra-

tive which is neither serialized melodrama nor "high" literature. This novel blends the characteristics of televised family melodrama (its focus on one family, living in a relatively small town, which experiences all manner of implausible occurrences while overcoming poverty, abuse and *el que diran*) and the complexity in form and content of contemporary Latina/o literature, generating a hybrid genre that I call the teleNOVELa.

This novel's title, *So Far From God*, accentuates its concern with hybrid spirituality and religious practices that encourage readings focused on *curanderismo*, Catholicism, and mysticism. Sandra Cisneros's reading of the work, however, offers a very different interpretative lens with which to approach this text. In praise of Castillo's innovation, Cisneros's review of the book focuses on the style and form of the novel, naming it a printed form of a "Chicana telenovela." Less concerned with plot development or character portrayals in *So Far From God*, Cisneros references this novel's contribution to the project of recovering what Saldívar-Hull (2000) refers to as the "alternative archives" of Chicanas' histories: "the gossip and rumors for which Chicanas are criticized and through which they are silenced; the lacunae of family stories . . . the late-night kitchen-table talks with Mexican immigrants to the barrios of the United States"(p.25). In savoring the references to melodrama, gossip and popular culture as significant and inseparable elements of this community's socio-political experience, Castillo extends Cisneros's concerns regarding practical feminism approaches which "break with traditional (hegemonic) concepts of genre . . . [to] articulate their feminism in nontraditional ways and forms"(p.54). Reading this narrative through Cisneros's interpretive lens, we find that Castillo is not simply experimenting with a hybrid genre; she deliberately blends the orality of women's "alternative archives" with scriptwriters' concern for narrative development as a way of preserving a part of women's cultural practices.

This novel is framed around the unlikely events that unfold and define the central character's life after her youngest daughter, known as La Loca Santa, dies at age three and then resurrects during her own funeral, only to remain forever homebound, claiming to be repulsed by the smell of other humans. This woman-centered narrative explores the protagonist's, Sofia, life and the lives and deaths of her older daughters: Esperanza, Caridad, and Fe, all of whom die as a result of their encounters with mainstream U.S. ethics of social climbing. This novel exposes the complexities and significance of creating a woman-centered community while revealing a working-class family's struggles with socio-economic oppressions and the dangers of patriarchal systems of power. In this novel, the need for *familia* and *vecinos* is furthered by a belief

in a hybrid spirituality that recovers the part of Chicana history that reveres the power of home remedies, storytelling and prayer. This is also a narrative concerned with the craft of writing that nods to a long tradition of literary seriality by offering chapter titles that read as melodramatic summaries.

Castillo's bold adaptation of Spanish-language telenovelas both critiques and employs the genre's melodramatic mode and narrative form. Melodrama, whether televised or in print, requires discussion of topics, characters and situations which would otherwise be labeled "taboo" outside of this "mode of high emotionalism and stark ethical conflict that is neither comic nor tragic in persons, structure, intent, effect" (Brooks, 1995, p.12). Castillo employs the characteristics and basic framework of telenovelas, since most of this novel takes for granted behaviors and beliefs that dominant culture (either U.S. American or Mexican) labels "taboo," such as sexual promiscuity, mysticism, stalking, incest, inbred marriages and discussions of sexuality. Highly sentimental and "morally questionable" situations arise in this novel when eccentric, self-assured, vocal characters negotiate their lives and struggles on the margins of U.S. social realities. Brooks (1995) explains this correlation between the melodramatic mode and its attraction to the marginalized and disenfranchised in any society. The blatant emotionalism expressed by the townspeople of Tome in *So Far From God* (and the unlikely events that ensue) are emblematic of the anxiety experienced by a people who live in the U.S., yet are denied their rights as citizens and ignored by the State. Sofia's eldest daughter, Fe, personifies this communal anxiety with her incessant "blood-curdling wails." After she has been rejected by her fiancé, only a few days before their wedding, Fe's reaction is to "let out one continuous scream that could have woken the dead" (Castillo, 1993, p. 30). Yet several weeks after trying to slap Fe out of her delirium and confronting the cowardly ex-fiance, Tom, to no avail, Fe's mother and sisters come to terms with her anxiety. Just as Fe's shrills become commonplace in her household, so do other characters' melodramatic reactions or situations throughout the novel.

Some of the most evident turn of events which mimic those of telenovelas are: Domingo's mysterious reappearance after years of absence from home and the stories that follow regarding his time away from Tome; La Loca's childhood resurrection which causes her aversion to strangers and her disgust at being touched by anyone; and the tragic death of each of Sofia's daughters. Since these characters inhabit a social space that is ignored by mainstream culture, they fully express their anxieties and frustrations without fearing repercussions outside of their community.

While exaggeration of emotions and life experiences is a frequently used

strategy in this text, it is not the only characteristic that links this novel to melo-dramatic serials, in print or televised. The emphasis on the "problems of love, sexuality and parenting" were at the core of family melodramas of Golden Age Mexican cinema and remain a basic tenet of telenovelas today (Lopez, 1985, p. 150). The intimate and contentious relationships which Sofi and her daugh-ters sustain with each other and their partners underscore the complexities of family melodrama. When she's seventeen, Sofi marries Domingo, who disap-pears after their fourth daughter is born to feed his gambling addiction and returns decades later hoping to pick up where they had left off. This rela-tionship does not represent a feminist discourse, since Sofi falls madly in love with a gambler who abandons his family and then passively returns once the children are grown. Yet, as Craft (1996) explains, while it may seem that their "romantic attachments or that their transactions and entanglements with men contaminate them to the extent that their own journeys to self-discovery and definition are truncated . . . These entanglements form the very heart and soul of the telenovela" (p.200–1). In fact Sofia, Esperanza and Caridad each expe-riences an awakening as the result of their melodramatic relationship or encounter with a man.

While their life choices may not initially represent a feminist discourse, their self-discovery embodies an alternative way of enacting feminist ideals. For instance, only when Sofia compares her life of household chores to Domingo's laid-back and lazy disposition, does she decide to run for Mayor and develop a collective where men and women can equally share their work load. After Esperanza finally decides to leave Ruben, she recognizes her need to pursue her career and her independence. And though she is fated to "disappear" while covering a story in the Middle East, she has at least freed herself from an unre-warding and degrading relationship. Caridad comes to a similar realization after she is brutally raped by her last "boyfriend." After months of recovery and a miraculous restoration of her physical features, Caridad chooses to pursue a spiritual calling. Therefore, while these women's melodramatic relationships may not have been fulfilling or empowering in any way, when they compare themselves to their male counterparts they achieve a level of awareness that empowers them to seek independence and well-being.

A heavy reliance on melodrama is not the only characteristic that likens the form of the telenovela with that of Castillo's novel. Like telenovelas, *So Far From God* is a narrative that offers definite endings or narrative closure and that appeals to a wide audience of women, men and children. More importantly, its descriptive language mimics the camera work of melodramatic serials that rely heavily on visual close-ups to make meaning when using language becomes

inappropriate or redundant. This novel describes the intimate details of a working-class family in the border town of Tome, New Mexico. Just as telenovelas focus on the triumphs and tragedies of a close-knit network of family and friends, Castillo's novel utilizes this trope to highlight the multidimensional relationships between a set of highly complex characters. Sofia's intimate courtship with Domingo, for instance, is described in great detail. However, where the telenovela would offer close-ups of Sofia's struggle to defend Domingo and marry him despite her family's disapproval (and her local priest's refusal to perform the ceremony), this scene is quickly developed in the text and followed by a more lengthy and intricate description of Sofi's oppressive domestic situation as Domingo's wife. Instead of focusing on our heroine's tear-stained face, mascara running and ruining a newly-applied coat of make-up, this narrative uses the trope of suspense and camerawork to build up to Sofi's moment of awakening. This chapter is entitled, "Sofia, Who Would Never Again Let Her Husband Have the Last Word, Announces to the Amazement of Her Familia and Vecinos Her Decision to Run for la Mayor of Tome," proclaiming the life of a headstrong woman who is awakened to her oppressive condition as Domingo's wife. The novel builds suspense describing how Sofi, "Sounding mysterious and full of importance all of a sudden," takes her time while pouring her comadre a cup of coffee. Withholding pieces of information (as serials often do to encourage viewers to tune in again), she slowly explains her political pursuits to her best friend. She begins, " 'Here's my idea,' Sofi said, sitting down, with a hand on her comadre's arm, certain that her plan was going to excite her friend as much as it did her. 'I have decided to run for mayor . . . !"(p.136). Almost as if delaying gratification, then, the close-up does not linger on this woman's physical beauty or on *la comadre's* reaction after receiving this news. Instead, a close-up draws attention to Sofi's composure and determination when relating her decision to her closest friend. Sofi has found self-confidence and is firm in her convictions, so the narrator explains how she sits down "with a hand on her comadre's arm, certain that her plan was going to excite her friend as much as it did her" (p.136). However, when *la comadre* criticizes Sofi's political aspirations, Sofi does not swoon or give in.

Rather than provoke empathy for a swooning protagonists, close-ups work to highlight Sofi's self-confidence and wit. Reappropriating the mechanism whereby women are often objectified on the screen, this novel describes moments of women's socio-political triumph and horror in great detail as if conducting an audiovisual close-up and mimicking the slow panning of the camera lens. Rather than objectify, the close-ups emphasize a character's vis-

ceral reactions when fighting against mainstream culture, or suffering from it, to shock the reader into understanding the gravity of each woman's situation.

The text's emphasis on oral history achieves similarly subversive ends. Just as telenovelas rely heavily on conversation to advance a plot and remind viewers of what they might have missed, *So Far from God* similarly references Chicanas' and Latinas' oral tradition via the "weaving together of various strands of oral history [i.e. gossip, storytelling, hearsay, and passing down of medicinal remedies] within the text" (Craft, 1996, p.206). Gossip in this narrative plays a crucial role to both inform readers of information previously denied them and to highlight an alternative source of women's power and agency. The orality of *chisme* is part of the allure of telenovelas and the reason for the character Domingo's popularity with the other characters in this text: "the favorite *chisme* that went around about him was that he had been lying down in the Silver City, running a gambling operation and living the high life . . . Domingo had found this addition to the story amusing, even something to boast about with his friends"(p.40–1). Gossip functions in this scene to keep the readers up to speed on information they would otherwise not have regarding Domingo's character traits. However, it also creates an aura of mystique regarding this character's unexpected return.

Though not always the case in reality, *chisme* in this text is as reliable (and at times helpful) as a tactical maneuver as it is a catalyst within serialized melodramas. When Sofi decides to run for mayor, for example, the reader is privy to the cultural capital of "*mitoteras*" or liars. As Sofi phones her *comadre* to share her news, *la comadre* admits to exaggerating some facts about the story, because "she wanted to heighten the drama of the 'emergency call' for when she repeated the story later to the other comadres"(p.133). Yet, Sofia takes *chisme* for granted and actually capitalizes upon it in order to begin campaigning; she knows that telling her *comadre* of her postulation for mayor was the same as telling the entire town. While orality as gossip, hearsay, or *chisme* may incite chaos and intrigue in telenovelas, it is resignified in this work for the sake of political campaigning, community-building, and as a reminder of the wit and humor inherent in women's storytelling.

Though adapting a melodramatic mode, close-ups, and oral history to write her telenovela, Castillo carefully differentiates her novel from the mass-produced serials at every turn. She distinguishes between this "Chicana telenovela" and telenovelas more generally, through an omniscient narrator who addresses the denigrating potential of mass-produced cultural products. Just as Cleófilas in *Woman Hollering Creek* suffers from her dominant reading of her serial, the narrator in *So Far From God* references Domingo's "demoral-

ized" attitude after tragically losing his daughters at the hands of mainstream culture: "he was just sitting there all demoralized in his Lazy Boy watching telenovelas, and predictions by *Walter* . . . or talk shows like *Cara a Cara*" (p.216). Domingo's attitude towards the end of this novel is of a man who, emasculated and ignored by townspeople and family members alike, is left to ponder the effects of his gambling problem. What is demoralizing, then, is not that Domingo is watching television programs, but that—like Cleófilas—he is passively absorbing the information. Warning against the correlation between this novel and Domingo's television programs, Castillo chastises his passive reception of the programs while celebrating Sofi and La Loca's desire to employ television and gossip as tactical maneuvers.

Like Cleófilas, Sofi's eldest daughter, Fe, garnered materialistic aspirations which led to her cancerous death. To comment upon the dangers of passively believing what television programs want to offer as the "American Dream," the narrator sarcastically explains that Fe was working at a factory where her health was seriously threatened because she "had only wanted to make some points with the company and earn bonuses to buy her house, make car payments, have a baby, in other words, have a life like people do on T.V." (p.189). It is no coincidence that Fe's passing was so anti-climactic compared to her sisters'. The narrator is nearly speechless when explaining that Fe was diagnosed with a cancer produced by the toxins she was handling at work; a job she acquired for the sake of purchasing her "long-dreamed-of automatic dishwasher, microwave, Cuisinart and . . . VCR" (p.171). The difficulty in narrating Fe's illness and death lies in its anti-climactic and ordinary nature. Unlike her sisters, "after Fe died, she did not resurrect as La Loca did at age three. She also did not return ectoplasmically like her tenacious earth-bound sister Esperanza" (p.187). Fe's suffering and death are not only social commentaries on the horrid working conditions in factories or *maquiladoras*. Her illness and death also serve to critique her generation's lust for individualism and material wealth at the expense of family and community. Like Cisneros, Castillo underscores characters' viewing practices and critiques their desire to attain a televised version of upward mobility or social climbing at the expense of one's cultural heritage and community. In doing so, Castillo encourages readers/viewers into more negotiated or oppositional interpretations of television programs.

Alternatively, Castillo adopts the form of the telenovela for the same reason that she speaks of "taboo" topics as commonplace: to discredit the stereotypes attached to them, while suggesting an alternative connection to and use for melodramatic serials. Castillo's creation of a resignified telenovela as one

that speaks to and about working-class families of indigenous ancestry is innovative, for it reappropriates "the product and instrument of the dominant classes and the servant of dominant ideologies" (Lopez, 1985, p. 6) and utilizes it to speak of the families, and particularly women, who are marginalized and/or silenced in telenovelas. However, the novel's imitation of the telenovela offers more than a progressive version of this genre; it refers to an equally hybrid audience or reader.

Castillo fashions a hybrid text which combines Saldívar-Hull's "feminism on the border" with the basic tenets of serialized melodrama, in order to reach a different kind of reader or audience: one who finds solace in the predictability of telenovelas's plots, yet demands a more complex, socially conscious, and empowered set of characters than those featured in most televised serials. Relying on the framework of serialized melodrama, Castillo privileges the experiences of disenfranchised characters whose struggles mirror those of her implied readers—Latinas/os living on the margins of U.S. mainstream culture and the "ingenious ways in which [they] make use of the strong, thus lend[ing] a political dimension to everyday practices"(de Certeau, 2002, p. xvii). She formulates an alternative teleNOVELa, which engages the basic tendencies of family melodramas "focused on the problems of love, sexuality, and parenting" (Lopez, 1985, p.150), while featuring complex, working-class Chicanas who live and die on their own terms. Rather than craft an "anti-telenovela," Castillo formulates the kind of subversive and complex melodramatic serial not yet available on television.

Franco (1986) laments that what is crucially missing in romance narratives and melodrama ultimately "is any form of female solidarity; the plots of both types of narrative reinforce serialization of women—the very factor that makes their exploitation, both as reproducers of the labor force and as cheap labor, so viable even in corporate society" (p. 137). Equally dissatisfied with telenovelas, Cisneros and Castillo utilize their creativity to revise women's reception of melodramatic serials, so that they no longer put women to shame, but push Latinas toward independence, self-reliance, and solidarity. Each writer recognizes women's need for solidarity and community and offer women alternative and empowering narratives with which to fulfill their need for melodrama, romance, gossip and women-centered coalitions.

References

Acosta-Alzuru, C. (2010). Beauty Queens, *machistas* and street children: The production and reception of socio-cultural issues in *telenovelas*. *International Journal of Cultural Studies 13*(2), 185–203.

Barrera, V., & Bielby, D. (2001). Places, faces, and other familiar things: The cultural experience of telenovela viewing among Latinos in the United States. *Journal of Popular Culture, 34*(4), 1–18.

Brooks, P. (1995). *The Melodramatic imagination: Balzac, Henry James, melodrama, and the mode of excess.* New Haven/London: Yale University Press.

Castillo, A. (1993). *So far from God.* New York: Plume.

Cisneros, S. (1991). *Woman hollering creek and other stories.* New York, NY: Vintage Books.

Craft, L. J. (Spring, 1996). *Testinovela/telenovela:* Latina American popular culture and women's narrative. *Indiana Journal of Hispanic Literatures, 8,* 197–210.

De Certeau, M. (2002). *The practice of everyday life.* Berkley, CA: University of California Press.

Franco, J. (1986). The incorporation of women: A comparison of North American and Mexican popular narrative. In T. Modleski (Ed.), *Studies in entertainment: Critical approaches to mass culture* (pp.119–138). Bloomington, IN: Indiana University Press.

González, J. A. (1992). The cofraternity of (un)finishable emotions: Constructing Mexican telenovelas. *Studies in Latin American Popular Culture, 11,* 59–92.

Hall, S. (1980). Encoding/Decoding. In S. Hall (Eds. et al), *Cultures, media, language.* (pp.128–38). London: Unwin Hyman.

Jones, R. & Oliver, M. (2007). Young urban women's patterns of unprotected sex with men engaging in HIV risk behaviors. *AIDS and Behavior, 11*(6), 812–821.

Latin American Subaltern Group. (1993). Founding statement. *Boundary,* 2(20), 110–121.

Lopez, A. (1985). The melodrama in Latin America: Films, telenovelas and the currency of a popular form. *Wide Angle, 7,* 4–13.

Moraga, C., & Anzaldúa, G. (Eds.). (1983). *This bridge called my back: Writings by radical women of color.* NY: Kitchen Table Women of Color Press.

Moraña, M., Dussel, E. & Jáuregui, C. (2008). *Coloniality at large: Latin America and the postcolonial debate.* Durham, NC: Duke.

Mulvey, L. (2001). Visual pleasure and narrative cinema. In M.G. Durham & D.M. Kellner (Eds.), *Media and cultural studies: Keyworks* (pp. 393–404). Oxford: Blackwell Publishers.

Pew Hispanic Center (2008). Quarter of Latinos get no health information from medical professionals, New Survey Finds. Retrieved April 13, 2010 from http://pewhispanic.org/files/reports/91pdf.

Phelan, J. (October 1998). Sandra Cisneros's 'Woman hollering creek': Narrative as rhetoric and as cultural practice. *NARRATIVE, 6*(3), 221–236.

Rodriguez, E. (2001). *The Latin American subaltern studies reader.* Durham, NC: Duke University Press.

Saldívar-Hull, S. (2000). *Feminism on the border: Chicana gender politics and literature.* Berkeley, CA: University of California.

Sinclair, J. (2009). The de-centering of cultural flows, audiences and their access to television. *Critical Studies in Television, 4*(1), 26–38.

Section IV

Enduring Issues for Television in the Era of Global Hybridity

13. *Globo vs. Sistema Brasileiro de Televisão (SBT)*

Paradigms of Consumption and Representation on Brazilian Telenovelas

Martín Ponti

In 2001 Sistema Brasileiro de Televisão *(SBT)*, a small contender within Latin America's media industry captured a large segment of audiences away from Globo, the leading multi-media conglomerate in Brazil. SBT's rise in ratings resulted in part to the successful telenovela *A Picara Sonhadora (The Mischievous Dreamer)*, whose plot centered on the life of a department store clerk and all the entanglements resulting from her having to live at her place of work. This story initiated the network's entrance into the competitive world of serialized melodramatic programming whose core audience would be envisioned by the network as belonging to the lower working classes. As I will argue, SBT marketed their serials to an economic niche group that the hegemonic media industry led by Globo traditionally ignored. Globo's programming, while popular, is nonetheless ideologically constructed to play on the fantasies and values of the upper middle classes. Therefore it is my intent to analyze the success of *A Picara* in its ability to cater to a previously ignored economic nich group, as the confluence of various corporate decisions and socio-political events. Ultimately the convergence of the social and the corporate allowed SBT to capture viewer's attention away from Globo's programming.

In terms of corporate decisions, the reference is to SBT's deal with Mexico's Televisa. This joint venture granted SBT access to Televisa's successful scripts, while also providing technical and artistic support for reproducing

Televisa's telenovela model in Brazil. SBT selected *A Pícara* due to Televisa's categorization of this serial as a product aimed at audiences from the lower socio-economic classes. SBT's decision to produce a telenovela conceived as a product for a specific economic niche group comes as a clear response to Globo's overt marketing to an audience whose ideologies resemble those of the upper middle classes. As it has been previously documented (O'Dougherty, 2002), Globo's programming targets and plays on the fantasies of the middle class' inclusion into the upper and elite classes. I will examine how the poor and the working classes are transformed into participants-viewers and consumers of the Brazilian industry through SBT's selection of programming and corporate alliances.

It is not coincidental that this interpellation or inclusion of the working classes is addressed by SBT's programming during the early-1990s, when Brazil's economic collapse further widened the gap between the working and middle classes. Nonetheless, the representations of these economic events by Globo were presented as events affecting only the upper middle classes (O'Dougherty, 2002). Globo's exclusion became evident to other networks such as SBT who was able to capitalize on Globo's failure and began addressing the needs of a neglected audience. In order to make this case, the analysis here will center on the period between 1990–2001. These years corresponded to the rise and fall of Fernando Collor de Mello's presidency along with his failed economic plan, Globo's exclusion of the lower social classes from its programming, and finally SBT's strategic selection of telenovelas aimed at Globo's ignored audiences. Gaining these audiences was a way of establishing ratings for a relatively new network. This chapter focuses on *A Pícara Sonhadora* because it was the first telenovela produced by a Brazilian network to specifically target the lower working classes. The plan by SBT created a precedent for the network to follow and for its competition to consider. This paper focuses on media's prevailing economic discourses. Part of the analysis here also rests on the role played by telenovela models-paradigms in mediating viewers and industries. Since there are various telenovela models I find it important to define these models in relation to the needs of this essay.

The Telenovela Paradigm

Sex, tears, love, and vengeance sum up some of the basic elements found in most Latin American telenovelas. The conjunction of these emotions coupled with technological developments, and formulaic plot lines have turned these melodramatic serials into widely consumed and exported products of Latin America's cultural industry (Allen, 1995). Telenovelas as a whole do not

encapsulate univocal messages emanating from one hegemonic industry. The industry is made up of multi-lingual, multi-national corporate networks that might collaborate on certain grounds but ultimately act independently based on their own economic models and paradigms of what constitutes a telenovela.

Despite over fifty years of existence, the telenovela paradigm, with its strict formulaic plots, have for the most part remained untouched. What has varied is the network's approach to the formula. For example, telenovelas produced by Televisa have been described as extremely weepy (Lopez, 1995), whereas those produced by Globo incorporate elements of realism, and other qualities, while still maintaining its melodramatic mode (Mazziotti, 2006). These models have defined the telenovela for its networks and equated each network's formula to its specific country. Also, telenovelas are serialized narratives produced in Latin America by Spanish-language and Portuguese-language television networks, where the narrative comes to an end after a predetermined amount of episodes. Most telenovelas range between 90 to 150 1-hour episodes that air throughout the day, including during prime-time. Soap operas such as those produced in the United States, the United Kingdom, and Australia, have an indeterminate amount of episodes. Furthermore, Anglo soap operas are a female 'housewife' genre, whereas telenovela audiences are more heterogeneous, yet they can vary depending on the airing of the telenovela (Mumford, 1995). For example the five and six o'clock telenovela is aimed at pre-teen audiences of both sexes and the 9 o'clock telenovela is projected to the coveted prime-time audience groups of adults between the ages of 18 to 35. Although telenovelas and soap operas share a common history found in the radio dramas of the 1930s, there are clearly marked differences (Estill, 2005; Mazziotti, 2006).

Another common defining element of the telenovela and its predecessors is the radio serial and its reliance on the melodramatic genre whose thematic premise is a drama of identity, framed within a love story (Brooks, 1976). In melodrama, the search of one's self takes place in a dualistic world where good always triumphs over evil. Specifically, melodramatic plots situate love struck couples in a society where sentiment and love fulfills all the necessary requirments for narrative closure. The couple's ensuing triumphant union not only closes the narrative, but it also restores the order temporarily threatened by its evil characters. Through the romantic union of the couple and the downfall of the evil characters, melodramatic narratives serve as moralistic tales showcasing the triumph of heterosexual love over adversity, and anything that may challenge the status quo is suppressed.

Equally important as is the telenovela paradigm in understanding its use and deployment by the media industry to construct a product easily identifiable for and by its consumers, it is also necessary to interject that within the

criticism and academic inquiry of telenovelas there has also existed a paradigm of criticism. This criticism has evolved from defining the telenovela as a dangerous ideological tool of capitalism, to its ability to create and forge an identity. It is not my goal to provide the history or the backdrop of this evolution of criticism, but rather to guide and situate the reader within the prevailing discourses and how this essay positions itself vis à vis the existing discourses. Despite the success of the telenovela to situate itself as the staple of Latin American television, there is a tendency to deride this tele-visual genre due to a "perceived" lack of artistic and cultural value (Baldwin, 1995). Later, popular forms of serialized tele-visual narratives were regarded valuable cultural products (Allen, 1995; Ang, 1985; Modleski, 1982; Mumford, 1995). Within the Latin American context, investigators such as Jesús Martín-Barbero (2000) and Nora Mazziotti (2006) turned the telenovela into a legitimate object of study. Mazziotti focused mostly on cataloguing the various telenovela models developed by the major producers of serialized fiction: México, Venezuela, and Brazil, while also positing the social practices surrounding telenovelas. While the work of scholars like Mazziotti shed light on such important issues, there is a lack of attention on secondary media players such as SBT in their attempts to situate themselves in a market dominated by media sources with a long history of governmental support. In part my research wishes to raise questions concerning how minor media players navigate saturated airwaves and create and secure an audience without the infrastructure and support of their stronger counterparts.

Globo and SBT, the Exclusion-Inclusion of Lower-Working Classes

Throughout the 1990s Brazil experienced a series of political and economic events that framed and dictated the nation's television programming. The airwaves were saturated with the return of democracy and the triumph of Collor de Mello's presidency. This initial period of hope was soon overshadowed by staggering inflation, the ousting of Collor de Mello due to corruption charges, and the disintegration of the Brazilian banking system. Brazil's turbulent political and economic situation was mediated by television giant Globo, as a transgression perpetrated not against the country as a whole, but as an event affecting mostly the upper middle class (O'Dougherty, 2002). While Globo reaches 90% of Brazilian households, the network envisions itself as a crusader of the upper middle classes. Its nightly telenovelas construct a viewer-citizen identity that envisions Brazil as an opulent progressive country led by an elite middle class (Straubhaar & Viscasillas, 1991). As I argue, Globo's overt

catering to this small affluent minority led other smaller networks vying for a share of Globo's audience to cater to the ignored masses.

Globo began as a small family-owned television station, not linked to any political or military regimes. This separation between media and government was short lived, but it was possible since funding and investments came from foreign investors. In 1962 Roberto Marinho started TV Globo through financial and technical support from the Time-Life Corporation. This audio-visual venture helped TV Globo establish the needed infrastructure to unite all of Brazil, at least through television, and help propagate United States consumer goods (Fox, 1997). However by 1971, Globo achieved network status and consolidated production mostly of telenovelas and news. During this year, Globo was able to produce up to14 hours of original Brazilian programming, enabling Marinho to push out U.S. programming from prime time hours and implement his personal project-model of programming known as *Padrão global de qualidade* (Fox, 1997). This model of *global quality pattern* set strict guidelines for television programming. Some of the guidelines related to technical principles, but the overarching principle had an ideological tone. The *padrão* model of programming was instituted as a favor to the government for financing the buyout of Time-Life, enabling the push out of American programming and products and forging a new relationship between the state and the media (Fox, 1997). The main focus of Globo's programming became marketing Brazilian products and *Brazilianess*. Brazilian identity would be mediated through the goals and aspirations of the upper middle class and foregrounded through state intervention. Brazil would be marketed through one of Globo's mottos *"Brazil, as it should be."*

State intervention reached its peak after several military coups beginning in 1964. In order to maintain power, the regime used corporatist institutions such as mass media to mobilize public support and to assert their legitimacy. Case in point, the last two military governments of Geisel and Figueiredo (1973–1985) perceived citizen discontent initially due to faltering economic growth. The regime's response was to open the regime to more inclusionary policies via symbolic inclusion through the media (Straubhaar, 1989). Several campaigns were launched to make Brazilians feel proud about their country. Slogans such as "Este é um pais que vai para frente" (This is a country that progresses) were constantly displayed on television. According to Straubhaar, Brazil's most powerful network, Globo TV, united with Geisel and Figueiredo by incorporating these feel good campaigns within their programming. The telenovela became Globo's and the regime's favorite outlet by incorporating images of a "positive Brazil" which has been able to recover economically (Straubhaar, 1989).

However, this close relationship between Globo and the military regime did not prove eternal. The periods of rupture can be traced between 1974 and 1985, during the transition to civilian rule. During the transitional period many sociopolitical movements began demanding and campaigning for elections of civilian candidates. State governors, local leaders, regional media (excluding Globo), and mass street demonstrators led these movements. For more than four months in 1984, they took to the streets to challenge the regime's leadership. Many non-Globo newspapers and radio programs covered the demonstrations while Globo continued to maintain minimal and "negative" coverage of the events. The constant and visible coverage by secondary independent media created enough pressure for Globo to reassess their practices. Just three months after the January demonstrations, Globo aired a one hour special documenting and presenting a major election rally in Rio. Many segments were re-broadcasted throughout the day, even interrupting their prime-time telenovela lineup (Straubhaar & Viscasillas, 1991).

One hypothesis for this shift in politics on the part of Globo could be its realization that they were falling behind its audience. As stated by Straubhaar, it must be remembered that although TV Globo has generally created consensus by exercising ideological leadership through their widely watched programs, the network is above all a commercial enterprise, and they were not willing to alienate much of its audience for political causes which seemed to be failing. Also, it is also important to note that Globo's frustration with the regime and its granting of television licenses to other networks such as the Manchete Group and SBT led Globo to distance itself from the state. If the military regimes were not going to help Globo maintain their media monopoly, then in turn, they would not support a failing regime.

Globo's distancing from government was further evidenced by their support of middle class struggles during the Collor de Mello's presidency. Fernando Collor de Mello took office in 1990 and he was the first democratically elected President of Brazil in 29 years. His presidency soon faced the challenge of battling inflation. Collor's answer was to launch the "Collor Plan," whose goal was to reduce the circulating money supply by forcibly converting large portions of consumer bank accounts into unspendable government bonds (O'Dougherty, 2002). At the same time President Collor increased the printing of currency, a contradictory measure to combat inflation. However, the presidency's most polemic economic plan, which eventually led to Collor de Mello's overthrow, was the freezing of bank accounts. Anyone who had more than 1,200 *cruzeiros* (the Brazilian currency) had their bank account frozen for 18 months. This measure was taken in order to avoid currency flight (Baker, 2009). However elite groups were informed prior

to this change and placed their money in foreign accounts. Brazil became divided after Collor's measures. This created a social divide among the rich and the middle class, since the middle class felt punished and betrayed by the ruling elite and the government. This discontent from the middle class led to the ousting of the Collor de Mello presidency. His presidency suffered the most when in 1992 Collor was accused by his brother Pedro of corruption. The investigation was headed both by the Brazilian congress and the press. In October of that same year, the Brazilian Chamber of Deputies voted to bring charges against him, which eventually led to his impeachment and the loss of rights to hold political office for eight years. The media-driven impeachment and trial concentrated mostly on the plight of the middle class (O'Dougherty, 2002). The middle class was victimized and portrayed as the real victims of Collor's mismanagement and corrupt policies. The working class and the poor were never interpellated in the corruption charges. The media and particularly Globo focused on how the middle class, their targeted audience, lost socioeconomic standing during Collor's presidency. The sole focus of the media on the upper middle class totally disregarded the experiences of the lower working classes. Although neoliberalism created and helped fuel this middle class struggle, neoliberalism also helped to bring into the national imaginary the plight of the economically ignored. This inclusion was made possible by the break up of the media monopolies through sales of government owned television channels, which in part were bought by Silvio Santos, allowing him to create SBT.

The most recent rendition of *A Pícara* was produced by Globo's home rival, the SBT network. Silvio Santos is the owner, CEO and the leading on-screen talent of the second-ranked broadcaster SBT. Their unofficial motto is "we're number two and proud of it." SBT began capturing audiences in 1981 as Santos hosted a 12 hour Sunday variety show. Santos' show was the vehicle for two private lotteries begun by Grupo Silvio Santos, called *Baud a Felicidade* (treasure chest of happiness) and *Telecena*. The dream of overnight economic success is a constant theme of the network since its anchoring programs are lottery shows. Also, the public is very aware of Santos overnight rise to fame and fortune—he went from underemployed street vendor to CEO. Due to these lotteries, Santos' group has grown into a $1.5 billion-a year industry, of which SBT retains $400 million from sales and ad revenue. Such growth has led advertisers to accept that SBT's lower-middle income core demographics merit attention. However in 1990, Santos' most significant deal was with Televisa, Mexico's and Latin America's largest Spanish-language media conglomerate. Both networks signed a $200 million dollar contract, granting SBT the right to produce in Brazil any telenovela script owned by

Televisa within a ten year period (Cajueiro, 2001). Silvio Santo's SBT gained interest in Televisa after successfully importing dubbed Mexican telenovelas. The rating for each imported novela ranged an average 11–16 points, significantly high numbers translating into a growing interest by the sponsors. Economic returns were substantially rewarding for SBT since it required very little investment in importing already produced telenovelas. Santos' familiarity and experience with Televisa's products pushed him to enter the competitive world of telenovela production. SBT began producing their first telenovela based on the script of one of Televisa's former hit, *La Pícara Soñadora*, which translated into Portuguese as *A Pícara Sonhadora*. With this first production, SBT was able to steal a share of Globo's audience by producing Televisa-style telenovelas that are known for their 'baroque scenery' (Martín-Barbero, 2000) and their extreme weepiness, in comparison to Globo's productions known for their realism and openness towards taboo topics. Besides thematic similarities, SBT followed Televisa's production patterns closely (Cajueiro, 2001). Also following Televisa's production strategies, SBT's first and subsequent telenovelas capped their expenses to a maximum of $43,000 per episode. This was almost half of what Globo was spending on a single episode at the time. In order to limit expenses, each telenovela was limited to a range of 90 to 96 one-hour episodes, of which only 35% of the scenes were shot on location. The cast must be kept under 30 members, containing only a handful of recognized actors, preferably ones that have not worked recently, enabling the company to limit/control wages. All in all SBT built their telenovela business by following the rule of quantity, speed, and cost, allowing them to produce a budget conscious product that can yield high profits through a loyal viewership.

SBT and Melodramatic Consumption

In his introduction to melodramatic serials, Allen (1995) characterizes the genre of telenovelas as a tool of modernity that has operated throughout Latin America. Dramatic serials have played a key role in transmitting ideologies such as consumer capitalism. For Allen the fact that serials began as products lauched by corporations to push household products rather than promoting artistic pursuits, have turned serials into ideological vehicles for modernity. Furthermore, because Latin American telenovelas are episodic and are seen over a period of time, they have restructured viewers' daily activities around the need to consume a cultural product and the consumer goods that these products launch through advertisement (pp. 1–24). Allen's consideration will be taken up within this chapter, since through the unpacking of plot, charac-

terization, and setting it is possible to see this product as a tale for and by modernity. This occurs through the main character's over-acceptance of a consumer identity that is transmitted to audiences who identify with the leading character of the telenovela.

Specifically, SBT's *A Pícara* tells the love story between Milla and Carlos. Milla Lopes, a young hard working, but penniless girl decides to live in a department store since she cannot afford housing. During the day, Milla works in the Sole-Rockfields toy department in order to pay her costly law school tuition. Once the department store closes for the day, Milla enjoys all the goods offered by the shopping center without having to pay for a single item, since the only security guard on premise is her uncle. Nevertheless, Milla's honesty is unquestioned since she keeps records of all the items she uses in a little book to be paid after finishing law school. Before that ever happens, Milla falls in love with another toy clerk named Carlos. Little does she know, Carlos' real name is Alfredo Rockfield, the future heir to the Rockfield fortune. After all identities and living arrangements are revealed, the couple marries and lives happily ever after. In terms of Milla's unpaid expenses, the Rockfield family generously forgives Milla's debt, since she is now a Rockfield and everything that she has done is simply the act of a *pícara*, a mischievous act as referenced by the title. It is worth mentioning that the title of this telenovela created some controversy due to the uses in Portuguese of the word *pícara*.

While the word *pícara* exists in the Portuguese language to mean mischievous, it is uncommon. In colloquial Brazilian Portuguese the derivation of the word *pica* from *pícara* is used in place for a vulgar form of the word penis. Due to this meaning, before the telenovela aired it created a series of spoofs and a lot of media buzz since most people found that the title *The Dreaming Penis* was not apt for a serial targeting a younger female teenage audience. Nonetheless the decision to keep the original title was a response by Santo's telenovela executives who wanted to reproduce the Mexican version, which in its original airing proved to be very successful for Televisa. The decision taken by SBT executives reinforced the corporate imperative of results based on former and verifiable success, versus the importance of social, cultural, and linguistic relevance. However for this essay the spoofed title is very revealing since Milla will *penetrate* a higher economic sphere through marriage and her physical insertion in a space created to index the lifestyle of a higher class, as shopping centers do. In a sense *pica* stands in for Milla, and what the spoofs have done is transpose the male organ as a feminine tool, which is supported linguistically since the gender of *pica* in Portuguese is also feminine. The linguistic play on words is ultimalty reducing the male experience in favor of the feminine through the resignification of the term *pica* and validating the female experience over the male which modernity has limited. Specifically

though the analysis of setting, plot, and characterization, I argue that *A Picara* is a vehicle of modernity in its advancement of a capitalist ideology framed within the story's discourse of a strict work ethic, the dream of a liberal education, and the drive for personal independence and progress. However this tale of modernity supports the gendered experiences of women. The ideology of modernity within the structural elements of the story come into play with the embedded ideology found in the structure of the story while also found in the industry and the nation undergoing neoliberal restructuring. In order to elucidate convergence of modernity with neoliberal restructuring, this essay will first discuss an analysis of the structural elements of the story (setting, plot, and characterization) and will conclude with an explanation of the industry undergoing neoliberal changes.

Setting and Characterization: Locating the Consumer-Viewer

SBT captured Brazilian audiences not by producing high quality programming like Globo, but by turning lower socio-economic viewers into virtual consumers of mass produced products. It is suggested that the audience's identification with the main character, who inhabits a department store and consumes its products frenetically, allows the viewer to visually consume, as does their heroine. Case in point, the majority of the scenes where Milla is consuming the store's products occur at night, when she is alone in the store. The only witness to Milla's consumption is the viewer, a virtual accomplice accompanying Milla on her nightly shopping sprees. The department store becomes the site where Milla and the viewer revel in the enjoyment of consumption and the status and benefits that these products provide. It is in the store where Milla is able to have a space to live, study, work, and ultimately find a husband who loves her and allows her to continue shopping. What enables this happy ending is Milla's identification with the consumerist lifestyle, which allows her to reach her dreams. Her identity as a consumer serves as a model for those who identify with the leading character.

Equating the department store as the space that helped forge a consumer identity is well documented (Nava, 1997; Felski, 1995). Traditionally the department store has been the institution most closely identified with the creation of modern consumerism. As stated by Nava:

> The department store was from the late nineteenth century central to the iconography of consumer culture; it exemplified the ubiquity of the visual in the new 'scopic regime,' and should be read as one of the archetypal sites of

modernity which both produced and was produced by the experience of
women. . . . Woman played a crucial part in the development of these tax-
onomies of signification—in the acquisition of goods which conveyed symbolic
meanings about their owners—since it was women who went to the depart-
ment stores and did the shopping (p. 64).

Nava's argument is grounded on a larger gendered analysis that validates
women's participation within modernity. For Nava modernity has typically
emphasized the male urban experience. However by focusing on consumption,
particularly in the experience of the department store, which is a modern con-
struct, woman's participation within modernity is made visible. As Nava sug-
gests, as consumerism expanded throughout the latter part of the 19th and
20th century, women moved into the public spaces such as that of the depart-
ment stores, which in turn invaded the interiority of the home with mass pro-
duced goods. Therefore for Nava, consumerism and consumption are key
terms associated with women's entry into public life, a phenomenon she
attributes to modernity. In this chapter, modernity is a "constructed narrative"
(Nava, p. 57). It will be defined as the constant search of progress, exempli-
fied in the values of consumerist middle class society.

Specifically, the department store permitted women's entrance by direct-
ly targeting them as shoppers, and as a work force, as is also the case with Milla.
These particular shopping venues simulated the entrance of lower socioeco-
nomic class women into the middle class by targeting lower middle class
women through objects perceived as upper middle class items (Nava, p. 61).
Objects for sale were turned into spectacles, worthy of theater-like presenta-
tion. Department store design and construction evoked other sites of specta-
cle such as the museum or exhibition halls which housed under one-roof
unheard of quantities of goods, thereby allowing customers for the first time
to physically see, touch, and try the products without any obligation of pur-
chase. Mass consumption turned department stores into a tourist attraction
and the mere act of the spectacle implies consumption in the visual form.
Fashion displays, free make-up samples, fancy coffee shops and restaurants were
all included in the design of the department store to allow customers the
opportunity to visualize themselves using and participating in these pleasures
in order to index the lifestyles of the middle class. Similarly, this is what Milla
does for her audience. As she consumes each product she is modeling the
behavior expected of her audience. It is not coincidental that Milla's selection
of specific dolls became instant sold out items in real life, since its audience had
to also consume what Milla was buying. Also the shopping center, by offer-
ing diverse buying opportunities, created an urban public female made to 'feel
at home,' since the merchandise around her belonged to the private realm.

Targeting female shoppers and female employees was intended to make women feel comfortable for socializing and above all spending money. Whether imaginary or real, the capacity to socialize and consume within the confines of the department store constructed a female identity in relation to their private-public spheres and the objects perused or purchased (Nava, p. 72).

Reflecting upon public and private spaces leads us to establish a connection between Habermas' (1991) conception of private and public spheres. Habermas traces the emergence and development of the terms public and private taking into account a linear historical phase. A neat historical procession of events clouds the terms private and public, when they come into contact with an industrial society. Habermas explains the mutable characteristics of the terms through the following example. Generally, state buildings considered public are not always opened to the public since they house personal and private information. Besides reflecting the mutability of the terms, the example displays how the terms not only oppose each other, but also depend on one another. To exemplify, Habermas distinguishes how citizens in ancient Greece participated in the political (public) scene by obtaining private autonomy over their household, by participating as masters of their home within a patrimonial slave economy. The public here functions as a 'status attributing factor,' whereas, during the Middle Ages, it constituted a social sphere. According to Habermas (1991), representation of the self, or a valuable cultural production, has since the Middle Ages expressed itself within the public realm. Worthwhile representations make themselves present only in the public and never in the private. Habermas' last point raises serious problems by diminishing the value of cultural artifacts created within the private realm as not being worthy or possessing the capacity of transferring outward successfully. However because the term public is not strictly fixed and depends on the private, one can argue for public experiences as valuable as those made in public.

Similarly in *A Pícara,* Milla's domestic circle is centered in a public area as is the department store. Milla's interiority is made public visually as it reaches the viewers home and the viewer's private desires are realized along with the protagonist through their identification. In *A Pícara* we can clearly see how the public sphere ultimately depends on the private. Such is the case with Carlos' father who is publically the person in charge of the department store. In reality, the father's public corporate persona made visible within the sphere of the store is subjugated to the rule of his mother. It is the matriarch who secretly runs the store from the sphere of the home. Therefore, it is her position that allows her to defend Milla when the truth about her status is revealed. Ultimately it is the matriarch who operates from her home who is responsible for the department store; and she will be the one to intervene and defend Milla when the truth about her status is revealed. It is the matriarch

of the family who understands Milla's manipulation of the public sphere to benefit her private concerns and realizations. The conflation of the private and the public can also explain the success of the telenovela which is predicated on its viewer identification with a consumer-viewer who will make public from the space of the home-department store, the economic desires of an underrepresented class. When Milla shops so do the viewers. Specifically, consumption turns the private into a public affair, where various social statuses come into contact.

The working class achieved social emulation and status through their buying experiences within the department store. As stated by Vleben (1953), the consumer establishes social status by imitating, equaling, or attempting to excel the buying habits of people in higher economic status. Similarly in *A Pícara*, Milla strives to enter the middle class by studying law, but meanwhile she wants the benefits of that class, but cannot afford the lifestyle. In order to alleviate her needs, Milla opens her own line of 'credit' or 'loan' that she intends to pay back once having completed law school. The middle class commodities consumed by Milla not only help her to live a better life, but how she uses the goods creates an idealization of such social class. For example, our pícara believes sleeping each night on a different bed guarantees a better tomorrow. The more luxurious the bed and its accompanying beddings, the easier it becomes to face the cruel world in the morning. According to Milla, quantity and cost results in happiness, a theory that owners of shopping centers intend to expand to the masses through sales. In other words, for consumers, an upper middle class lifestyle can be achieved through sales.

Milla as the Model of Middle Class Behavior

In *A Pícara*, middle class does not exist as an actual social class, but functions as an ideal worth reaching. Within the Brazilian context, middle class is defined as a socioeconomic group that rejects governmental institutions, shows aversion towards politics and holds a strong consumerist attitude. The excess or the intensity of consuming is the indispensable marker of middle class identity (O'Dougherty, 2002). Belonging to the middle class in the early nineties meant traveling and consuming outside of national borders. Family trips to Disneyworld, with an obligatory stop in Miami to purchase household appliances to take back to Brazil, became the norm for those who could afford to travel. Brazil's economic situation led the middle class to consume frenetically. This accumulation of goods would counterbalance the loss of economic status, in an attempt to reclaim the middle class status that the economic plan executed by the presidency of Collor de Mello, in the early nineties

helped to disintegrate (O'Dougherty, 2002). Consuming outside of Brazil was a conscious political move on the part of the middle class, to show the government that they were tired of their archaic protectionist laws, high prices, inefficiency, and corrupt system. Here, in a way, the middle class was advocating for neoliberal restructuring. Furthermore trips outside of Brazil served as a rite of passage for the middle class, as a way of acquiring cultural capital associated with modernity, and allowing them to participate within a transnational social circuit, which would situate Brazilians in the first world. Because saving was impossible, middle-class people found themselves dragged into frenzied consumerism characterized by the stockpiling of goods. However as argued in this essay, viewers of *A Pícara*, the lower socio-economic classes, are able to shop frenetically, as does the middle class, but the former achieve this consumption visually through the medium of television. In turn this viewership allows SBT to gain a loyal audience. SBT created the possibility for its ignored viewers to visually shop through audience identification with Milla and the access she has to the department store.

Actually, characters in the telenovela never reach middle-class since they simply jump from poverty to wealth. Middle class exists only as a dream never able to materialize. All the characters in *A Pícara* fit into the lower working class or fit into the wealthy realm. The portrayal of the working class fits within two categories. Either they work arduously to reach financial success or they steal in order to make easy money. Our *pícara* Milla embodies both combinations because she works in a toy store during the day, goes to law school for an education and at night she "borrows" merchandise enabling her to envision herself as middle class. Constructions of the wealthy characters similarly follow a dual vision. Either they are extremely generous aristocrats, or they embody evil social climbers. The telenovela characterizes those people who become rich without a proper education as social misfits and opportunists like the Luchini family. The Luchinis, an Italian family who immigrated to São Paulo represent the social misfits due to the patriarch's lack of education. Although they amass a great fortune from their pasta factories, they cannot achieve the social status of the aristocrats, and thus are perceived as the "petty bourgeoisie." Other characters make fun of their 'nouveau riche' status. In *A Pícara*, selling pasta is not a prestigious job compared to selling mass produced commodities in a department store. Pasta is simply part of daily sustenance, a raw material, but mass produced merchandise and a liberal education allow people to reach a dream and to socialize outside of their own class.

The telenovela presents formal education as the only acceptable way to ascend socially. High society does not frown upon Milla once she enters that class because she received an education. *A Pícara Sonhadora* presents the

idea that education provides people with an appropriate degree of socialization, particularly necessary for immigrants. Milla's uncle is an Italian immigrant who feels blessed living in Brazil because of all the opportunities the country has given him. Although he has no home or money, he feels he has been able to raise Milla with the "right" values and within the space of the department store, offering Milla a myriad of products, a home, and a space for studying. His acceptance of her living in the store while working her way through school suggests that education and consumtion is the dream of the working immigrant class' inclusion in society. Milla's clear record keeping is what keeps her illegal activity "legal." She constantly repeats that what she is taking from the department store without buying it, in reality is being consumed as "credit" which she intends to pay back with interest, once she graduates from law school. And what better way to end the story than to have someone pay for your credit debt. It is also interesting to note that Carlos's character is also pretending. By pretending to be a simple worker, in a sense he is policing not only his workers, but he is also learning about their lifestyles and taste. In other words Carlos is learning marketing traits that will enable him to run the company much more successfully once he takes control of the store. Also the story suggests Milla will be working as a lawyer. It is interesting that the romantic story combines both law and consumption along with the policing of the social classes. Through her knowledge of the law and her position as a new elite, consumption would be protected and increased through her understanding of the laws. This is pure neoliberalism at work, the institution of the law protecting the free market. If we were to extrapolate Carlos' knowledge of the working class, added to Milla's personal knowledge of the poor, her knowledge of the law, and her new economic status, it can turn Sole Rockfield's department store into one very successful economic venture.

The story's plot and thematic development reproduces western values and desires inscribed within the grand narratives of modernity, whereby the fulfillment of progress and order are achieved through the tenets of education and a strict work ethic. However, the telenovela's deployment of these master narratives of modernity is extended through a transnational media industry undergoing neoliberal transformations. According to David Harvey (2005), neoliberalism is an economic practice aimed at liberating entrepreneurial restrictions that hinder free trade. Instituting a framework of a freely functioning market enables the state to secure individual private property rights, and individual liberties that translate to entrepreneurial freedoms. Neoliberalism glorifies the entrepreneur as the ideal citizen who through its investments and capital accumulation encourages the disbursement of wealth among the various social levels both locally and globally. This type of citizen

can only surface within a state that protects 'freedom' through the maintenance of a strong military and legal-legislative body. The road to a neoliberal state include turning over state owned and regulated enterprises to private business. Neoliberalism sought this separation since powerful corporations in alliance with an interventionist and a regulatory state were seen as socially unjust and oppressive, at a time when the West was 'threatened' by communism and fascism. The withdrawal of state intervention has consistently retracted throughout various nations since the 1970s. The retreat is characterized by massive deregulations, privatizations of national resources-industries, and the gradual decline of state intervention-investment in social programs (Harvey, 2005). The state's retreat would economically create a trickle down effect, benefiting society as a whole if productivity is continuously increased without the intervention but rather the support of the state. The trickling down of wealth would not only eliminate poverty domestically but also worldwide, since free market and trade create interdependent transnational economies dominated by global entrepreneurs. Beginning in the late eighties and reigning throughout the nineties, the neoliberal model replaced and attempted to end the active involvement of the state and its responsibility to provide for its citizens (Harvey, 2005).

Latin American television industries such as SBT, evinces neoliberal ideologies and practices that coalesce within the modernizing goals of its programming, such as *A Pícara*. Its plot shows elements of a disjunctive ideological construct that can deploy multiple hegemonic processes. Ultimately, *A Pícara*'s plot search for modernity constructs viewers-consumers within the confines of the Brazilian nation, while the needs of the neoliberal television industry producing *A Pícara* must re-inscribe the telenovela not as a local or national product, but as a global product that can be placed within a diverse market. The transnational industry producing *A Pícara* forgoes the national in favor of tapping into a continental market that can situate its product within a global economic order of television distribution. The disjuncture created by the telenovela's need to produce local programming, which can be distributed massively within a competitive continental market extending from Latin America to other global television networks, is ultimately linked by the common thread of consumption.

Conclusion

The Brazilian network SBT discovered a way to produce a successful telenovela that targets female audiences from lower socio-economic levels whose dream, at least as it is presented by the telenovela, is to reach middle class standing.

Through *A Pícara*, SBT provides its viewers the opportunity to symbolically participate publicly by urging them to purchase their products, either visually, or in actuality, while also allowing them to socialize. In turn for providing women a vision of class ascension, the network gained high profits, thereby implicating everyone in the process of modernity. *A Pícara Sonhadora* is a clear example of melodrama that interpolates the traditionally ignored lower working classes, but at the same time it serves the needs of a neoliberal middle class which ultimately wants to maintain their control-status. Their status is maintained by acknowledging that the working classes also spend, buy, and use credit. In turn the working classes become dependent on the upper middle classes to finance their dreams, keeping them in a never ending cycle of debt and aspirations. SBT's influence in media has been evinced in its ability to reach a segmented audience by drawing on their dreams and aspirations.

References

Allen, R. C. (Ed.). (1995). *To be continued: Soap operas around the world.* NY: Routledge.

Ang, I. (1985). *Watching Dallas: Soap opera and the melodramatic imagination.* London: Methuen.

Baker, Andy. (2009). *Market and the masses in Latin America: Policy reform and consumption in liberalizing economies.* NY: Cambridge University Press.

Baldwin, Kate. (1995). Montezuma's revenge: Reading Los ricos también lloran in Russia. In Allen, R.C. (Ed.), *To be continued: Soap operas around the world* (285–300). NY: Routledge.

Brooks, P. (1976). *The melodramatic imagination: Balzac, Henry James, melodrama, and the mode of excess.* New Haven, CT: Yale University Press.

Cajueiro, Marcelo. (2001). SBT, Televisa ink pact. *Daily Variety, 271,* 12.

Estill, A. (2005). Closing the telenovela's borders: 'Vivo por Elena's' tidy nation. *Chasqui, 29*(1), 75–92.

Felski, R. (1995). *The gender of modernity.* Cambridge, MA: Harvard University Press.

Fox, E. (1997). *Latin American broadcasting: From tango to telenovela.* Luton: University of Luton Press.

Habermas, J. (1991). *The structural transformation of the public sphere.* Cambridge, MA: MIT Press.

Harvey, D. (2005). *A brief history of neoliberalism.* Oxford: Oxford University Press.

Lopez, A. M. (2005). Our welcomed guests: Telenovelas in Latin America. In R. C. Allen (Ed.) *To be continued . . . Soap operas around the world* (pp. 256–275). NY: Routledge.

Martín-Barbero, J. (Ed.). (2000). Art/communication/technicity at century's end. *Politcs in Latin America.* NY: St. Martin's Press.

Mazziotti, N. (2006). *Telenovela: Industria y prácticas sociales.* Bogotá: Norma.

Modleski, T. (1982). *Loving with a vengeance: Mass-produced fantasies for women.* Hamden, CT: Archon Books.

Mumford, L. S. (1995). *Plotting patriarchy: Soap opera, women, and television genre.* Bloomington, IN: Indiana University Press.

Nava, M. (1997). Modernity's disavowal: Women, the city and the department store. In
 P. Falk & C. Campbell (Eds.), *The shopping experience* (pp. 56–91). UK: Nottingham
 Trent University.

O'Dougherty, M. (2002). *Consumption intensified: The politics of middle-class daily life in
 Brazil.* Durham, NC: Duke University Press.

Straubhaar, J. (1989). Television and video in the transition from military to civilian rule
 in Brazil. *Latin American Research Review, 24,* 140–154.

Straubhaar, J. D., & Viscasillas, G. (1991). The reception of telenovelas and other Latin
 American genres in the regional market. *Studies in Latin American Popular Culture,
 10,* 110–125.

Veblen, T. (1953). *The theory of the leisure class.* NY: Penguin.

14. "Trashy Tastes" and Permeable Borders

Indian Soap Operas on Afghan Television

Wazhmah Osman

It has been described as "addictive like Opium" and "uncontrollable like Satan" by prominent Islamists in Afghanistan. Television, more specifically the tele-visual representations of women (both foreign and Afghan) on Afghan television stations, have instigated a series of escalating gender battles between "Islamists," "moderates," and others. Religious militants have called for severe punishments for women and men engaged in what they deem anti-Islamic media productions and programming. Outraged mullahs (religious clerics) have also successfully petitioned the government to ban some of the "provocative" television serials and films. The broadcasting of these television programs has inspired a series of riots and protests from opposing sides. Additionally, the Committee to Protect Journalists and Reporters *sans frontieres* have been documenting a rise in acts of violence perpetuated against female news anchors, singers, and actors in Afghanistan.

Gender has always been a contentious issue in Afghanistan. However, in light of recent events, gender has become a particularly volatile matter. Since 9/11 and the start of the "War on Terror," Afghan women have been put under the Western spotlight in popular culture, evident in the proliferation of media such as fiction films, television programs, documentaries, books, and news that focus on their plight under repressive Islamic regimes. These media have been critiqued by scholars from a variety of disciplines concerned with

the overwhelming portrayal of women as victims, without accounting for their actual or potential agency, thereby perpetuating stereotypes of women under Islam that have gained new currency since 9/11 (Abu-Lughod, 2002; Hirschkind & Mahmood, 2002). The powerful visual imagery that is the off-spring of this prolific body of work and which originates from Afghanistan but is produced in Western institutions, ricochets globally between America and Europe, and other nations, circulating widely through genres as diverse as law, popular culture, and high art. Likewise, Afghan institutions are forced to "talk back" to the global circulation of images of Afghan women. Yet while issues pertaining to "Afghan Women" have been reverberating globally on an unprecedented volume and scale, little attention has been given to the cultural productions that constitute gender subjectivities in the daily lives of Afghans.

This chapter explores how and why Indian telenovelas have become one of the critical factors in the current Afghan cultures wars with their contesting claims of Afghan identity and conversely why Iranian soap operas have not been as popular or contentious. It also includes an analysis of television's catalytic role and function in fueling public discourses around gender issues by grappling with the following question: Why is the tele-presence of women as compared to their circulation in other media particularly problematic to the Afghan religious sector?

The research for this chapter was gathered in the summers of 2004 and 2008 and during the 2009–2010 academic year. My methods are largely media ethnographic (Abu-Lughod, 2004; Mankekar, 1999; Rajagopal, 2001). Although the majority of the television viewers I interviewed are from Kabuli households, I have also included data from other major cities such as Jalalabad, Pul-i-Alam, Bamiyan, Andkhoy, Asadabad, and Panjshir. Outside of the cities, television viewing is sporadic and dependent on whether electricity has reached the smaller towns and villages and/or the inhabitants can afford generators. For this reason, although most households have a television set, radio tends to dominate in rural areas.

The Kabuli television viewers in this study represent a cross-section of the society from a wide range of neighborhoods. To the north of the Kabul River are the wealthy neighborhoods of *Wazir Akbar Khan* and *Shar-i-Now* that cater predominantly to wealthy international consultants and the old elites of Kabul. The north also includes the nouveau riche neighborhoods of *Khair Khana*, *Shirpoor*, and *Quallah Fatullah* as well as the middle class neighborhoods of *Karteh Say*, *Macroyan*, and *Karteh Char*. On the south side of the Kabul River are the lower income neighborhoods that encompass the "Old City." In addition to these recognized and demarcated neighborhoods, the

chapter also includes data from households located in the ever-rising slums of Kabul. Officially known as "informal settlements," these houses are built higher and higher into the surrounding mountains of the city. The inhabitants of the "informal settlements" who currently do not pay taxes and do not own deeds to their homes are slowly coming under the purview of the government via new initiatives that aim to grant property rights and official recognition to them.

After nearly a decade of the Taliban's strict ban on all media except their own Sharia radio and despite a precarious political situation, Afghanistan is experiencing a surge in new media outlets with over two dozen new television stations, hundreds of publications, and a fledging film industry. A new configuration of resources from a combination of foreign, domestic, private, and public sources has enabled this unprecedented proliferation of media. In Afghanistan, the medium at the heart of the most public and most politically charged debates surrounding gender is broadcast television. Both the state-run broadcasting organization, Radio Television Afghanistan (RTA) and the growing number of private television stations such as Tolo (Sunrise), Emrose (Today), Noor (Light), Farda (Tomorrow) are facing government bans, charges, and/or fines based on Article 3 of the Post 9/11 constitution, which prohibits anything that is deemed to be "contrary to the sacred religion of Islam." The Ministry of Information and Culture, among other governmental and non-governmental bodies, enforces this section of the constitution and ensures that television stations abide to the government's dictates.

Love Them or Hate Them: The Alternate Lives of Soap Operas

Although the religious right has targeted many different genres of television programs, from Afghan versions of Western reality shows such as *Pop Idol* and *Top Model* to music video call-in shows, as well as the news, it is the dramatic Indian serials that have consistently born the brunt of their charges. With varying degrees of success, the parliament has passed several bills in an attempt to ban Indian soap operas from Afghan television. These Indian serials resemble Latin American telenovelas and American soap operas in their melodramatic performances and domestic content, and have also over time adopted the lavish sets and costumes stylistically associated with Bollywood films (Das, 1995). However, unlike Western dramatic serials and similar to Latin American telenovelas, they are not open ended in form, and often last between one to two years.

As a result of the historical dominance of Bollywood in the region as well as a new configuration of dynamics, it is no secret that the vast majority of Afghans love Indian films and Indian dramatic serials. Although the Indian soaps are inching forward in popularity, this does not diminish the fact that Afghans are also avid consumers of the news. Afghan filmmakers who associate aesthetically with the Iranian avant garde often complain about the "lowbrow" and "trashy" tastes of their fellow country people who flock to see the latest Bollywood blockbuster but do not possess the "sophistication" and "cultivation" to appreciate high art films, Iranian cosmopolitan films, global independent films, and documentary films. People from abroad, both the returning Afghan expatriate community and Westerners working for international organizations, echo a similar distaste. A young female expatriate from France who works for the United Nations expressed a lack of comprehension and ridicule for her middle-aged Afghan driver's love of Indian soap operas. She told me in an interview: "Oh I know about those Indian programs. All I hear is *Tulsi, Tulsi, Tulsi.* Around a certain time my driver comes in to my office to make sure that we're leaving on time. If I have to stay later at work he asks to leave for an hour to go watch *Tulsi.* God forbid, we were running late a few times and he was driving like a maniac and nearly killed us."

The categorization of Indian serials as a lower art form is symptomatic of the development of soap operas and television more generally in the West. As feminist and television scholars have shown, from their onset both the medium of television and the genre of soap operas were gendered as feminine (Corner, 1999; Murray, 2005; Newcomb, 2006; Spigel, 1992). In Post-World War II United States, television executives and commercial advertisers deployed daytime soap operas as a means of interpellating a new suburban American family by targeting housewives. As the name suggests, soap companies along with other industries aimed at constructing proper notions of womanhood via the new technology of television, sponsored and created soap operas with the broader goals of selling soap, kitchen appliances, and other modern household products.

Additionally, during this time, the credit industry surfaced to enable most Americans to buy television sets they could not otherwise afford. As opposed to theater or concert performances, which were available only to the elites of society, television began to reach the masses, and thus became known as "the Poor Man's Theater" (Boddy, 1992). The combination of being gendered as feminine along with its low-class status is what led to an overall devaluing of both the genre and the medium in the West. In fact, in her famous study of the popular primetime television soap opera *Dallas*, Ang (1985), discovered

that most of fans she interviewed, recognizing the lowly status of the genre, made excuses about why they enjoyed watching the program.

However, this is not the case in Afghanistan. When the state broadcasting company first started broadcasting the television signal in 1974, most households could not afford television sets. Owning a television set and watching television was elusive, a sought after activity that was a sign of high status and wealth. Growing up as part of a middle-class Afghan family, we did not own a television set and would gather with the rest of the extended family at my grandparents' house to watch the nightly programs. Even though the conditions for television ownership are not quite as strenuous today, it is still difficult for the average Afghan family not employed by foreign organizations to acquire a television set and therefore it continues to be a status symbol. Additionally, the soap operas are aired in the evenings at 7:00 PM and 9:00 PM and target entire households. This is the prime time for broadcasting for somewhat different reasons than in the West. Due to the precarious present day situation in Afghanistan, in the evenings the majority of people stay indoors and consume media at home. Women, generally, do not go to the movie theaters or watch television in public places. The evenings are also the time when electricity is most consistent.

Since there is no history of stigmatization, the storylines and subject matters of the Indian serials, though still pertaining to domestic issues, are considered worthy entertainment to be enjoyed by both men and women. The fan base of these serials cuts across societal lines and includes police officers, politicians, and even prominent warlords. A number of high ranking warlords and/or politicians are even known to cut short their evening prayers in order to not miss the start of their favorite soap operas. Dramatic epic stories of mythic and historic proportions often involving unrequited love between tragic heroes and heroines have a long history in the literary and poetic spheres as well as traditions of orality of Afghan society. So, in contrast to their Western counterparts, for the indigenous Afghan population, viewing television soap operas and/or dramatic serials is a valued and cherished past time.

Far from Mere Entertainment:
Will Television Save or Destroy Afghanistan?

The popularity of such television programs and television's own intrinsic qualities are recognized by elites interested in Afghanistan. From television executives to government officials, religious leaders, international governmental and

non-governmental consultants and advisers, a considerable amount of hopes and fears are being funneled into the medium. They are well aware of television's power, especially in a country like Afghanistan, and have come to the same conclusions about the medium's inherent potential as media scholars.

In developmentalist circles and political science terminology, Afghanistan is frequently described as a "failed," "broken," "fragmented," or "collapsed" nation (Rubin, 2002; Ghani & Lockhart, 2008). Having replaced the earlier classifications of "late state formation," "the rentier state," and "third world despotism," (Rubin, 2002) such terms continue the pervasive rhetoric of "failure" in Western discourse and thereby glosses over progressive historical achievements of nations like Afghanistan (Abu-Lughod, 2006; Mitchell, 1991, 2002). Yet at the same time it cannot be denied that currently, Afghanistan, having experienced thirty years of guerilla warfare and international militarization, has lost its previous state, civil, and governmental infrastructural capacities. Decades of ethnic, religious, and gender violence have left an almost indelible mark of disunity, and fractured any sense of a cohesive society. Therefore, the language of "failure" can be useful, keeping its problematic colonial and neo-colonial epistemological roots and agendas in mind, but only as a starting point to understanding the complexity of contemporary Afghan social worlds.

In order to fix the broken, collapsed, and failed nation that is Afghanistan, or to use the official language, "nation building" or "reconstruction" can only happen via a mass venue for healing and purging, remembering and forgetting. For that, there is no better or worse medium than television.

The technology's electro-visual mass appeal, sensory integration, simultaneity of exposure, and broadcasting potential which imbue it with a false sense of communal live-ness has always made television a source of social power, and cultural imaginings, both dystopic and utopic. In a country where the vast majority of people are illiterate and access to computers and the internet is limited, television becomes an even more powerful medium. As television scholars have theorized, television has the eerie ability of conjuring face to face community gatherings but with the power of reaching large scale audiences (McLuhan, 1962; Ong, 1982; Williams, 2003; Parks, 2005). It is no wonder then that the hopes and fears of many people are riding on the future of television in Afghanistan.

Feminist, cultural studies, and television scholars particularly from the Birmingham Centre have also located television, due to its mass appeal, as a site of cultural contestation (Hall, 1997; Morley, 1992). In light of television's technological aspects and Afghanistan's current social climate, the heated and

volatile nature of debates surrounding television and television programming is not surprising. When a television station abruptly stopped airing a popular Indian soap opera, *Kum Kum*, in the Spring of 2008, most likely due to pressure from the government, the resulting uproar and clamor could be heard both in online forums and on the streets as fans demanded answers. The show's diasporic fanbase (who watch Indian soap operas on satellite television) used the Internet to voice their anger while the Afghan community held protests outside of the Ariana Television Network (ATN) headquarters in Kabul to demand answers. Religious groups have also begun broadcasting television programs aimed at teaching the tenets of Islam although further analysis into their popularity and viewership is needed.

Therefore, in an increasingly competitive television mediascape, one way to ensure a share of the audience market and therefore advertising revenue is through airing Indian dramatic serials. For owners of private television stations, it is a matter of understanding the consumption patterns and tastes of their fellow country people and then delivering programming that appeals to those tastes. For instance, in order to compete with two of the most popular television stations, Tolo TV and Ariana Television Network (ATN), Emrose TV, a new entrant on the scene, which launched in 2008, took the bold risk of showing Indian telenovelas unedited. The manager of the station was subsequently arrested and served two months in prison. After several years of intense fighting with religious authorities, Tolo TV and ATN, launched in 2004 and 2005 respectively, began self-censoring the content of their Indian soap operas by a combination of blurring, fading, and re-editing any "inappropriately" exposed parts of women's bodies and also Hindu religious idols.

It is important to note, however, that the battles over censoring women's bodies are only in the context of terrestrial television. Pornography and pornographic imagery is readily available and accessible on satellite television, which reach approximately fifty percent of households in Kabul. In addition, such content is also downloadable on cell phones even in remote provinces, and available for sale in the form of cheap video disks (DVDs) behind the counter in every media kiosk in all shopping bazaars. This is most likely due to the fact that the owners of terrestrial television stations, constrained by technology, are obliged to heed government supervision in order to maintain or secure a limited frequency wave.

Although little research has been done to study the circulation and technologies of video disks and cell phone videos in informal markets, media ethnographers have begun to explore how satellite television is rapidly transforming the mediascape in Gulf countries from Syria to Iraq. They have

demonstrated how the continual attempts by religious authorities in Arab countries to block some programming and commission others confirm that television drama is far from mere entertainment (Abu-Lughod, 2004; Salamandra, 2004).

In early May of 2008, the Afghan government issued a decree to ban the televising of Indian serials. Many television stations complied, but Tolo TV and ATN refused on the grounds that the vague media laws do not give the government the power to ban entire programs, but only small portions, which can be altered or removed. Media owners are currently challenging the legality of government censorship and in the process, defining the media laws in the Afghan courts. In the case of broadcast television, the fight is being lead by Tolo TV. Thus, what seems like an act of acquiescing to the religious censors, on the part of Tolo and ATN, for re-editing Indian serials, is in fact an act of defiance.

Cultural Imperialism or National Fascism?

One of the main grievances of the religious groups against the Indian soap operas is that they are "Hinduizing" Afghan culture and therefore tainting what is imagined as a pure Islamic Afghan culture. Since the Indian dramatic serials address issues such as adultery, divorce, and other domestic issues, the faith-based groups have also charged the programs with "immorality." They have voiced fears that Afghan women and youth are particularly susceptible to emulating the "improper" lifestyles and customs of South Asians.

This type of criticism assumes that certain types of audiences do not possess the media savvy and intelligence to have more complicated readings, and therefore are easily duped and swayed. This harkens back to early communication theory, coming from the Frankfurt School and World War I propaganda studies (Adorno & Horkheimer, 1969) and their American colleagues (Lasswell, 1927; Lippmann, 1993; McLuhan, 1962). These studies imagined the media as a weapon in the arsenal of Fascism; controlling and conforming people's thoughts, behaviors, and actions to the wishes and suggestions of media producers and/or societal elites. This simplistic model of an all powerful media injecting a passive population with messages has long been replaced by reception and audience research which have shown that audiences can ward off, appropriate, and/or reinterpret media messages (Ang, 1985; Fiske, 1988; Hall, 1997; Katz & Lazarsfeld, 2005; Morley, 1992).

Additionally, by projecting a pure homogenous culture, this type of crit-

icism does not take into account Afghanistan's complex media history and shifting consumption and production patterns. From its formative days, Afghanistan's media landscape has been in the spheres of influence of its powerful neighbors' Iran, India, and to a lesser extent Soviet/Russian media and dominated by their exported cultural products. This was a result of both geographic proximity and cultural affinity. Early Afghan filmmakers, musicians, and other media makers were often trained abroad in one of these neighboring countries. Additionally, Iranians and Afghans share dialects, Farsi and Dari respectively, of the same language of Persian; although Pashto is also an official language of Afghanistan.

During the Soviet Occupation, many Afghans sought refuge in Pakistan due to Iran's relatively restrictive immigration policies. According to most statistics, the numbers were two to one with approximately three million Afghans escaping to Pakistan and one and a half million Afghans taking refuge in Iran. During their decade long exile, a relatively large part of the Afghan population became fluent in either Urdu and/or Hindi. In fact, most Afghans can understand the imported Indian dramatic serials without the common over-dubbing in Dari. As a result of the immigration patterns in which more than half of the Afghan population was exiled during the war, the popularity of Indian media is at an all time high while Iranian media is waning.

This brief history illustrates the fact that Indian cultural traces have been a part of Afghan culture for a long time. With the ever expanding reach of new technologies, globalization theory reminds us that cultures are never insular, impermeable, and static but always in flux and transforming (Appadurai, 1996; Ginsburg et al, 2002). Just as media technologies cross borders, so do technologies of violence. Despite its reputation as a hostile and impenetrable country, acquired thanks to British and Russian-Soviet colonial mythologies, and also due to its harsh and mountainous geography, Afghanistan is no more impervious to cultural influences than any other country. Yet, this is not to say that the broader charges of cultural imperialism are not legitimate. As a result of the destruction of its cultural institutions such as its media, education, and museums, culturally speaking, presently, Afghanistan is particularly unsedimented and unsettled.

Therefore, questions of cultural vulnerability and cultural imperialism take on a new urgency in a place and space where the possibilities of redefining national identity are wide open. The common concern amongst media activists and cultural critics is that distinctive heterogeneous cultures are being erased, tainted, and/or diffused by the homogenizing force of Western capital expansion and media globalization. If we look at concrete economic fac-

tors and worldwide media ownership trends, it is clear that a handful of Western corporations dominate the film, music, and television industries (Bagdikian, 2000; McChesney, 2004; Schiller, 1976, 1991). These very real structural imbalances enable wealthy Western nations to aggressively produce, distribute, and market media products with alluringly high production quality. Therefore, flows of media products are disproportionately one way, from wealthy Western countries to developing or third world nations. In this respect, although the consumption of media products might be global, the production and distribution and therefore financial benefits are skewed in the direction of the West. Such capitalistic strategies, techniques, and ventures coupled with the exploitative history of colonialism and imperialism of the West have left many former colonies out of the global picture—both literally and metaphorically. The usual suspect and target of the media imperialism argument is American media products with their Americanizing effects. Yet in the case of Afghanistan, is there real cause to worry about Indianization of media and culture more broadly?

New media scholarship is revealing that the tides of change are dissociating "global media" from American media, and new global players are emerging from non-Western countries. Indian media exports are finding avid consumers all over the world (Ganti, 2004; Larkin, 2008). Even the effectiveness of Western formats, supposedly void of any cultural specificities, crossing borders are being challenged, as in the failed case of the British melodrama *Crossroads* in Kazakhstan (Mandel, 2002). A not so new media behemoth is vying for the coveted position of becoming the new "global media."

Although the Islamists use the rhetoric of cultural imperialism in order to incite fears of cultural homogenization, their arguments are actually grounded in the promotion and imposition of a strict version of Islam. This is a direct attempt at erasing Afghanistan's diverse cultural history and varied experiences with Islam. The type of Islam that they are preaching is a specific orthodox brand of Islam that, although around for over one century in Afghanistan, has only recently re-emerged and re-energized. A new configuration of external forces resulting from Cold War politics has re-animated internal religious fringe groups and fanatical sects into powerful movements, but whether they actually enjoy popular support is currently up for debate on television and other media.

Here it is important to stress that the vast majority of Afghans self identify as Muslim and so do the fans of Indian soap operas interviewed for this study, but practices and ideologies vary accordingly. Likewise, distinctions have

been made between practices of Islam in everyday contexts and Islamism as a legal and political framework (Asad, 1993, 2003; Göle & Ammann, 2006; Mahmood, 2005). Therefore, despite their invocation of cultural imperialism, the religious authorities in Afghanistan, with their authoritarian decrees against the media or women's rights, often target not only Hinduism, but challenge plurality and the multiplicity of voices within Islam. In fact, a number of the Indian serials to which the religious authorities have objected actually represent Indian or Pakistani Muslims.

However, the Islamist diversion does not diminish the question: Is the powerhouse next door overshadowing and impeding the development of an indigenous Afghan aesthetic and artistic style and culture?

The fact is that it is less costly for Afghan television stations to buy Indian and Iranian dramatic serials than produce their own programs. While making Afghan versions of reality format shows is within their means, to produce high quality dramatic serials is outside the scope of these recently established media outlets. In other words, they cannot compete with the established media industries of India and Iran that have the wealth to invest in expensive productions and the extensive production experience.

After almost three decades of war and instability marked by first foreign invasion and subsequent civil strife, Afghanistan is in flux artistically, religiously, and culturally. Many of Afghanistan's media producers frequently lament Afghanistan's tragic recent history and wonder where Afghanistan's media would be and what it would look like aesthetically if its path of development had not been halted just as it was emerging. This is particularly the case with television, since three years after its introduction as a new national medium, the communist coup, followed by the Soviet invasion, erupted in 1979. During this brief time period, Afghanistan's television programming consisted of nightly broadcasts of musical concerts, news, and a variety program, but no dramatic serials.

Recognizing the structural imbalances, transnational organizations such as the British Broadcasting Corporation (BBC) and UNESCO are trying to even the cultural playing field by training local Afghan men and women to produce their own media. By all accounts, BBC World Trust's mission is to introduce modernity, democracy, and capitalism to post-communist countries. Originally called the BBC Marshall Plan of the Mind, it was formed after the fall of the Berlin Wall in order to "to transfer skills and knowledge of democratic principles and market economies via national radio and television to assist the transition process . . ." (Mandel, 2002, p. 213). Afghanistan being a perfect candidate for the BBC's mission, their base of operations there is one of

their largest with a staff of about 200 local project employees. According to BBC World Trust's Website, "conflict and chronic instability have characterized Afghanistan's modern history" and therefore their objectives are to assist the government in creating national unity by bringing an awareness of human rights with special attention to gender rights.

In an effort to meet their mandate, the BBC World Trust launched the Afghan Women's Hour in January of 2005, which broadcasts on RTA. This weekly variety program explores issues concerning women's role in society. Likewise, UNESCO helped the non-profit organization, Voice of Afghan Women Association, start Afghanistan's first women's community television channel by paying for broadcasting equipment and governmental registration fees to secure a frequency. With their socially conscientious mandate, these transnational organizations have a progressive multicultural and plural approach to nation building. However, the effectiveness of these media networks cannot be accepted without further analysis into the nature of collaborations between sympathetic western institutions and the lives of people in Afghanistan.

Performances of Non-Performativity and Practices of Unlooking

Yet despite the cultural exchange, Afghan audiences are quick to draw distinctions between Afghan and Indian forms of cultural expression. Even the most avid fans of Indian telenovelas make very specific delineations between "their culture" and "our culture," thereby Othering their favorite shows as foreign. They often ground their arguments in the second commandment and Islam's general stance against the representation of the human form (Armbrust, 2000; Mitchell, 2006). In addition, Islamic ways of looking are marked by lowering your gaze and practices of un-looking. Similarly, Islamic forms of performance and self-expression can best be described as the performance of non-performativity and unexpression; the exception being the Sufi order.

Therefore, in reference to the Indian dramatic serials, "music and dancing," "bright colorful clothes," "ornate accessories," "lighting of candles," among other expressions of "decadence" are understood as "Hindu forms of worshiping" and signs of "being Hindu not Muslim." Such characterizations of Hindu expressions of devotion and how it permeates Hindu cultural practices actually echo the academic concept of "darshan," which literally means "seeing" in Hindi, but more broadly describes the holistic and embodied expe-

rience of engaging with deities. Scholars of Indian culture have illustrated how images, and visuality more generally, do in fact form an integral part of Hindu modes of being (Eck, 1998; Pinney, 2004; Rajagopal, 2001).

In addition to grounding their difference in Islamic practices, Afghans also readily identify themselves as "sangeen" in contrast to their perceived notions of Hinduness. *Sangeen* is a Persian word that literally means heavy; rooted in the word for rock/stone, *sang*. Connotatively it is an adjective used to describe qualities of being reserved, rational, unemotional, and stoic. To be described as *sangeen* and be associated with its sought after virtues is something that Afghans of all genders aspire to. To achieve *sangeen*-ness entails an entire way of being and behaving, complete with its own color schemes and modes of dressing.

Therefore, it is surprising that Afghan audiences of both genders reacted unfavorably to the broadcasting of *Nargis (Narcissus)* in 2008, an Iranian dramatic serial, which by all standards is imbued with *sangeen*-ness, both aesthetically in terms of the settings and in the attributes of the protagonist, Nargis. The common complaint was verbalized as "dill em tang may showad," which literally means "it suffocates my heart," but is more broadly interpreted as lackluster, tedious, dull, and dreary. One woman explained "We have color television but it might as well be a black and white set for *Nargis*," referring to the "taareek" or dark color schemes of the show. Other people made similar comments about the dark chadors and robes of the women and men in the show.

In this respect, the concepts of *sangeen* and *darshan* are useful theoretical tools in understanding the ways in which people perceive their own and other cultures but they cannot be applied as absolute signifiers of either culture. As the case studies illustrate, in actual practice, every experience cannot adequately fulfill the hard to achieve modes of being completely *sangeen* or in a full state of *darshan*, nor can cultures be reduced to one set of homogenizing conditions.

No wonder then, that many Afghan television viewers admitted their affinity for Indian dramatic serials in contrast to the recent arrival of Iranian imports while simultaneously proclaiming their Afghan *sangeen*-ness. "What can I say, most people like 'rangahiya roshan' [bright colors]," stated a viewer. Many women, especially Kabuli women, associated the aesthetics of "bright colors" and unveiled women of Indian soaps with "azadi" or freedom/liberation. When asked about what made the Iranian soaps less liberatory, many could not answer beyond their visual differences. In fact, textual analysis reveals that the heroines in the Iranian dramatic serials tend to have more

agency and be more active in the domestic and public sphere than their Indian counterparts. "Yes, its true," one woman said, "the women drive and work outside of the home in *Nargis* but I still think *Zora* (an Indian import) is more free."

Liberatory or Regressive? Weak Heroines and Strong Villainesses

Although for entirely different reasons from the religious critics, some women also adamantly expressed why they thought the Indian shows were regressive and as such bad role models for Afghan women. They mentioned that popular Indian soap operas such as *Henna, Dolhan*, and *Kum Kum* represented women in subservient and subordinate positions. They objected to the protagonists' *Henna, Widya* (from *Dolhan*), and *Kum Kum*'s, "weak personalities" and "characters." One woman stated, "I cannot believe how much abuse and torture they take from their in-laws," while another commented, "All they do is cry and cry and cry . . . such crybabies." According to these women, most of whom actively advocated for and demanded the shows be cancelled, the only "strong" and "intelligent" women in the shows were villainous sisters-in-law, mothers-in-law, and aunts-in-law who were perpetually conniving and strategizing how to torment or even kill the new brides in order to gain access to property and wealth bestowed upon their male relatives.

Yet overall, the responses from female viewers were positive. Although it is difficult to understand the contradiction in self dis/identifications and dis/tastes among Afghan audiences in terms of Iranian and Indian soap operas, the liberatory and empowering aspects of soap operas are well documented. Feminist media scholars have challenged the common perception that women's genres have a "dumbing down" effect on society. Reception studies on romance novels, women's magazines, and soap operas have revealed that in fact these genres with their focus on women's issues offer a subversive space where women can not only escape but also challenge the male gaze and other forms of patriarchal social order and control (Das, 1995; Radway, 1991; Mankekar, 1999).

It is precisely this public engagement with familial and cultural issues pertaining to women's rights and positions in society that is a source of strife for the Islamists and celebration for the defenders of the Indian soap operas and other genres of television programming. Arguments about the "in/suitability," "in/appropriateness," and/or "im/morality" of women's representations in Indian and other serials are arguments about cultural authenticity grounded in claims about what constitutes true Afghan identity. However,

national identity cannot ever be reduced to a singular truth. A sense of a nation's sensibilities can only come into focus through the blurry lens of cultural contestations.

The Afghan Public Sphere and the Ongoing Culture War

In this context, the struggle for women's rights in Afghanistan has been a battle between modernist state policies and the more restrictive and repressive interpretations of codes encapsulated in tribal and Islamic laws since at least the turn of the twentieth century. As such, women's lives and bodies have been under the jurisdiction and regulations of tribal/religious elders and historically relegated to the private sphere. To bring these issues up for public reflection and discussion via television is dually counter-hegemonic because it enables Afghan reformers to attack the power base of religious militants and talk back to the international community which has Afghanistan in its purview of influence.

In this battle over television and gender rights, it is a mistake to interpellate or pre-judge Afghan society as "conservative," as many Western journalist accounts of the media situation have done. Granted, that conservative forces in Afghanistan have become much more powerful and militant as a result of the thirty years of warfare but it must be underlined that the cultural contestations are presently unfolding and ongoing. In other words, there are many groups vigorously fighting in the cultures wars and none can claim victory at this moment. Media activists joined by women's rights activists are challenging conservative elements to keep the media independent. Presently, the media in Afghanistan remains technically free from direct state/religious censorship, albeit precariously.

In this battle over television and gender rights, it is also a mistake to associate the discourse of progress, human rights, and modernity with the West alone. This line of thinking oversimplifies the complex encounters between the West and the East by solely crediting the production of democratic models and principles to the Western mind.

Historically, in the early twentieth century and in the late 1960s through the 1970s, it was state-sponsored media that has advocated for women's rights in Afghanistan. These media initiatives were part of the government's larger project of modernizing Afghanistan, which was launched in 1964 with the ratification of an equal rights amendment to the constitution. However, the modernist policies that attempted to end obligatory veiling and increase equal opportunities for education of women came to an abrupt halt with the

Soviet Invasion in 1979. The subsequent Occupation and Civil War gave rise to religious and tribal extremism. Out of these regimes that were severe in their doctrine and violent in its enforcement, the Taliban are of course the most notorious, though most certainly not the only ones.

In post 9/11 Afghanistan, Islamists, with the support of conservative members of the government including high-ranking justices and parliamentarians, use the new constitution to launch their attacks on the independence of media and freedom of the press. Whereas the 1964 constitution provided the pillars of support for the women's rights movement and the state television's modernist agenda, the 2004 constitution has given legitimacy to the opponents' repressive faith based claims. In the drawing of the constitution, Hamid Karzai, on the verge of elections, made compromises with Islamist groups to appease their aggrandized power base; just as he has done now with the signing of the new Shiite "Marriage" Law (see description by Boone, 2009) before the upcoming elections.

Therefore, in this "post-war" environment where the government has to readily acquiesce to the power of religio-tribal warlords and drug traffickers at the expense of the many, where the judicial system and the electoral system are fraught with corruption, where the vast majority of people think that the presidential and parliamentary elections are a sham, and where the rule of law is virtually non-existent, the closest functioning institution that offers any recourse for justice or hope for democracy is the media generally and television more specifically. Scholars have explored the potential of video, audio recordings, and print forms to mobilize social change (Sreberny-Mohammadi & Mohammadi, 1994; Ginsburg, 1998a; Juhasz & Gand, 1995), thereby revealing how marginalized groups within a society use the media in their negotiation and contestation to assert their cultural and political claims in public culture and the public sphere. An integral part of this research is scholarship on the formation of publics, counter-publics, and split publics (Appadurai, 2006; Calhoun, 1993; Dornfeld, 1998; Rajagopal, 2001).

Conclusion

It is for the reasons of basic human rights and human dignity, that Habermas's (1991) concept of the public sphere draws academics and activists from vast disciplines to invoke its power potential, despite perhaps being empirically flawed. As Calhoun (1993) reminds us, in its pure theoretical essence, the public sphere by its definition offers a third space for people to make their voices heard. As Habermas describes it, between the oppression of the state and the

tyranny of commercial culture, the public can invoke the public sphere via mass media to express their own opinions in critical dialogue with one another; thereby challenging oppressive forces/institutions by making them accountable to "the tribunal of the people." Since without a public sphere, people cannot coalesce into a strong public to voice their concerns, it is imperative to protect principles of an independent media in all nations but especially in a dystopic one like Afghanistan.

In stable countries, the terms of the debate are set and defined but in a country where guns, local militias, and physical force are the status quo, protecting the one institution which has the most representational and democratic tendencies, is particularly important. As the case of abortion rights demonstrates (Ginsburg, 1998b), controversial cultural issues also inspire violence in the West but different institutions are in place to check and balance each other's powers. In Afghanistan, wealthy media owners hire many body guards and live behind gated mansion fortresses while low level television personalities and reporters, especially female ones, are subjected to threats, physical attacks, and even death for providing people with programming they want to watch and which engages with their concerns. In Afghanistan, it can be argued, as I have, that the media "remains an institution of the public itself, operating to provide and intensify public discussion" (Habermas et al, 1974, p. 402). It has not yet "refeudalized" into a degenerate culture of consumption and fake "publicness" constructed by a highly specialized media corps of public relations professionals serving special interest groups.

References

Abu-Lughod, L. (2002). Do muslim women really need saving? Anthropological reflections on cultural relativism and its others. *American Anthropologist, 104*(3), 783–790.

Abu-Lughod, L. (2004). *Dramas of nationhood: The politics of television in Egypt* (1st ed.). Chicago, IL: University of Chicago Press.

Abu-Lughbod, L. (2006). Writing against culture. In Ellen Lewin (Ed). *Feminist anthropology: A reader.* Oxford: Blackwell.

Adorno, T. W. & Horkheimer, M. (1969). *Dialectic of enlightenment.* New York: Continuum.

Ang, I. (1985). *Watching Dallas: Soap opera and the melodramatic imagination* (New edition.). New York: Routledge.

Appadurai, A. (1996). *Modernity At large: Cultural dimensions of globalization* (1st ed.). Minneapolis, MN: University of Minnesota Press.

Appadurai, A. (2006). *Fear of small numbers: An essay on the geography of anger.* Durham, NC: Duke University Press.

Armbrust, W. (2000). *Mass mediations: New approaches to popular culture in the Middle East and beyond* (1st ed.). Berkeley, CA: University of California Press.

Asad, T. (1993). *Genealogies of religion: Discipline and reasons of power in Christianity and Islam*. Baltimore: The John Hopkins University Press.

Asad, T. (2003). *Formations of the secular: Christianity, Islam, modernity*. Stanford, CA: Stanford University Press.

Bagdikian, B. H. (2000). *The media monopoly* (6th ed.). Ypsilanti, MI: Beacon Press.

Boddy, W. (1992). *Fifties television: the industry and its critics*. Champaign, IL: University of Illinois Press.

Boone, J. (2009). Worse than the Taliban, new law rolls back rights for Afghan women. *The Guardian*, Tuesday March 31. Retrieved from http://www.guardian.co.uk/world/2009/mar/31/hamid-karzai-afghanistan-law

Calhoun, C. (1993). *Habermas and the public sphere*. Cambridge, MA: MIT Press.

Corner, J. (1999). *Critical ideas in television studies*. Oxford: Oxford University Press.

Das, V. (1995). What kind of object is it? In Daniel Miller (Ed). *Worlds apart: modernity through the prism of the local*. London: Routledge.

Dornfeld, B. (1998). *Producing public television, producing public culture*. Princeton, NJ: Princeton University Press.

Eck, D. L. (1998). *Darsan: Seeing the divine image in India* (3rd ed.). New York: Columbia University Press.

Fiske, J. (1988). *Television culture* (New edition.). New York: Routledge.

Ganti, T. (2004). *Bollywood: A guidebook to popular Hindi Cinema*. New York: Routledge.

Ghani, A., & Lockhart, C. (2008). *Fixing failed states: A framework for rebuilding a fractured world*. Oxford: Oxford University Press.

Ginsburg, F. D (1998a). Institutionalizing the unruly: Charting a future for visual anthropology. *Ethnos, 63*(2), 173–201.

Ginsburg, F. D. (1998b). *Contested Lives: The abortion debate in an American community,* (Second Edition). Berkeley, CA: University of California Press.

Ginsburg, F. D., Abu-Lughod, L., & Larkin, B. (2002). *Media worlds: Anthropology on new terrain*. Berkeley, CA: University of California Press.

Göle, N., & Ammann, L. (2006). *Islam in public*. Istanbul: Istanbul Bilgi University Press.

Habermas, J., Lennox, S., & Lennox, F. (1974). The public sphere: An encyclopedia article (1964). *New German Critique,* (3), 49–55.

Habermas, J. (1991). *The structural transformation of the public sphere: An inquiry into a category of bourgeois society*. Cambridge, MA: MIT Press.

Hall, P. S. (1997). *Representation: Cultural representations and signifying practices* (1st ed.). London: Sage Publications & Open University.

Hirschkind, C. and Mahmood, S. (2002). Feminism, the Taliban, and politics of counter-insurgency, *Anthropological Quarterly,* 75(2), 339–354.

Juhasz, A., & Gund, C. (1995). *AIDS TV: Identity, community, and alternative video*. Durham, NC: Duke University Press.

Katz, E., & Lazarsfeld, P. (2005). *Personal influence: The part played by people in the flow of mass communications*. Piscataway, NJ: Transaction Publishers.

Larkin, B. (2008). *Signal and noise: Media, infrastructure, and urban culture in Nigeria.* Durham, NC: Duke University Press.

Lasswell, H. (1927). The theory of political propaganda. *The American Political Science Review, 21*(3), 627–631.

Mahmood, S. (2005). *Politics of piety: The islamic revival and the feminist subject.* Princeton, NJ: Princeton University Press.

Mandel, R. (2002, October). A marshall plan of the mind: The political economy of Kazakh soap opera. In Faye D. Ginsburg, Lila Abu-Lughod, and Brian Larkin (Ed.). *Media worlds: Anthropology of new terrain.* Berkeley: University of California Press.

Mankekar, P. (1999). *Screening culture, viewing politics: An ethnography of television, womanhood, and nation in postcolonial India.* Durham, NC: Duke University Press.

McChesney, R. (2004). *The problem of the media: U.S. communication politics in the twenty-first century.* New York: Monthly Review Press.

McLuhan, M. (1962). *The Gutenberg galaxy: The making of typographic man.* Toronto, ON: University of Toronto Press.

Mitchell, T. (1991). *Colonising Egypt.* Berkeley, CA: University of California Press.

Mitchell, T. (2002). *Rule of experts: Egypt, techno-politics, modernity.* Berkeley, CA: University of California Press.

Mitchell, W. J. T. (2006). *What do pictures want? The lives and loves of images.* Chicago, IL: University of Chicago Press.

Morley, D. (1992). *Television, audiences and cultural studies* (1st ed.). New York: Routledge.

Murray, S. (2005). *Hitch your antenna to the stars: Early television and broadcast stardom* (1st ed.). New York: Routledge.

Newcomb, H. (2006). *Television: The critical view* (7th ed.). Oxford: Oxford University Press.

Ong, W. J. (1982). *Orality and literacy: The technologizing of the word.* New York: Routledge.

Parks, L. (2005). *Cultures in orbit: satellites and the televisual.* Durham, NC: Duke University Press.

Pinney, C. (2004). *Photos of the gods: The printed image and political struggle in India.* Oxford: Oxford University Press.

Radway, J. A. (1991). *Reading the romance: Women, patriarchy, and popular literature* (2nd ed.). Chapel Hill, NC: University of North Carolina Press.

Rajagopal, A. (2001). *Politics after television: religious nationalism and the reshaping of the Indian public.* New York: Cambridge University Press.

Rubin, B. R. (2002). *The fragmentation of Afghanistan: State formation and collapse in the international system,* (2nd ed.). New Haven, CT: Yale University Press.

Salamandra, C. (2004). *A new old Damascus: Authenticity and distinction in urban Syria.* Bloomington, IN: Indiana University Press.

Schiller, H. I. (1976). *Communication and cultural domination.* White Plains, NY: International Arts and Sciences Press.

Schiller, H. I. (1991). *Culture, Inc.: The corporate takeover of public expression.* Oxford: Oxford University Press.

Spigel, L. (1992). *Make room for TV: Television and the family ideal in postwar America*. Chicago, IL: University of Chicago Press.

Sreberny-Mohammadi, A., & Mohammadi, A. (1994). *Small media, big revolution: Communication, culture, and the Iranian revolution*. Minneapolis, MN: University of Minnesota Press.

Williams, R. (2003). *Television: Technology and cultural form* (3rd ed.). New York: Routledge.

15. *Importing and Translating* Betty

Contemporary Telenovela Format Flow within the United States Television Industry

Courtney Brannon Donoghue

In an early episode during the first season of *Ugly Betty* (2006–2010), the American Broadcasting Company (ABC) ran commercials featuring the show's star America Ferrera and special co-star Salma Hayek exclaiming, "Two big reasons to watch next week's *Ugly Betty*. ¡America and Salma! ¡Más caliente! ¡Tan grande!." In addition to the impressive audience numbers and critical acclaim earned by the show during its premiere 2006–07 season, the program was presented and positioned as a United States interpretation of a distinctly Latin American form and franchise. This teaser trailer functioned beyond typical advertisements by emphasizing certain words in the Spanish language, playing generic salsa music in the background and marking the *Latinidad* (a monolithic Latina identity and perceived cultural unity) of both actresses. The ad reflects larger industrial, critical, and popular conversations about *Ugly Betty*'s place within the telenovela genre. The goal of this chapter is to address a number of questions regarding the rise of *Ugly Betty* as a transnational cultural product. How is the telenovela format adapted within the U.S. television cultural industry? What are key industrial debates surrounding the flow and adaptation of a telenovela from Latin America to the U.S.? How is Latinidad represented and constructed through the characters of Betty and the Suarez family? What does *Betty* reveal about Latino and immigrant experiences within in the contemporary U.S.?

The global exchange of media across various regions has increased in recent decades, namely through a more lucrative and complex television market (Havens, 2006, p. 5). Cross-cultural borrowing has emerged as a key method for cost-effective innovations within many television industries (Keane,

Fung, & Moran, 2007; Moran & Malbon, 2006). As this chapter will illus-
trate, the Latin American telenovela has gained global attention as a popular
transnational business model through increased exports and more recently as
a flexible format (Havens, 2006; Mato, 2005). The ABC "dramedy" (an
American television genre combining elements of the sitcom and serial drama)
Ugly Betty is an adaptation of the global hit *Yo Soy Betty, La Fea* (1999–2001),
a telenovela from Colombia that embodies the international flow of television
formats from Latin America to the contemporary U. S. television industry. The
thrust of this chapter is to examine contemporary telenovela flows through the
particular context of *Ugly Betty* in the U.S.

Methodologically, this study relies on industrial and critical discourse and
textual analysis. This chapter examines multiple sites across the U. S. televi-
sion industry, media professionals, media critics, the television text, and the his-
torical context in order to interrogate the complex nature of format adaptation.
The first section outlines some of the theoretical issues and implications at stake
within the flow and adaptation of telenovelas globally, namely "the interna-
tional telenovela debate" (Biltereyst & Meers, 2000). It provides a brief
overview of earlier academic debates regarding television trade and flow and
discusses the television format as an important business strategy that is dom-
inant within the current global media climate. The next section examines the
format within the context of contemporary industrial discourse surrounding
the telenovela business model and the adaptation of specific programs for both
Latino and general market U.S. audiences. Interviews, reviews, marketing, and
industry reports reveal how Fox and ABC fashioned this model during Fall
2006, which marks a strategic attempt for U.S. networks to embrace Latin
American programming. The final section considers how discursive emphasis
by producers, critics, and audiences on telenovela authenticity and geo-cultural
origin complements issues of Latinidad, inclusion/exclusion, and immigration
within *Ugly Betty*'s narrative. Similar to the traveling of telenovela formats from
Latin America to the U. S., the show explores the difficulties of border cross-
ing into and within a predominantly Anglo-American society, namely through
borders of race, class, and gender. Overall, by combining an industrial and tex-
tual analysis, this critical essay argues that the adaptation of the *Betty* within
the U. S. reveals a unique journey of the telenovela format emerging simul-
taneously as both a Latin American and U. S. transnational media product.

The International Telenovela Debate

Within globalization and media studies, discussions surrounding the impor-
tation of the telenovela and its influence abroad emerged as part of the "inter-
national telenovela debate" (Biltereyst & Meers, 2000). According to Biltereyst

and Meers (2000), this debate focuses on "hard structural and political economic arguments" about the capital control of the local Latin American broadcasting system (p. 394), programming formats, and worldwide export to regions such as North America, Europe, Asia, and the Middle East (Acosta-Alzuru, 2003). On the one hand, early studies on international television flow, such as the United Nations Educational, Scientific and Cultural Organization (UNESCO) study that found programming from the U. S. dominated Latin American television during the 1970s (Nordenstreng & Varis, 1974). On the other hand, in previous decades scholars such as Antola and Rogers (1984), Rogers (1985), Sinclair (1999), and Straubhaar (1984) have seen the trend reversing, whereas Latin America began to produce more locally and import less. Although the international telenovela trade began in the 1950s, larger nations such as Mexico, Brazil, and Venezuela greatly increased exportation of their telenovelas abroad by the 1980s (Antola & Rogers, 1984, p. 186–7). While Rogers (1985) considered this increased importation into the U. S. specifically as a "special kind of 'reverse media imperialism'" (p. 33), Sinclair argues that these revisionist models focus too heavily on "marginal contra-movements" that disguise the economic power structures in global media (as cited in Biltereyst & Meers, 2000, p. 398).

Increased access to satellite and cable channels and changing regulatory reforms ushered in a new globalized era of the television market by the mid-1980s and resulted in further diversity and mobility of programs worldwide (Havens, 2006, p. 26). Outside the U. S. and Europe, telenovela distributors across Latin America have seen continued growth in global television sales. This led to the expansion and ease in the telenovela trade internationally and increased demand for remaking popular telenovelas for other local television industries. According to Havens, "the number of companies selling telenovelas abroad has grown more than fivefold in the past decade, and international sales of the genre grew from $200 million to $341 million between 1996 and 2000" (2006, p. 34). One example of the contemporary global television flow of the telenovela is through the process of selling and adapting a particular program as a format. This is a business model within the transnational television trade that functions as a cultural technology or a road map to be duplicated (Havens, 2006; Mato, 2005; Moran, 1998; Waisbord, 2004). Television formats vary in genre including reality television, gameshows, sitcoms, weekly serial dramas, and telenovelas. Television formats such as Colombia's telenovela *Yo Soy Betty, La Fea*, Israel's drama *In Treatment* (began in 2008), or Britain's teen drama *Skins* (began in 2007) are used as the basis of new programs and are sold internationally as cultural exports in order to adapt the narrative, characters, and style for other local audiences. By legally licensing a program format including the name, content, etc., the producer has the ability to borrow

from the original program as a successful model and the flexibility to localize the format (Moran, 1998, p. 21).

For some critics and industry professionals, the emergence of successful formats such as *Ugly Betty* and *In Treatment* complicate previous notions of U.S. media imperialism (Waisbord, 2004, p. 361). While the global success of one Latin American telenovela format such as *Betty* is not an indication that the U.S. dominant flow of media is shifting to a more egalitarian exchange, network priorities and patterns of program exchange are pursuing the increasingly popular international format. In order to maintain a profitable audience share and develop product differentiation, networks actively look abroad for new ideas (Bielby & Harrington, 2008; Keane et al., 2007; Moran, 2006). At the 2009 National Association of Television Producers and Executives conference, the producers, distributors, and other industry panelists focused on the cost benefits and reliability of purchasing global television formats. One of the panel's titles seemed to summarize the theme of the entire conference. The title read, "The HITS Factory: Transatlantic Formats = Ratings and $," and focused on the success rate, profitability, and speed of adapting formats for the American market (NATPE, 2009). As will be further discussed, the success of adapting formats from different cultural contexts and geo-linguistic regions varies widely. Therefore, it is important to note that the major networks' search abroad tends to focus on Anglo-linguistic territories. The transatlantic format exchange is a different cultural export model and context from the Latin American telenovela.

Buying the format for a telenovela and creating a local version has become common worldwide since 2000 (Havens, 2005, p. 286). Around this period, U. S. soap opera producers began incorporating telenovela production and programming practices in order to reinvigorate lagging daytime shows such as ABC's *Port Charles*. These changes included twelve-week story arcs that focused on a group of characters and specific theme and ending with a loosely closed narrative. However these changes did not significantly increase viewers and ABC canceled the show in 2003 (Bielby & Harrington, 2005, p. 389). Additionally, an increasing number of formats from Latin America began development within the U.S over the past decade. Mato (2005) explains the sale of the basic structure of the telenovela functions as a format that includes the concept, plot, and main characters while subplots and other details are added after adaptation to 'localize' the product for a culturally specific market (p. 427). For example is NBC's interest in developing an English-language version of the Colombian *Sin Tetas No Hay Paraiso* (*Without Breasts There is No Pparadise*) (Gold, 2007; Newberry, 2008 & 2009).

With a significant U.S. Latino population as well as the proliferation of niche-targeted cable channels, the U.S. networks understand that by import-

ing and adapting programming they can reach a larger and far more diverse market sector (Dávila, 2001). In order to reach both Spanish-language and general market audiences, ABC, Fox's My Network TV, National Broadcasting Company (NBC), and local production companies buy telenovela format rights with intentions to adapt and localize successful global telenovelas for a large U. S. audience. In turn, the process of adoption and adaption of telenovela formats have provoked debates among scholars, producers, and audiences. The debates concern how ABC's *Ugly Betty* and Fox's My Network TV *Desire* and *Fashion House* should be classified, marketed, and decoded. This will be explored in the following section.

Adapting the Telenovela Format Business Model

The global popularity and profits of telenovelas such as *Yo Soy Betty*, Argentina's *Lalola,* Brazil's *O Clone* (*The Clone*) have caught the attention of the global media conglomerates. Global media players have recognized the genre's ability to produce revenue. According to telenovela distributor Alejandro Parra (cited in Carugati & Alvarado, 2005), "the novela is not just a program, it is a platform upon which to develop other businesses" (p. 5) including a format franchise, soundtrack, spin-off series. The telenovela has moved beyond national programming and international export to a globally sought-after business model for remaking programs locally. Instead of acquiring rights to a finished, importable product, producers now want to localize their productions for regional/national audiences. This model has worked successfully in many markets across Europe, Asia, and the Middle East (Bielby & Harrington, 2008, p. 73). However, adapting the telenovela business model within the American industry has resulted in mixed to little on-air success outside of *Ugly Betty.*

Due to this trend, the U.S. television industry in the past decade has purchased and produced an unprecedented number formats from game and reality show to sitcoms and dramas. The networks have had a few successes and a number of flops. Specifically, the major networks ABC and Fox tested the telenovela model by purchasing formats and producing their own localized versions during the 2006–2007 television season. This section will explore how both networks utilized different strategies for producing and marketing localized telenovela formats during this period. Fox adhered closely to Latin American telenovela narrative and programming characteristics, whereas ABC made claims of blending both U.S. and Latin American television traditions. In turn, these two strategies ignited an industrial debate during the 2006–07 television season regarding the nature of genre conventions and the telenovela format. Using industrial discourse of television executives, producers, writ-

ers, and critics across the U. S. and Latin America, I will explore how questions of genre and international television flow revolve around a show's cultural authenticity and geographical origin.

In September 2006, a new prime-time program network, My Network TV, premiered on stations owned-and-operated by sister company, Fox. Initially, the network announced plans to target a large, often ignored sector of the U.S. audience, 18-to-49-year-old English-speaking Latinos. Produced by Fox's television division Twentieth Television, two English-language telenovela adaptations aired, *Desire* (*Mesa Para Tres/ Table for Three*) and *Fashion House* (*Salir de Noche/ Out at Night*). Programmed as a prime-time telenovela, each program ran Monday through Friday for one hour (Alvarado, 2006, p. 3). While a telenovela traditionally lasts for 180 episodes, *Desire* and *Fashion House* consisted of 65 episodes each and narrative closure occurred at the end of 13 weeks. After the three-month period, two new franchises or adaptations of a Latin American series began on the same continuous cycle. Additionally, each show carried a second audio program (SAP) with a Spanish audio track, which was heavily marketed toward Latino audiences.

My Network TV producers were concerned about implementing the distinctive modes of production and exhibition of the telenovela. In a *World Screen* interview, the president of programming at Twentieth Television, Paul Buccieri stated:

> We tried to take the most dramatic storyline and adapt it . . . We will be producing novelas that will be stripped five nights a week, and each will have a beginning, a middle and an end. It is my understanding that our competitors [ABC and NBC] are producing novelas that will air once a week, and to me, that is not very different from regular drama series that air on U.S. networks (cited in Alvarado, 2006, p. 4).

Many within the U.S. industry, including Buccieri, emphasized the importance of a telenovela remake adhering to traditional programming practices. For My Network TV, directly translating and adapting a telenovela such as Colombian *Mesa Para Tres* into English and utilizing the five nights a week programming practice constituted the label of an "English-language telenovela" ("Twentieth Television," 2005, p. 1).

Although slow to attract both a general and Latino audience, Buccieri and his network continued to support their "product." For attracting a wider audience beyond the Latino market, he anticipated that "some time is necessary for an educational process about this format. Once it sets in and people understand the genre, it fits. The reviews have been favorable. We're sticking with it" (cited in Garvin, 2006, p. 19). Fox executives were more concerned with training the American general audience toward this programming pattern and not about issues of cultural specificity or adaptability for local television

norms. However, this model of adapting telenovela formats did not receive the audience numbers that were anticipated. My Network TV stopped airing their English-language telenovelas by the end of the 2006–07 season and now relies mostly on unscripted and syndicated programming.

ABC's early market strategy made claims to authenticity and deliberate marketing of their program as a Latin American remake, a prime-time "soap opera." The show is a remake of the highly successful Colombian telenovela from Radio Cadena Nacional (RCN), *Yo Soy Betty, La Fea*, about a shy, smart and clumsy "ugly duckling" who works for a fashion company. In the South American version, all ends well as Betty eventually wins the love of her boss and, via a makeover, turns into a beautiful swan. Since the original *Betty*'s run between 1999–2001, the format has been exported to over 70 countries, including India, Germany, Greece, The Netherlands, Russia, Spain, Israel, Brazil and Mexico. In licensing the *Betty* format, local producers pay for the format "bible," which may include specific story arcs, characters, scripts, and promotional materials (Moran & Malbon, 2006, p. 23). In some cases, the series creator may help adapt the format for another national market. Specifically, the creator of the original *Betty*, Fernando Gaitan, actively participated in the adaptation process by serving as a writer for the Mexican and Spanish remakes and as an executive producer for the U.S. version (Fuente, 2006).

Although My Network's fate would prove otherwise with their local audiences, *Ugly Betty*'s producers relied on the ease of adaptability assumption. Yet, ABC opted to rely on the popular telenovela source material and the *Betty* franchise without the five nights a week programming practices of the telenovela. After five years of development and two failed attempts, Salma Hayek, Silvio Horta and Ben Silverman co-produced a pilot with Reveille Pictures and Ventarosa (Ryan, 2006). While the format centers on Betty, the intelligent moral center for both her family and the magazine, the ABC version was adapted for an ensemble cast of characters. According to show runner Horta, "you pack each episode so full, and do it so quickly—you have to readjust for the American pace and the American appetite. We're doing [*Ugly Betty*] as a nighttime soap opera, with each episode having a beginning, middle and end, rather than trailing along like daytime soaps" (cited in Garvin, 2006, p. 14). A show runner is the industry term for the person who runs the everyday operations of a television show. Many times this involves developing the show's concept and writing the episodes. Less concerned with the traditional telenovela programming practices, Horta emphasizes the localization of melodramatic style and humor for diverse U.S. audiences, especially for Latinos.

When adapting a format for another market, scheduling can be a key. Bielby and Harrington (2008) argue that the U.S. *Betty* was "de-telenovela-ized" because of its once a week schedule and the lack of narrative closure. My

Network TV attempted to adapt the daily schedule with English-language telenovelas that presented the betrayal, love, and family characteristics of the genre. In addition, *Ugly Betty* was produced as a U.S. prime-time hour-long serial dramedy (sitcom and serial drama). Dramedy distinguishes *Ugly Betty* from the telenovela. Unlike My Network TV who emphasized their authentic interpretation of the telenovela, ABC and Horta constructed *Ugly Betty* as a hybrid. This raises questions when translating a genre-specific format. Many within the U.S. industry agree that *Ugly Betty* diverges from traditional telenovela practices and conventions. When asked about the current wave of American telenovela remakes, My Network TV executive Buccieri contends the following:

> There's no difference between *Ugly Betty* and any other dramatic series or 'dramedy' on [U.S.] network television. It's got no set ending and it's not nightly. Those two elements are what *make* a novela. You've got a cliff-hanger every night, the show builds to a climax, it's over, and the characters are never seen again (cited in Garvin, 2006, p. 11).

Many critics appear to agree. William Booth (2006) of the *Washington Post* considers the show "not technically a telenovela. It is instead a one-hour comedy with soap telenovela notes" (p. 9). Barry Garron (2006) from the *Hollywood Reporter* agrees, "This isn't a telenovela simply translated into English, like the two dreadful series on My Network TV. This is a warmhearted dramedy, which gushes charm and family appeal" (p. 1).

In exporting the *Betty* format to the U. S., the American version is not solely a soap opera or an "authentic" telenovela, but exists somewhere in-between as will be argued further in the following section. Overall, it appears that in order to produce a successful and sustainable telenovela format within the U.S., the producers must focus on blending telenovela and soap opera elements. This localization strategy served well for *Ugly Betty* and reflects the notion of "cultural proximity," a concept that suggests audiences are more likely to prefer media products that reflect their own culture and media traditions (Straubhaar, 2007). However, My Network TV's adhered to telenovela conventions through retaining the programming and closure of the telenovela in order to create English language versions. *Desire* and *Fashion House* suffered with critics and audiences for attempting a literal telenovela translation. So what made *Ugly Betty* a culturally specific *and* successful adaptation? The following section focuses on critical and popular discourse surrounding *Ugly Betty*'s place as a telenovela format and its Latino interpretation within the U. S. context.

Traveling and Translating Betty: Negotiating Latinidad through Race, Class, and Gender

Waisbord (2004) argues that "[television] formats are de-territorialized; they have no national home; they represent the disconnection between culture, geography, and social spaces that characterizes globalization" (p. 378). Never meant to remain fixed within its original context, on the surface level he contends that a format is a "pasteurized, transnational product" that functions generally as a nationally neutral "McTV" similar to the adaptability of McDonald's food all over the world (p. 372). Effectiveness and flexibility of the product are more important than a format's national origins according to Waisbord (p. 378). As illustrated in the previous section, the industrial process of adapting a telenovela is anything but a neutral project that removes all signs of cultural territory (p. 378). While the Betty format exhibits flexibility as described by Waisbord, the format does not always function as a one-size-fits-all media product. Instead, the journey of the telenovela format within the U. S. intentionally incorporates its Latin American origins illustrating the difficulty of adapting and classifying the genre within another cultural context.

The remainder of this chapter will present a textual and discursive analysis of the show's first season, 2006–07, in order to interrogate the claim that all formats are neutral technology devoid of "original" cultural or geographical markers (Waisbord, 2004). How does *Ugly Betty* acknowledge or reflect these industrial debates regarding the telenovela? How does the show reflect the journey of media from Latin America to the United States? Unlike the "pasteurized" or "deterritorialized" format described by Waisbord, *Ugly Betty* explores its place as a telenovela format through genre allusions and functions as a complicated, albeit problematic, representation of the contemporary Latino immigrant experience within the contemporary United States. Specifically, the Betty character must negotiate borders of race, gender, sexuality, and class. Themes of the telenovela's origin, transnational travel, and cultural translation appear throughout the industrial, popular, and critical discourse around *Ugly Betty*. Through the format and the character of Betty, the show becomes a space for narrating and negotiating a version of the Latino/a experience within the U. S. at this particular moment within the 21st century.

As the program's title implies, Betty Suarez (America Ferrera) does not adhere to dominant norms of beauty according to the fashion industry—the tall, white stick-figure generic runway model. Instead, Betty is a short, full-figured Latina with braces, glasses, and a loud sense of style who lives in Queens, New York. She lives with her widowed, Mexican immigrant father Ignacio (Tony Plana), older sister Hilda (Ana Ortiz) and nephew, Justin (Mark

Indelicato). The series begins when Bradford Meade (Alan Dale), head of Meade Publications, purposefully hires Betty to be a plain, asexual assistant for his philandering son and editor of *Mode* fashion magazine, Daniel (Eric Mabius). Additionally, the office includes the creative director, Wilhelmina (Vanessa L. Williams), her assistant, Marc (Michael Urie), the receptionist, Amanda (Becki Newton), the tailor, Christina (Ashley Jensen) and Henry the accountant (Christopher Gorham). While the show revolves around an ensemble cast of characters and plotlines, this section will analyze the character of Betty through critical, textual, and audience analysis in two parts: 1) transitions from Queens to Manhattan and 2) the Suarez family as working class Latinos, including the Mexican immigrant father.

Betty and the City

As the unlikely, average Latina heroine, who plays against decades of limited, one-dimensional roles, Betty has resonated with a diverse U. S. audience as illustrated by critical reviews and online message boards accustomed to seeing the stereotypical Latina "hoochie, maid or gang member" (Diaz, 2006, p. 3). Historically, Latinos/as have been absent from prime-time television, making up only 4 percent of characters (Heinz-Knowles et al., 2002, p. 5). Significantly, Ferrera's Betty became the first Latina character to lead a prime-time show (Diaz, 2006). From conception through development, Horta and producers were, "very passionate about this character being a Latina . . . [because] it'll be a different slice of life that you just don't see on television" (cited in Ryan, 2006, p. 8). Betty represents the experience of the first-generation Latina, who the *Boston Globe*'s Johnny Diaz (2006) suggests is trying "to fit into mainstream [America] while negotiating a bicultural reality" (p. 4).

One of the most interesting changes within the *Betty* franchise has been the level of audience interactivity. For example, issues of Latino representation were major areas of debate on online discussion boards during the first season (audience posts were collected during this 2006–2007 season). One self-identified Latino viewer on the IMDB.com message board lauded the show's "real" representations, "we need more real shows, about real people, for real people. That is reality television to me" (dosmaridos). Another viewer on the same site praised the family dynamic, "And finally!!!!! A Mexican-American family that rings truer to life than any I've seen in a while" (Blanche-2). Other fan sites such as the UglyBettyBlog illustrate the viewer connection to Betty's character:

> It takes someone from the margins who is so much like the rest of us . . . and in
> turn, we share her life on the margins, we experience her world, her point of view,
> and we find out that the world around her is not as attractive or desirable as we

though it was. We sympathize with her marginal world, and we see the world through her eyes" (TxCowPatty).

However, when the Suarez family visits extended family in Guadalajara, Mexico at the end of season one, a number of the Spanish-speaking audience members criticized the stereotypical representation of Mexico and the inconsistency in language. Specifically, characters were speaking mostly English and Betty's Mexican family shifted from Nicaraguan to Puerto Rican accents. What is unique about this moment in the television industry is how audiences increasingly have more outlets to respond to the show's narrative, characters, and visual style than ever before. Namely, *Betty* has an active international, online fanbase due to the show's accessibility via a computer or cell phone allowing for further audience participation and feedback. Additionally, audiences are able to log into the ABC website and purchase clothes worn on the show or follow one of the character's blogs. Contemporary digital technology has helped to shape the recent telenovela format flow due to audience reception, by allowing increased interactivity and feedback.

Furthermore, Latino audiences who are familiar with telenovelas would immediately understand how *Ugly Betty* plays with genre conventions. For example, there is the villainous character, Wilhemina, who schemes out loud to herself or there is a hair–pulling fight between Betty's sister and the neighbor. Other telenovela references include a guest performance by Angelica Vale who played Letty on the Mexican *Betty* format. There is also a Spanish-language telenovela-within-a-show that Betty's father watches. For example, one telenovela scene that Betty's father watched featured a nun who was pregnant with a priest's baby. The nun was played by Mexican producer and actress Salma Hayek who began her career as a telenovela actress. The campy allusions to the Latin American genre offers multiple reflexive moments playfully nodding to a knowing Latino and/or telenovela-watching audience who are familiar with the genre's conventions. The U.S. *Betty*'s references consciously call attention to its knowledge and connection to telenovela conventions as well as the format's specific journey from Colombian telenovela to U.S. prime-time soap opera or dramedy.

If viewers are to accept the preferred interpretation of the show encouraged by the network and producers, Betty is merely a progressive, non-stereotypical Latina. By examining the text via a more complicated, oppositional reading surrounding the intersection of Betty's gender, race, and class within her bicultural reality, a more complicated view of intersectionality is revealed. Betty must navigate between two separate worlds—her working-class neighborhood in Queens and the posh, cutthroat fashion business in Manhattan. In the pilot (Season 1, Episode 1 aired September 26, 2006), receptionist Amanda greets Betty on the first day. Seeing Betty's

Guadalajara poncho, she slowly enunciates "Are you DE-LIV-ER-ING some-thing?" Amanda assumes this Mexican American woman cannot speak English nor be a professional colleague. Not only do Betty's curvy figure, dark hair, and features mark her as different, her Latino heritage is emblazoned on her poncho. Throughout season one, *Mode* employees call Betty everything from a "human piñata" to "chimichanga." Within these scenes of quippy dialogue, her Latinidad becomes the butt of the jokes.

Since her migration to New York City and inclusion in the fashion world is never fully complete, Betty's journey to Manhattan can be read as a "fish-out-of-water" tale (Levin, 2006). Throughout the program, the character trips and stumbles her way from one awkward situation to another. Perhaps the biggest issue of all is how Betty's looks do not translate to the Anglocentric fashion world. In the episode "Queens for a Day" (Season 1, Episode 3 aired October 12, 2006), Hilda gives Betty a makeover for an important meeting. Her new look is revealed against a reggaeton background as she proudly struts down the street of her Queens neighborhood. Her transformation includes big curly hair piled on top of her head, a brightly patterned ill-fitting outfit, fake nails, and heavy makeup. According to critic Rebecca Traister (2006):

> [Betty's] look doesn't translate in Manhattan, and it provokes the most scathing round of jeering she's yet received. The other assistants photograph her as if she's a zoo animal, and Wilhelmina scoffs, 'It looks like Queens threw up.' The message is clear: Queens pretty is not Manhattan pretty. Poor pretty is not rich pretty. Latina pretty is not white pretty (p. 21).

While *Ugly Betty* shifts the Latina, working class experience from invisibility to visibility, this move does not come with an inclusive pass to her largely white, upper-class workplace. Claudia Milian argues that Betty is a metaphor for U.S. Latinos and "the unacknowledged parenthetical presence that stands for Latinas and Latinos in few positions of power" (cited in Diaz, 2006, p. 14). Yet, Betty's visibility serves to highlight her racial and her class difference in relation to her colleagues. Even though she is able to cross the border from Queens to Manhattan, she does not fully make the transition from exclusion to inclusion. Within the first season, most critics and audience members appear to admire Betty for her work ethic, loyalty, and ability to remain true to herself. Yet, Betty remains the Manhattan fish-out-of-water who serves as the punch line inside and outside of the text.

An Immigrant's Tale: The Suarez Family

The multi-generational Suarez family does not represent the stereotypical Anglo-American nuclear family of earlier television programs. Betty's moth-

er died when Betty was a teenager, and Hilda raises her son mostly without a father. As acknowledged on a number of fan online message boards, *Ugly Betty* represents a contemporary, generic "every" American Latino family who speaks Spanglish, whose daughters talk about their quinceañeras (the coming of age celebration for a 15 year old girl in Latino culture), whose parents watch telenovelas and prepare empanadas and flan. Ferrera suggests that the appeal of the Suarez family is that, "it's not about stereotypes. They're not hitting piñatas every weekend. More important than having Latinos on TV is having a representation of the variations of what a Latino is" (Keveney, 2006, p. 24).

The show represents not only a first generational Latino experience, but also a working class Latino experience (Hodgson, 2000, p. 11). Telemundo executive, Ramon Escobar, reflects: "It's the journey, it's the struggles, it's the obstacles . . . [which] often include poverty, class conflict and institutional insta-bility, something the U.S. soaps ignore" (Martinez, 2005, p. 3). The economic and cultural struggles of the Suarez family come to represent the cultural speci-ficity of the telenovela as well as the Latino experience. They deal with insur-ance coverage, money worries, sibling rivalry, and so on. For example, Betty battles with her father's HMO in order to continue to refill his heart med-ication, "he needs his medication . . . this is a real person's health, not a case number." As Betty moves back and forth between her two worlds during sea-son one, Hilda and others question how her professional drive conflicts with family responsibility. She tells Betty, "these things don't happen to people like us. You [need to] be more realistic."

In the episode, "The Lyin,' the Watch and the Wardrobe" (Season 1, Episode 5 aired October 26, 2006), Ignacio reveals "I was trying to protect you. I don't have a social security number, you can't get one if you're in this country illegally . . . and I am." Throughout his first season arc, Ignacio is reported as an undocumented immigrant, arrested, assigned to a case work-er, turned down for a green card, and returned to Mexico to wait for a visa. Portrayed as a devoted father, Tony Plana's Ignacio becomes a three-dimen-sional, emotionally complex character speaking to a major contemporary socio-political issue. Some critics and fans see the show as an attempt to reflect a dimension of the difficult and painful reality of immigrating to the U.S. as a Latino as well as the effects of deportation, while others protest that this explanation detracts from the typical political and economic causes of immi-gration. One viewer on the *Ugly Betty* IMDB.com message board applauded the characterization of a Mexican American father. The viewer stated, "The father is dedicated and loving (and present!), with a fierce loyalty to his favorite daughter" (Schmidt). Additionally, CNN senior producer Rose Arce (2006) applauded the show for addressing this issue:

It's heartening to see something Latino holding its own in English. It means there has been a coming together, a melting in the melting pot. That's the thing that makes the United States a special place for immigrants. That it welcomes and assumes their culture. That it goes out its way to welcome the millions of Betty's out there into their home (p. 7).

Arce compared *Betty* to the American assimilationist metaphor for immigration where difference is celebrated, easily overcome, and then completely forgotten.

However, *Betty*'s emphasis on immigration and the treatment of Ignacio's undocumented status was also a point of criticism. One writer suggested "for *Betty* to be challenging and cutting-edge . . . [the show needs] to visually capture the sometimes-discombobulating sense of living and working as a cultural nomad" (cited in Acosta, 2007, p. 3). Another online critic proclaimed "Thank you, *Ugly Betty*, for dramatizing the immigration process. It's been real, but let's ditch the ankle bracelet [from the crazy, stalking social worker]. It's worth a couple of jokes, but that's it. Give Ignacio a real love interest, some buddies, a freaking hobby. Stop saddling him with heart medication and case workers" (Ward, 2007, p. 4). Similar to Betty's difficulties adjusting to Manhattan in season one, Ignacio's difficulties as an undocumented immigrant are mainly played for laughs during the first season.

Cultural transition and translation can be a difficult and messy process as illustrated by the failure of My Network TV to adapt telenovelas or a painful and disruptive one as the case of Ignacio's struggles to be granted U.S. citizenship illustrate. From the industrial debates in the previous section to the personal struggles of the Suarez family, this show is both a charged portrayal of the adaptation process of the telenovela format as well as a portrayal of a Latino family in the contemporary United States. Overall, *Betty* represents immigration as a place of negotiation somewhere between inclusion and exclusion, and the difficulties of a fish-out-of-water operating between two worlds.

On a broader scale, this show is another example of the complex intersection between global television flows, culture, identity, and national borders. As argued by Hilmes (1997), Kraidy (2010), Kumar (2006), and Moran (1998), television has long served as a communal space for nation building connected by a common identity and feelings of belonging. By translating any global television format for local, national audiences, a program should be read as a complex negotiation between forces of globalization and its place as a national product (Moran & Malbon, 2006, p. 155). The case of *Ugly Betty* illustrates the challenge of localizing a format into an American television product.

Betty as a format may be dislocated and removed from its physical or geo-

graphical place where the show initially was produced. What is unique about the U.S. adaptation of the *Betty* format is that it retains its telenovela sensibilities or "cultural odor" or imprint (Iwabuchi, 2002, p. 27). Iwabuchi suggests a cultural odor of "any product may have various kinds of cultural association[s] with the country of its invention" or, in the case of the telenovela, the Latin American genre tradition. *Betty*'s format journey from Latin America to the U. S. is a unique one in which its cultural fragrance, in this case Latinidad, remains a central theme. While I am making a distinction between form and content, this case study illustrates how a format can still retain cultural markers of its Latin American origin. The story of the Suarez family and Betty's migration to New York, like the traveling telenovela format, is a transnational one across various national spaces, contexts, and cultures. By traveling from Latin America to the U.S., *Betty* becomes something new and transformed—simultaneously both a Latin American and American media product. It is in this context of the Latino immigration and American experience that *Betty* resides and should be understood as a multi-layered transnational media product.

Conclusion

The larger implications of this study is how the adaptation of the telenovela within other regions and nations is more complicated than Waisbord's (2004) notion of the format as a "pasteurized, transnational product" or whether the U.S. *Betty* is a telenovela or not. Instead, the *Betty* franchise's adaptation within the U. S. illustrates how the telenovela format is a fluid and flexible product with the ability to incorporate the complicated history of national border crossing, immigration, and the Latino experience within the United States. While *Betty* maintained viable ratings shares since its premiere, the show was not renewed beyond its fourth season, 2009–2010. *Betty* can be classified as a success since so many format attempts have failed in the first few episodes. Yet, this case illustrates the difficulty of adapting the telenovela genre for the U.S. general audience and, more specifically, Latino audiences. Yet, in light of the cultural flexibility of the *Betty* format, this journey reveals the largely messy and many times uneven path of adapting the telenovela in other contexts.

This essay serves to illustrate how older models of global media flow, nation, genre, and industry need to be reconsidered within the changing climate of the 21st century media industries. Many contemporary theories of television flow and formats are unable to fully interrogate discursive and textual context that shows the unique adaptation and interactive experience of the telenovela format within the United States. Within industrial discourse, the

question of how to categorize *Betty* and My Network TV's programs narrowly framed the debate around genre conventions and authenticity.

Furthermore, the changing technological and commercial nature of the television industry has impacted the ways in which U.S. and global audiences interact with the show. As illustrated by audience online interactivity and responses, adapting *Betty* in the digital era of the 21st century allows these audience members to speak to each other and to Betty's producers through blogs, online forums, and message boards.

The *Betty* franchise continues to be adapted globally. In Brazil, a television market that already imports the U.S. *Betty* and the Mexican *Betty*, a locally adapted *Betty* called *Bela, a feia* (*The Ugly Beauty*) premiered on TV Record in 2009. Additional research could address how different versions of the Betty format perform and interact differently in different markets. How do notions of nationality, culture, and identity within these various contexts further complicate theories about the flow of an individual format? As the *Betty* franchise and other telenovelas continue to be adapted within Asia, the Middle East, Latin America, and Europe, further cross-cultural research is needed to understand global flow of this television form from a culturally specific and methodologically thorough perspective.

References

Acosta, B. (2007, February 9). Am I having a laugh? *Austin Chronicle* online. Retrieved from http://www.austinchronicle.com/gyrobase/Issue/column?oid=oid%3A444427

Acosta-Alzuru, C (2003). Tackling the issues: Meaning making in a telenovela. *Popular Communication, 4*, 193–215.

Alvarado, M. (2006, June). Big love, big business. *World Screen* online. Retrieved from http://www.worldscreen.com/print.php?filename=novelas0606.htm

Antola, L., & Rogers, E (1984). Television flows in Latin America. *Communication Research, 11*(2), 183–202.

Arce, R. (2006, October 16). America's Latinization: Shakira, salsa and *Ugly Betty*. Retrieved from http://www.cnn.com/CNN/Programs/anderson.cooper.360/blog/2006/10/americas-latinization-shakira-salsa.html

Bielby, D.D., & Harrington, C.L. (2008). *Global TV: Exporting television and culture in the world market*. NY: New York Press.

Bielby, D., & Harrington, C.L. (2005). Opening America? The telenovela-ization of U.S. soap opera. *Television & New Media, 6*(4), 383–399.

Biltereyst, D., & Meers, P. (2000). The international telenovela debate and the contra-flow argument: a reappraisal. *Media, Culture, & Society, 22*, 393–413.

Blanche-2 (2006, October 26). Message posted to http://www.imdb.com/title/tt0805669/board

Booth, W. (2006, October 26). Building Betty. *Washington Post* online. Retrieved from

http://www.washingtonpost.com/wpdyn/content/article/2006/10/20/AR200610
2000260.html?nav=emailpage

Carugati, A., & Alvarado, M. T. (2005). The business of love. *World Screen* online. Retrieved from http://www.worldscreen.com/print.php?filename=0605novelas.htm

Dávila, A. (2001). *Latinos, Inc.: The marketing and making of a people*. Berkeley, CA: University of California Press.

Diaz, J. (2006, November 8). Ugly beauty: Real latina values are the attraction in ABC's stereotype-busting hit. *Boston Globe* online. Retrieved from http://www.boston.com/ae/tv/articles/2006/11/2008/ugly_beauty?mode=PF

Dosmaridos (2006, October 25). Self-identified Latino poster. Message posted to http://www.imdb.com/title/tt0805669/board

Fuente, A. M. (2006, November 19). Beating the telenovela bushes from another Betty. *Variety* online. Retrieved from http://www.variety.com/index.asp?layoutprint_story&articleid=VR1117954163&categoryid=14

Garron, B. (2006). *Ugly Betty* review. *The Hollywood Reporter*. Retrieved November 18, 2006, from http://www.metacritic.com/tv/shows/uglybetty

Garvin, G. (2006, September 28). *Ugly Betty* producer grows into his role. *Miami Herald* online. Retrieved from http://miamiherald.com/mld/miamiherald/entertainment/columnists/glenn_garvin/15618090.htm

Gold, M. (2007, October 23). Accent on talent. *Los Angeles Times* online. Retrieved from http://articles.latimes.com/2007/oct/23/entertainment/et-casting23

Havens, T. (2005). Globalization and the generic transformation of telenovelas. In G. R. Edgerton & B. G. Rose (Eds.), *Thinking outside the box: A contemporary television genre reader* (pp. 271–292). Louisville, KY: University of Kentucky Press.

Havens, T. (2006). *Global television marketplace*. London: bfi.

Heinz-Knowles, K., Henderson, J., McCrae, A. P., & Grossman-Swenson, S. (2002). *Latinos on prime-time TV: Report III, 2001–02*. National Hispanic Foundation for the Arts. Retrieved from http://www.hispanicarts.org

Hilmes, M. (1997). *Radio voices: American broadcasting, 1922–1952*. Minneapolis, MN: University of Minnesota Press.

Hodgson, M. (2000, September 18). Ugly Betty woos Colombia viewers night after night. *London Guardian* online. Retrieved from http://www.guardian.co.uk/world/2000/sep/18/martinhodgson

Iwabuchi, K. (2002). *Recentering globalization: Popular culture and Japanese transnationalism*. Durham: Duke University Press.

Keane, M., Fung, A. Y. H., & Moran, A. (2007). *New television, globalisation, and the east Asian cultural imagination*. Aberdeen: Hong Kong University Press.

Keveney, B. (2006, November 15). Ugly Betty is sitting pretty. *USA Today* online. Retrieved from http://www.usatoday.com/life/television/news/2006–11–15-ugly-betty-main_x.htm

Kraidy, M. M. (2010). *Reality Television and Arab Politics: Contention in Public Life*. New York: Cambridge University Press.

Kumar, S. (2006). *Gandhi meets primetime: Globalization and nationalism in Indian television*. Urbana: University of Illinois.

Levin, G. (2006, August 15). Plot: Pretty is as pretty does. *USA Today* online. Retrieved

from http://www.usatoday.com/life/television/news/2006–08–14-ugly-betty-inside_x.htm

Martinez, I. (2005, November 1). Romancing the globe. *Foreign Policy,* Nov/Dec 2005. Retrieved from http://yaleglobal.yale.edu/article.print?id=6442

Mato, D. (2005). The transnationalization of the telenovela industry, territorial references, and the production of markets and representations of transnational Identities. *Television & New Media,* 6(4), 423–444.

Moran, A. (1998). *Copycat television: Globalisation, program formats and cultural identity.* Luton: University of Luton.

Moran, A. & Malbon, J. (2006). *Understanding the global TV format.* Bristol: Intellect.

National Association of Television Program Executives conference program. Retrieved \ from http://natpe.org.

Newberry, C. (2009, March 7). Argentina: Mip territory reports. *Variety* online. Retrieved from http://www.variety.com/article/VR1118001789.html?categoryid=3579&cs=1&query=telenovela+remake

Newberry, C. (2008, February 21). Sony TV nabs Argentine telenovela. *Variety* online. Retrieved from http://www.variety.com/article/VR1117981252.html?categoryid=19&cs=1&query=telenovela+remake

Nordenstreng, K. & Varis, T. (1974). Television traffic: A one-way street? Paris: UNESCO Report.

Rogers, E. M. (1985). Telenovelas: A Latin American success story. *Journal of Communication,* 35(4), 24–36.

Ryan, M. (2006, November 16). The subversive delights of *Ugly Betty. Chicago Tribune* "The Watcher." Retrieved from http://featuresblogs.chicagotribune.com/entertainment_tv/2006/11/ugly_betty_laun.html>

Schmidt (2007, February). Message posted to http://uglybettyblog.com

Sinclair, J. (1999). *Latin Amercan television: a global view.* Oxford: Oxford University Press.

Straubhaar, J. (1984). Brazilian television: Decline of the American influence. *Communication Research,* 11(2), 221–40.

Straubhaar, J. (2007). *World television: from global to local.* Los Angeles, CA: Sage.

Traister, R. (2006, November 4). Class act. *Salon.* Retrieved from http://www.salon.com/mwt/feature/2006/11/04/ugly_betty/index.html

Twentieth television rolls out novela franchise. (2005, December 14). World Screen online. Retrieved from http://www.worldscreen.com/print.php?filename=20th1214.htm

TxCowPatty (2006, October 25). Am I dreaming? Message posted to http://www.imdb.com/title/tt0805669/board

Ugly Betty. dir. Sarah Pia Anderson, et al. Touchstone, 2006–10.

Waisbord, S. (2004). McTV: Understanding the global popularity of television formats *Television & New Media,* 5(4), 359–383.

Ward, J. (2007, March 23). *Ugly Betty:* Don't ask, don't tell. Retrieved from http://www.tvsquad.com/2007/03/23/ugly-betty-dont-ask-dont-tell/

16. *Arab Television Drama Production in the Satellite Era*

Christa Salamandra

The dramatic miniseries, or *musalsal,* dominates public culture in the Arab world. This is particularly true during Ramadan, which has given the genre its form, and has in turn been shaped by it. In the weeks running up to the holy month—and peak broadcast season—the city of Damascus becomes a film set, as producers rush to finish their 30-episode programs. Since the rise of pan-Arab satellite stations in the 1990s, Syria has developed the Arab world's leading television drama industry. An average of 35 Syrian *musalsal-s* air on consecutive Ramadan evenings, when television viewing becomes a secular ritual: streets empty after sunset, as families gather around television sets in homes, restaurants, and cafés. Dramatic depictions of past and present, culture and society, customs and values are discussed and debated in conversation and in the transnational Arabic language media. *Musalsal-s* have opened a unique space for social and political critique. Their creators contend with a new set of dictates imposed by religiously conservative markets in an Islamicizing Arab public sphere.

The beginning of private production and the rise of satellite technology converged in the early 1990s to produce what has become known as the Syrian "drama outpouring" (*al-fawra al-dramiyya*). Syria's industry has grown to rival that of Egypt, long the center of Arab media production. Syrian dramas now attract vast audiences throughout the Arab world and in numerous diasporic communities beyond. Drawn from intensive fieldwork among drama creators in Damascus and programming executives in the United Arab

Emirates, this chapter explores the cultural politics of *musalsal* production in the satellite era. I address the ways in which the demise of socialism, the perceived failures of nationalism, and the rise of Islamism are reshaping the work of cultural production, and argue that despite—indeed, in response to—these conditions and constraints, Arab drama creators produce critical depictions of society and politics that resonate with Arab audiences.

The Musalsal

The *musalsal* (literally "series") has played a starring role in the satellite-driven transformation of Arabic language media. Variety channels such as MBC (Middle East Broadcast Center) and Infinity offer Arab viewers a host of formats, such as game shows, situation comedies, reality programs, talk shows, music videos, and cooking shows. The *musalsal* stands out among them, both in production volume and audience response. In Syria it is referred to simply as "drama," having eclipsed an older dramatic form, the *sahra* (literally, "soirée"), made-for-television film. In 1967, television pioneers Ghassan Jabri, Hani al-Rummani and Faisal Yassiri produced the first Syrian Ramadan *musalsal*, *The Misers* (*al-Bukhala'*), a dramatization of ninth century author al-Jahiz's classic *Kitab al-Bukhala'*. Over the next forty years, an Egyptian and smaller Syrian television drama industry developed, with a distinct set of conventions and a range of subgenres, including historical, contemporary social, comedy, folkloric, and the science fiction-like "fantasy"(*fantasiyya*).

Although largely neglected by media studies specialists, Arab drama series feature in a small but fascinating anthropological literature on terrestrial television of the 1980s and early 1990s. Abu-Lughod (1993, 1995, 1998, 2003, 2005a, 2005b) and Armbrust (1996a, 1996b) examined the production and consumption of specific television dramas at a time when limited program choice united national audiences in the act of watching and responding. My own work on the series *Damascene Days* demonstrated how state-produced dramas, seemingly designed to engender nationhood, may instead enhance sectarian, regional and class divisions (Salamandra, 1998, 2000, 2004). While these series were sometimes purchased by and aired on various state-controlled television stations across the Arab world, their target audiences remained Egyptian and Syrian, respectively. With the spread of satellite technology, the pan-Arab scale has displaced the national in content and reception, as dozens of series vie for over a hundred million viewers. This fragmented, transnational mediascape of the Arab satellite era poses methodological challenges for research on both production and consumption (Salamandra, 2005). New media require producers themselves and ethnographers who study them to think beyond the nation.

The Setting

In Arab societies where overt public debate is often stifled, and civil society curtailed, television dramas become a permissible, although beleaguered, mode of alternative expression. This holds true for those who create series, those who write about them, and the audiences who watch and discuss them. Continual attempts by Arab state and non-state forces to block some series, and commission others, confirm that television drama is far from mere entertainment (Abu-Nasser, 2005; Aji, 2006; Ambah, 2008a, 2008b; Slackman, 2006; Worth, 2008). In fact, Syrian dramas are taken seriously enough to spark protests and diplomatic tensions. Ethnic groups in Syria habitually complain when series depict them in ways they deem negative (Salamandra, 1998, 2004). The Turkish government took issue with references to the Armenian genocide in *Brothers of the Earth* (1996). American officials lobbied complaints about the perceived anti-Semitism of 2003's *Dispersed*. The United States persuaded Qatar State Television to suspend broadcast of *The Road to Kabul* (2004), a Syrian-Jordanian co-production, after eight episodes. The Americans feared the series' sympathetic depiction of mujahidin fighting the Soviets would attract new recruits to the Iraqi insurgency. Ironically, promotional clips of the series portraying a fanatical Taliban angered some Islamic groups, who issued their own complaints against the show's producers and cast (Dick, 2005). In Ramadan 2008, tribal groups in Saudi Arabia successfully lobbied for the removal of two 19th century Bedouin themed series from the airways, on the grounds that they might incite tensions among tribes. Occasional death threats against directors and broadcasters underscore the *musalsal's* influence (Aji, 2006; Hammond, 2008; *New York Times*, 2008).

Several factors underlie television drama's centrality. In a tradition where the written word is highly valued, and the major forms of expressive culture have, until recently, been literary—specifically poetic—low readership figures and meager book production reflect what some Arab scholars see as a deep crisis of intellectual life (*United Nations Development Programme*, 2003, p. 4). Books are relatively expensive; satellite dishes increasingly affordable, and television has largely supplanted cinema and theater.

In addition, pan-Arab satellite television stations have proliferated, particularly those owned by the wealthy governments and citizens of the Gulf Cooperation Council (Saudi Arabia, The United Arab Emirates, Qatar, Oman, Kuwait, and Bahrain). Roughly 500 pan-Arab stations crowd the satellite mediascape. About half of these are free to air. Some are specialty channels featuring news, arts, music videos, religious programming or cooking shows; others are variety networks broadcasting a range of programs. Drama series

feature prominently on the grids of the most widely-watched stations, particularly during Ramadan. As MBC producer Fadi Ismail boasted:

> The influence of Arab television has been, in the last 10 years—actually since MBC started in '91—more important and more serious in all Arab societies than 30, 50 or 60 years of work by political parties and ideologues for Arab unity . . . the most unifying factor is now TV, and maybe Arab drama (personal communication, August 13, 2008).

For drama creators, such success entails the steep cost of economic liberalization, a process rife with bittersweet consequences. Throughout most of its history, Syrian television was state-owned and controlled; its employees were uniformly low in status, socially marginal, and relatively impoverished. Privatization in the early 1990s and the rise of pan-Arab satellite stations in the middle of the decade coalesced to swell production. The vertiginous flow of capital has created a star system, bringing some wealth and fame, and leaving many more struggling. Older professional hierarchies are overturned, as pioneers become has-beens, and upstarts become celebrities. A transnational industry of fan literature, in print and on the Internet, bestows social legitimacy on a lucky few (Weyman, 2006). The rest endure the insecurities of a flexible labor market, and an unstable geopolitical situation.

Economic liberalization without democratization leaves drama creators controlled but unsupported. Syrian television is increasingly transnational, but must operate within the confines of a state whose attitude towards the industry remains ambivalent. Sometimes the regime embraces drama television as an emblem of Syrian national culture, or a safety valve for oppositional voices. Frequently, it tightens the reins on television's potential subversion. Most usually, it appears to treat television drama as a low priority. While government censorship persists, public sector involvement in production shrinks. GCC satellite networks, both private and public, now finance the industry. Sometimes private producers fund series and then market them to GCC stations. More often Gulf stations finance dramas and receive exclusive Ramadan first broadcast rights in return. Series are shown throughout the year, but it is the coveted holy month primetime that makes fortunes and reputations. Ramadan, with its shortened work hours and family gatherings, has become associated with television drama watching. It is a time when viewership swells, showcase productions air, and advertising rates soar (Kraidy & Khalil, 2009, pp. 99–100).

Syrian producers argue that a lack of state regulation or protection exposes them to the caprice of Gulf business practice. Unlike Egypt, Syria does not limit the number of foreign *musalsal*-s its state television stations air. While Egypt's foreign ministry promotes packages of Egyptian series to GCC net-

works for the Ramadan primetime, the Syrian state has left its drama producers to fend for themselves in a competitive market. As Syrian screenwriter Najib Nusair puts it, "We have become like vegetable peddlers, selling series from sacks on our backs as if they were potatoes." Some Syrians argue that the term "industry," *sina'a*, is a misnomer; drama production is merely an "activity" that has little infrastructure and could vanish at the slightest downturn. Nusair points to the black garbage bags Syrian producers use to distribute funding as a symbol of this precariousness:

> They take a garbage bag, put money in it, and distribute it to the scenarist, the actors, equipment rental, and that's it; nothing else. Practically all Syrian drama now is financed from the Gulf, and it is basic, it's not like there are big, complex companies with capital and stocks. Bank notes come in a black bag and get distributed. And this is related to infrastructure. The infrastructure we have amounts to a camera and editing machine. This is all we have. And you have seen, you went to the filming locations, and these are real sites they rent from the black bag, natural places: cafes, houses, hospitals . . . it's built on relations not of industry, but of simple commerce. There are no advertising companies interfering, it's a sector on its own, separate. The production companies are just investments: you buy *musalsal-s* the same way you buy Nescafe . . . this year there were thirty eight Syrian series; next year there might be zero. So there is nothing you could call an infrastructure, nothing. There's the garbage bag, what we call the black bag, what they put money in, and make drama (personal communication, July 19, 2006).

Programming decisions appear equally haphazard. In addition to avoiding the Syrian state censors' ever shifting red lines, drama creators must please buyers in the religiously and socially conservative GCC states. They complain of a "social censorship" harsher than the most draconian strictures of former president Hafiz al-Asad's era. In the absence of reliable ratings or audience research, it is GCC station owners and managers, often expatriate Arabs, who decide what is aired. Complaints about privatization reflect inter-Arab tensions. Artists in many cultural contexts bemoan commercialism, and laments over popular taste and ratings exigencies abound. Syrian television creators view the enemies of art not as a generalized national audience, or even amorphous "market forces," but as a specific group of wealthy, parochial and over-privileged foreigners who are out of touch with what Arab audiences need, if not what they want. Industry figures point to a-worst-of both-worlds situation, as economic liberalization without democratization leaves them vulnerable to both Syrian censors and Gulf buyers. "People like me feel betrayed by authority, be it capital or the gun," argued a well-known cinema and television director, "We have lost the historical moment."

For Syria's cultural producers, the drama stakes are high. The industry

encompasses much of the country's intellectual and artistic community. Industry figures note that when political parties were banned in the 1960s, activists became writers and journalists, but continual restrictions on press freedom and new employment opportunities have rendered them TV makers. Many of the country's leading directors, writers, actors, visual artists, and photographers use television work to supplement meager incomes from more "serious" endeavors. Yet they understand the global reach and social significance of the *musalsal*. Like their Egyptian counterparts, Syrian intellectual and activist drama creators believe in the power of their mass medium to transform Arab society, and often see themselves at the vanguard of a modernizing process (Abu-Lughod, 2005a, 2005b). For many, didactic concerns trump all others. They seek to shed light on issues difficult to broach in non-fiction media, hoping to spark discussion and, ultimately, social and political transformation. As they are keenly aware, they operate in commercial conditions not of their own choosing. Paradoxically, economic liberalization and globalization converge to expand audiences, but threaten to constrain social critique and derail reformist impulses. As they cope with the vagaries of conservative GCC buyers, drama creators reflect on what they feel they have lost. Resentments brew against the markets that seem to block progress. As a pioneer television director, himself a European-educated urbanite, put it:

> In the old days, we were poor, but our art was our own. We produced work that we felt was good for Syria. Now we have become like merchandise, slaves to a bunch of Bedouin who have no appreciation for our urban civilization (Salamandra, 2006)

Islamization

Many Syrian drama creators, long critics of the Ba'thist regime and its erstwhile socialist policies, now express nostalgia for secular socialism, eliding the conservative Islam of the Gulf ruling elites and the political Islam of movements such as the Muslim Brotherhood as forces against art and progress. Yet such forces have gained legitimacy as anti-imperial expressions of authentic Arab modernity. In much of the Arab world, notions of cultural authenticity are increasingly conflated with Islam. In contemporary Arab intellectual discourses, authenticity, *asala*, is associated with religion, and with revivalist Islam in particular, where it refers to fundamentalism in the literal sense, to a return to a pure Islam of scripture, of Qur'an and *hadith*, and the era of the Prophet Muhammad (Kubba, 1999, p. 132). The conflation of authenticity with religion is a hallmark of Arab modernity, and marks a shift in 20th century Islamic thought from the jurisprudential to the cultural and symbolic. The "clash of civilization" (Huntington, 1998) discourse prevails, and Arab intel-

lectuals—including television creators—face pressure to defend their secular viewpoints against charges of Westernization. They have adopted a range of strategies to reconcile Islamic authenticity with their own secular proclivities.

A few directors address religion directly, distinguishing a "true" Islam from fanaticism. Hatim Ali's *Unable to Cry* of 2005 treats Islamic revivalism, implicitly criticizing the perceived rigidity of the Qubaisiyat, a Syrian network of women's prayer groups. Najdat Ismail Anzour broaches the timely topic of religiously-inspired suicide bombings with *The Beautiful Maidens (al-Hur al-'Ayn)* of 2005 and *Renegades (al-Mariqun)* of 2006. Treatment of current events marks a departure for Anzour, who created the popular "fantasy" *(fantasiyya)* genre, fantastical adventure stories "with no time or place" *(la makan wa la zaman)*, in the late 1990s.

Much of the hype surrounding the fact-based *Beautiful Maidens*, in the Arab and Western media and in conversations among TV creators and critics, revolved around its terrorism subplot. Its condemnation of militant Islam echoes that of the Saudi state. Yet the series also levies a powerful critique of Saudi society and its treatment of foreign Arabs, particularly women. Anzour describes the claustrophobic environments to which non-Saudis working in Saudi Arabia are relegated:

> The first idea that came to my mind is the episode that occurred in Saudi, the attack on the residential building. I felt that the expatriates living in the Gulf countries, and especially in Saudi Arabia, are not able to integrate completely into Saudi society. They can't become part of the society, but live in special compounds *(kantunat)*, in closed communities, to a certain extent. There are no inclusive social relations between the Arab expatriates and the Saudi citizens (personal communication, December 27, 2006).

Anzour reveals a claustrophobic world of highly educated, upper-middle-class women who have left university study and successful careers in Jordan, Egypt, Syria, Lebanon and Morocco to accompany their husbands to the Saudi kingdom, where restrictions on women in public life exceed those of any other Arab or Muslim majority nation. Most scenes take place in the luxurious yet sterile apartment complex to which the wives are largely confined. Pampered yet bored, deprived of meaningful work and intellectual stimulation, torn from family support networks, they pester their husbands and turn on each other. The hothouse environment renders wives vulnerable to husbands' physical and emotional abuse.

A series of car bombings forms a menacing backdrop to ongoing warfare in and among the cloistered families of *The Beautiful Maidens*. Infighting extends to the workplace, where sociopaths like the Syrian engineer Samer find a niche to mistreat coworkers and conduct shady business deals. One thread fol-

lows an antiterrorism poster campaign commissioned by Samer's company, in which Lebanese artist Jamal educates his employers in the semiotics of shape and color, signifying both Arab creative potential, and the Arab world's inability to nurture its talent. In order to work, Jamal, like his neighbors and colleagues, must endure *ghurba*, a stifling exile. His wife 'Abir paints colorful canvases within the confines of their apartment, and dreams of the world beyond.

The Saudis' polished professionalism after the housing complex is attacked tempers this critique. A suspect is rapidly arrested, and humanely treated. An investigator insists on time consuming, rapport-building interrogation methods despite pressure from his superiors, and treats his family with affection and respect. His inquiry uncovers links to the Afghan mujahadin and drug running, thus implicating United States foreign policy and undermining the militants' claim to moral authority.

The Beautiful Maidens draws on an historical event: the 2003 al-Qaeda-linked bombing of an expatriate compound in Riyadh. In other televisual treatments of terrorism, would-be evildoers are thwarted or, more often, have a change of heart before carrying out their deeds, and adopt a more liberal interpretation of Islam in the end. Here a secular critique of Islam is itself Islamized (Salamandra, 2008).

Another strategy invokes the past, aestheticizing Islam as costume history, or folklorizing it as bygone tradition. Big-budget historical epics set in the golden ages of Islamic Empire combine elaborate period sets, luxurious costumes, and extra-filled battle scenes with themes of good and evil, Muslim community against foreign enemy. Yet by invoking al-Andalus (Islamic Spain), as director Hatim Ali has in *Hawk of the Quraysh* (*Saqr Quraysh*) of 2002, *Cordoba Spring* (*Rabi' Qurtuba*) of 2003, *Petty Kingdoms* (*Muluk al-Tawa'if*) 2005, and *The Fall of Granada* (*Suqut Gharnata*) of 2007, drama makers recreate a cherished instance of Muslim tolerance. This use of history allows drama to reconfigure a cosmopolitan disposition in Islamic terms. Ali argues:

> I think we are on the brink of a true war of civilizations, one that is not limited to a battle of ideas, but is about to develop into a confrontation with traditional and probably not traditional weapons, in the future. In light of this, I began a project about the rise of the Andalusian state, which is probably a unique, exceptional experiment in the history of human kind, were you found, in one place on earth, Muslims of all ideologies, ideas, and aspirations, with Christians—the original inhabitants of the land, and Jews. The presence of all of these in one place, in a democratic atmosphere, in a dialogue of civilizations, enabled the establishment of one of the most important human civilizations, the Andalsuian civilization, which was, I think, the gate through which Greek civilization entered what is Europe today (personal communication January 7, 2007).

Najdat Anzour adopts a similar approach in *Ceiling of the World* (*Saqf al-'Alam*) of 2007, contrasting reactions to the recent Danish cartoon controversy with 10th century Arab explorer Ahmad ibn Fadlan's journey to Europe, a tale of Muslim tolerance. Here a Syrian student at the University of Copenhagen abandons her Ph.D. research to write a screenplay about the medieval Arab traveler. She hopes to remind Arab audiences, and especially supporters of violent anti-Danish protests, of a time when Muslim cosmopolitans helped civilize a backward, barbaric Europe.

Series set in the more recent past take a folkloric turn, celebrating the customs and traditions of the Damascene *hara*, the old city quarter. Director Bassam al-Malla employs this strategy to great success in *Bygone Days* (*al-Khawali*) of 2001, *Salhiyya Nights* (*Layali Salhiyya*) of 2004, and *The Neighborhood Gate*, (*Bab al-Hara*) Parts I-IV of 2006–2009. Al-Malla romanticizes an era at the cusp of living memory, with Old Damascus stock characters—barbers, merchants, storytellers, midwives, hummus sellers—slice-of-life depictions of antiquated customs and traditions, and valiant acts of anti-colonial resistance. The *hara*, the old city neighborhood, appears a utopia of social integration and mutual assistance, where disputes are settled amicably, and class differences barely ruffle the surface. Neighbors stand behind the leader they recognize, the *za'im*, and scorn France's well-armed representatives. They also pool resources to aid resistance fighters camped on the outskirts of the city, whose appearances are accompanied by heroic musical strains. Al-Malla's treatments have become ever more Islamized: imams grow more prominent, and call-to-prayer scenes recur, and the city's role as a major stop on the *haii* (pilgrimage) route to Mecca is highlighted (Salamandra, 2008). Yet by associating Islamic references with a bygone era al-Malla's work betrays a secularist agenda; making the *hajj* becomes, like wearing a fez or riding a donkey, an antiquated practice. Religion is valorized, yet safely relegated to an idyllic past.

"Our Problems"

Nostalgic historical projects, and those channeling contemporary Islamist sentiments into state-sanctioned forms, attract large-scale funding from private and public GCC sources—primarily Saudi and United Arab Emirati—and international media attention (Abu-Nasser, 2005; Aji, 2006; Slackman, 2006). Yet within the contested field of Arab cultural production, their creators face accusations of pandering to what screenwriters Mazen Bilal and Najib Nusair call "prevailing values in the societies of the oil states" (1999, p. 8). Contemporary social drama with little Islamic reference—a time-honored, much-loved *musalsal* genre—is increasingly difficult to finance, as Syrian state

involvement in production shrinks, and regional market forces prevail. Syrians continue to produce such series, often drawing on the strength of a few successful directors and writers. They struggle to win airtime on pan-Arab networks. Paradoxically, their *musalsal-s* addressing "our problems," as viewers put it, find mass audiences in Syria and beyond.

Damascus is known as the birthplace and "beating heart of Arab nationalism" (*qalb al-'uruba al-nabid*), and many Syrian television makers still cling to Arab socialist ideals. The senior generation, including esteemed directors Haytham Haqqi, 'Ala' al-Din Kawkash, and Ghassan Jabri, were trained in the former Soviet Union or Eastern Bloc nations and passed on a social realist aesthetic to their young apprentices, who have transformed it with fast-paced, slick camera work and higher production values. The form is considerably updated; the social concern remains central. Social dramas often take the state to task—usually gingerly, sometimes openly—for not living up to its social welfare rhetoric. In Syrian *musalsal-s* aired during my fieldwork period, Ramadan 2006, marginality—both social and physical—formed a significant theme. *Echo of the Soul* (*Sada al-Ruh*), portrayed patients in a humanistic experimental psychiatric facility. The protagonist, a young doctor returning from a residency in Great Britain, uses the prestige of his European training to transfer patients to a beautiful terraced mansion, where the life stories he uncovers reflect the social and political traumas of recent Arab history. *Open Courtyard (Fusha Samawiyya)* sheds sympathetic light on another group of outcasts: single adults. Divorced women, struggling artists, impoverished bachelors build an unlikely family in their shared Old City house. In a central thread, Syria's Ottoman-derived, Islam inspired personal status law, which grants fathers custody of boys from the age of thirteen and girls from fifteen, is taken to task. Both series show complex, endearing characters facing—and more rarely overcoming—social and economic hardship.

Two series depicted the alienating poverty of the informal settlement, a pet cause for reform-minded scriptwriters. Damascus is largely absent from the scholarly literature on shantytowns, and is rarely invoked in discussions of urban blight. Yet an estimated 40% of Damascus dwellers live in "haphazard neighborhoods" (*al-harat al-'ashwa'iyya*) as they are referred to in Arabic (UNEP, 2006, p. 32; UNECOSOC, 2008). Also called *mukhalafat*—literally: violations—these informal, often illegal settlements share the afflictions of (sub)urban poverty in much of the Global South: deficient infrastructure, crowding, hazardous construction, inadequate services, unemployment, and crime. Like informal districts elsewhere, they house recent migrants from the countryside, a phenomenon signaled in drama through rural dialects, clothing, and the drinking of mate, a practice brought by emigrants returning from late Ottoman-era sojourns in Latin America. For many, these settlements that

"encircle Damascus like a bracelet," as one screenwriter put it, have become not a first stop to urban integration, but barriers to upward, or inward, mobility. Drama makers depict haphazard neighborhoods as sites of crime and social dissolution, in contrast to traditional or popular quarters (*harat sha'abiyya*) that are associated with high moral values and contiguous social relations. They are shown not as enduring tradition, but as a product of state corruption and neglect.

Syrian drama confronts audiences with the consequences of neoliberal policies in stark social realism. On-location filming distinguishes the Syrian industry from its studio-based Egyptian counterpart; series set in poor neighborhoods require months of filming in narrow, crumbling alleyways and tiny dilapidated houses. They bring drama makers and their audiences into intimate contact with what are, for most middle class Syrians, dangerous nether regions on the margins of consciousness. In Rasha Sharbatji's *Gazelles in a Forest of Wolves* (*Ghazlan fi Ghabat al-Dhi'ab*), the cottage industries of an informal economy prove as haphazard and precarious as the settlement itself. In one telling scene, a young woman carries her hollowed-out zucchini to market, to sell—through a middleman—to middle class women, who stuff them with meat and rice, and call them their own. A cyclist, balancing a tray of food on his head, wobbles his way through the crowded neighborhood knocks her to the ground, smashing her vegetables and destroying days of labor. The Sisyphean struggle to carve out a secure existence renders settlement dwellers vulnerable to power and corruption. This arrives in the form of a prime minister's delinquent son. Behind the smoky windows of his silver Mercedes, Samir prowls the neighborhood, finding easy prey among youth seeking a way out of poverty and social stigma. These struggling university students face an unpromising future; and a powerful patron seems to offer a leg up. Yet like the political system itself, Samir takes without giving: in the end, his lackeys get no more than a broken hairdryer in return for their pandering.

The second series depicting (sub)urban poverty, *Waiting* (*al-Intizar*), forms the focal point of my fieldwork. The script's co-authors, journalist Najib Nusair and novelist Hassan Sami Yusuf are Syria's highest paid screenwriters. Sought after by producers and directors, their screenplays focusing on "our problems," as Syrian viewers put it, command critical respect and loyal followings. After a decade of screenwriting, the pair has garnered a reputation for artistic "depth" (*'umq*). Directed by Laith Hajjo, best known for his biting satirical comedy sketch series *Spotlight* (*Buq'at Daw'*), *Waiting* revolves around a Robin Hood figure and a low-level journalist. Both are sons of the haphazard *hara*, neighborhood, in which most of the action takes place. Episode one begins with a pulsating set of establishing images taking viewers from the heart of elite downtown Damascus, through increasingly downscale

areas, and finally out to the dilapidated suburb of Dweila'a. Here 'Abbud, a foundling whose house the camera never visits, robs clothing from boutiques in the city's wealthy districts and distributes it among his neighbors in the dead of night. Two orphaned brothers eke out a living polishing middle class floors; one leaves to make his fortune in Dubai, but returns with little more than cosmopolitan pretensions and curry recipes. Their next door neighbors, the four beautiful daughters of vegetable seller Abu Asad, try different paths out of Dweila'a, but marriage, prostitution and affairs with wealthy married men all backfire. Journalist Wa'il remains loyal to the low-paying state newspaper; his wife Samira urges him to try al-Jazeera. His socialist ethos appears delusional. Given results of kleptocratic Ba'thist rule, and the harsh realities of economic liberalism, most *Waiting* characters, like so many urban Syrians, turn to the informal economy, as public sector employment shrinks, and private sector jobs require connections. Wa'il waxes romantic about the neighborhood's goodness and humanity; Samira rails against its dirt and danger, a position the series producers share, and underscore in the series' dramatic turning point. While playing soccer in the neighborhood's only available clearing—a rubble-strewn lot at the edge of a busy highway—the couple's youngest son is struck by a minivan and blinded.

The series' central concept is a myth of departure—most characters are waiting to move on from a neighborhood, and a state of being, they perceive as a mere way station to a better life; most, it is implied, will never leave. This frustrating limbo symbolizes what *Waiting's* creators see as the Arab condition. Self-improvement through education, the solution Arab drama of an earlier generation once offered, has lost credibility after decades of expanded university access has failed to stem growing levels of poverty and underemployment (Abu-Lughod, 2005a, 2005b). Bearing witness to abuse and suffering, and taking the system—often vaguely defined—to task, becomes a dramatic preferred strategy. Cynical Syrian intellectuals speculate, in hushed tones over coffee, that the "powers that be," (*al-sulta*) permit, even commission, such depictions to appear liberal, and at the same time remind viewers that resistance is futile (cooke, 2007).

Drama creators certainly do not perceive themselves as state mouthpieces. But they concede that all they can do is expose problems, suggest causes and provoke discussion. Rather than pointing to tradition or illiteracy, *Gazelles* and *Waiting* blame structural inequality, and the ruling elite that perpetuates it, for social and economic ills. The recourse to "illegality" among the weak is used to underscore the state violence of the powerful, in which nothing is haphazard. Power is exposed, resisted, but not overcome, in drama, as in Arab daily life. In *Gazelles* the villainous son, thought to have been murdered by a young woman he harasses, secretly survives, recovers abroad, and returns to Syria and

his dastardly ways. In *Waiting,* engagements are broken and marriages fail, a drug addict falls off the wagon, and ʿAbbud is murdered by a rival. Happy endings, it seems, are difficult for satellite era drama creators to envision.

Depictions of quotidian struggles in poor urban areas contrast ever more sharply with the heroic and the folkloric offerings crowding the Ramadan airways. Neither *Gazelles* nor *Waiting* won a coveted Ramadan time slot on any of the GCC stations, perhaps due to a delayed production schedule. Both appeared on Syria' state satellite station, and *Gazelles* was aired on the country's first private station, *Sham.* Both garnered an enthusiastic local following, and post-Ramadan rebroadcasts on stations such as MBC and Infinity met with positive reviews. Their 2006 Ramadan competition included MBC's celebratory biopic of Khalid bin al-Walid, a hero of the Islamic conquests, and part one of the folkloric Old Damascus tale *The Neighborhood Gate*. Here the broadcast flow undermines authorial intent. The juxtaposition of *Waiting*'s quiet desperation, and *Gazelle's* corruption, with the splendor of Islamic empire and the nobility of anticolonial struggle appears to buttress the Islamist cause. Contemporary social dramas do not paint pretty pictures. Collectively, Syrian drama contrasts a degraded present with a magnificent past.

Drama creators are aware of this contradiction, yet remained committed to exploring social issues, however they fall in the broadcast flow. They see themselves as artists first, but maintain an activist role, however obliquely. As *Waiting*'s director Laith Hajjo puts it:

> Drama has a responsibility on all levels: social, political and economic. It doesn't solve problems; it exposes them. I never think of myself as a social reformer, that's not my task. Art was never intended to reform society or fix its problems, but to shed light those problems, to point to them, however small, so that people will begin to ask why, and try to solve them. Without this function, art is, in my opinion, vacuous and insignificant (personal communication October 17, 2006).

Conclusion

Series like *Waiting* and *Gazelles* are subject to levels of censorship from governments (Syrian and GCC) and television stations. Drama makers are neither entirely controlled, nor completely free. They try to exploit, and their censors seek to curtail or co-opt this limited autonomy. Each Ramadan creators and broadcasters push the limits; states, Islamists and others attempt, with varying degrees of success, to rein them in (Worth, 2008). Fearing this margin of freedom, the Arab League—an association of largely authoritarian Arab states—produced a charter calling upon media makers to show "respect for the dignity and national sovereignty of states and their people, and refraining [sic]

from insulting their leaders or national and religious symbols" (League of Arab States, 2008).

Critical treatments of politics, society and religiosity continue to surface through layers of interference. Syrian drama creators have a prominent podium from which to speak; yet their voices join a cacophony, a swollen televisual flow that threatens to drown them out. They address, often daringly, the challenges they and many Arabs now face. Drama creators continue to critique the conditions of neoliberalism, in which they believe collective welfare gives way to individual ambition, and the disrupted social relations and frustrated ambitions of the haphazard neighborhood become ubiquitous. As *Waiting*'s screenwriter Najib Nusair puts it:

> Today, society is like any piece of cake, if everyone takes a bite, eventually that's it, it all goes, is lost. Meaning individual salvation destroys society more than crime, and other things that are illegal. Individual salvation in society is like someone taking his piece from the society, and then letting it burn. *Insha'allah* it will burn, it's nothing to us (personal communication, July 19, 2006).

Drama series and their makers reflect and critique the condition of contemporary Arab societies. The waning of socialism, the rise of Islamism, and the unconvincing promise of political participation produce a sense of ambivalence and uncertainty that media makers share with the wider Arab world. The tensions these forces engender emerge in the discourses of industry professionals, in the dramas they produce, in the media debates surrounding them, and in their reception by a global Arab audience. Drama creators both accommodate and resist the neoliberal and Islamic revivalist currents that are reshaping Arab public culture. They strive to maintain artistic integrity and promote social and political transformation, but they must do so through the very institutions and structures they seek to reform. Here television drama provides a valuable point of access not only into the politics of Arab cultural production, but also into the wider complexities and contradictions of Middle Eastern modernity.

References

Abu-Lughod, L. (1993). Finding a place for Islam: Egyptian television serials and the national interest. *Public Culture, 5*, 493–513.

Abu-Lughod, L. (1995). The objects of soap opera. In D. Miller (Ed). *Worlds apart: Anthropology through the prism of the local* (pp. 190–210). London: Routledge.

Abu-Lughod, L. (1998). The marriage of feminism and Islamism in Egypt: Selective repudiation as a dynamic of postcolonial cultural politics. In L. Abu-Lughod (Ed.), *Remaking Women: Feminism and Modernity* (pp. 243–269). Princeton, NJ: Princeton University Press.

Abu-Lughod, L. (2003). Asserting the local as the national in the face of the global. The ambivalence of authenticity in Egyptian soap opera. In A. Mirsepassi, A. Bassu & F. Weaver (Eds.), *Localizing knowledge in a globalizing world: Recasting the area studies debate* (pp.101–127). Syracuse, NY: Syracuse University Press.

Abu-Lughod, L. (2005a.). *Dramas of nationhood: The politics of Television in Egypt.* Chicago, IL: University of Chicago Press.

Abu-Lughod, L. (2005b.). On- and off-camera in Egyptian soap operas: Women, television and the Egyptian sphere. In F. Nouraie-Simone (Ed.), *On shifting ground: Muslim women in the global era,* pp. 17–35. New York, NY: The Feminist Press at City University of New York.

Abu-Nasser, D. (2005, October 11). Anti-terrorism TV show assailed by some Arabs. *Seattle Times.* Retrieved from http://community.seattletimes.nwsource.com/archive/?date=20051011&slug=syria11

Aji, A. (2006, September 26). Syrian director faces death threats. *Washington Post.* Retrieved from http://www.washingtonpost.com/wpdyn/content/article/2006/09/26/AR2006092600643.html

Ambah, F. S. (2008 a., August 3). Subversive soap roils Saudi Arabia, *Washington Post,* A17.

Ambah, F. S. (2008 b., September 27). Young Saudis reinvent Ramadan, *Washington Post,* A13.

Armbrust, W. (1996a.). *Mass consumption and modernism in Egypt.* Cambridge,MA: Cambridge University Press.

Armbrust,. W. (1996b.). The white flag. *Mediterraneans, 8/9,* 381–391.

Bilal, M. & Nusair, N. (1999). *Syrian historical drama: The dream of the end of an era (al-drama al-tarikhiyya al-suriyya: Hilm nihiyat al-'asr).* Damascus: Dar al-Sham.

cooke, m. (2007). *Dissident Syria: Making oppositional arts official.* Durham, NC: Duke University Press.

Dick, M. (2005). The state of the musalsal: Arab television drama and the politics of the satellite era. *Transnational Broadcasting Journal, 15.* Retrieved from http://www.tbsjournal.com/Archives/Fall05/Dick.html

Hammond, A. (2008, September 15). Unholy row as Saudi clerics slam Ramadan TV. *Reuters.* Retrieved from http://uk.reuters.com/article/televisionNews/idUKLC20580020080915

Huntington, S. P. (1998). *The clash of civilizations and the remaking of the world order.* New York, NY: Simon & Schuster.

Kraidy, M.M. & Khalil, J.F. (2009). *Arab television industries.* London: Palgrave Macmillan and British Film Institute.

Kubba, L. (1999). Towards an objective, relative and rational Islamic discourse. In R. Meijer (Ed.), *Cosmopolitanism, identity and authenticity in the Middle East* (pp. 129–144). London: Curzon.

League of Arab States. (2008). *Arab League satellite broadcasting charter.* Unofficial English translation. *Arab Media and Society.* Retrieved from http://www.arabmediasociety.com/?article=648.

Salamandra, C. (1998). Moustache hairs lost: Ramadan television serials and the construction of identity in Damascus, Syria. *Visual Anthropology, 10*(2–4), 227–246.

Salamandra, C. (2000). Consuming Damascus: Public culture and the construction of social identity. In W. Armbrust (Ed.), *Mass mediations: New approaches to popular culture in*

the Middle East and beyond (pp. 182–202). Berkeley, CA: University of California Press,

Salamandra, C. (2004). *A new Old Damascus: Authenticity and distinction in urban Syria.* Bloomington, IN: Indiana University Press.

Salamandra, C. (2005). Television and the ethnographic endeavor: The case of Syrian drama. *Transnational Broadcasting Studies, 14,* 1–22.

Salamandra, C. (2008). Creative compromise: Syrian television makers between secularism and Islamism. *Contemporary Islam, 2*(3), 177–189.

Slackman, M. (2006, July 6). Damascus journal: For Ramadan viewing, a TV drama against extremism. *New York Times.* Retrieved April 1, 2008 from http://www.nytimes.com/2006/07/06/world/middleeast/06syria.html?_r=1&scp= 1&sq=damascus%20journal%20for%20ramadan%20viewing&st=cse&oref=slogin

United Nations Development Programme, Arab Fund for Economic and Social Development. (2003). *The Arab human development report 2003: Building a knowledge society.* New York: United Nations Publications. Retrieved from http://hdr.undp.org/en/reports/regionalreports/arabstates/name,3204,en.html

United Nations Economic and Social Council. (2008). Press Release: UN ECOSOC regional meeting on sustainable urbanization opens in Bahrain. Retrieved from http://www.un.org/en/ecosoc/newfunct/amrregpr.shtml

United Nations Environment Programme. (2006.) *Geo yearbook 2006.* Nairobi: United Nations Environment Programme.

Weyman, G. (2006). *Empowering youth or reshaping compliance? Star Magazine, symbolic production, and competing visions of shabab in Syria.* M.Phil Thesis in Modern Middle Eastern Studies, University of Oxford.

World briefing: Middle East. Saudi Arabia: Clean TV shows, or else. (2008, September 13). *New York Times,* p. A8.

Worth, R. F. (2008, September 27). Arab TV tests societies' limits with depictions of wine, sex and equality. *New York Times,* p. A6.

Contributors

Melixa Abad-Izquierdo is a doctoral candidate in the Dept. of History, Stony Brook University. Her research focuses on Mexican television and Latin American cultural industries.

Courtney Brannon Donoghue is a doctoral candidate and Assistant Instructor in the Dept. of Radio-Television-Film at the University of Texas—Austin. Her research includes global communication.

Daniela Cardini is Lecturer in Television Studies at IULM University, Milano, Italy. She examines soap opera production, reception, and globalization of television markets.

Mari Castañeda is Associate Professor in the Dept. of Communication and the Center for Latin American, Caribbean, and Latino Studies at the University of Massachusetts, Amherst. Her research includes political economy of global communication, and Latina/o media studies.

Héctor Fernández L'Hoeste is Associate Professor in the Dept. of Modern and Classical Languages at Georgia State University, Atlanta, GA. He directs the Center for Latin American and Latino/a Studies (CLALS) at Georgia State. His research includes Latin American cultural studies.

Robert Forbus is Assistant Professor in the School of Business at Central Connecticut State University, where he teaches business communications. His research includes television advertisements.

Tamar Ginossar is Research Assistant Professor in the Department of Communication and Journalism, and the School of Medicine at the University of New Mexico. She specializes in community-based participatory research and health disparities.

Jaime S. Gómez, is Professor in the Dept. of Communication at Eastern Connecticut State University. His research includes media aesthetics, production, and information technologies in education. He is an award winning documentary producer and director.

Petra Guerra is Assistant Professor in the Dept. of Communication at the University of Texas-Pan American. Her research and teaching includes public relations, health communication, and campaigns.

George Ngugi King'ara is a doctoral candidate in Media Studies at CCMS, University of KwaZulu Natal, South Africa. He teaches broadcast journalism and screenwriting in Daystar University, Kenya.

Soo Young Lee is Associate Professor at Sogang University. Digital media is her research focus. Her research includes health communication via the Internet and social network services such as Facebook.

Catherine Medina, is Assistant Professor in the School of Social Work, Puerto Rican/Latino Studies Project at the University of Connecticut. Her research covers HIV, health disparities, and social change.

Wazhmah Osman is a doctoral candidate in the Dept. of Media, Culture and Communication at New York University.

Sung-Yeon Park is Assistant Professor at Bowling Green State University. Her teaching and research includes media, gender and culture, and intercultural/international communication.

Martin Ponti is a doctoral candidate in the Spanish, French, Italian, and Portuguese Department at the University of Illinois-Chicago. His research addresses Latino and Latin American melodramatic production.

Cacilda M. Rêgo is Associate Professor in the Dept. of Languages, Philosophy and Speech Communication at Utah State University. She conducts research on Brazilian film and television.

Diana I. Rios is Associate Professor in the Dept. of Communication Sciences and the Institute for Puerto Rican and Latino Studies (IPRLS). She is interim director of IPRLS. Her research focuses on ethnicity, race, gender and sexuality in mass media and cross-cultural processes.

Christa Salamandra is Associate Professor of Anthropology at Lehman College, City University of New York. Her research includes Arab television drama production in Damascus and Dubai.

Belkys Torres is a doctoral candidate at the University of Notre Dame and adjunct professor at Miami Dade College. She specializes in U.S. Ethnic Literature, Latina/o Literature, and Feminist Theory.

Gi Woong Yun is Associate Professor at Bowling Green State University. His Internet research interests include selective posting online, newspaper online business models, and online media framing.

Index